DRAWI

A COMPLETE GUIDE

Nature

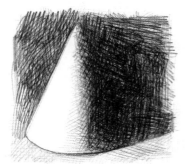

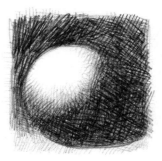

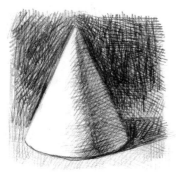

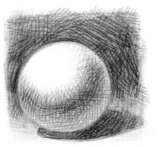

First published in Great Britain in 2021
Search Press Limited
Wellwood, North Farm Road,
Tunbridge Wells, Kent TN2 3DR

Reprinted 2023, 2024

Based on the following books in The Art of Drawing series by
Giovanni Civardi, published by Search Press:
Drawing Scenery (2002)
Drawing Light & Shade (2006)
Drawing Techniques (2007)
Flowers, Fruit & Vegetables (2011)
Drawing Pets (2012)
Understanding Perspective (2012)
Wild Animals (2013)

All titles originally published in Italy by Il Castello Collane
Techniche, Milano

Copyright © Il Castello S.r.l., via Milano 73/75, 20010
Cornaredo (Milano) Italy

English translations by Linda Black, Julie Carbonara, Paul Enock,
Burravoe Translation Services and Cicero Translations.
English translation copyright © Search Press.

ISBN: 978-1-78221-880-7
ebook ISBN: 978-1-78126-849-0

Suppliers
If you have difficulty in obtaining any of the materials
and equipment mentioned in this book, then please visit
the Search Press website for details of suppliers:
www.searchpress.com

MIX
Paper | Supporti
responsible forest
FSC® C01252
www.fsc.org

DRAWING

A COMPLETE GUIDE

Nature

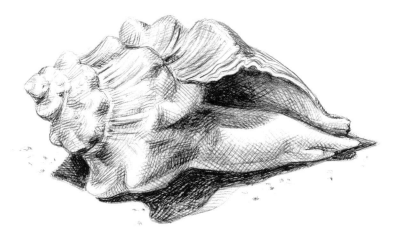

Giovanni Civardi

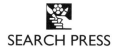

SEARCH PRESS

CONTENTS

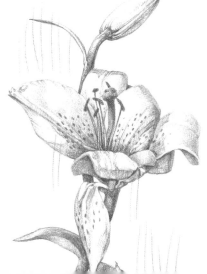

DRAWING
TECHNIQUES

INTRODUCTION

Drawing was one of the first means of expression and representation invented by man when he drew on the walls of prehistoric caves, and it is still extremely valid, both as an artistic representation of reality and as a means of expressing pure imagination. To be able to draw means, above all, to be able to 'see', to understand rationally, to feel emotions, and to master the techniques which allow us to fully express our thoughts and moods.

This first chapter focuses on the main drawing media, with some small details on what effects can be achieved with them. There are plenty of manuals which deal extensively with drawing materials and how to use them, but my teaching experience has taught me that, initially, those who are new to drawing need comprehensive and simplified information on the most common media and on the results which can be achieved with each. Furthermore, techniques on how to use them can be learnt through experimentation, practice and constant application (although throughout the rest of this book, I shall endeavour to show some methods for working with the materials explored in this chapter to draw subjects accurately). Personal choices and mastering the subject can come later, when necessary, as there is no point in anticipating ideas or making suggestions which would not be acted upon or, worse, could dishearten if given too soon.

The example drawings shown throughout this chapter represent different periods in my career and should not be taken as examples of a drawing style to imitate, but simply as an indication of the purely technical results which can be achieved with the various graphic media. Moreover, they are all of a highly figurative nature – many decidedly academic – as they are easier and more useful subjects to study to begin learning to draw from life. But don't stop here: as soon as you feel comfortable with the various media and how to use them, try to go beyond reality; that is, use them as a source of inspiration and stimulation which will put you in touch with your deepest feelings, and then communicate them by drawing. Bear in mind that, for the true artist, technique is indeed essential but only as a tool which, once mastered, must adapt to and serve your expressive needs.

MATERIALS AND EQUIPMENT

The materials and equipment used for drawing today are, essentially, those which have been used traditionally for centuries: pencils, pens, brushes, inks, papers, etc.. The diagram below features those which are indispensable when first starting to draw.

Drawing paper comes in many types, colours and qualities, each with distinctive characteristics which make it more or less suited to the different media techniques (for example, charcoal needs a rough surface, while pen flows more easily on smooth paper). To see the effect of different media on different surfaces, experiment with some of the examples opposite.

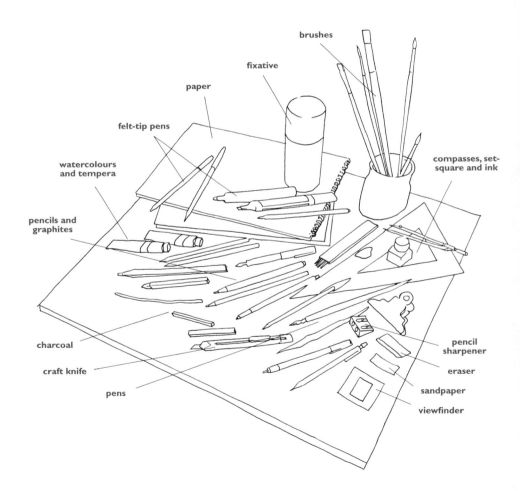

brushes

fixative

paper

felt-tip pens

watercolours and tempera

compasses, set-square and ink

pencils and graphites

charcoal

pencil sharpener

craft knife

eraser

pens

sandpaper

viewfinder

STROKES DRAWN ON SMOOTH PAPER WITH DIFFERENT MEDIA

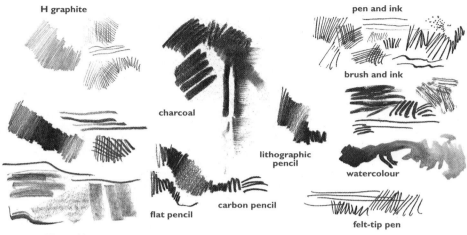

H graphite

pen and ink

charcoal

brush and ink

lithographic
pencil

watercolour

9B graphite

flat pencil

carbon pencil

felt-tip pen

STROKES DRAWN ON ROUGH PAPER WITH DIFFERENT MEDIA

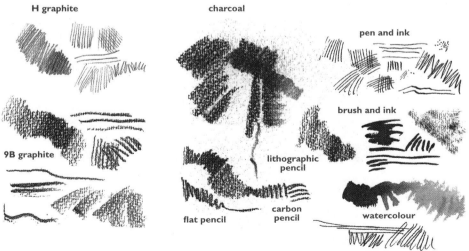

H graphite

charcoal

pen and ink

brush and ink

9B graphite

lithographic
pencil

flat pencil

carbon
pencil

watercolour

felt-tip pen

BASIC TECHNIQUES

THREE-STAGE MODEL

 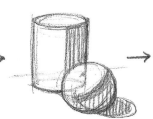 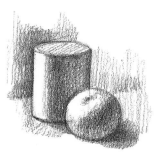

Stage 1 Suggest the relative proportions of the objects.

Stage 2 Determine the shapes, tracing the contours of the shaded areas.

Stage 3 Complete the form, emphasizing tonal values.

TONES

Tonal gradations (dark to light) can be achieved in different ways: by varying the pressure (examples **A** and **B**), by cross-hatching (example **C**) and by dilution (example **D**).

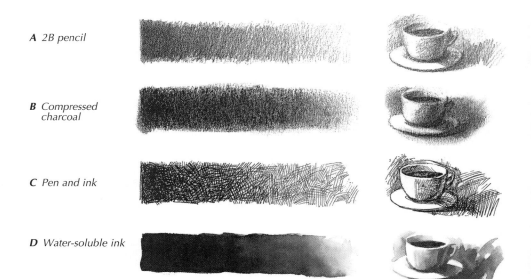

A 2B pencil

B Compressed charcoal

C Pen and ink

D Water-soluble ink

LIGHT AND SHADOW

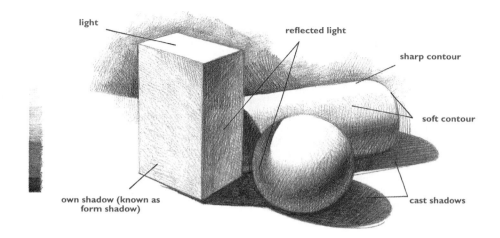

light

reflected light

sharp contour

soft contour

own shadow (known as
form shadow)

cast shadows

LINE AND TONE

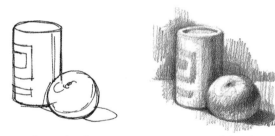

linear drawing

tonal drawing

CREATING TONES WITH HATCHING, CROSS-HATCHING AND OTHER TECHNIQUES

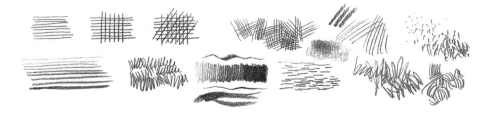

PENCIL AND GRAPHITE

Pencil is the most widely used drawing medium as it is cheap and versatile. Besides the traditional wood-encased pencils, there are other types of pencils: graphite or lead (thin sticks, held in mechanical clutch pencils); waxy, lithographic pencils; water-soluble pencils; flat, carpenter's pencils; and very thin (micro) leads, held in propelling pencils.

Graphites are graded in a decreasing scale from 9H (the hardest) to H, and in an increasing scale from B to 6B (the softest). Beyond this grade (up to 9B) graphites are made in thick sticks for easier handling. HB is the medium grade, neither too hard nor too soft. Hard graphites, also called 'technical' leads, draw faint, clean, even lines, while the soft types are more 'artistic' and accurately represent the different levels of pressure in freehand drawing. A drawing's dark tones can be achieved either by increasing the graphite's pressure on the paper, or by drawing increasingly close lines over one another at right angles (cross-hatching). Tones can be blended into one another by smudging with a finger, with a wad of cotton wool or with a rolled paper stump.

EXAMPLES ON MEDIUM-TEXTURED CARD

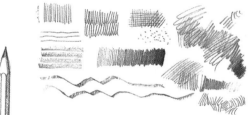
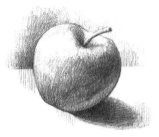

2H hard pencil or graphite

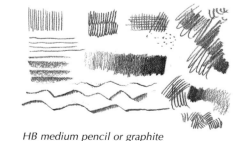

HB medium pencil or graphite

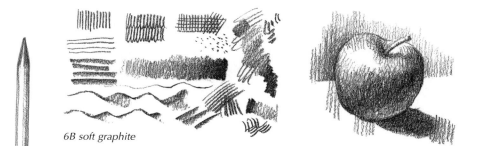

6B soft graphite

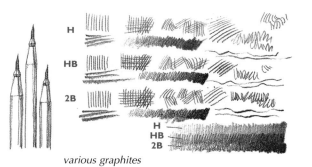
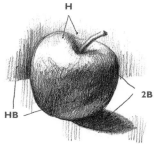

H

HB

2B

H
HB
2B

various graphites

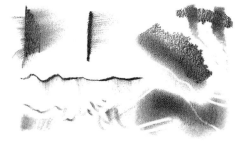
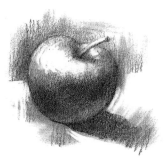

9B soft graphite and rolled paper stump

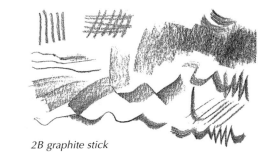

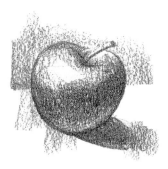

2B graphite stick

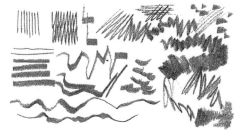

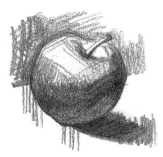

flat pencil

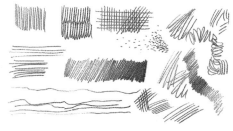

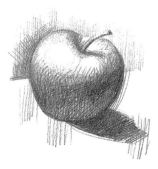

very fine lead

graphite dust and highlights added with an eraser

lithographic pencil

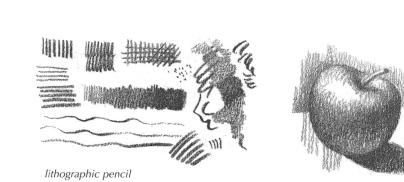

water-soluble pencil

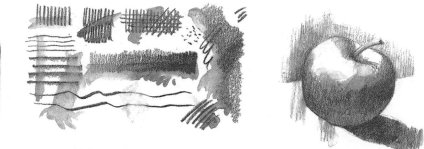

The drawing shown on this page
is a portrait study, done from life
on fairly smooth paper, 42 x 56cm
(16½ x 22in), using 2H pencil.
It's fairly linear in drawing style,
and a faint tonal grading has been
achieved with a combination of
intense and regular cross-hatching.
The hard pencil (which I have kept
well sharpened) has enabled me
to complete the drawing in quite
a pale tone showing little contrast,
and made more intense by using
increased pressure in places.

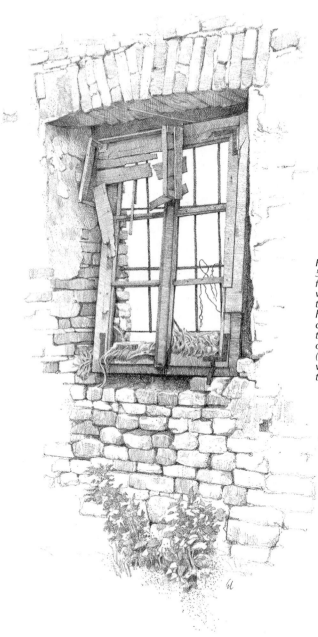

*H and 2H pencil on paper, 40 x
50cm (16 x 19½in).This is a study
for an etching. The cross-hatching,
with its even strokes, mimics the
traditional etching process, and
helped me solve some tonal and
compositional problems before
tackling the copper plate. Its size is,
of course, much smaller: 20 x 30cm
(8 x 12in). Dotting can be used as
well as hatching, as you can see at
the base of the wall.*

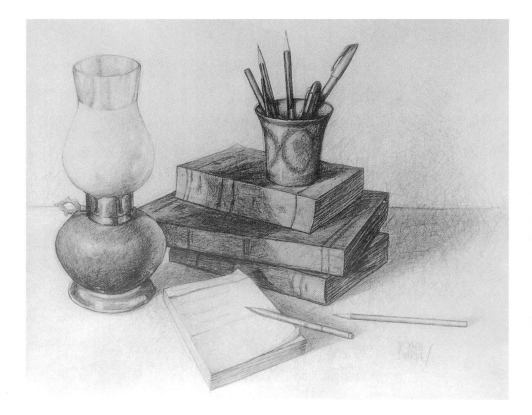

Lamp and Books (above) and Tools (opposite). Both are made with HB, 2B and 4B pencil on paper, 50 x 70cm (19½ x 27½in).

The two drawings shown on these pages are examples of the type of exercises you do early on in art school. The aim is to train students to observe reality and give them the opportunity to tackle simple problems of composition, perspective and chiaroscuro. Both drawings have been done by placing the paper vertically on the easel and 'giving shape' to the objects by using light, but irregular and fairly intense, cross-hatching. The monotony of some areas has been achieved by dotting, in this case by striking the sheet hard with the point of a soft pencil.

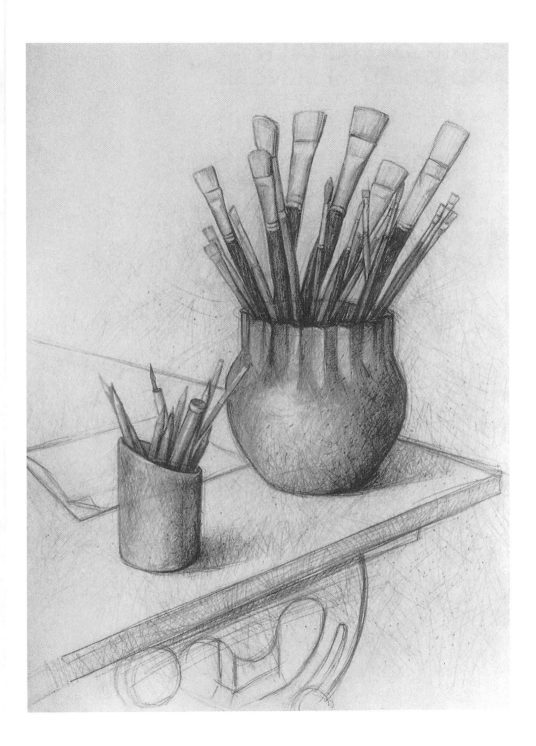

CHARCOAL, CHALK AND CARBON PENCIL

Willow charcoal is made by charring small twigs of willow: it is soft and leaves a dusty residue. Compressed charcoal (in stick or pencil form) is made from compressed coal dust and will give deep black strokes. Charcoal is ideal for fast, immediate drawings, with strong tonal contrast, but is less suitable for achieving minute detail. Smudging charcoal is even easier than graphite and the same methods are used, but be careful not to overdo it as you risk ending up with a drawing which lacks power, is photographic and structurally weak. Instead, it can be better to use a kneadable putty eraser to lighten or vary tones and 'carve' the lights. A type of charcoal often used for figure and landscape studies is 'sanguine', which has a particularly bright and warm colour.

EXAMPLES ON MEDIUM-TEXTURED CARD

 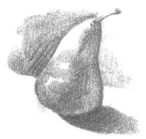

willow charcoal

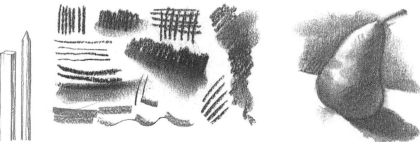

compressed charcoal

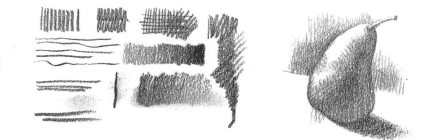

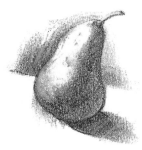

carbon pencil

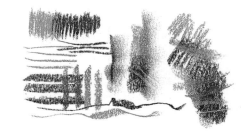

black, grey and white chalk

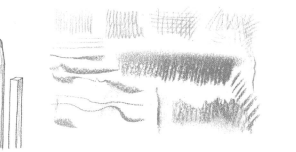

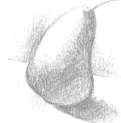

sanguine

21

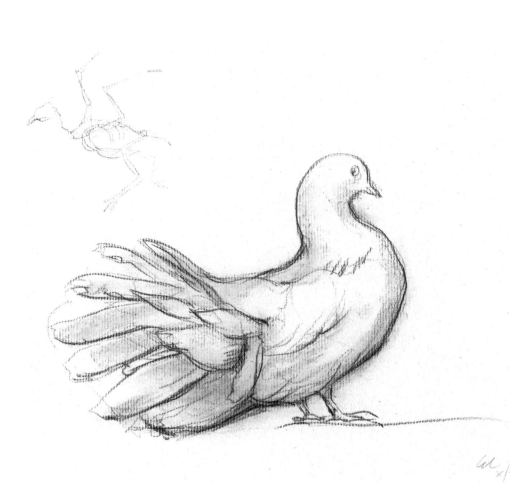

Even a simple sketch, a sort of visual note,
can be interesting and expressive. Practise
drawing quickly and concisely. First study the
subject's shapes and proportions carefully but
then be spontaneous and inquiring, and make
the drawing an interpretation rather than a
pedestrian and formal replica of the model.

For the small sketch at the top, I used a well-
sharpened carbon pencil. For the bottom sketch
I used sanguine for the medium tones and
compressed charcoal for the supporting lines, on
rough wrapping paper.

Willow charcoal and carbon pencil have been used for this drawing made on 45 x 55cm (18 x 21½in) smooth paper. I drew the outline of the flowers accurately in hard pencil (2H), keeping the pressure light as you can see on the right. I then worked on the chiaroscuro with the charcoal, smudging it with my fingers and some cotton wool. Finally, I adjusted tones and highlights with a kneadable putty eraser: I worked gently on leaves and flowers, then more markedly on the background contours. A few direct touches of carbon pencil have helped give some areas a more definite and sharp look.

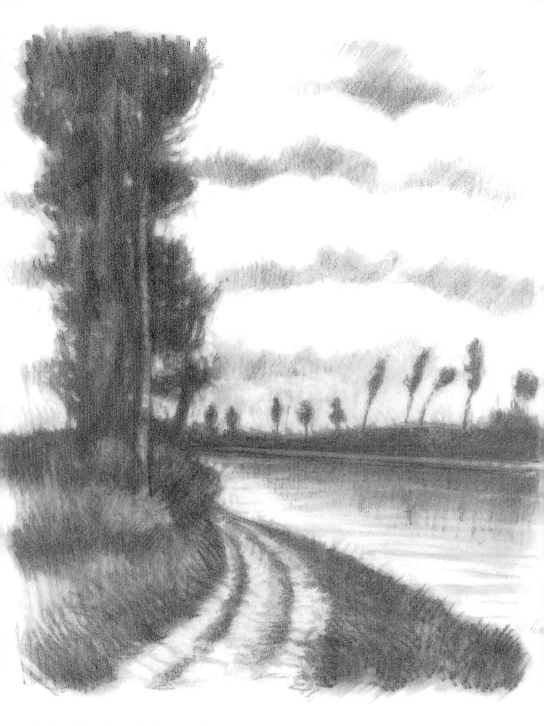

Lombardy Landscape. Carbon pencil on paper, 30 x 40cm (12 x 16in).

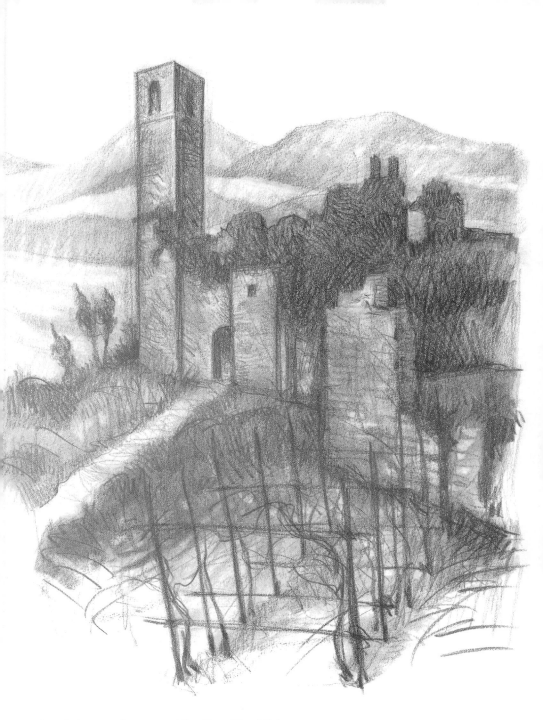

Ruins. Carbon pencil on paper, 30 x 40cm (12 x 16in).

INK

Although Indian ink (black or brown) is most commonly used for drawing, coloured and water-soluble inks, which spread when moistened with the tip of a brush, are also very useful. Ink drawings can be done with a variety of tools: nibs of different shapes and sizes; fountain pens; ballpoint or technical pens; and brushes and pointed bamboo reeds. It is better to use fairly heavy, smooth, good-quality paper. Dark tones are created by increasing the density of hatching, cross-hatching or dotting.

EXAMPLES ON MEDIUM-TEXTURED CARD

fountain pen

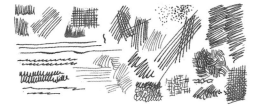

Indian ink and fine nib

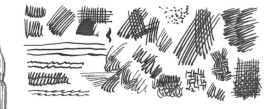

Indian ink and thick nib

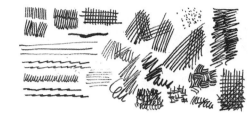

bamboo reed pen

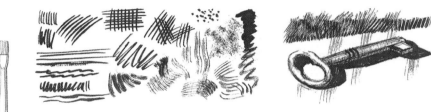

Indian ink and brush

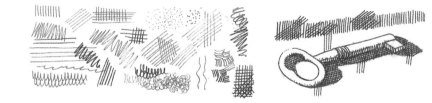

technical pen (0.2 to 0.6)

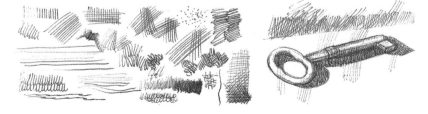

ballpoint pen

 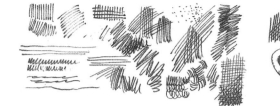 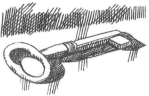

fine-tipped felt-tip pens

 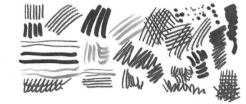 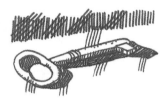

thick-tipped felt-tip pens

 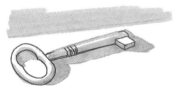

*felt-tip pens with chisel-shaped tips and
regular felt-tip pens*

pen, brush and water-soluble ink

Although the theme of these studies is not exactly cheerful, they were well-suited to a complex pen exercise in preparation for an etching. I used 35 x 35cm (14 x 14in) smooth paper and black Indian ink with three different nibs: very fine for the drawing on the right; slightly less fine for the one on the left and even less fine for the one below. I adjusted the chiaroscuro by way of short, close hatching, as well as cross-hatching of varying density. Be careful not to scratch the paper with the nib, especially where you want to add the more intense blacks (which should always remain somewhat 'transparent' and should not be too thick to avoid creating smudged marks).

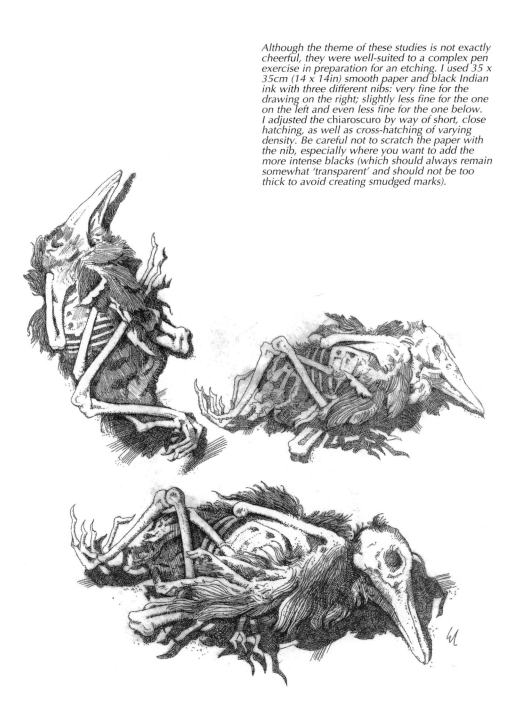

WATERCOLOUR, TEMPERA AND MIXED MEDIA

'Wet' techniques, in which inks or pigments are diluted with water, are widely used in artistic drawing. Although they are not, strictly speaking, 'graphic', they achieve a look which is closer to painting. Monochrome watercolours (usually in dark shades such as sienna and sepia) and water-soluble ink have been used for a very long time. When applied with a brush, directly or to complement a pen drawing, they enable you to achieve a wide range of tones and very smooth rendering. Mixed media is the simultaneous and combined use in the same drawing of different media.

The examples on the following pages show only some of the many possibilities, and I suggest you experiment to find your own, in sympathy with the aesthetic and expressive results you aim to achieve, and taking advantage of unintentional effects.

EXAMPLES ON MEDIUM-TEXTURED PAPER

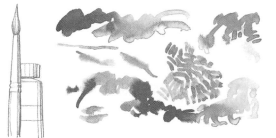
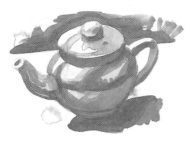

watercolour or water-soluble ink

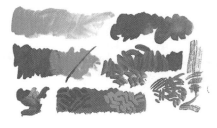
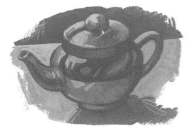

white and black tempera

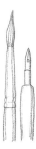 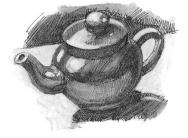

ink, acrylic, white tempera

 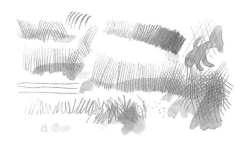 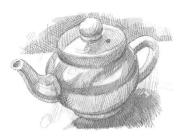

pencil and watercolour (or water-soluble ink)

 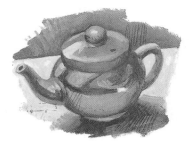

oil and carbon pencil

The examples shown here are drawings done
with mixed media, i.e. combining different
media to achieve particular graphic effects.
They are, therefore, slightly removed from the
traditional concept of 'drawing', but I have
included them here hoping that they will
encourage you to experiment.

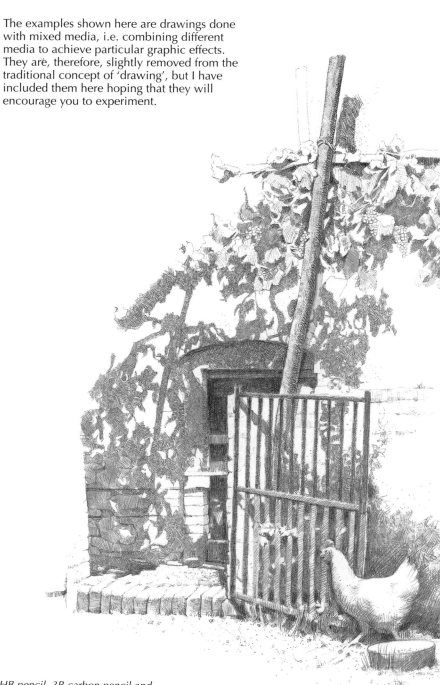

*HB pencil, 3B carbon pencil and
water-soluble ink on smooth card,
45 x 51cm (18 x 20in).*

Preliminary drawing in pen, tempera and sepia Indian ink on smooth card, 15 x 20cm (6 x 8in). The colour is partially removed with a small damp sponge.

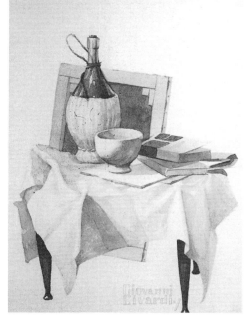

Monochrome grey watercolour applied with a round bristle brush (no. 8) on smooth card, 20 x 25cm (8 x 10in).

DRAWING FROM LIFE

To conclude this section I would like to share with you some drawings done by Vittorio Menotti, an engineer and amateur painter, in the early 1900s. They are an example of how the study of drawing was seen over a century ago, and compared to today's drawing you can see that methods have not changed much. Drawing from life (landscapes, people, still life) remains the main way of exploring techniques in order to master them, without worrying too much, initially, about aesthetic matters. Of course, tastes have changed: nowadays we appreciate immediate and impetuous drawing, rather than the 'academic' reproduction of reality; however, it is almost always worthwhile to go through this rigid experience before you can achieve a freer and more personal language.

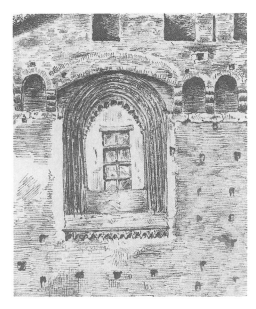 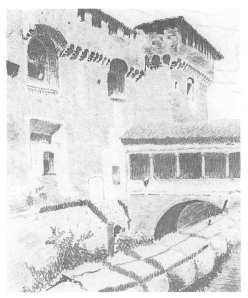

Window of the Sforza Castle, Milan. Pen and sepia ink on paper, 8 x 10cm (3 x 4in).

View of the Sforza Castle, Milan. Pen and sepia ink on paper, 9 x 11½cm (3½ x 4½in).

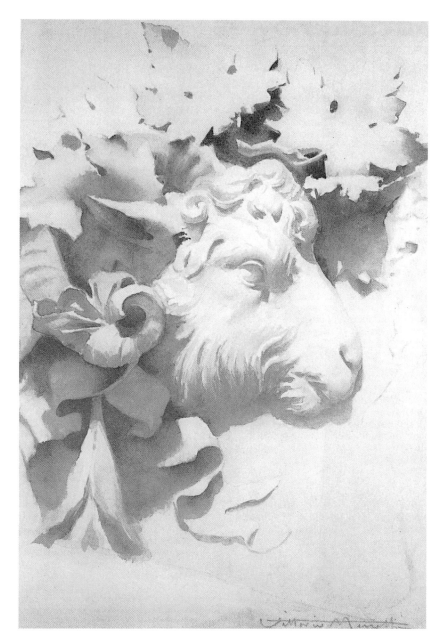

Ram. Grey water-soluble ink,
25 x 35cm (10 x 14in).

PRACTICAL ADVICE

LIGHTING

The quality of lighting and the surface on which one draws are very important for working comfortably. Studio lighting must be bright enough not to tire one's eyes, come from just one source (a window, if daylight, or a lamp if artificial) and its position must be such that it doesn't create ugly shadows on the page. When outdoors, avoid direct sunlight as this alters tonal relationships.

SUPPORTING YOUR DRAWING

The drawing surface ideally should be vertical, such as an easel, as this position reduces perspective distortion, and is suitable for drawing on a large-size sheet and studying the subject from life. More often you will work on tables of varying inclination. In both cases it is useful to have a seat set at the correct height to allow you to draw comfortably and, above all, to avoid incorrect positions which can be damaging to the body. Avoid, wherever possible, horizontal tables.

To draw from life outdoors, you will need a stiff folder or a small board to rest on your knees. If you use a sketchbook, you won't need any other support, otherwise you can fasten a sheet on to the board with some masking tape or pins. MDF, with its smooth surface, provides good support, but make sure you place a few sheets between it and your drawing paper (especially if you are using a pencil) to make the strokes less hard.

PAPER

Try various types of paper: smooth, rough, textured, coloured, of different thickness and weight. Pencil, especially if soft, and charcoal require rather rough and stiff paper; pens flow more easily on smooth non-absorbent paper; mixed media and diluted ink work better on fairly stiff card. Always choose the best quality paper you can afford as the mediocre or poor-quality type may indeed free you from the inhibition one feels when faced with a blank sheet (whereby we don't care if we waste it as it is cheap) but almost invariably yields disappointing results. For little sketches or composition studies you can use run-of-the-mill photocopy paper. However, what I said doesn't mean that you can't draw good sketches on wrapping paper or newsprint.

HOLDING A PENCIL

The way you hold the pencil (whether you are right- or left-handed) is strictly personal. The usual way to hold it is as if you were writing, but when drawing you should bear in mind a few things: hold the pencil (or pen, or brush) with your fingers not too close to the tip, at least 2.5cm (1in) from it, so that you control it well, both manually and visually; do not hold it too tight to avoid getting tired. When drawing it should be your wrist that moves, rather than just your fingers and it should be in a decisive motion; vary not just the pressure but also the angle of the pencil on the paper to achieve different degrees of thickness and variations in pencil strokes.

The usual holding position is comfortable only when drawing on a tilted plane, but it becomes difficult to maintain if the sheet you are working on is in a vertical position. In this case, especially with charcoal, the drawing tool can be kept in the hand, arm almost stretched, in a movement embracing the whole limb. You'll soon master these positions as they come fairly naturally; however, practise them in order to assume the correct pose from the start.

DRAWING WITH PENCIL

Pencils can be sharpened mechanically with an appropriate sharpener (besides the conventional blade sharpeners, table, hand-held or electrical types are also available), but the best way is to use a sharp knife to make a gradual taper to the lead giving it a long or short point. While a long point is fine for hard grade graphite, the soft grade type breaks easily even with light pressure and must, therefore, be supported by the surrounding wood. With a little practice you will learn to cut away the wood correctly. You can make the points of all types of graphites and charcoal very sharp by rubbing and rolling them on a strip of fine sandpaper. Very thin leads don't need sharpening.

A trick to avoid smearing the surface on which you are drawing on in pencil or ink, is to protect it by placing a sheet of tracing paper under the hand you are using.

Use erasers as little as possible because even the softest is abrasive and damages the paper's surface. Use them, instead, to draw, i.e. to lighten tones, to outline contours and highlights, or to hatch an area in pencil or charcoal.

DRAWING WITH CHARCOAL

Both willow and compressed charcoal are rather crumbly and leave dusty tracks on the drawing surface. To get rid of excess coal dust you just need to blow on it, but you can also keep the sheet vertical so that your hand won't accidentally touch it, causing the dust to fall. When you have finished working you can remove charcoal or graphite residues with a kneadable putty eraser, taking care not to erase too hard but, rather, blotting gently.

Protect soft graphite and, especially, charcoal drawings by applying repeated, even layers of fixative. Cans which spray evenly and reliably are available. Keeping the drawing vertical, hold the can 30–40cm (12–16in) away and spray first vertical then horizontal bands, rather quickly, without stopping or lingering to avoid bright halos. If you want to fix large drawings or technical studies, you can use conventional hairspray, which is cheaper and reasonably effective. When spraying the fixative make sure there are no objects close by which could be damaged by the lacquer. It is best to do the job in a sheltered corner outdoors to avoid breathing in the fumes.

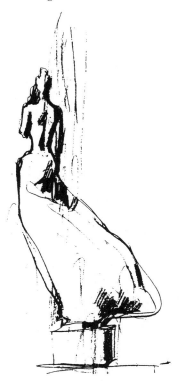

DRAWING WITH INK

When using pen and ink first draw a rough and very light pencil sketch with a hint of hatching. This will help you when you go over it with Indian ink but it should not constrict you to the point of making the drawing too even, almost mechanical, and lacking in freeness. Pencil strokes can be removed with a kneadable putty eraser when the work is completed, although make sure the ink is dry first. Practise drawing with a pen straight away, without worrying too much about possible inaccuracies, as only by doing this will you achieve the spontaneity, the confident strokes and the immediacy which characterize this technique.

Pens should be kept tilted at about 45 degrees. They flow easily on smooth paper, but tend to catch on a rough surface. However, you can draw on rough surfaces using nibs with a thick, slightly rounded point, or with bamboo reeds. Unless you are trying to achieve feathered effects, avoid any absorbent papers as they make working with pens difficult.

Bear in mind that ink (especially Indian ink) will become concentrated and more difficult to use if its container is left open, as its water component evaporates and thickens the solution. To offset this, every now and then add one or two drops of water to loosen the ink, preferably distilled water, making sure that these additions do not make the ink too light.

Clean nibs thoroughly and frequently while working, and get rid of ink deposits with a damp cloth: don't use paper as it will leave filaments, which may make the stroke less sharp. Any unwanted stains or smears can be removed with a blade kept perpendicular to the sheet or with an appropriate eraser, paying attention not to damage the paper. Alternatively, you can hide them with white tempera or typist's correction fluid.

UNDERSTANDING

PERSPECTIVE

INTRODUCTION

'Don't just look, see! The outline is achieved through its interior shapes.' – Giovanni Civardi

Different artistic cultures and traditions have devised many and various methods of tackling perspective to overcome the problem of representing spatial depth on a flat surface. The most frequently used – linear perspective – was given its theoretical formulation during the Italian Renaissance. This method cannot be achieved simply from looking; instead, it corrects our vision, making it more rational.

Before this development, and in other, older civilizations such as those of China and Japan, perspective was not given a rigorously 'optical' treatment, but a predominantly hierarchical one. Although understood as thoroughly 'natural' by the cultures that produced them, these forms of perspective had a symbolic function, representing reality in ways not suggested by the natural perspective of the eye. Objects and figures, for example, could take on importance and dimensions unrelated to their actual positions in space, referring more to their thematic importance or social status – for example, a figure of a king would be drawn deliberately larger than the figures around him to convey his importance. Other forms of representation have been developed for other ends: both for practical purposes, as in the case of architectural, engineering and scenographic drawings – for example, axonometric (measured along straight axes) and curvilinear projections (with curved axes), and to meet aesthetic or expressive needs (such as reverse perspective as applied in Byzantine art and in the painting of icons).

In recent times, computer-processed projections have greatly simplified many tasks, with suitable software packages to meet every architectural or industrial requirement. For the artist, however, it is still both useful and necessary to possess at least a rudimentary theoretical understanding of which of the various kinds of perspective is best adapted to solving the practical problems of the spatial representation that may be encountered when drawing a landscape or object from life. Indeed, perspective is employed in portraying real objects as they are observed (drawing from observation) as well as in the graphic representation of planned or imagined objects and environments. The use of perspective techniques may therefore serve the artist in various ways: in correctly portraying the subject that is being observed from life, in checking for correctness when depicting an object, figure or environment from a photograph and in correctly constructing an object or environment from the imagination (an architectural project, illustration, etc.). In short, when simply drawing any object by eye, artists might find they get better results if they consider (and choose to apply) the basic principles of perspective without thereby sacrificing their expressive and stylistic freedom.

Alongside the interpretation of perspective, it is important that the artist also investigates the structure of the subject. An object's structure indicates the way in which its parts relate to the whole. For this reason, a structural drawing also tries to bring out traces of relevant features, such as its essential planes and the axes of its sections, which remain hidden from view but may be guessed at, as if in see-through projection. This kind of treatment completes the representation of perspective by building up and evaluating the individual proportions of each part and the overall arrangement.

Investigation of both perspective and structure will provide guidelines for drawing with confidence and fluency. A freehand sketch from life of any subject, be it man-made or organic, simple or complex, will be better understood, expressed or corrected using the rules that the theory of perspective has uncovered and formulated. The idea is certainly not to regiment artistic expression or to put it in a cage, but rather to render its outcomes and ideas more plausible and effective.

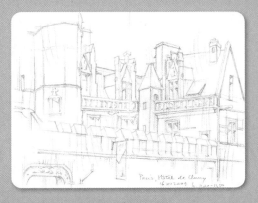

Sketchbook page. Pencil on paper,
9 × 14cm (3½ × 5½in).

GETTING STARTED

TOOLS

When you are drawing from life, the subject itself will often suggest the most suitable tools and the right methods to tackle its perspective. In the photograph, right, I have assembled some tools and materials which you may find useful to have at hand: sheets of paper, sketchpad, tracing paper, bulldog clip, stencil for ellipses, a pair of compasses, ruler, protractor, fine graphite pencil (mechanical pencil), slide mount (framing device) and a 90-/45-degree set square.

Sometimes, other tools suggest themselves, and even everyday objects may be brought into play effectively, such as an old envelope or an out-of-date credit card. These perform the function of evaluating and drawing angles and straight lines surprisingly well.

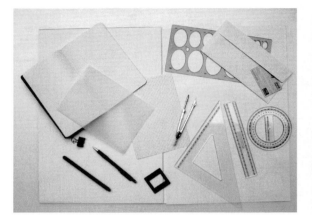

EXERCISES FOR DRAWING: SIMPLE LINES USING TOOLS OR WORKING FREEHAND

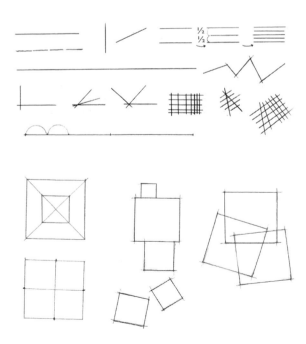

It is important to become proficient at assessing the orientation and length of lines and the sharpness of angles by eye, as well as in drawing geometrical layouts with precision and certainty, so that you can avoid having second thoughts or making blunders (for more information see page 71). For example, even if you are drawing freehand, a straight line still has to be a straight line, and angles, circles or ellipses have to correspond to these particular geometrical patterns, or at least suggest their properties in a sound and convincing way. One truly valuable method for training hand and eye coordination is by moving gradually from drawing lines with the aid of drawing instruments, such as a pair of compasses, rulers, set squares, etc., to executing the same lines freehand. This can be done in stages, moving from freehand copying of lines made using mechanical aids to free and immediate execution.

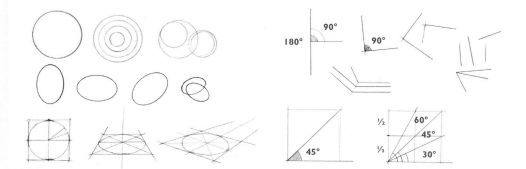

PRACTICAL METHODS FOR ASSESSING ANGLES AND EDGES BY EYE

It is not always easy to judge by eye – especially with precision – the directions taken by an object's principal lines and the angles that are formed between them. This is especially demanding when you are trying to depict an architectural construction, a building's interior or any other complex object while working from life. For this reason, artists have made use of some simple and readily available tools.

For example, a pencil can be used to gauge the positions and lengths of vertical and horizontal lines; a small cut-out cardboard frame or a photographer's slide mount (framing device), or a circle formed by your fingers, will isolate an interesting subject from its surrounding environment and aid in assessing compositional effects; and a pair of sticks or two fingers will help give you a good estimate of the sharpness of angles.

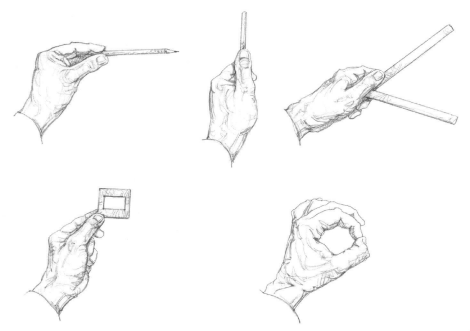

THE MAIN TYPES OF LINEAR PERSPECTIVE

The following diagrams show the most common types of perspective used in artistic representation. When observing an object from life, or when imagining an object, it is worthwhile considering straight away what would be the most effective perspective scheme to use for its optimal expression.

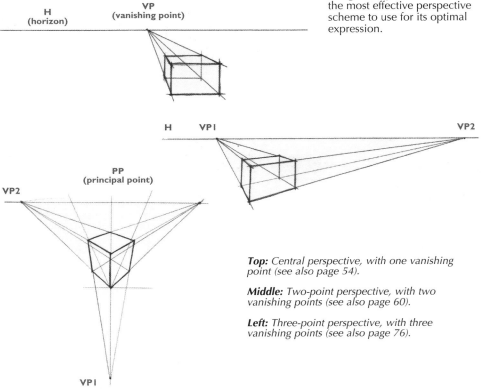

Top: *Central perspective, with one vanishing point (see also page 54).*

Middle: *Two-point perspective, with two vanishing points (see also page 60).*

Left: *Three-point perspective, with three vanishing points (see also page 76).*

POSITIONING THE OBJECT ON THE PAPER

When depicting an object according to the principles of linear perspective, you will need to refer to the points at which lines converge on the horizon (the vanishing points). These points are nearly always positioned off your drawing paper, perhaps at some distance from the page's margins. There are simple tricks for overcoming this difficulty (see also page 67). In order to estimate the location of these points and where to position the horizon line, it is a good idea to measure the angle formed between the object's main lines (or the main lines of the object simplified into a geometric shape) and project them on to the horizon line.

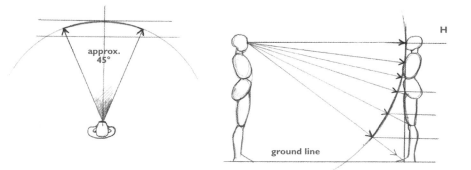

USING PHOTOGRAPHS AND THE PROBLEMS OF DISTORTION

Linear perspective applies a monocular (single lens) principle to represent space on a flat surface, but our vision is binocular. Our field of vision, or 'visual cone', has a generously angled apex of approximately 45 degrees, and this means everything we see is viewed in this arc. Objects within this area are not distorted and are seen in their true spatial proportions, according to our natural perspective. If the angle of the visual cone is less than 45 degrees, the image will be perceived as shrunk and flattened. If the angle is more than 45 degrees, the image will appear magnified and its proportions contorted to some extent. When

using a camera without specific equipment, such as a special lens or other optical compensator, the distortions in a photograph may not jump out because the tonal blending softens their appearance. Instead, they will show up more obviously in a drawing that has used this photograph as its only source of information. It is also worth bearing in mind that these dimension-altering effects show up more in photos of buildings or artificial objects, but appear subtler in photos of natural, organic forms such as faces, figures, flowers or landscapes.

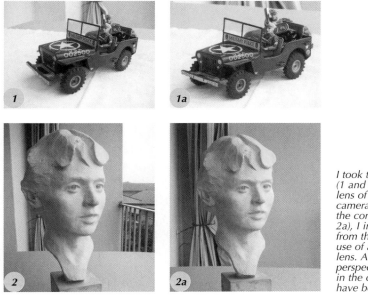

I took the distorted photographs (1 and 2) by bringing the normal lens of an ordinary digital camera close to the object. For the corrected photos (1a and 2a), I increased the distance from the object and made use of a low-powered zoom lens. Although contortions of perspective can still be seen in the corrected versions, they have been reduced sufficiently.

SPATIAL RECESSION AND DEPTH PERCEPTION

The objects that fill our field of view may be at varying distances but we perceive them accurately. The same indicators that we use in perceiving these spatial relations correctly can also help us depict them effectively in our drawings. Some examples include:

- **Size** – nearer objects appear larger than those in the distance.

- **Overlapping or occlusion** – an object that is partly covering or blocking another one places the blocked object further back.

- **The degree of detail used** – objects closer to the viewer are richer in features and in sharper focus than those further away.

- **Tonal intensity** – tones are stronger in areas closer to the observer.

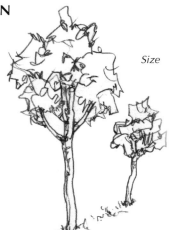

Size

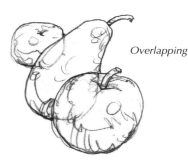

Overlapping

Detail

Tonal intensity

DECIDING WHAT TO INCLUDE AND HOW TO PLACE IT

In order to depict a subject accurately in relation to the picture space, you should do a few preliminary actions before starting the drawing. For example, you need to decide on the framing – which part of the environment or object do you wish to bring into the visual cone and into the picture? It is also necessary to assess the relative size of each object or group of objects – or at least their maximum height and width.

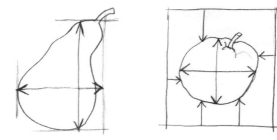

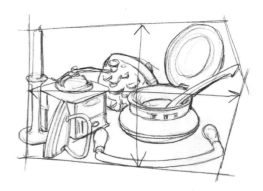

USING THE SQUARE AS A UNIT OF MEASUREMENT

The square, (and its three-dimensional counterpart, the cube), is a primary geometrical form which is widely used to facilitate the process of assessing dimensions and relations within complex objects and architectural constructions. Squares are easy to discern in any image or environment and they can be used as a benchmark unit with which to break down the whole object into smaller shapes, thereby making it easier to recognize directions and proportions both of the whole object and of its component parts.

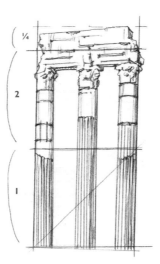

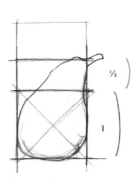

THE STAGES OF DRAWING FROM LIFE

When looking at the subject of your picture (or a photograph of it), try working through the following steps:

1 Identify the structural lines, both horizontal and vertical, and the level of the horizon.

2 Indicate the most important structural forms and the angles of the perspective lines.

3 Introduce the prominent details.

4 Define the minor details and the areas of light and shade.

The two examples, below and on the opposite page, should be sufficiently clear in the way they indicate progression through different levels of observation. The subjects are very different from one another, but they share a need for careful investigation of perspective.

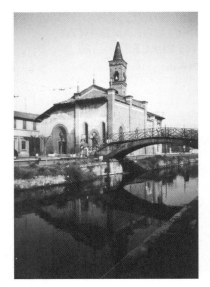

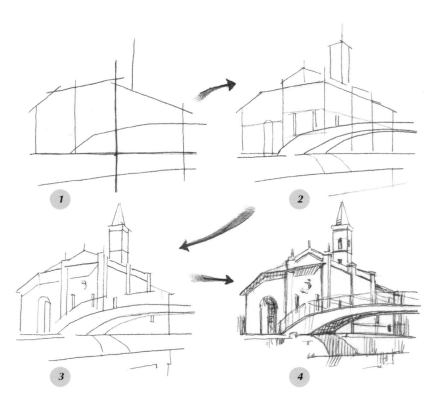

1

2

3

4

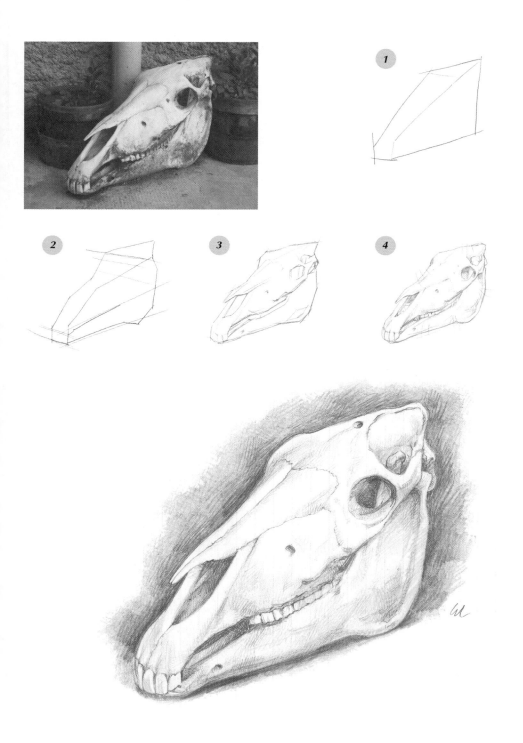

AERIAL PERSPECTIVE

When dealing with perspective, it is important to take into account the effect of the atmosphere over increasing distance. This is most noticeable in pictures of extensive areas of landscape, whether rural or urban. In such studies, not all of the spatial effects can be rendered by linear perspective alone. Atmospheric conditions mean that objects do not just look smaller the further away they are but they also become less sharp. Their detail decreases and their colours lose intensity, causing them to become tonally lighter.

Vapour and dust in the air cause these effects, which are intensified the further away the object is from the observer. This is known as aerial (or tonal) perspective.

The tonal gradation shown below and the accompanying photographs illustrate this principle quite effectively: clarity of detail and tonal intensity in the foreground gradually give way to blurred outlines and a reduction in chromatic intensity through the middle ground and into the background.

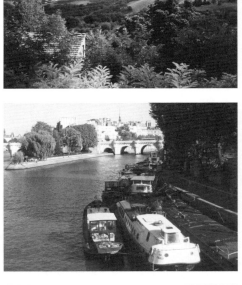

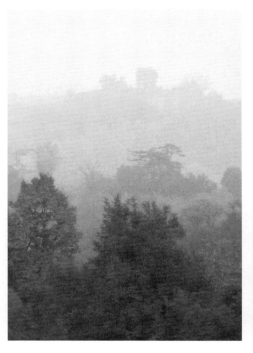

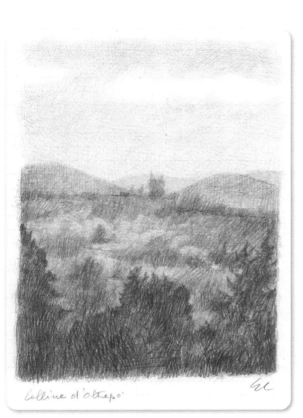

*The Hills of Oltrepò, Casteggio, Italy.
Pencil on paper (sketchbook page),
18 × 23cm (7 × 9in).*

Colline d'Oltrepò

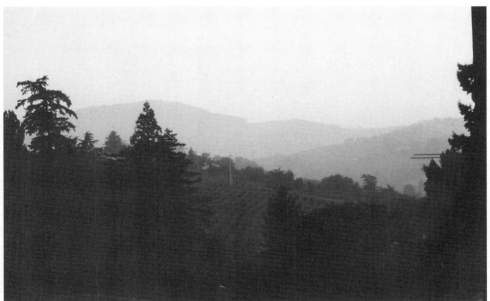

UNDERSTANDING
LINEAR PERSPECTIVE

A reproduction of the apparent form of an object, as it is seen when viewed from a fixed point, has come to be known as the perspective view (from the Latin verb *perspicere*: to see into the distance or to see clearly). By 'natural' perspective we mean the way our eyes perceive the dimensions of various objects and the spatial relations between them. This is achieved by means of binocular vision. Our natural perspective is adapted and applied as artificial (or linear, geometrical) perspective, which is governed by a series of simple principles, notably the following:

• The point of view is comparable to that of only one eye.

• Equal-sized objects appear to become smaller as they get further away.

• The image is created as if being drawn on a flat pane of glass (the picture plane) interposed between the viewer and the object being viewed – this picture plane is perpendicular to the line of vision.

• The horizon line is always at the observer's eye-level.

If you try looking at the object or the environment you intend to depict through only one eye, some of the above relationships between size and viewpoint will become easier to appreciate. The diagrams below review some of the operations employed in perspective drawing.

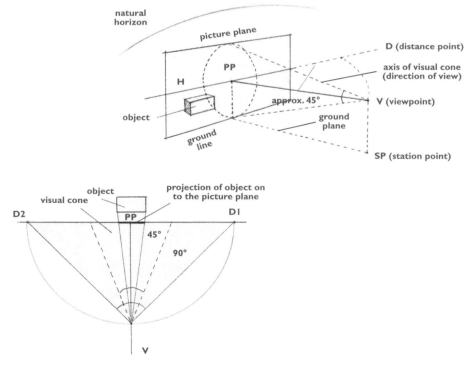

CHOOSING THE HEIGHT OF THE HORIZON LINE, YOUR POSITION AND VIEWPOINT

Visual perception is relative to the vertical and horizontal axes of the observer's position. These axes are related, in turn, to the observer's centre of balance and the nature of the ground surface. The perspective horizon is, of course, a horizontal line, although in special circumstances, or for the purposes of artistic expression, an artist may opt to tilt this line a little to the left or right, and therefore the whole perspective as well.

People viewing such a picture tend to tilt their heads in order to re-establish the normal vertical axis, but in doing so, they will notice a dramatic tension and greater dynamism from the unorthodox viewing angle (see the photographic examples below).

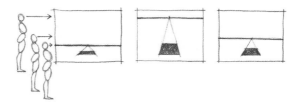

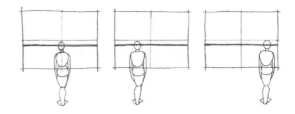

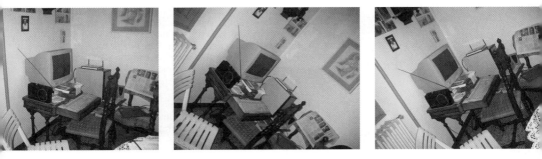

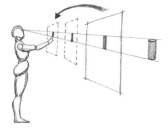

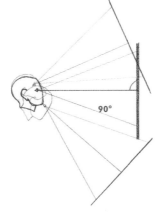

As the distance varies between the chosen viewpoint (the eye of the observer) and the picture plane, the size of the object will change, but not its perspective.

The picture plane is always perpendicular (at right angles) to the axis of the visual cone and follows its orientation. Usually the observer will face the horizon and the plane is inclined upwards or downwards when their gaze moves in these directions.

The **ground plane** (GP) is the surface on which the observer, the observed objects, and the base of the picture plane are standing.

The **ground line** (GL) is the line along which the picture plane meets the ground plane.

The **picture plane** (also known as the perspective plane or picture plane) represents the picture or painting surface. Think of this plane as being a sheet of glass placed between the observer and the object, which always remains perpendicular to the horizontal ground plane and perpendicular to the direction of view. This remains the case, irrespective of whether the paper on which you are drawing is angled or lying flat on a work surface. The distance between the viewpoint and the picture plane can be varied at the artist's discretion.

The **horizon line** (H) or 'terminal circle' is the circular line that marks the limits of the earth's surface visible to the eye of an observer. It is represented by a (horizontal) line that crosses the picture at the observer's eye-level (viewpoint). The horizon line is also the location of the vanishing points (points at which perspective lines convergence), which are the points at which all straight horizontal lines that are parallel to each other would meet if they were extended into the horizon. If these lines meet the picture plane at 90 degrees, there is a single vanishing point, which coincides with the principal point (see opposite page); if they are at a 45-degree angle, the vanishing points coincide with the distance points. For lines remaining parallel to the ground plane but meeting the picture plane at other angles, the vanishing point is correlated to this angle of incidence. Each object in a composition can, depending on its position and orientation, have its own vanishing points and there may be many such vanishing points in the same perspective picture. In the case of two-point perspective, there are at least two vanishing points, each located on the horizon line on either side of the central line of vision (or median line), while in the case of three-point perspective, vanishing points are also added on the median line above and below the horizon line.

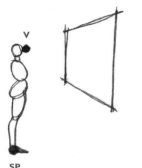

The **viewpoint** (V), or observation point, and the **station point** (SP) are, respectively, the location of the observer's eye and the place on the ground plane at which the observer is standing. The standing position is always perpendicular to the viewpoint.

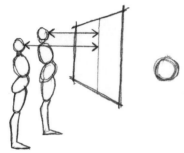

The distance between the observer and the picture plane determines the positioning within the frame, i.e. the size of the objects in the picture and their projection on to the image frame. When an eye at a fixed level moves closer to the object, the size of that object is increased on the picture plane. In standard conditions, the artist's distance from the picture plane (e.g. the sheet of paper) is equivalent to an arm's length.

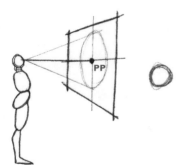

Visual rays are imaginary rays reaching out from the motionless observer's eye to touch all objects being observed. Taken together, these rays form the visual (or optic) cone, the apex of which has an angle of up to but not greater than 45 degrees either side of the direction of view, or central axis. The **principal point** (PP), or centre of vision, is the projection of the viewpoint on to the horizon line and it is therefore the point at which the direction of view pierces the picture plane.

At any one time, our eyes can only focus on those objects lying within an angle of vision of between 15 and 25 degrees on each side of the direction of view. If you wish to look at an object lying outside your initial visual cone, you will have to change your viewpoint and this will change the direction of view. For this reason, all the objects you intend to include in a perspective study must lie within this visual cone.

Some of these elements to aid in the rendering of perspective are optional, and some elements can be changed, such as the observer's position (viewpoint), the level of the viewpoint (horizon line), the distance of the observer from the picture plane and the observer's distance from the object.

CENTRAL LINEAR PERSPECTIVE

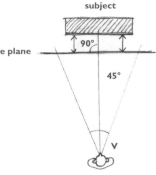

Central linear perspective (sometimes called parallel, frontal or single-point perspective) is based on the principle of a single point of convergence in a central position on the picture plane (the picture surface). All parallel, non-vertical lines converge on this point as they head into the distance. The horizon line will always correspond to the observer's eye-level and will be determined by the viewpoint, i.e. the position from which the object is being observed.

In central perspective, one of the sides of the drawn object, (which may be a house, a cube or a box, etc.), will be parallel to the side of the picture plane, while perpendicular lines to the picture plane and to the observer converge on a single point on the horizon line (the **principle point**, or PP). Vertical lines remain vertical in this perspective scheme and lines that are parallel to the base of the picture plane remain parallel to the horizon line. All other lines converge on the single vanishing point.

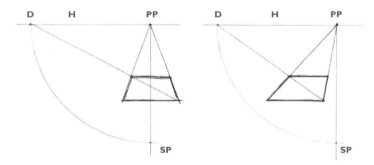

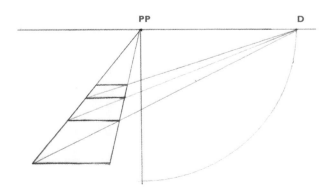

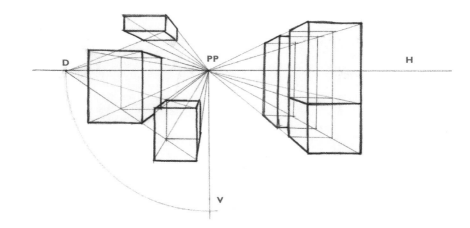

The diagrams opposite and above illustrate how central perspective works. The **distance point** (D) is similar to a vanishing point, but is used for determining the depth dimension of a geometric figure. It is positioned on the horizon line along from the principal point (PP) and its distance from the PP avoids excessive distortions. The distance between D and the principal point is the same as the distance from the **viewpoint** (V) to the PP. This distance point lies, therefore, on the circumference of a circle of the same radius or can be found by drawing a line from the standing position to the horizon line at an angle of 45 degrees to the vertical formed between the principle point and the standing position.

A complex subject, such as the human figure, lends itself to the use of the principles of central perspective. This can be aided by imagining the model inside a solid box, or, alternatively, imagining that the model is reclining on a rectangle.

55

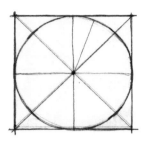

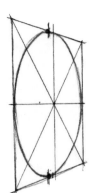

Drawing a circle in perspective (which produces an ellipse) is easier if it is drawn in a perspective square (which produces a trapezium). Begin by drawing the central and diagonal lines. You will notice that the major axis of the ellipse is not the same length as the diameter of the original circle.

The height of the ellipse will vary according to its relative position to the horizon line. It progressively diminishes as the circle approaches this line. This factor needs to be carefully evaluated when drawing cylindrical forms – whether manufactured ones such as bottles, columns, glasses, musical instruments, etc. or natural forms such as tree trunks, arms or legs of people and animals.

An easy approach to drawing a circle freehand is to insert its axes in a square frame and then 'rotate' its radius (see also examples on page 63).

H

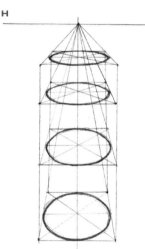

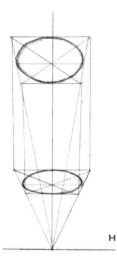

H

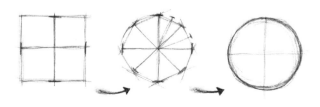

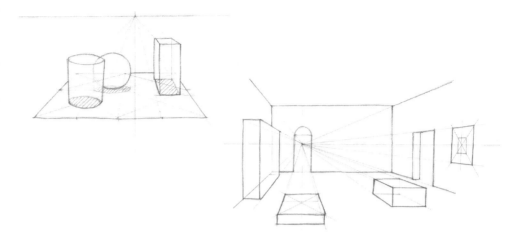

When applying perspective techniques in a freehand drawing from life, it is a good idea to simplify the process of analysis by breaking it down into several steps. For example:

1 Choose a suitable viewpoint for an effective division of the compositional frame.

2 Check that your chosen frame caters for the dimensions and format of the sheet of paper on which you are drawing: you can do this by holding the sheet out vertically at arm's length, and imagining that the central axis of your direction of vision passes through its centre.

3 Choose the type of linear perspective (central, two-point, etc.) that appears most appropriate for the needs of your subject.

4 Decide on an approximate perspective scale of measurement and orientation and set the vanishing point(s).

5 Sketch out the main vertical lines and the outlines of the objects, estimating their relative dimensions and proportions and applying the basic rules of perspective to verify the orientation and angle of the lines heading towards the vanishing points.

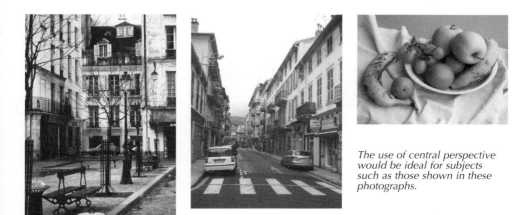

The use of central perspective would be ideal for subjects such as those shown in these photographs.

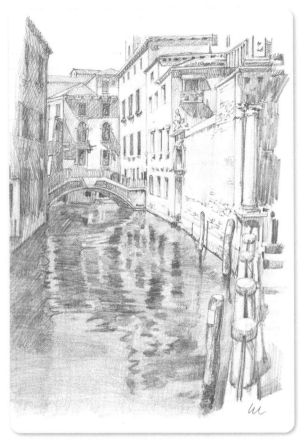

*Venice. Pencil on paper,
18 × 23cm (7 × 9in).*

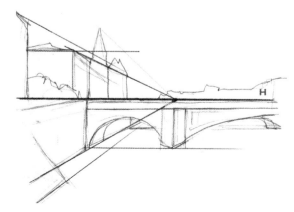

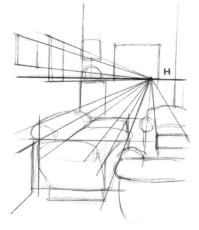

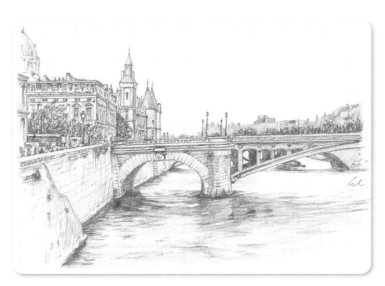

Conciergerie, Paris. Pencil on paper, 18 × 23cm (7 × 9in).

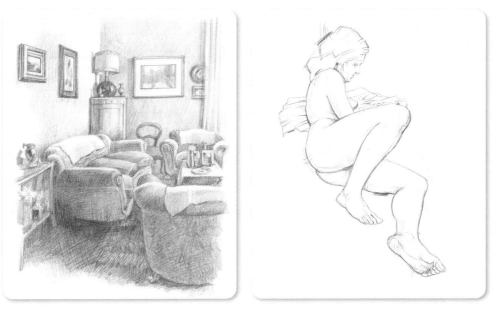

Interior of My House. Pencil on paper,
18 × 23cm (7 × 9in).

Elsa. Pencil on paper, 18 × 23cm (7 × 9in).

TWO-POINT LINEAR PERSPECTIVE

Two-point linear perspective (also known as oblique, angular or incidental perspective) allows objects to be positioned obliquely to the picture plane – i.e. objects viewed from a corner-facing angle, with all of their sides shortened. The observer's position is typically off-centre. This type of perspective therefore covers what is a very frequent observational stance for artistic representation.

As with other perspective schemes, the horizon line is always situated at the observer's eye level and may be placed at various levels on the paper, while vertical lines keep their verticality. With central perspective, remember the main benchmarks were the viewpoint (V) and the distance point (D). In two-point perspective, however, these points are of secondary importance. With this method, the dimensions and forms of objects are determined using the vanishing points (VPs). There are two vanishing points: one located to the left and one to the right of the observer somewhere farther along the horizon line. All of the non-vertical lines on each side of an object converge towards one of these points (this is, of course, what gives the object its shortened appearance), and the sides appear to shrink in height as they recede into the distance.

While there are typically at least two vanishing points, more than two may be used as any object in a complex composition which is not standing parallel to the others will require its own specific vanishing points on the horizon line. Additionally, vanishing points may be located above or below the horizon line when you want to depict inclined planes such as roofs, stairways and steep roads.

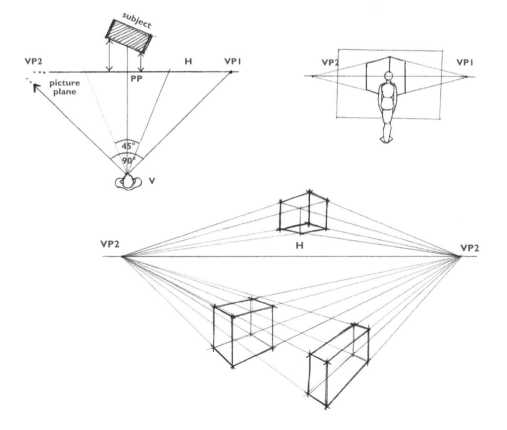

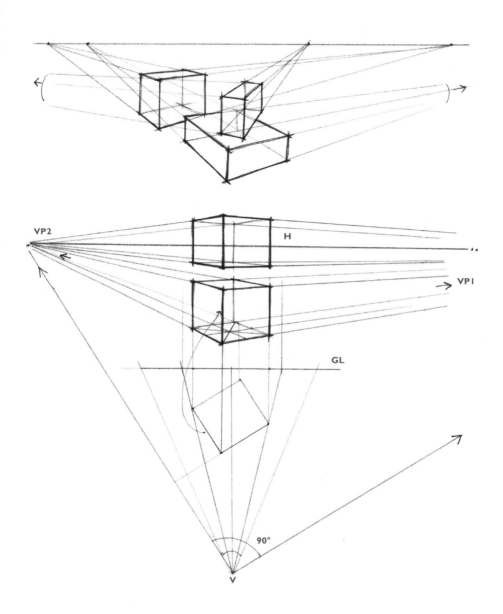

VP2

H

VP1

GL

90°

V

The diagrams opposite, on this page and overleaf illustrate some common uses of two-point perspective in artistic work.

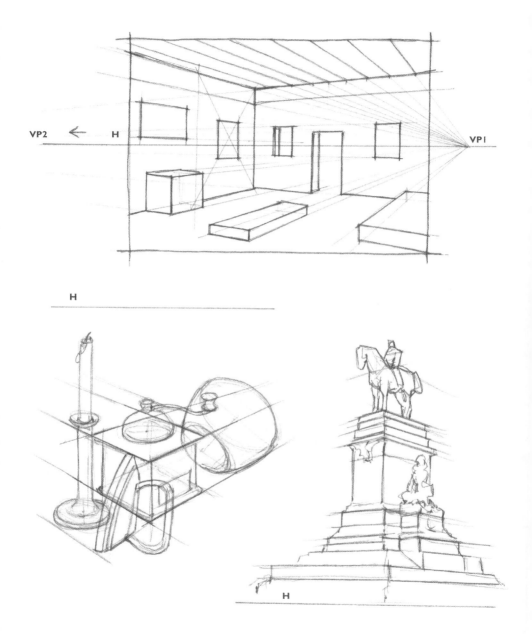

VP2 ← H

VP1

H

H

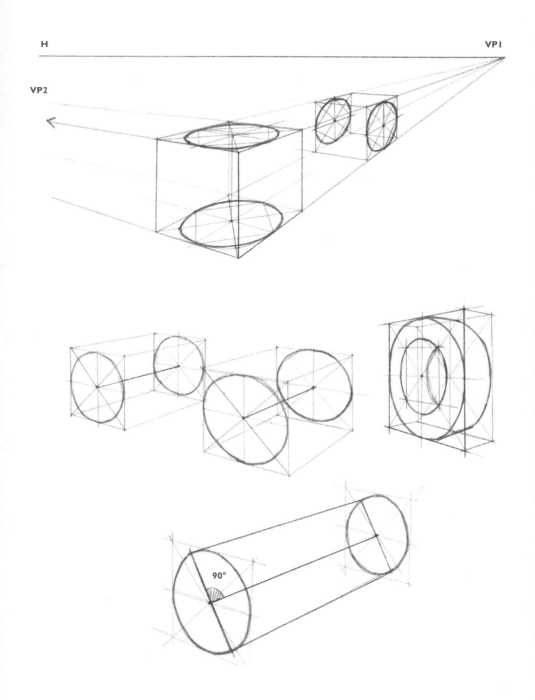

VP2

90°

In two-point perspective, circles may be drawn by using their perspective squares.

When subdividing a straight line or surface into two or more equal sections, it can be helpful to use the diagonals of a geometrical shape (such as a square or rectangle) that corresponds to the section of the line that you wish to divide, repeating the operation for each section.

This procedure is also useful when drawing architectural studies freehand from life, for example, when you need to position doors, windows and other features correctly in relation to the building's façade.

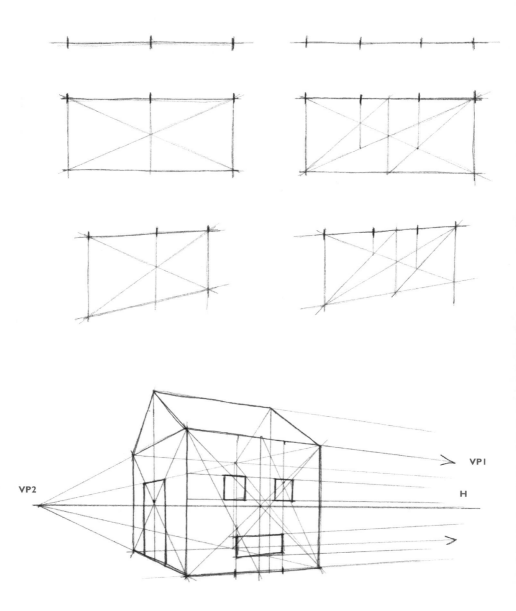

Thales' theorem on triangular proportionality is a very practical method for subdividing a surface into equal or unequal segments, and it can be used as a guide for delineating a procession of arches, for example. It can be applied in the following steps:

1 Plot the main lines of perspective.

2 Divide the straight line defined by the diagonals into segments of equal length on each side of the median (the vertical central line between the viewpoint and principal point).

3 Locate the surface segments by projecting upwards from the intersection of each segment's diagonal.

Reference photograph.

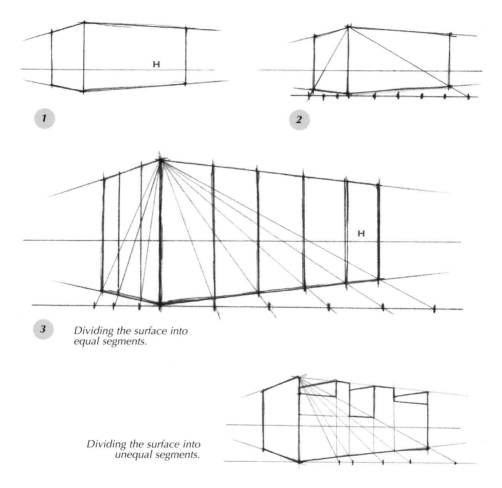

Dividing the surface into equal segments.

Dividing the surface into unequal segments.

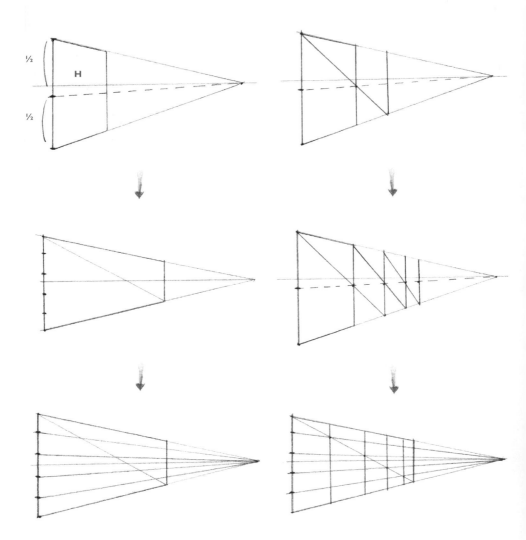

The diagrams above suggest further simple and intuitive methods for dividing a surface in perspective projection into equal segments.

The **vanishing points** (VPs) are nearly always located outside the frame of the composition, a large distance from the margins of the picture surface. Their precise location varies depending on the object being drawn and the observer's position in relation to that object. In such cases, it is possible to locate the vanishing points with a fair degree of precision just by using your judgement in extending the main perspective lines which form the object's outline to where your eye tells you they will meet. Use the following steps for a more accurate method:

1 Divide the vertical line that represents the corner of the object nearest to the observer into any number of equal segments.

2 Draw the lines which form the edges of the two oblique faces, estimating their approximate inclinations.

3 Project the same number of segments on to another vertical line drawn near the margin or on the margin itself. This procedure can be adapted for drawing architectural interiors.

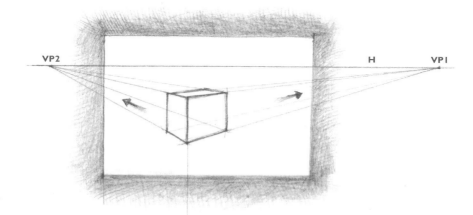

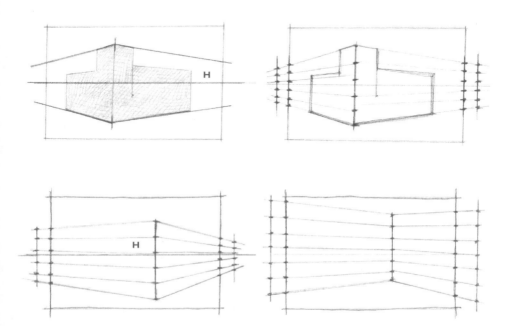

The various planes that make up a complex object may be inclined at different angles to the ground plane, which is always assumed to be parallel to the horizon line. The vanishing points of such inclined planes are therefore not found on the horizon line but above or below it, at heights that will reflect the degree of the angle of the inclined plane in question. If there are many such inclined planes with different slants in a composition, there will be many vanishing points. These points (on the diagrams marked **Pa**, **Pb** and so on) are, however, always located on a vertical line which projects from the horizon line and the point of intersection of this vertical with the horizon line will be the vanishing point derived from a horizontal, non-inclined plane.

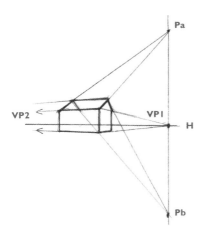

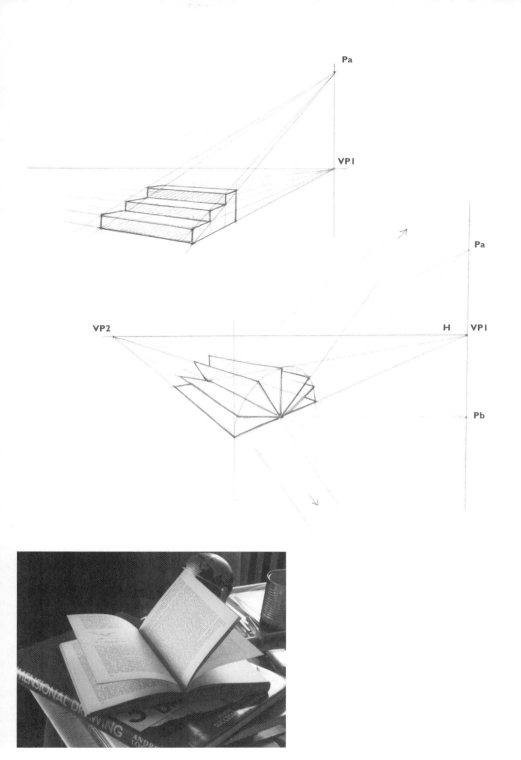

Inclining planes each have their own vanishing points located at different places on the horizon line, each of which correlates to the plane's incline.

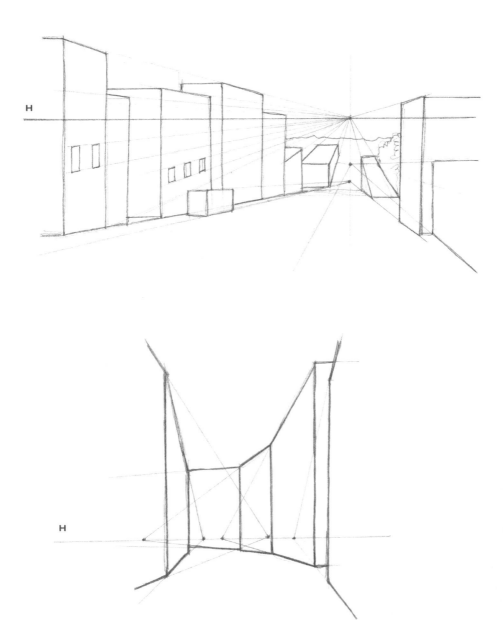

When drawing objects, figures or environments freehand and in perspective, it is easy to make errors that can distort your subject and lead to unsatisfactory results. Linear perspective does not accurately correspond to our natural vision, which is, indeed, more complex. Linear perspective 'corrects' and simplifies our vision, making it more rational. However, it should be added that it is by no means absolutely necessary – nor even useful – to apply linear perspective with unbending rigour. On the contrary, it is advisable to make adjustments to its rules and allow yourself artistic licence in the interest of improving the aesthetic result.

In the diagrams shown below, I have put together a few perspective howlers that are best avoided, exaggerating them a little in each case. The examples show the following:

- How, if the object is too close to the observer, or its vanishing points are not far enough apart, the resulting image will appear distorted to some degree, especially if it consists of recognizable geometric shapes.

- How cylindrical forms should show the correct relationship between the series of ellipses that make up their structure.

- How straight lines, angles, verticals, horizontals, etc. should be drawn precisely and steadily, even when working freehand, paying particular attention to points of juncture and the resultant angles.

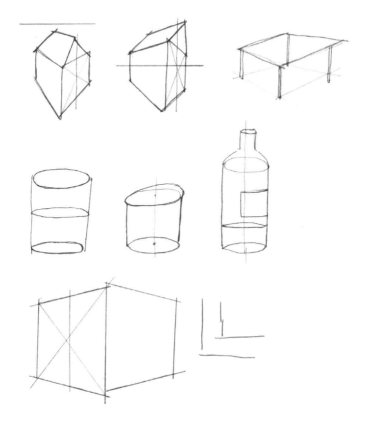

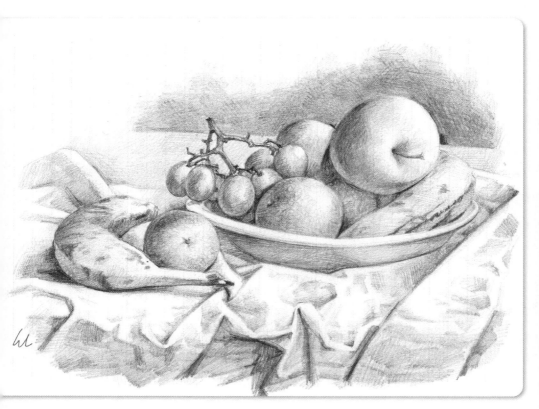

Fruit. Pencil on paper, 18 × 23cm (7 × 9in).

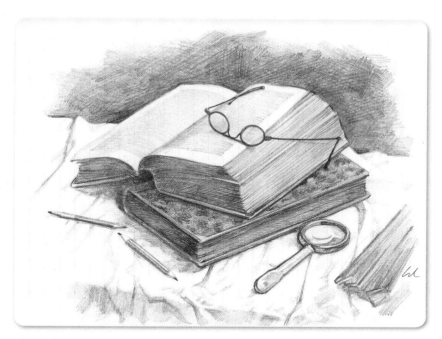

The Tools of Culture. Pencil on paper, 18 × 23cm (7 × 9in).

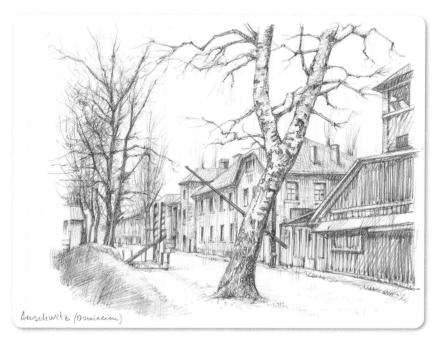

Auschwitz (Oswiecim)

Oswiecim (Auschwitz), Poland. Pencil on paper, 17 × 21cm (6¾ × 8¼in).

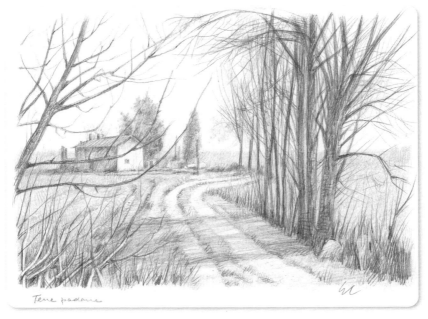

Landscape of the Po Valley, Italy. Pencil on paper, 18 × 23cm (7 × 9in).

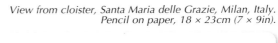

*View from cloister, Santa Maria delle Grazie, Milan, Italy.
Pencil on paper, 18 × 23cm (7 × 9in).*

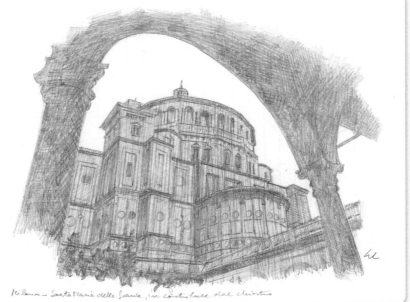

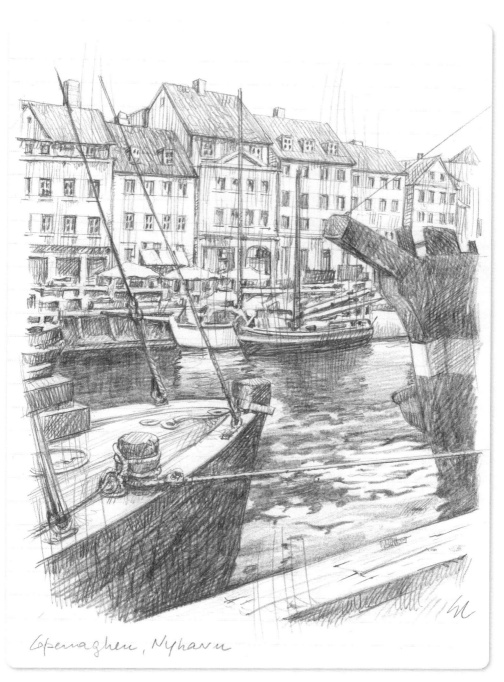

Nyhavn, Copenhagen, Denmark. Pencil on paper, 17 × 21cm (6¾ × 8¼in).

THREE-POINT LINEAR PERSPECTIVE

Three-point perspective is used when the observed object involves an aspect that is either very high or very deep, or when a composition is being viewed from above or from below. With the sides of the viewed object standing obliquely with respect to the image plane, it appears that the parallel lines on each side converge from three vanishing points. Two of these vanishing points are situated on the horizon line, while another point is located on a vertical line that passes more or less through the subject's central axis. This third vanishing point will be above or below the horizon line, depending on whether the viewpoint is directed from above or from below. This third point is best located at a distance from the horizon line to prevent the picture having an excessively distorted appearance.

As with two-point perspective, three-point perspective may use many vanishing points located at various levels with respect to the horizon line, depending on the angles of the various sloping sides that make up the complex composition. The observer's direction of view, (the centre-line of the visual cone), remains perpendicular to the image plane, but the image plane may also be inclined at various angles to the ground plane depending on variations in the standing position and direction of view.

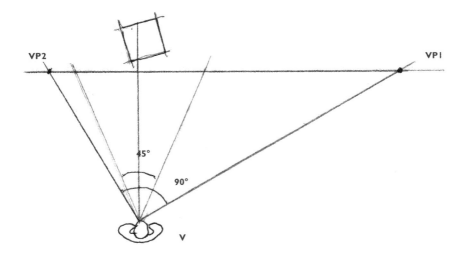

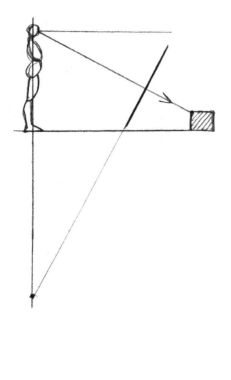

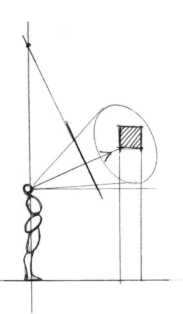

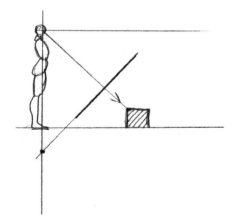

Unlike the previous two perspective types (central and two-point linear perspective), whose methods of calculation and usage reach back to the classical period of Western civilization, three-point perspective is a recent development. It links new ways of looking at the world through the use of photography and through viewing objects from high above ground level, such as when flying or looking out from very tall buildings. That said, three-point perspective is very often used in depicting smaller or medium-sized objects which are seen from above, or tall architectural structures viewed from below.

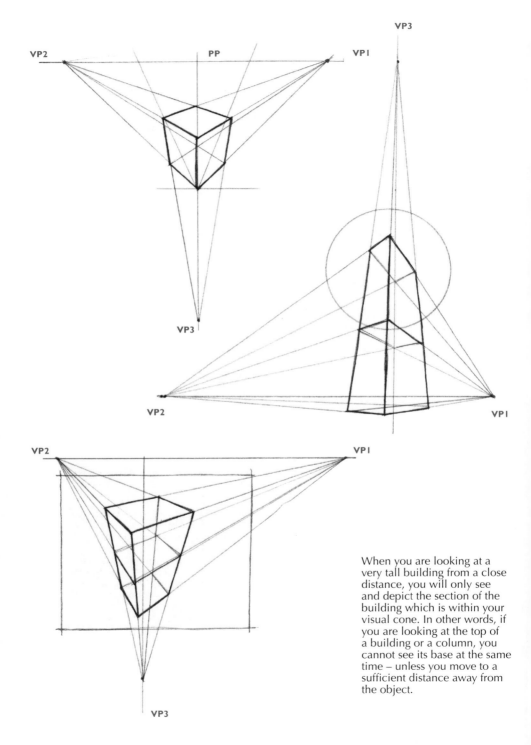

VP3

VP2 PP VP1

VP3

VP2 VP1

VP2 VP1

When you are looking at a very tall building from a close distance, you will only see and depict the section of the building which is within your visual cone. In other words, if you are looking at the top of a building or a column, you cannot see its base at the same time – unless you move to a sufficient distance away from the object.

VP3

Photographs exemplifying three-point perspective.

USING CONSTRUCTION LINES

'On voit tout autrement un objet dont on connait la structure.'
('When we know the structure, we see a completely different object.')
– Paul Valéry

The word 'structure' comes from the Latin verb *struere*, to construct – the way in which the parts of an object come together to form a whole, i.e. the relational arrangement between an object's composite parts. It is very important for an artist to understand a form, be it organic or man-made, in terms of its structural characteristics. This is achieved by seeing the object stripped of its inessential details, and therefore concentrating on it as an arrangement of simpler geometrical forms: cubes, oblongs, cylinders, etc.

It can also be helpful to supplement this intuitive investigative framework with a kind of X-ray vision, enabling the artist to visualize the non-visible lines of the object's linear and perspectival structure, as if viewed as a cross-section. This is partly based on symmetrical relationships and linear directions that are found between an object's parts, and partly on the logical sense they make together in terms of size and fit.

When drawing from life or executing a design drawing, the study begins by drawing lines freehand to indicate the relationships between the different planes, the subject's main axes and its thickness. These lines then act as directional guidelines and reference marks when the drawing is developed to the desired degree of precision. The lightly drawn lines may be left visible in order to heighten awareness of the object's structural framework, or they may be gradually overlaid by lines that come later, depending on the particular style of the artist and his or her picture.

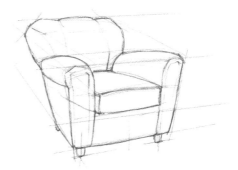

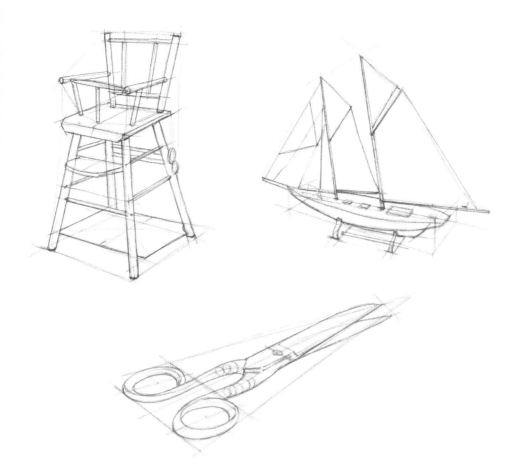

Drawing trees is an excellent starting point for understanding and sketching construction lines, as they have a number of straight elements.

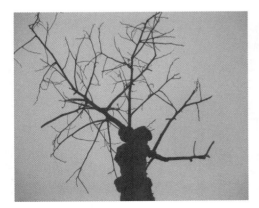

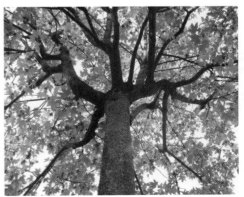

PROJECTED SHADOWS

Briefly illustrated on page 11, shadow falls in an area not illuminated by direct light. It includes self or **form shadow**, where the object casts a shadow on itself, and projected or **carried shadow** where the shadow falls on an adjoining object. The light source may be a natural one (the sun, moon or firelight, for example) or an artificial one (a lamp), and there may be a single source or multiple sources.

In a perspective view, light rays emanating from the sun are considered to be parallel to each other, while those coming from an artificial source are considered to be divergent or radiating in every direction (see diagram below, right). It is the projecting object that defines the shape of the resulting shadow and as such, the object often reveals unusual or unexpected aspects of itself.

The position and the extent of the shadow are determined by the position of the **light source** (S). If a vertical line is drawn from S to the horizon line, (directly down from the light source), this point (F), which coincides with one of the object's vanishing points, will also locate the vanishing point of the shadow's outlines. Point S can then be used to indicate the angle of incidence of the light rays on the object, while point P indicates the direction of the shadow. If the light source is in front of, or to one side of the observer, S will be located above the horizon line. If the light source is behind the observer, S will be located below the horizon line.

Light and shadow is explored in more depth in chapter 3, pages 92–147.

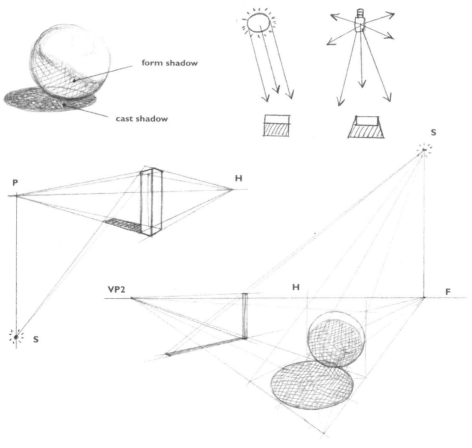

form shadow

cast shadow

P H

S

VP2 H F

S

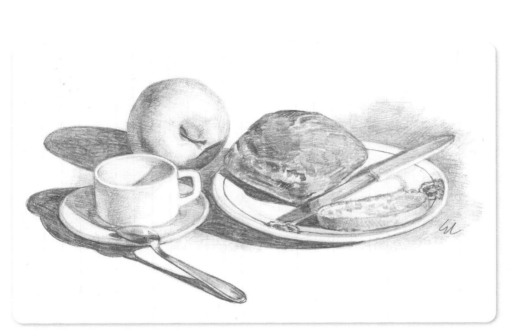

Breakfast is Ready. Pencil on paper, 18 × 23cm (7 × 9in).

Corinna. Pencil on card, 18 × 23cm (7 × 9in).

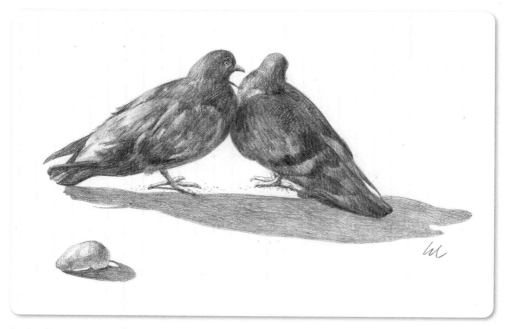

Loving Encounter. Pencil on paper, 18 × 23cm (7 × 9in).

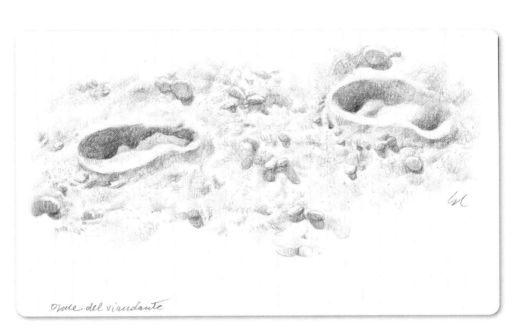

Footprints of a Passerby, Nice, France. Pencil on paper, 18 × 23cm (7 × 9in).

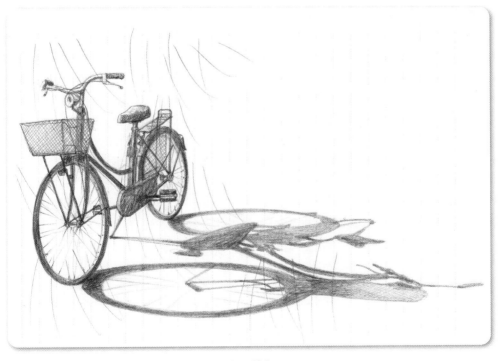

Shadow at Sunset. Pencil on paper, 18 × 23cm (7 × 9in).

REFLECTIONS

Reflections are an optical phenomenon caused when a light ray hitting a smooth surface bounces off this surface at an equal yet opposite angle. The reflecting surface may be horizontal, such as a puddle of water, vertical or inclined at varying angles, as in the case of a mirror.

If the surface is horizontal or vertical, the reflected image follows the same perspective projection and has the same vanishing points as the object being reflected (**1**). If the surface is inclined, however, the reflection will have its own vanishing points (**2**, **3** and **4**).

The principles of perspective governing the phenomenon of reflection are relatively simple: they state that the reflected image of each point on an object is positioned at precisely the same distance from the actual point on the object, either above, below or to the side. The principles of linear perspective decide the position, the proportions and the dimensions both of the object itself and of its reflection, subject to the axis and the symmetry of directions of the reflection.

The reflected image will take on different appearances depending on the condition of the reflecting surface and the distance of the object from this surface. For example:

- If an object is tilted forwards or backwards, this will affect the length and the direction of its reflection (**3** and **4**).

- If a reflecting surface is irregular or broken, it will produce irregular reflections, or none at all (**5**, **6** and **7**).

- The object's distance from the reflecting surface will determine which portions of it are reflected (**8**).

- In some circumstances, a reflected image will reveal aspects of an object that are not visible at horizon level, such as the underside of a table or a bridge.

- If a reflecting surface is not flat, but is concave or convex, the reflected image will be markedly deformed in complex ways according to the laws of curvilinear perspective.

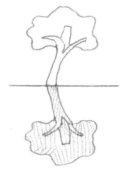

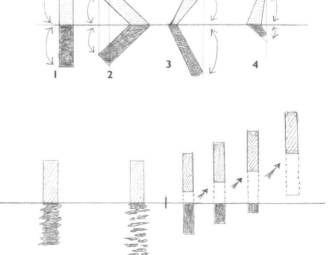

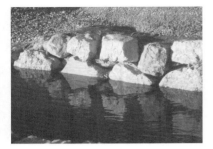

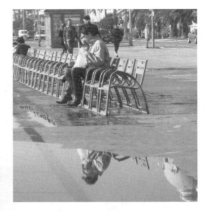

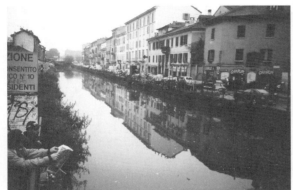

Taking photographs of reflections around you creates useful drawing aids.

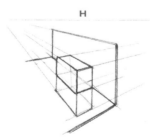

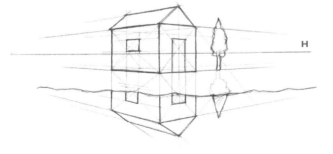

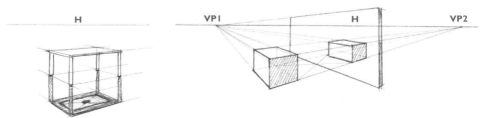

87

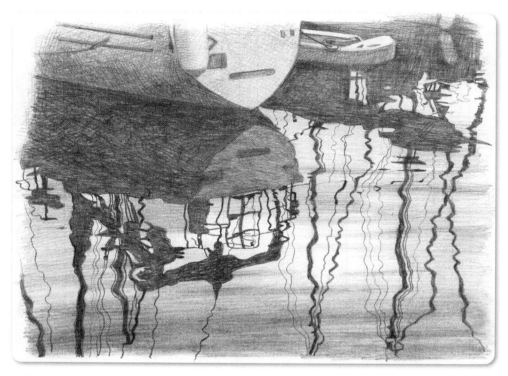

Reflections, Port of Nice, France. Pencil on paper, 18 × 23cm (7 × 9in).

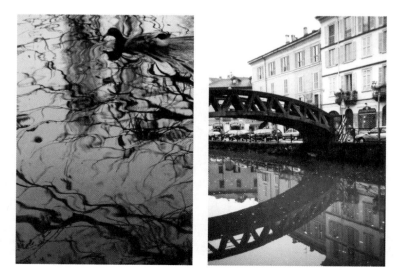

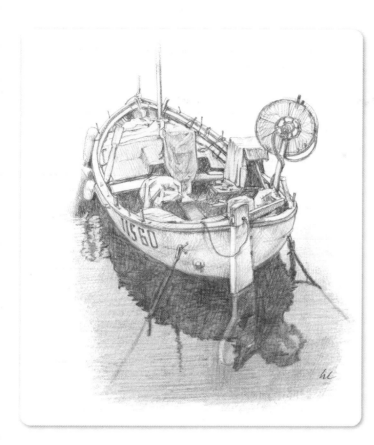

Jean's boat, Port of Nice, France. Pencil on paper, 18 × 23cm (7 × 9in). To see the photograph that inspired this piece, turn to page 157.

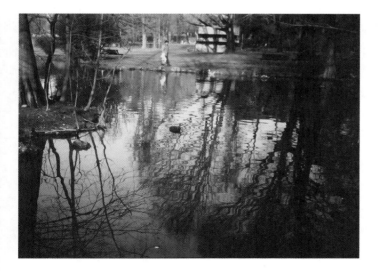

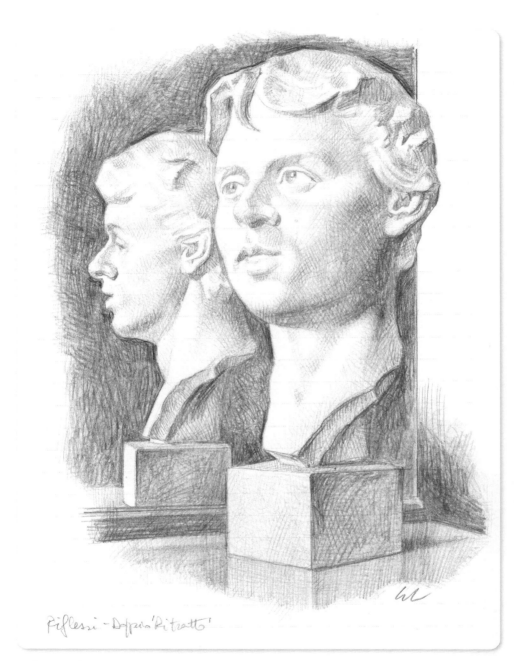

Riflessi – Doppio 'Ritratto'

Reflections: double portrait. Pencil on paper, 18 × 23cm (7 × 9in).

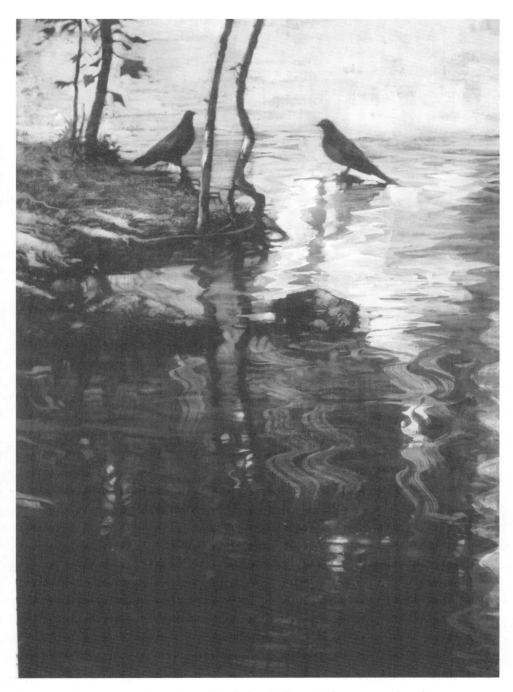

Pond in the Municipal Gardens, Milan, Italy. Black and white gouache on canvas board,
35 × 55cm (13¾ × 21¾in).

DRAWING LIGHT
& SHADE

INTRODUCTION

'The brightest days are followed by darkness.'
– Thérese de Lisieux

Chiaroscuro generally refers to the graduating tones, from light to dark, in a work of art, and the artist's skill in using this technique to suggest volume and represent mood.

Chiaroscuro has been used to suggest form in relation to a light source in the art of many civilizations – although it was unknown to early cultures such as the Ancient Egyptians. It came to the fore in Western art, and particularly in Italy, during the 16th century.

Many elements can influence the way in which *chiaroscuro* is used: the relationship between its own components (light and dark); the relationship with colour; the method of distributing the light and dark elements that characterize the composition and expressive quality of a painting; as well as social and philosophical attitudes. We can see examples of *chiaroscuro* in many of the works of the great artists: the blazing light and abysmal darkness of Rembrandt's etchings, demonstrating *chiaroscuro* elements 'of the soul'; a *chiaroscuro* in which light prevails over dark in the work of Giotto and Michelangelo; a pictorial *chiaroscuro* in which darkness prevails, but with the dark outlines shaded off, which tends to suggest a lively atmosphere around the volume of the bodies as in Leonardo; a tonal *chiaroscuro*, in which relations between light and dark are based on the quantity and quality of the light and shade that the colours absorb in themselves in the work of Titian and Giorgione; and a luminous *chiaroscuro*, in which the contrast between the illuminated parts and shadowed parts is violent, intense and unusual, as in the work of Caravaggio.

On the pages that follow I have tried to suggest some useful approaches to the complex topic of *chiaroscuro* by explaining the basic drawing techniques you will need and, especially, by suggesting methods of observation and experimentation. The play of light and shade involves any subject that can be portrayed, not only from a realistic or naturalistic view, but also, and perhaps more importantly today, in representation – in communicating emotions, moods, ideals, dreams, hopes and experiences.

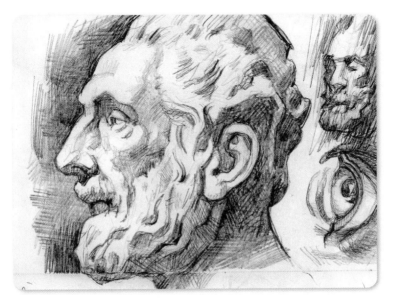

LIGHT AND SHADE

Light is energy emitted from a light source that is either natural or artificial, such as the sun, a flame or a lit lamp. Because of it, we can see objects. Transparent forms allow light to pass through them in varying degrees; opaque forms do not allow light rays to pass through them. On opaque forms, in particular, shadows are produced and they, in turn, can project shadows on to neighbouring surfaces. Very rarely does a surface absorb light completely; more frequently the light is, in varying degrees, reflected and diffused through the surrounding environment.

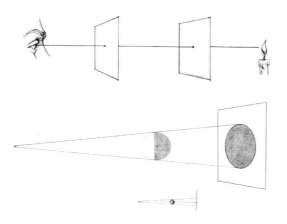

Rectilinear transmission of light and the formation of shadows.

Light is transmitted in a straight line. A light ray is a line of light that travels to a given point. Beams of light are all the light rays that cross a given surface.

To demonstrate the linear transmission of light, place a couple of pieces of card, each with a small hole, between your eye and the flame of a candle. A consequence of the rectilinear transmission of light is the formation of shadows and the way in which they are arranged. A tiny spherical light source produces a cone of light that projects, on a screen in the distance, also creating a shadow of an opaque sphere in between.

Point of maximum luminosity on a spherical object.

Consider the difference between the sun's rays as they reach Earth at the equator and poles. The intensity of light is strongest when the light ray is at 90 degrees to the surface on which it falls.

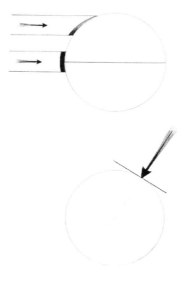

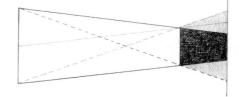

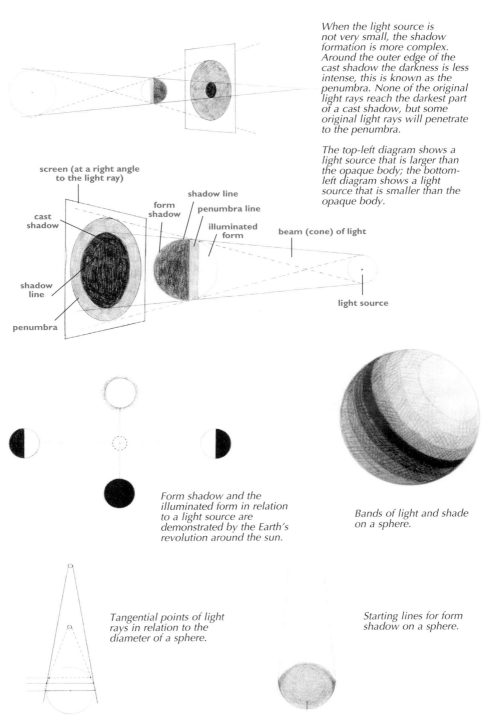

When the light source is not very small, the shadow formation is more complex. Around the outer edge of the cast shadow the darkness is less intense, this is known as the penumbra. None of the original light rays reach the darkest part of a cast shadow, but some original light rays will penetrate to the penumbra.

The top-left diagram shows a light source that is larger than the opaque body; the bottom-left diagram shows a light source that is smaller than the opaque body.

screen (at a right angle to the light ray)

cast shadow

shadow line

form shadow

shadow line

penumbra line

illuminated form

beam (cone) of light

penumbra

light source

Form shadow and the illuminated form in relation to a light source are demonstrated by the Earth's revolution around the sun.

Bands of light and shade on a sphere.

Tangential points of light rays in relation to the diameter of a sphere.

Starting lines for form shadow on a sphere.

95

From the circle (outline) to the sphere (volume).

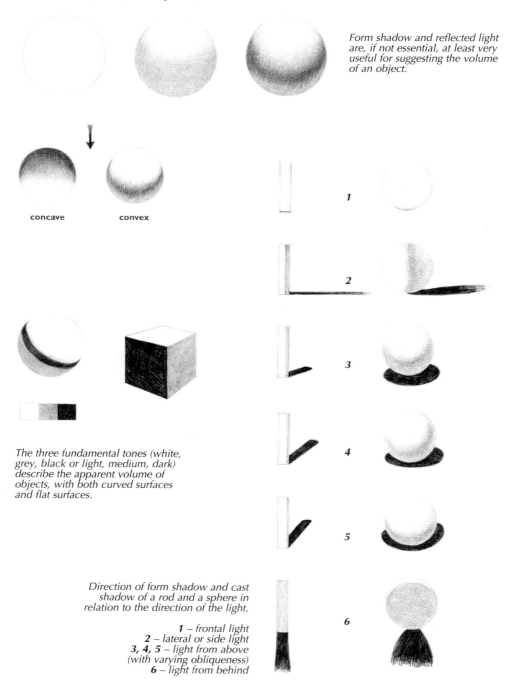

Form shadow and reflected light are, if not essential, at least very useful for suggesting the volume of an object.

concave convex

The three fundamental tones (white, grey, black or light, medium, dark) describe the apparent volume of objects, with both curved surfaces and flat surfaces.

1

2

3

4

5

6

Direction of form shadow and cast shadow of a rod and a sphere in relation to the direction of the light.

***1** – frontal light*
***2** – lateral or side light*
***3, 4, 5** – light from above*
(with varying obliqueness)
***6** – light from behind*

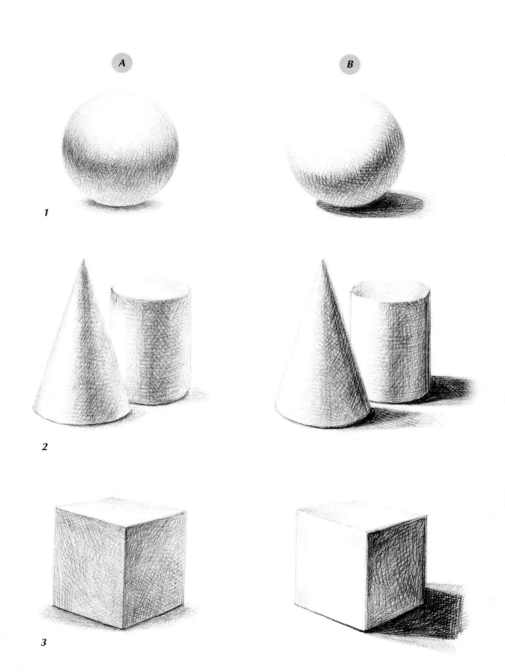

*Effects of diffused light (**A**) and direct light (**B**) on a spherical shape
(**1**), on cylindrical and conical shapes (**2**); and on objects with flat
sides (**3**). Diffused light on a cloudy day for example, produces less
distinct form shadows and graduated cast shadows. Direct light,
from an electric spotlight for example, produces both form and cast
shadows that are sharp and intense.*

97

FORM SHADOW AND CAST SHADOW

If light indicates an object's shape, shadows define its volume. **Form shadow** appears on an object as a result of lighting. **Cast shadow** is a shadow the body casts on to other surfaces, usually neighbouring objects or planes.

Cast shadow expresses the relationship between the object and the environment; its development and extension indicate the position of the light source, its nature, its intensity and the way in which the light rays hit the object. Form shadow nearly always contains reflected light which comes from the environment, and is very important for showing the volume of the object. Reflected light never has the same force as direct light, but lightens the form shadow in varying degrees. Consequently, the maximum intensity of this shadow is found along the shadow line, the boundary between the illuminated part of the body and its shadowed part.

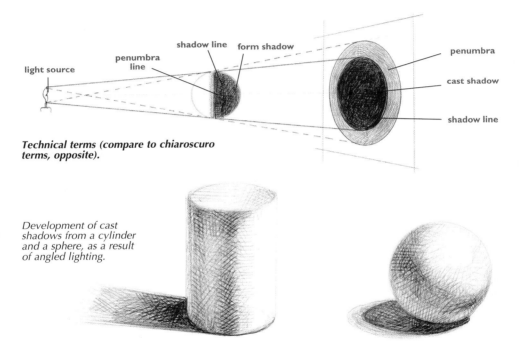

shadow line form shadow penumbra

penumbra line

light source

cast shadow

shadow line

Technical terms (compare to chiaroscuro terms, opposite).

Development of cast shadows from a cylinder and a sphere, as a result of angled lighting.

Types of lighting: form shadow produced by different directions of the light.

| front | side | back | angled | ¾ front | ¾ back | back top |

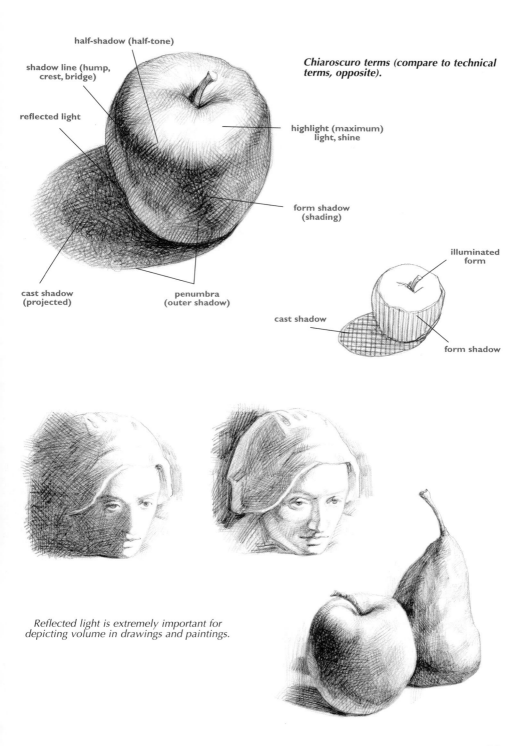

half-shadow (half-tone)

shadow line (hump, crest, bridge)

reflected light

Chiaroscuro terms (compare to technical terms, opposite).

highlight (maximum) light, shine

form shadow (shading)

illuminated form

cast shadow

form shadow

cast shadow (projected)

penumbra (outer shadow)

Reflected light is extremely important for depicting volume in drawings and paintings.

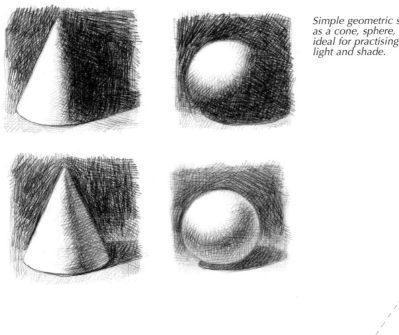

Simple geometric shapes such as a cone, sphere, or cube are ideal for practising the effects of light and shade.

A practical way of estimating the height of a tall object on flat land is to measure its cast shadow and compare it to the length of a shadow cast by a measuring rod.

A cast shadow can profoundly alter the shape of the body that produces it.

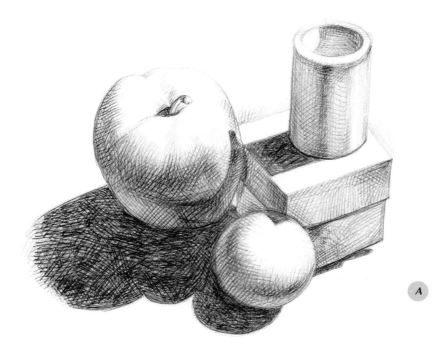

A

Form and cast shadow on simple objects exposed to direct natural light *(A)*
and slightly diffused light, from a large window *(B)*.

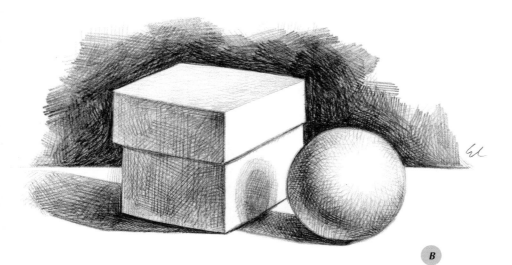

B

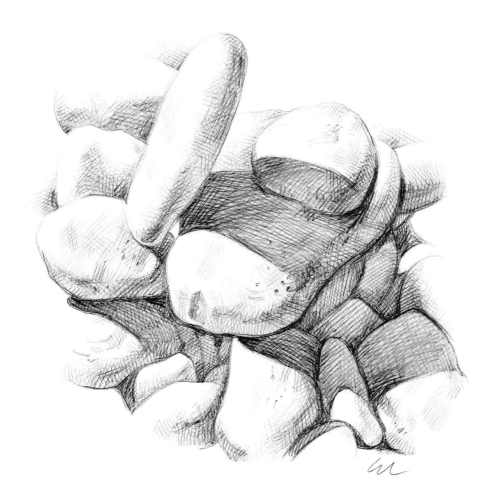

Stones and pebbles are good for studying the development of shadows cast by objects arranged in a complex way and by irregular shapes.

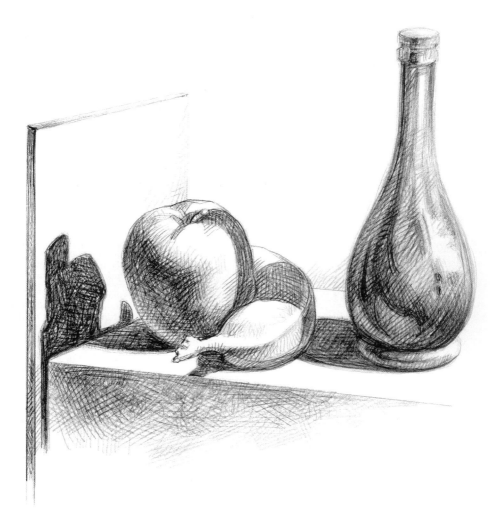

When drawing or painting a still life it is interesting to observe the development of cast shadows, apart from on neighbouring objects, on the surface it is arranged on and the vertical surfaces in the background as well.

PERSPECTIVE AND SHADOW THEORY

As described earlier in more detail (see pages 82–83), perspective plays an important part in light and its representation in art. 'Perspective' is the method of representing objects, landscapes, buildings or figures in order to suggest a sense of volume realistically on a two dimensional surface. In drawings it represents the object just as it appears to the eye of the onlooker. Objects, as a result of lighting, produce shadows on themselves and on adjacent surfaces. 'Shadow theory' considers the objects and shadows in relation to the light source so as to establish, using perspective, the limits of form and particularly cast shadows.

In linear perspective, a sense of depth is created by drawing objects progressively smaller as they go further away from the observer (viewpoint) and making them converge at a single point (vanishing point). Linear perspective is used in two ways: parallel linear perspective, where the object is seen frontally, and angular linear perspective where the object is viewed obliquely.

*In **parallel linear perspective** the horizontal lines of the sides of a solid cube are arranged into depth lines that converge to a central vanishing point, organized by distance points positioned on the horizon (see middle and bottom diagrams below).*

*In **angular linear perspective**, the horizontal lines of the objects positioned obliquely converge laterally on the horizon line from two vanishing points (see top three diagrams, opposite).*

In both cases the vertical lines of the objects remain vertical in the drawing. By varying the level of the viewpoint we obtain different perspectives: from above, from below, etc..

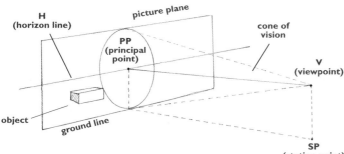

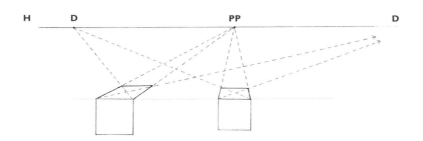

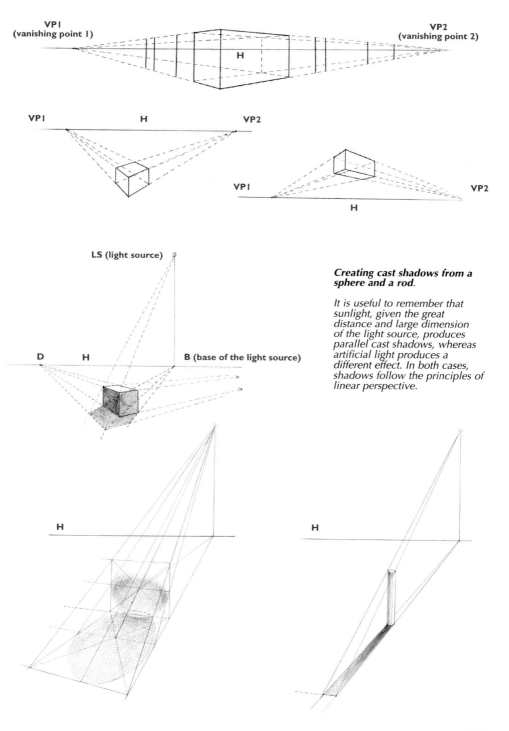

VP1
(vanishing point 1)

VP2
(vanishing point 2)

H

VP1 H VP2

VP1 VP2

H

LS (light source)

D H B (base of the light source)

Creating cast shadows from a sphere and a rod.

It is useful to remember that sunlight, given the great distance and large dimension of the light source, produces parallel cast shadows, whereas artificial light produces a different effect. In both cases, shadows follow the principles of linear perspective.

H

H

TONE AND TONAL VALUES

The term 'tone' refers to the intensity of an area, how light or how dark it is, irrespective of its colour. 'Tonal value' is the gradation of a tone in relation to other tones using a scale that ranges from white to black, the extremes of an intermediate series of greys. Tone is influenced by factors such as the intensity of the light in relation to the shadow (if the light is very bright, the shadow is very dark and the intermediate gradations are limited); the relationship with adjacent tonal values; the 'quality' of the light (natural, diffused, etc.); and the presence of reflected light.

Tone is also the overall effect of light and shade on a surface. You could also say tone is the effect produced by the contrasts between light and dark, by the arrangement of light tones and dark tones or their simplification. All these will be looked at more closely later on and are used to establish tonal structure, a fundamental 'constructive' element of a drawing or painting.

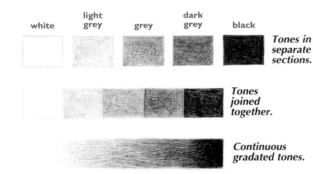

white **light grey** grey **dark grey** black

Tones in separate sections.

Tones joined together.

Continuous gradated tones.

Simplified scale of five tonalities. Our eye also perceives slight differences between similar tones according to whether they are side by side or slightly apart, surrounded by a dark or light surface, and so on. These differences in intensity are mainly noticed along the 'contact' line between tonal areas.

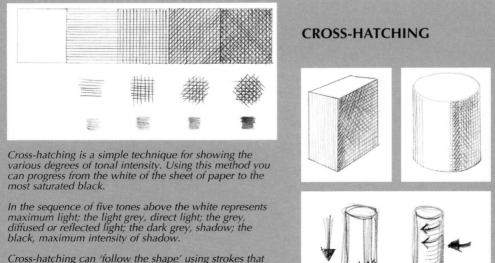

CROSS-HATCHING

Cross-hatching is a simple technique for showing the various degrees of tonal intensity. Using this method you can progress from the white of the sheet of paper to the most saturated black.

In the sequence of five tones above the white represents maximum light; the light grey, direct light; the grey, diffused or reflected light; the dark grey, shadow; the black, maximum intensity of shadow.

Cross-hatching can 'follow the shape' using strokes that follow the direction of the longest sides or 'contrast the shape' using short strokes that go against the longest sides.

Tone also indicates how light or dark a colour or surface is. To estimate the tonal value of a given colour it is useful to make a comparison between the scale above and the white to black tonal values. By putting a colour next to the colour table and half-closing your eyes, it is easy to identify the level of correspondence.

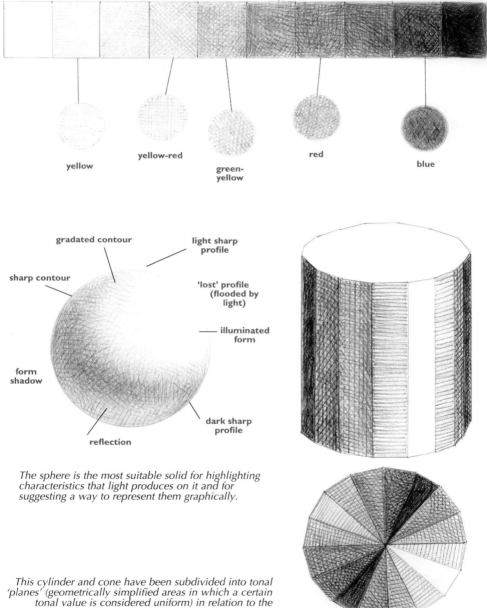

yellow

yellow-red

green-yellow

red

blue

gradated contour

light sharp profile

sharp contour

'lost' profile (flooded by light)

illuminated form

form shadow

dark sharp profile

reflection

The sphere is the most suitable solid for highlighting characteristics that light produces on it and for suggesting a way to represent them graphically.

This cylinder and cone have been subdivided into tonal 'planes' (geometrically simplified areas in which a certain tonal value is considered uniform) in relation to the intensity of light and shade.

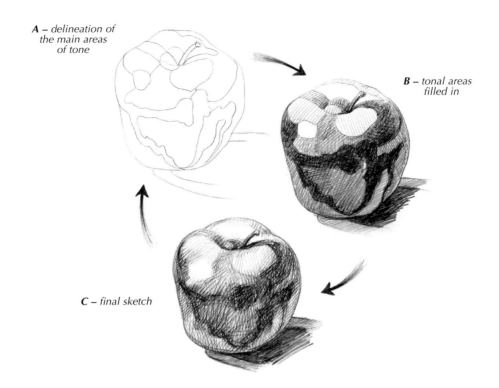

A – delineation of the main areas of tone

B – tonal areas filled in

C – final sketch

Areas of equal tonal intensity. To practise seeing the most appropriate tones for portraying the volume of an object, it can be useful to single out and outline the areas in which the tone appears to have uniform intensity.

In the sketch portraying the apple, for example, I have singled out five important tones (although there are really many more); whilst, in the sketch of the man's face below, I preferred to delineate the areas relating to just three tonal values: white, grey and black.

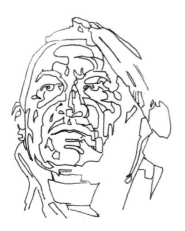

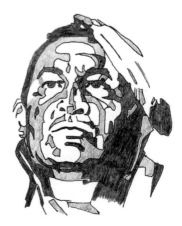

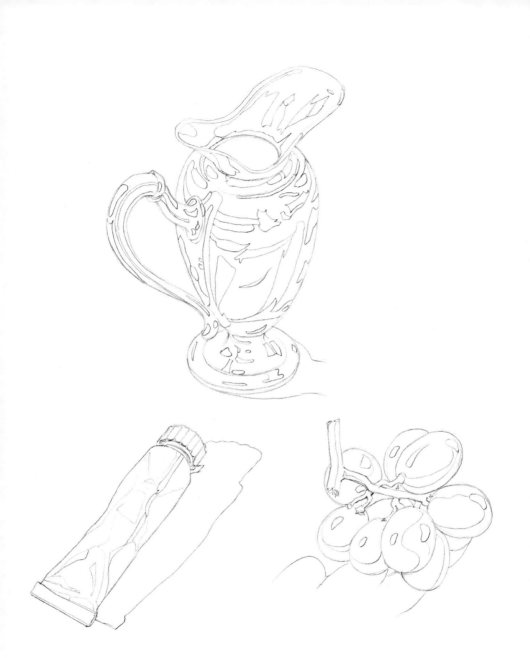

Assessing the tonal areas of metal or glossy objects is particularly complicated because of the shiny, reflective surface. Yet it is a very profitable, useful exercise in observation.

TONAL SIMPLIFICATION

In *chiaroscuro*, which is based entirely on the modulation of tones of shade, it is advisable to limit the range of tonal gradations to no more than eight or nine – or even fewer, if it is possible to do so without diminishing the means of expression. This gives 'consistency' to the portrayed shape, which may be weakened by over-emphasizing the shading.

Tonal sketches are a good way to practise recognizing and simplifying tonalities (see also page 112). This is how you can do it: half-close your eyes, single out the darkest areas, assess the most significant `local' tones, remember the main intermediate tones from among them.

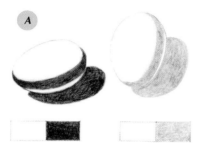

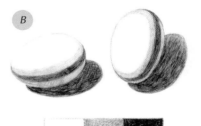

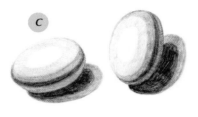

A – Simplification to three tones: white, grey and black.

B – Simplification to just two tones: white and black (that is, the illuminated form and the form shadow).

C – Simplification to four tones: white, light grey, dark grey, black.

D – Final sketch.

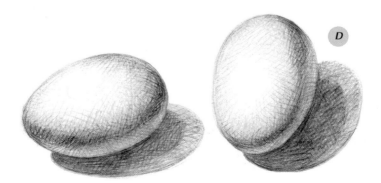

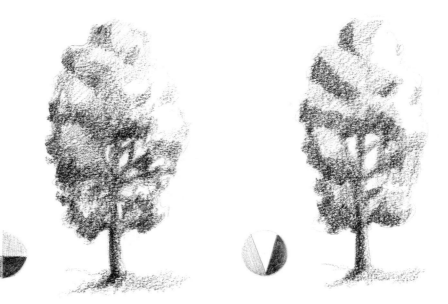

In drawing there are not many strict or binding rules (and it is wise to break them, sometimes, in order to understand their deeper meaning...), but mainly principles of good technique, of experience and of visual perception. One way of sharpening your powers of observation for shapes and tones is to portray the same subject using a progressively smaller number of tonal areas (from four, to three, to two, as shown on this page). Or, you can do it the other way round, from extreme tonal simplification to a richer range (as shown on the opposite page).

GRADATION OF TONES

Gradating tones are the means by which we produce *chiaroscuro*. The procedure is sometimes called 'shading' or 'adding value'. It consists in portraying the volume of bodies using tonal variation by observing, recognizing and comparing them to the different tonalities we see on the actual object. First establish the range of tones, singling out the area in which the tone appears darkest (for example, black or a certain degree of grey) and that in which it appears lightest (white) and the value of the dominant tone. Then, you can gradate the intermediate tones, assessing the changes between the various tonal planes.

It is possible to introduce 'accents' (the lightest and darkest) at appropriate places, in order to best suggest the volume of the portrayed object with maximum efficacy. Delineation of tonal areas is only used as an observation exercise: in the actual drawing, the tonal changes should appear decisive but gradual, without sharp linear contours. The most intuitive technical procedure for shading is hatching, and some examples of the various ways in which it can be produced are shown on this page.

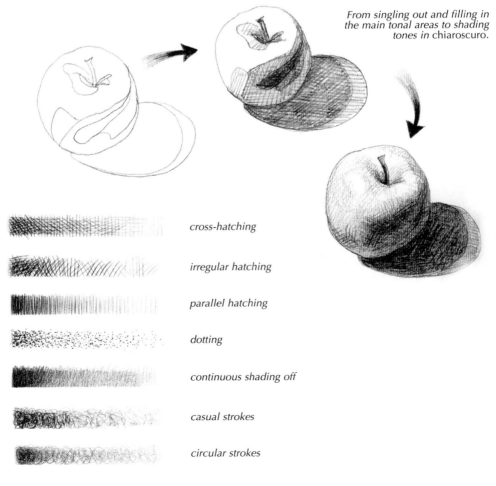

From singling out and filling in the main tonal areas to shading tones in chiaroscuro.

cross-hatching

irregular hatching

parallel hatching

dotting

continuous shading off

casual strokes

circular strokes

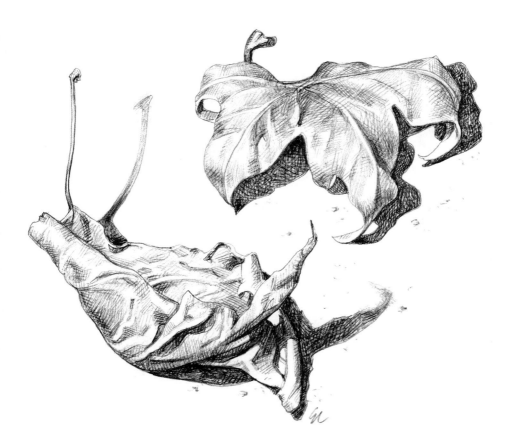

Dry leaves offer good opportunities for studying
very fragmented chiaroscuro: small illuminated
parts alternate with small shadowed parts,
sometimes in unexpected ways, suggesting strange
and curious shapes, not only in their form but in
the shadows cast on the ground.

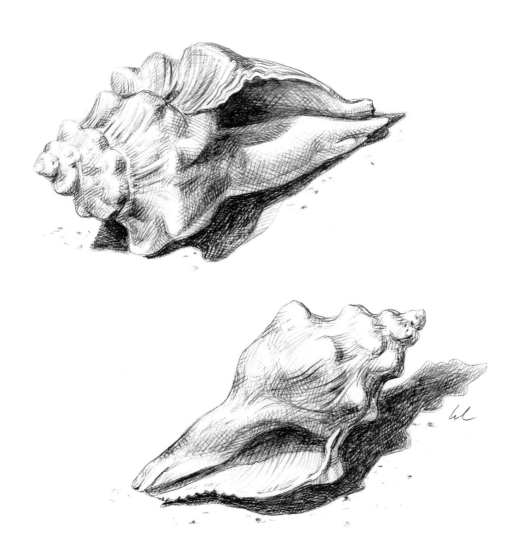

Shells are also interesting and complex models,
suitable for studying complicated protrusions,
recesses and grooves as well as areas of light
and shade. Their surface is smooth and shiny in
places: this helps us observe, on the same object,
the various ways in which light is reflected as it
falls on both rough and smooth surfaces.

Studying drapery has been, for
centuries, a special part of learning
how to draw, connected with the
practical need to portray the rich drapes
of clothing and furnishings that were in fashion
until not long ago. Even today, despite the radical
change in artistic and environmental trends, it can
be a useful and interesting exercise. Arranging
drapery can be an 'invention', but the folds
themselves cannot be 'invented' and are more
convincing if captured directly from life. The
way in which the folds are arranged depends
on the consistency of the fabric, the weft of
its surface and its colour. Of course not
all folds need to be portrayed: instead,
it is necessary to capture enough of
the overall development of the shapes,
characteristics of the fabric and tonal
range to suggest the volume and flow
of the material.

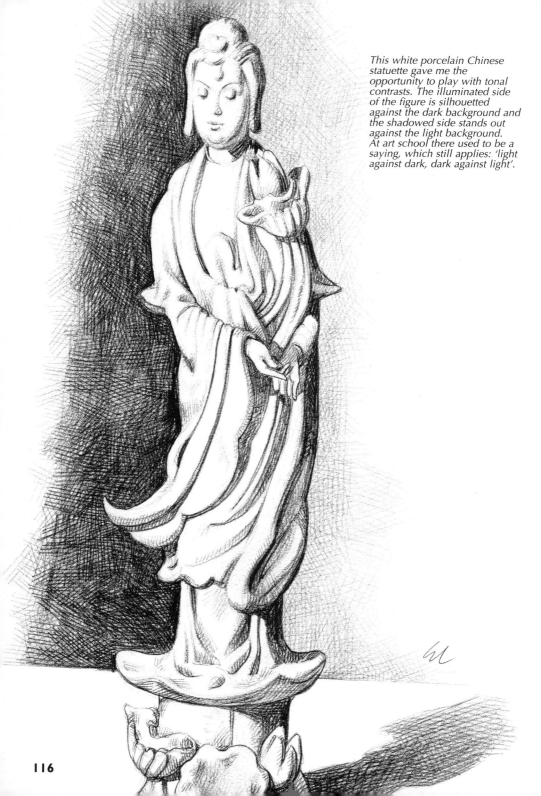

This white porcelain Chinese statuette gave me the opportunity to play with tonal contrasts. The illuminated side of the figure is silhouetted against the dark background and the shadowed side stands out against the light background. At art school there used to be a saying, which still applies: 'light against dark, dark against light'.

The same technique can be adopted for many different subjects. The hatching is more incisive, almost sharp, in the drawing that depicts the plaster-cast model of an ear, whereas it is softer and more delicate in the description of the petals of a rose.

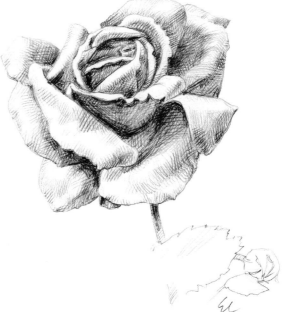

TONAL KEY AND TONAL CONTRAST

In a drawing or painting, the tones are based on a reciprocal relationship; this means a tone may appear lighter or darker in relation to another tone, especially if they are adjacent.

For example, an illuminated (white) area assumes greater force if surrounded by a much darker tone (such as the examples on pages 116 and 117). Through tonal contrasts the volume of an object becomes obvious and is more defined.

Tonal key refers to the predominant relationship between the tones of a drawing or painting; in other words, to the general, overall degree of luminosity or darkness. Defining the tonal key and relative contrasts is a decisive factor in producing a successful work of art, since it adds solid coherence to the composition and suggests an appropriate mood. For example, a high tonal key is suitable for delicate effects, a middle tonal key inspires an atmosphere of tranquillity and balance, and a low tonal key creates drama.

The high tonal key (1) is achieved by using tones situated towards the light end of the scale (in this example, divided into five degrees of tonality).

The low tonal key (2) uses the range of dark tones, situated at the opposite end of the tonal scale.

The middle tonal key (3) is described by intermediate tones, situated in the central part of the tonal scale or by the entire tonal range.

Tonal contrast sometimes corresponds to the tonal key, but not always. For example, a middle contrast can be associated with a middle key but a low contrast can correspond to a high key (depending on how the tones are placed) or, for the same reason, to a low key.

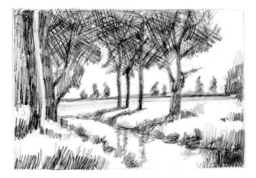

High tonal contrast (tones situated at both ends of the tonal scale).

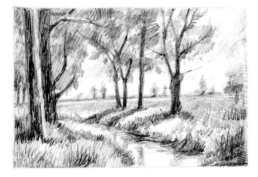

Middle tonal contrast (tones drawn from the whole tonal range or from the mid range).

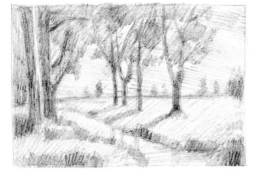

Low tonal contrast (tones taken from adjacent positions, especially in the dark section of the tonal scale).

CREATING EFFECTIVE SHADING

There are various ways of producing a good *chiaroscuro* work, especially in relation to the graphic tools (graphite, charcoal, etc.) or pictorial tools (oil, tempera, etc.) chosen by the artist. Yet, for all these, it is possible to single out a common method, useful for acquiring or sharpening powers of observation and tonal technique.

1 Carefully observe the object, capture the overall proportion, tone and form.

2 Draw, with light strokes that are close together, the main shadows (although avoid adding areas of tone that are too uniform or have vague boundaries, identify the darkest and lightest areas only).

3 Add the main tonal gradations observed on the object and in relation to the environment.

4 The lightest tones are produced, usually, with clean white paper and you can outline them with a slightly darker area, so as to make them stand out more.

5 Evaluate the development and success of the *chiaroscuro* by observing the object and the drawing with half-closed eyes.

6 Refine the tones and tonal values until you obtain the appropriate intensity and the right relationship between them; evaluate the correctness (on the object, on the drawing and in relation to the environment) of the contrasts and accents.

In a good *chiaroscuro* work (remembering always that it is about an exercise in observation, and not necessarily about works of art) the shadows must be decisive, quite sharp but not hard, with a certain transparency and able to suggest the development of the planes. Tonal changes should be soft, although firm and well defined, and the points of maximum luminosity situated in the right position, produced with decision and with a coherent, meaningful effect.

HB graphite **6B graphite** **water-soluble graphite**

pen and ink (or ballpoint pen) **willow charcoal** **compressed charcoal**

Some tools that are suitable for creating chiaroscuro.

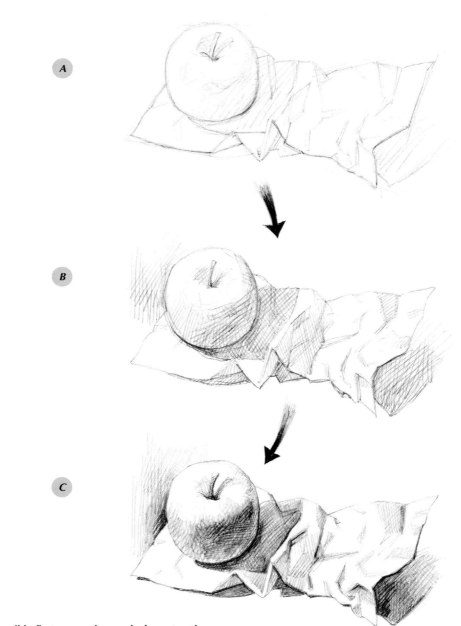

A possible first approach – gradual construction of tones.

Stage A: linear outline.
Stage B: indicating the main tones.
Stage C and successive stages: elaborating and linking the tones.

121

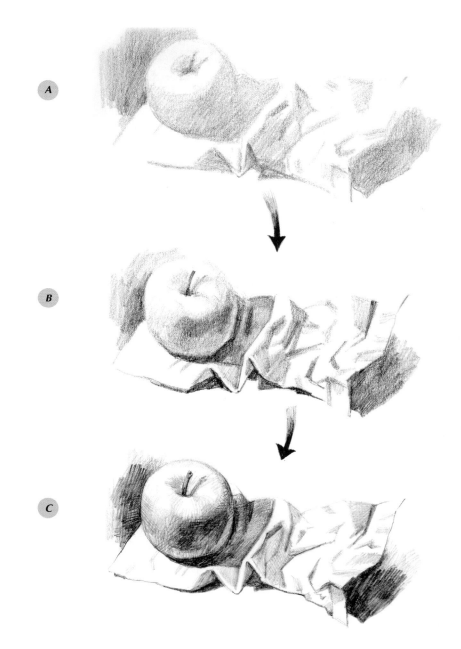

A second approach – setting out the dominant tone.

Stage A: singling out the light and shadowed areas.
Stage B: introducing a third tone.
Stage C and successive stages: producing the
chiaroscuro.

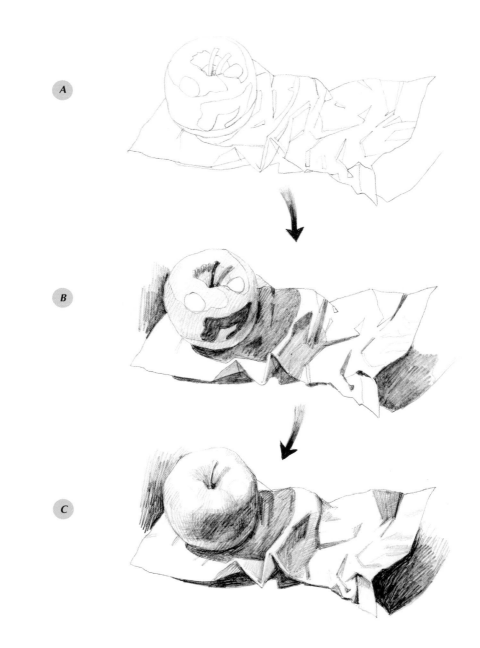

A

B

C

A third approach – setting out the tonal areas.

Stage A: outlining areas of uniform tone.
Stage B: filling in individual areas.
Stage C and successive stages: shading off and
graduating tones.

123

STUDY OF SHADOWS ON PLASTER CAST GEOMETRIC SOLIDS

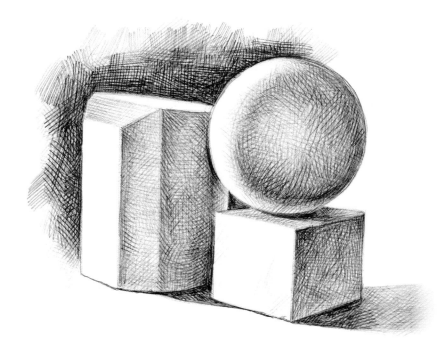

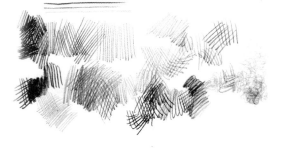

0.5 HB micro lead.

A very fine graphite lead allows you to produce a wide range of tones by simply crossing the strokes more or less densely. Take care to leave some transparency and light in the more intense shadows as well.

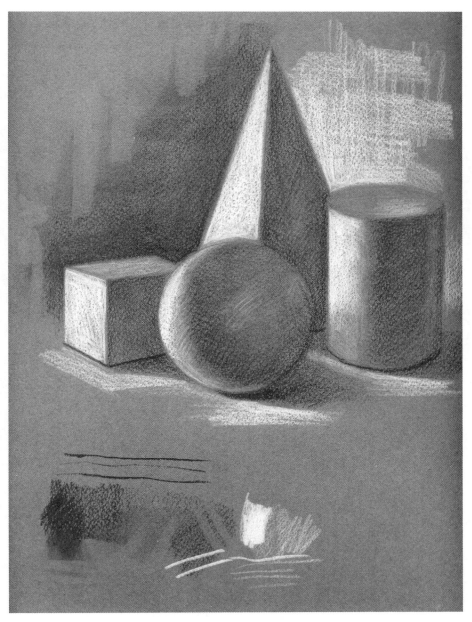

Black compressed charcoal and white gesso, on coloured paper.

The use of coloured paper of a moderately dark tonality allows you to depict objects merely by indicating the darker tones of shade and the lighter areas, illuminated by the light. The intermediate tone is indicated by the medium itself.

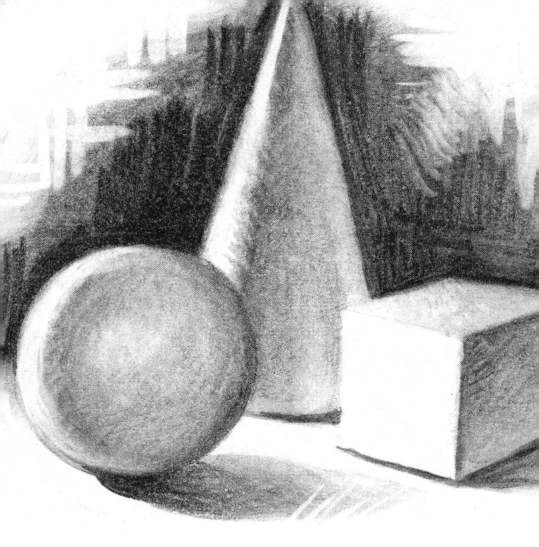

Willow charcoal.

The 'willow stick' (obtained by charring small willow twigs) offers a very wide range of greys. Gradation can be achieved by shading off with your finger or a piece of soft cloth. The illuminated areas are emphasized by lightening or removing the charcoal strokes with a kneadable putty eraser.

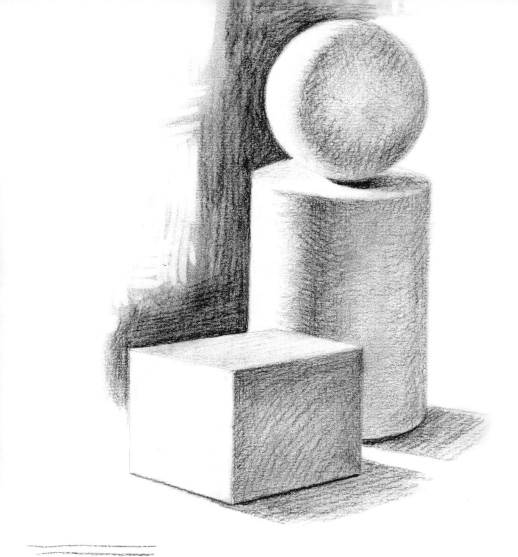

Compressed charcoal.

Unlike willow charcoal, compressed charcoal produces very intense dark tones and presents some major difficulties in obtaining the more delicate gradation of light tones. In darker areas it is advisable to avoid a too uniform and compact thickening of tone by, instead, using a slightly graduated hatching.

Similar in use to the black compressed charcoal is 'sanguine', a warm, delicate, reddish-brown chalk, very suitable for nude and portrait studies.

On the following pages (pages 128–131), you will find some black and white photographs of plaster casts and simple natural elements. They are useful for doing some preliminary exercises in *chiaroscuro* technique before approaching the study of similar subjects directly from life. The 'copy from plaster cast' method has always been considered a tedious and, nowadays, out-of-date and scholastic practice. And yet, it is fundamental for learning the technique element of drawing, and carefully and calmly analyzing the *chiaroscuro* effects produced by the various objects and different angles of lighting. The white, uniform surface of the plaster cast enables us to single out the more delicate tonal changes and provides the opportunity to observe them very accurately, reproducing them without the complications of colours or movements.

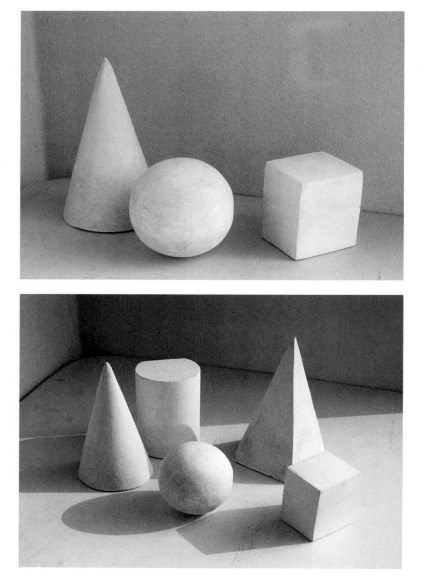

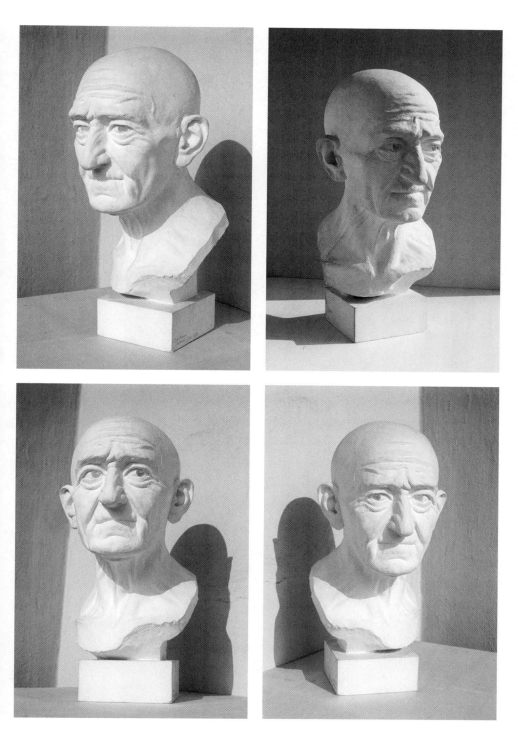

129

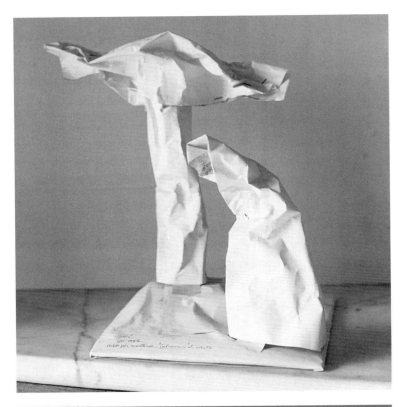

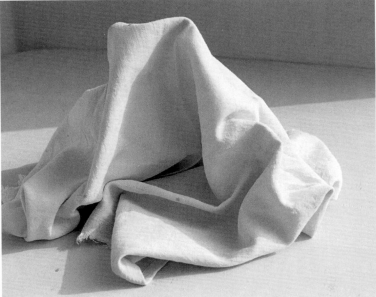

130

COMPOSITION

Tonal structure – the way in which the light and dark areas are organized and the contrasts that derive from them – constitutes an important aspect of composing a painting or drawing. Composition is, in fact, the arrangement of the various elements of a picture to create a coherent and meaningful whole. In composition we try to find the most suitable solution for organizing the layout of the forms and tones, according to the principles of balance or unbalance, symmetry or asymmetry, inactivity, or dynamism and tension. These principles are not exact and binding rules but are, rather, generally the result of artistic experience and aesthetic reflection on partly instinctive observation.

Analyzing the works of artists who have made use of *chiaroscuro* to compose their pictorial works, in various periods and various styles, is particularly useful.

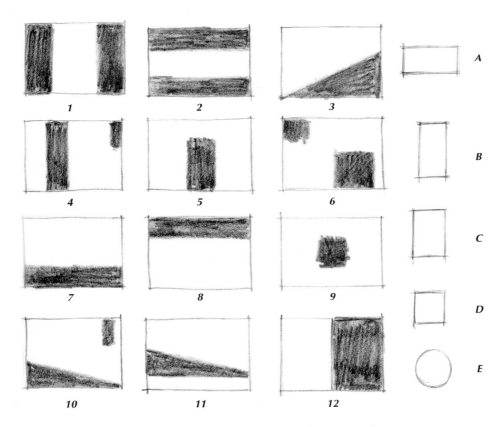

The format of the medium (A–E), which is traditionally rectangular (more rarely square or round), suggests the way in which to arrange the elements of the picture – the composition in relation to the expressive meaning you wish to give it. This can, depending on how it is organized, arouse different feelings; balance/ symmetry (sketches 1, 5, 9, 12); unbalance/asymmetry (1, 3, 4, 6); weight/gravity (7, 8); inactivity (5, 7, 9); dynamism/tension (3, 10, 11).

Tonal sketches taken from famous paintings.

This is a very effective exercise for improving your ability to compose pictures including the use of chiaroscuro.

1 – *Portrait of R.L. Stevenson (1887).*
 John Singer Sargent.
2 – *Sick Bacchus (1593). Michelangelo Merisi*
 da Caravaggio.
3 – *The Tub (1885). Edgar Degas.*
4 – *The Absinthe Drinker (1876). Edgar Degas.*
5 – *The Lacemaker (1664). Johannes Vermeer.*

VOLUME AND RELIEF

The quality (direct or diffused, intense or weak) and type (natural or artificial) of light determine the aesthetic result of the picture. Varying the light can also vary, sometimes in a surprising way, the appearance of the shapes. They may stand out or the finer features of the surface disappear.

The light, in fact, emphasizes the relief of whatever it is illuminating and gives the feeling of volume, space and atmosphere. Sculpture and architecture are also affected by light; form being influenced by whether light directly hits or barely touches the surfaces and shapes, creating sharp or soft, intense or weak shadows and creating the subtlest variations of *chiaroscuro*.

Below: The human face shows clearly the various expressive effects of different lighting. We encounter these images on a daily basis, perhaps without even consciously thinking about them.

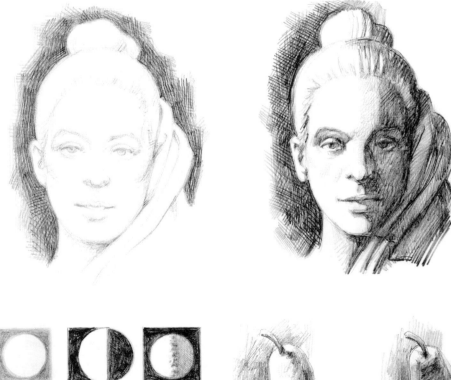

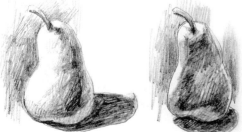

Light in front of the subject flattens the relief and suggests a flat, rather than solid shape. Side lighting, on the other hand, highlights the volume, dividing the overall shape into two halves, one of which is well lit and the other in shadow.

Side or lateral light can bring out
even the smallest of rough features.
Natural shapes (vegetable or mineral) are easy
to find and are fun to draw, experimenting with
the various shadow effects produced by various
types and direction of lighting. Be careful when
drawing the human body however, as directional
lighting can alter shapes and create unpleasant
visual effects.

AERIAL PERSPECTIVE

Aerial perspective considers the effects of tonal gradation produced by distance. When creating landscape pictures, for example, the objects in the foreground (nearest the observer) are very sharp and the tones and colours more intense. In the middle and background, however, these characteristics gradually fade away, are toned down and become hazy. Graduating the tones – from intense in the foreground to soft in the distance – effectively suggests the feeling of depth and the recession of space.

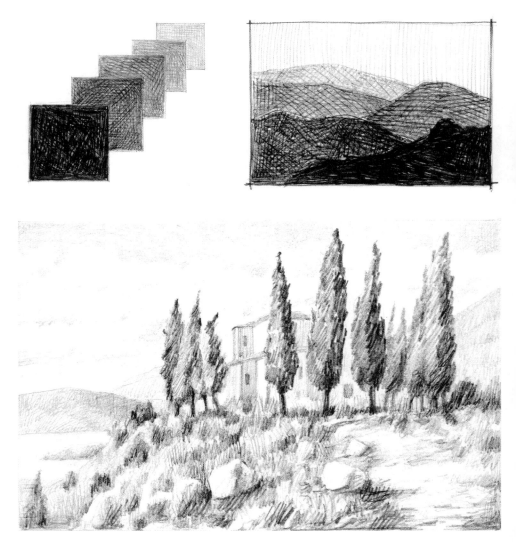

Pictorial examples of aerial perspective are innumerable and a good way to study (by drawing schematic tonal sketches) the effects obtained by the greatest Western artists, from the Renaissance to the Impressionists.

Above: Tonal sketch from The Virgin of the Rocks *(London, National Gallery) by Leonardo da Vinci.*

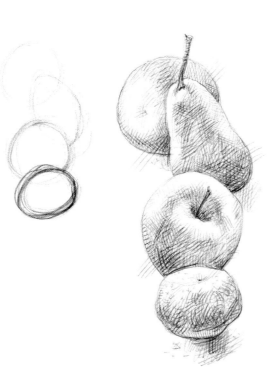

At short distances (in still life or figure drawing, for example) the effect of aerial perspective is, of course, very modest. You can suggest the feeling of depth by accurately and sharply outlining the elements that are nearest to the viewer and by using softer tones to outline objects or parts that are a bit further away. Another important device is to partially overlap the shapes, so that they form a sort of visual connection as they recede.

EFFECTS OF *CHIAROSCURO* IN ART

The use of *chiaroscuro* in art has always existed, to some extent, but it came to the fore during the Italian Renaissance and rapidly spread to the whole of Western art, including contemporary art. Various periods and cultures have made different use of *chiaroscuro*, attributing it with a variety of characters: for example, highly expressive and dramatic (Caravaggio), or a profound existential experience (Rembrandt), or a glance at intimate, suspended life (Vermeer), or, again, the brightness of the sun in nature and a luminous atmosphere (Monet). Examples of it and its decline in importance are, of course, innumerable. It can be a good exercise to examine some artists' works from various periods and in various styles, making tonal and compositional studies of them (if possible, taken from works directly observed in galleries).

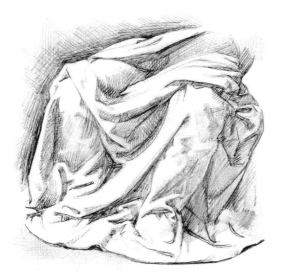

Study of Drapery (circa 1478). Leonardo da Vinci.

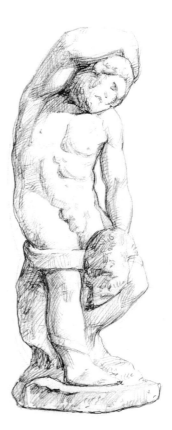

Slave (Atlas) (1519).
Michelangelo Buonarroti.

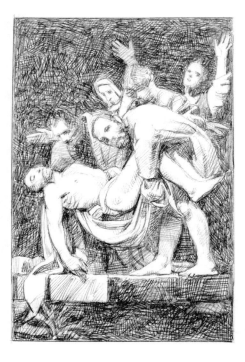

Deposition (1602).
Michelangelo Merisi da Caravaggio.

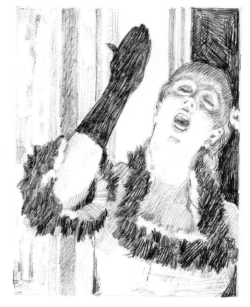

Café Concert Singer (1878). Edgar Degas.

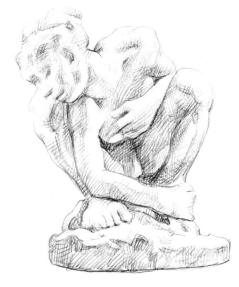

Crouching Woman (1882). Auguste Rodin.

STUDIES FROM LIFE

It seems appropriate to present here a small collection of my drawings, produced with various techniques at different times during my artistic career. The aim is not to exhibit my own work or propose examples to copy. Anything but. These works should suggest a variety of means and topics with which you can practise observing *chiaroscuro* and, above all, encourage you to find and follow your own means of expression: find (through careful study of the natural) the most personal and appropriate ways of freely expressing your true personality, emotions and investigative curiosity.

Drawing, with its technical skills learnt well, is the most complete and thorough tool for seeing and knowing the world around us and those who inhabit it, and for expressing the emotions that all this arouses in us.

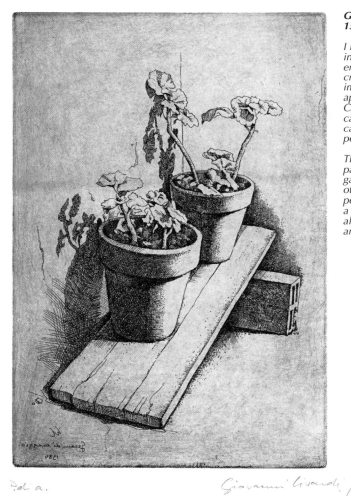

Geraniums. Etching, 15.75 x 21.5cm (6 x 8½in).

I have included several etchings in this section, a copper-engraving technique where the cross-hatching is of fundamental importance for depicting the appropriate chiaroscuro values. Careful observation of etchings can suggest similar results that can be achieved in pencil or pen and ink.

This small study portrays a pair of pots with flowers in my garden, sloping away from each other in a precarious position: perhaps a poor subject, but a pretext for focusing on the almost abstract play of light and shade.

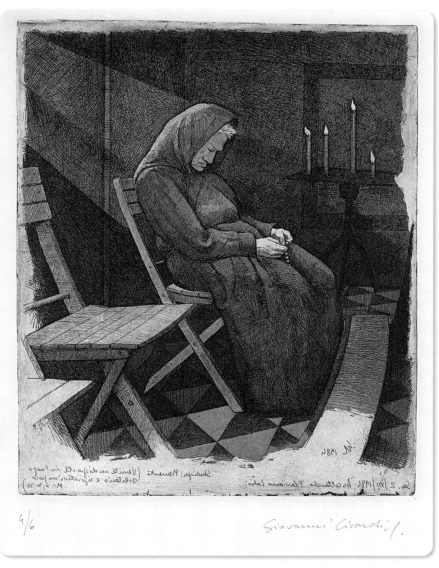

Rosina in Caravaggio's Sanctuary. Etching and aquatint, 21.5 x 26.5cm (8½ x 10in).

Even a very dark environment presents many tonal shifts. In this case, the intense light coming from a small window 'sculpts' everything it touches and depicts its volume. It is best not to accentuate the contrasts in tone too much and study, instead, the subtle modulations; on the praying figure's face and hands and on the floor, around the candles for example. In etching, the final print inverts the original image drawn on copper and this should be born in mind in the composition and in any written notes.

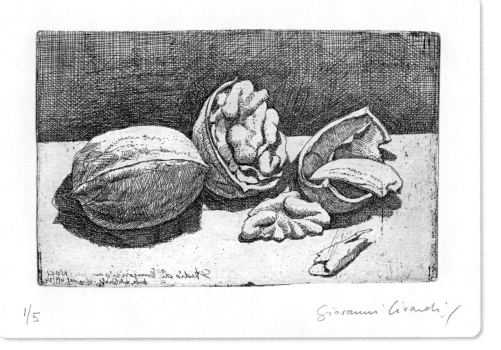

1/5

Giovanni Girardi

Top: Shells and Kernel: Fragments. Etching, 16 x 10.5cm (6 x 4in).

Left: Birth. Etching, 6.5 x 6.8cm (2½ x 2¾in).

Opposite: Elsa's Wait. Tempera on canvas board, 30 x 40cm (11¾ x 15½in).

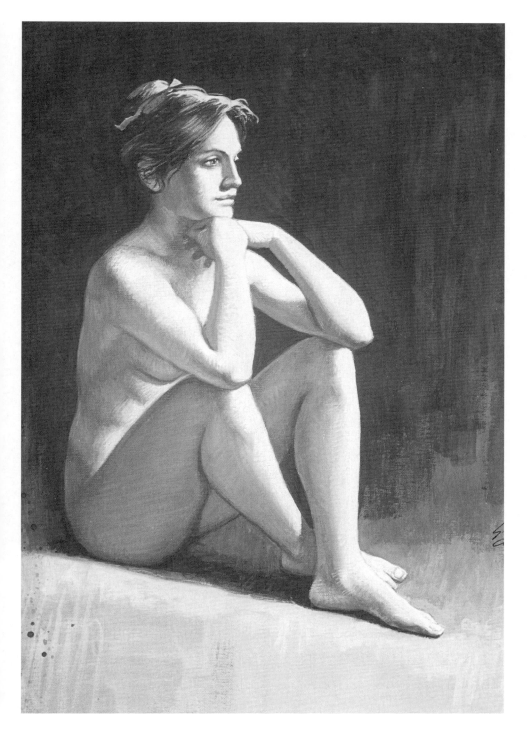

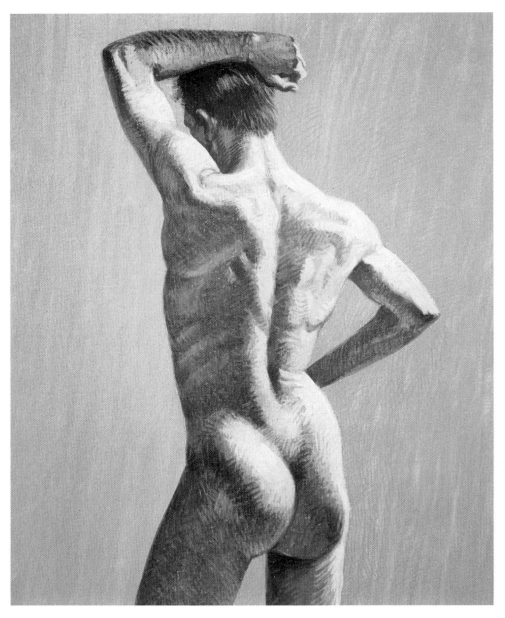

Study of Nude. Tempera on canvas board, 25 x 35cm (10 x 13¾in).

Lateral lighting is suitable for emphasizing the anatomical details and muscular play of the human figure. However, do not overdo the chiaroscuro or use a skimming light, as the effect can be distorting and even unpleasant. Light reflected by the environment, however, is useful for indicating the body structure accurately and with a sense of volume.

The Shadow of the Rose on my Table. Etching, 9.5 x 19.5cm (3¾ x 7½in).

A rose lit from above with a single electric light bulb produces a very definite chiaroscuro effect with few intermediate tones. The visual weight of the dark background is in the upper part of the drawing, but is balanced by the vertical arrangement of the two roses and the shadow that one of them casts on the table.

Fragments of Ancient Times. H graphite on cardboard, 36 x 51cm (14 x 20in).

This preparatory study for a book illustration is an excellent example of tonal contrast (see page 118). The play of chiaroscuro between the inlaid work on the building, the overlapping floors and the depth of the setting almost cancels out the crouching figure that is broken down into tonal fragments. In reality the intense sunlight created sharp shadows but the deep darkness of the porch from which the scene is viewed renders them rather pale.

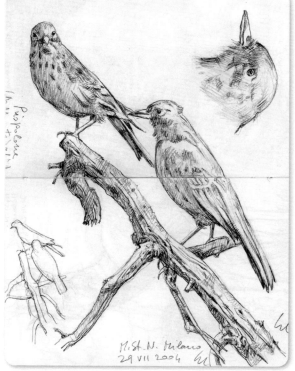

From the Traveller's Notebook (Visual Diary, series 2, no. 2). 0.5 HB graphite, double page, 14 x 18cm (5½ x 7in).

The true artist is always alert: everything that happens around you or springs to mind can be the object of a work or, at least, a sketch or a simple explorative drawing. I keep a small visual diary – I use pocket-sized notebooks – that I gradually fill with notes of images, thoughts and emotions. This is good practice for all artists. You will realize, then, that chiaroscuro is found everywhere, but drawing it from life can lead to discovering aspects that are unexpected.

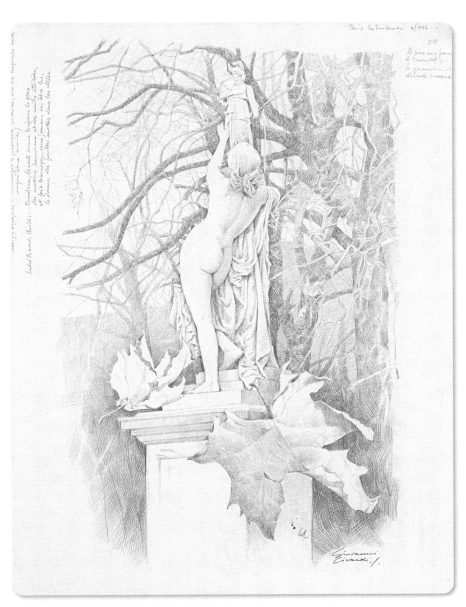

**Leaves (Paris, Les Tuileries): Homage to Boldini. H, HB graphite
on paper, 42 x 55cm (16½ x 21½in).**

Chiaroscuro *does not necessarily have to be associated with
intense tones of shade. This drawing shows a fine and delicate
central structure that is nevertheless rich in tonal changes, and
chiaroscuro is used to create a misty, autumnal atmosphere.*

DRAWING
SCENERY

INTRODUCTION

By focusing on drawing scenery, this chapter avoids any arguments over the definition of 'landscape'. Scenery is all-encompassing. It includes natural features such as plants, trees, rivers, seas and mountains, as well as the whole environment, both rural and urban, in which man and animals live, and which man has changed through cultivation and construction.

In this chapter, scenery includes landscapes, seascapes and a few man-made structures, though none are mutually exclusive. You only need look at the history of painting – past and present – to realize the importance of the 'landscape' genre and the sometimes profoundly different ways it has been perceived and interpreted by artists over the centuries.

To paint well, you need to draw well. The artist needs to know at least the basics of perspective and composition. The aim is not to achieve a sterile and academic result for its own sake, but to learn the art of drawing in order to be able to bend it and shape it to your artistic needs; or, if necessary, to reject it altogether.

This chapter is an attempt to offer a simple and concise overview of the many aspects of drawing scenery, highlighting some of the problems a beginner will be faced with and giving pointers (based on my teaching experience) on how to approach them to achieve good results. To this end, it is important to note that, besides learning and experimenting with drawing techniques, one needs to learn to 'see' reality – to observe what surrounds us – in order to be able to translate graphically what we perceive. I have included a number of photographs alongside the drawings and diagrams in this section so that, if you lack the opportunity to study scenes 'from life', you can start practising using these sample images. Should you wish to use these images for studying, ensure that your drawings are made in a personal style and with the techniques you like, and are not influenced by my own style of drawing.

TOOLS AND TECHNIQUES

Simple and popular media – such as pencils, charcoal, pastels, pen and ink, watercolours and felt-tip pens – can all be used for drawing scenery. Each medium, however, gives different results, due not only to the specific characteristics of the material and the techniques used, but also to the drawing surface (which can be rough or smooth paper, canvas, white or coloured paper, and so on). The drawings shown on these two pages have been done with media that, although commonly used, effectively conveys nature's tonal complexity, shades and details.

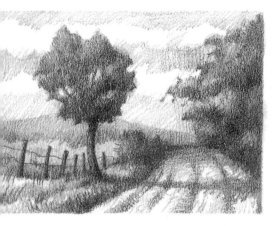

Pencil (H, B, 2B) on rough paper.

Pencil is the medium most commonly used for any type of drawing, but it is particularly suited to drawing scenery as it allows spontaneity and is convenient to use. It can be used for complex drawings, or for small studies and rough reference sketches. For the latter, very fine graphite (lead) is suitable, while for the former you can use thicker graphites in a softer grade. Graphites in mechanical holders as well as pencils (graphites in a wooden casing), are graded according to their consistency: from 9H (very hard) to 6B (very soft).

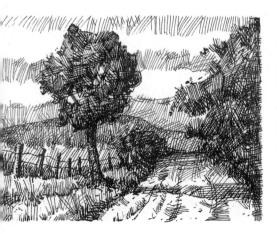

Pen, nib and Indian ink on medium-rough paper.

Ink is also often used by artists. It can be applied with a brush, or a nib, but to obtain special effects you can use bamboo reeds, oversized nibs, quills, or a small sponge to make marks. Tones can be made more, or less, intense by varying the density of the cross-hatching and it is therefore advisable to draw on fairly smooth, good quality paper (or board) which will not fray or soak up ink. For drawing out of doors, fountain pens, 'technical' pens, felt-tip pens and ballpoint pens are the most suitable.

Compressed charcoal on rough paper.

Charcoal is perhaps the ideal medium for drawing scenery as it is easy to control when laying out tones, and allows the artist to achieve quite sharp detail. To exploit its versatility and its evocative power, however, it should be used 'broadly', concentrating on the overall rendering of 'shapes'. Compressed, rather than willow charcoal, is also a handy medium when drawing outdoors, although you have to take care not to smudge the paper. Charcoal strokes can be blended and smudged by rubbing with a finger, and tones can be softened by blotting with a soft eraser (a kneadable putty eraser). When completed, the drawing can be protected by spraying it with fixative.

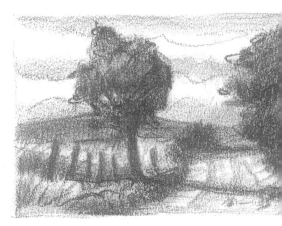

Diluted ink on NOT paper.

Watercolours, water-soluble inks and water-diluted Indian ink are very suitable for drawing scenery, in spite of being closer to painting than to drawing as they use a brush and require a comprehensive and expressive tonal vision. For quick, outdoor studies you can use water-soluble graphite or coloured pencils (to blend strokes easily, wipe them with a water-soaked brush); it is also preferable to stretch your paper so that the surface does not cockle.

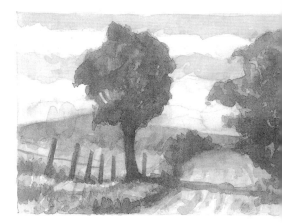

Pen and ink, watercolours, and white tempera on coloured paper.

'Mixed' media means using different materials to achieve a drawing with unusual effects. Although they are considered 'graphic' materials, their more complex application requires good control, and a good knowledge of the tools themselves, if we are to avoid muddled results with little aesthetic meaning. Mixed media are very effective on textured and coloured – or dark – surfaces.

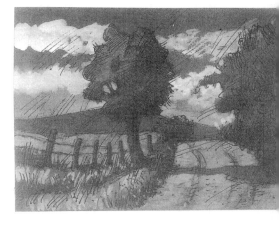

PRACTICAL ADVICE

There are opportunities for drawing scenery all around us. Many famous artists drew and painted what they saw from the window of their study or from the hotel they in stayed during their trips. Part of the pleasure of drawing, however, lies in the search, even far away, for a suitable, 'inspiring' subject. You may happen upon interesting vistas from a train, or bus. Some people have even painted scenes from a plane. But much more often, you will explore on foot, by bike or by car – the true 'landscape artist' is one who works outdoors, known as *en plein air*.

DRAWING OUTDOORS

If you intend to draw outdoors you can expect adverse or irritating situations to occur and you will have to take care of them.

A common problem is a psychological one. You will have to overcome the unease which comes from working while being watched by curious passersby or boisterous children. Don't worry: you will also meet interesting people!

The weather can also cause problems. Make sure you take the right type of clothing for the season: comfortable shoes, a hat and a large umbrella in neutral colours for working in the shade or for sheltering from the rain. If the weather is bad you can even draw from inside your car, sheltered from rain, wind and cold.

If you travel on roads with little traffic, take care when stopping and looking around.

EQUIPMENT

For essential information on drawing techniques and equipment, I suggest that you read the first chapter in this book *Drawing Techniques* (see pages 6–37).

When working outdoors, a folding chair, a few soft pencils (or whichever media you have chosen), and a sketchbook made of good quality paper are useful. If you do not have a sketchbook, you can fasten single sheets (quarter sheets, which measure 38 x 28cm/ 15 x 11in are ideal) on board with some masking tape.

Carry a small bag as well to hold (besides the appropriate drawing tools), a bottle of water, a few rags or paper tissues to clean your hands, a drink and some food for a revitalizing snack.

DRAWING TECHNIQUES

As mentioned, drawing techniques are covered in the first chapter of this book, but let us recap a few points.

For good results, make sure that you always keep your pencils sharpened with a knife or a pencil sharpener. To keep graphites in mechanical holders well sharpened, rub and roll them on a piece of sandpaper. Very fine leads and charcoal do not need sharpening.

If you want to draw wide strokes, hold the pencil at an acute angle to the drawing surface. Placing a sheet of tracing paper under your hand while you work will protect your pencil or charcoal drawings from smudging. When you have finished working, spray the whole drawing with an appropriate 'fixative'.

Never use an eraser. If a stroke has not worked, do not erase it. Draw another close to it to correct it and, if necessary, a third one and so on, until you have achieved the result you want. If you erase the imperfect lines, you will be left without terms of reference by which to make your alterations, and it will be like having to draw a new line. Basically, you will not be able to 'use' the imperfection as the basis for making your change. When you are happy, you can trace the correct lines with firmer strokes and erase the wrong ones.

Indian ink becomes viscous if the container is left open for long. You therefore need to add one or two drops of water occasionally. For the same reason, nibs should be cleaned often with a rag. Remember that clean nibs glide more easily on fairly smooth paper.

Do not work on a drawing for too long without taking a break. Every now and then stop, let your mind wander a little and examine what you have done from a distance.

CHOOSING A SCENE

Choosing a scene to draw from life is fairly difficult, because only rarely do you manage to catch it in ideal conditions so that it is more than just generically interesting. If you are studying particular features

(for example, trees, clouds or water) or carrying out a simple technical exercise, all you have to do is to observe the individual element carefully. But if your drawing is to be followed by a more complex one in preparation for a painting, or aims for an aesthetic meaning of its own, or is intended to analyze the complexities of perspective and composition, you need to spend more time observing the scene carefully before you start drawing it. Do this even if your work will be limited to rough sketches to capture the basic elements.

PLANNING A SCENE

When you reach a spot that looks promising, do not settle for what you see immediately but, if possible, walk slowly in different directions looking at the scene from different viewpoints (for example, you could sit on the ground or stand on a low wall).

At each location draw quick little sketches that outline the main 'shapes' – light and dark – of the scene (sketch them without worrying about the exact shape of the objects, concentrating instead on their tonal contrast, their relative dimensions, and their proportional relationship); and evaluate the 'format' of the drawing (that is, whether it is more effective as a landscape or a portrait). Organize the composition, and insert or eliminate certain elements (see pages 166, 168 and 180), choosing a close-up, detailed view or a panoramic, concise view.

The time you spend planning (observing, moving around, sketching, selecting, etc.) is not wasted. On the contrary, it is extremely useful as it solves perspective and compositional problems, highlights the feelings and emotions a certain landscape inspires in us, and lessens that 'fear of emptiness' we are all likely to feel when we are faced with a blank sheet and we do not know where to start.

LEARNING FROM OTHERS

It can be both enjoyable and informative to get together with fellow artists interested in drawing scenery and to go on outings. On these occasions each artist pursues his or her aims and keeps to his or her style, but the fact that everyone is working on the same subject, in the same conditions, using different media from slightly different viewpoints, allows interesting comparisons and useful exchanges of opinion, as people learn not only from their own experience but also from that of others.

LINEAR PERSPECTIVE

Perspective is a graphic method which represents spatial depth on a flat surface. In this chapter I have summarized the geometrical principles of linear perspective, whereby you achieve the effect of objects or scenery elements disappearing into the distance by decreasing size of the objects represented. Following these simple principles the artist can correct, or better understand, the 'intuitive' perspective naturally perceived by the eye. For more information about perspective, refer to the second chapter in this book, *Understanding Perspective* on pages 38–91.

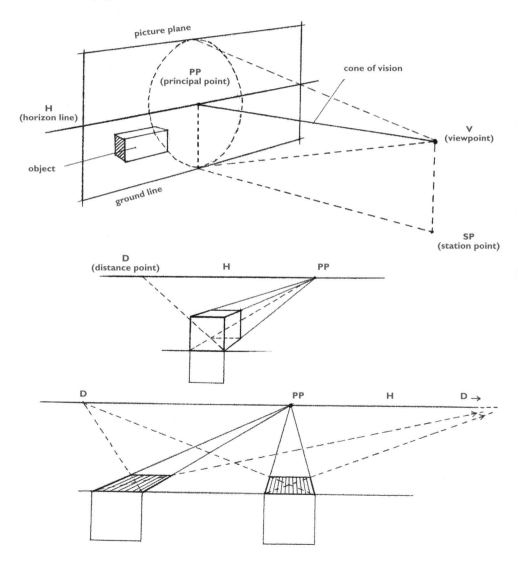

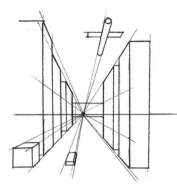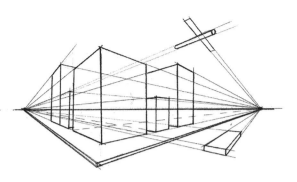

Central (or parallel) linear perspective is based on the principle that the non-vertical parallel lines converge on a single point in the distance. The horizon line always corresponds to the height of the viewer's eye and is determined by the viewpoint, i.e. by the position from which you are looking at an object or a scene.

Two-point linear perspective, also known as angular (or western) linear perspective, on the other hand, considers two vanishing points that are positioned towards opposite ends of the horizon line. The objects (which for simplicity's sake are represented as geometric solids) are viewed from the side. Vertical lines remain vertical, but their height appears to diminish towards the horizon and they also appear to decrease in depth. Horizontal lines converge at one of the lateral vanishing points, showing the objects 'foreshortened'.

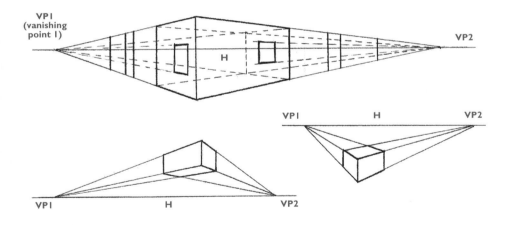

The sketch shown on the right outlines the basic elements that should be considered when drawing scenery. If you hold the drawing surface vertically you will find it easier to draw the horizon line, to compare it with life and to find the vanishing points. Before sketching a scene – especially if you are going to include buildings and structures – draw a little perspective diagram, so that you can verify, and if necessary amend, what you have observed. Remember, however, that perspective is a 'convention' and should not be applied too literally; it should be secondary to aesthetic values, and the rules 'broken' if necessary.

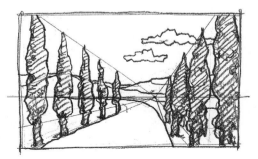

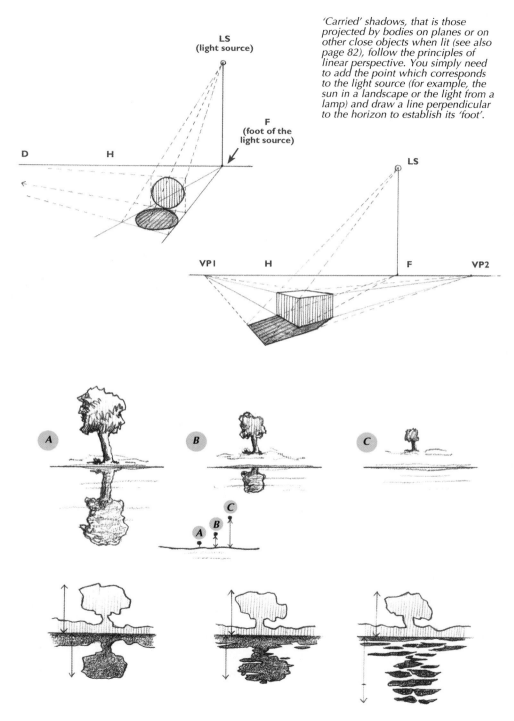

LS
(light source)

F
(foot of the
light source)

D H

'Carried' shadows, that is those projected by bodies on planes or on other close objects when lit (see also page 82), follow the principles of linear perspective. You simply need to add the point which corresponds to the light source (for example, the sun in a landscape or the light from a lamp) and draw a line perpendicular to the horizon to establish its 'foot'.

LS

VP1 H F VP2

A

B

C

A B C

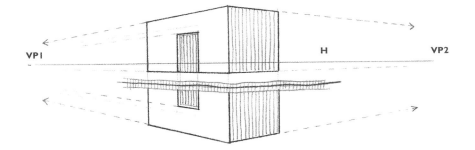

VP1 H VP2

Water mirrors the objects on its surface, and their outlines can be drawn following the rules of perspective, bearing in mind that the liquid surface is always horizontal. It is, however, extremely useful to observe carefully from life, as reflected images look different depending on the circumstances. They are almost mirror-like if the water is still; they break up if the water is slightly rough, and they almost disappear when the surface is very rough.

The tree sketches at the bottom of the opposite page show these effects, as well as the effect of the distance of the object from the water's edge.

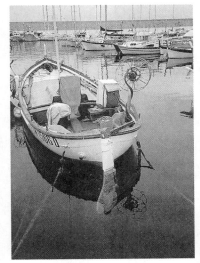

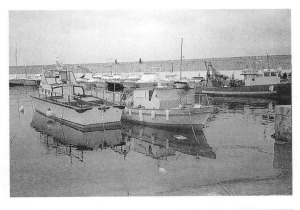

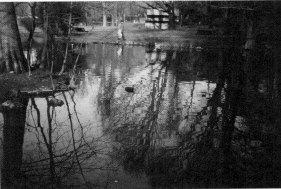

The photographs you see here can be used as a study aid to drawing reflections in some typical situations. My advice is to lay a sheet of tracing paper over the photograph, and draw only the outline of the boats or trees and their reflections on the water. These exercises will help your drawing greatly, especially if you are clever enough to outline just the main waves and breaks and leave out unnecessary fine detail.

157

It is good practice, especially when you have just started drawing scenery, to use photographs on which to identify and mark the main elements of perspective: the horizon line, the vanishing points and the spot where they converge. If possible, take the photographs yourself and then compare their perspective analysis from life, at the exact location from which you took the photograph.

View from above. Note the horizon is at the top of the drawing.

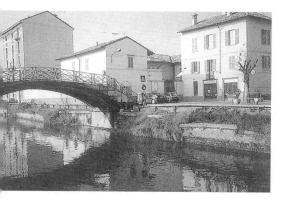

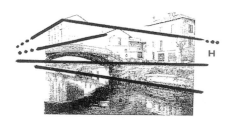

The horizon is in the middle: the lateral vanishing points are outside the edges of the photograph.

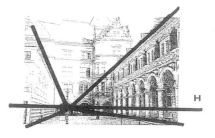

Central perspective.

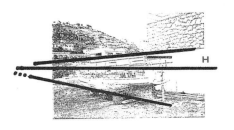

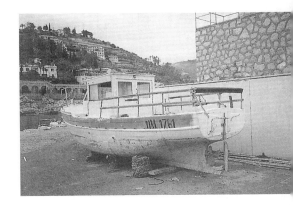

The camera lens can distort the perspective of objects; careful comparison with reality will enable you to make the necessary corrections.

Central perspective.

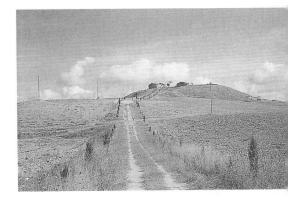

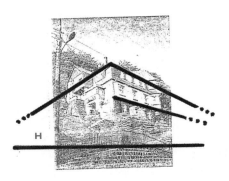

View from below: the horizon is at the bottom of the drawing.

AERIAL PERSPECTIVE

Linear perspective does not allow a faithful representation of space within a scene, as objects do not simply seem smaller the further away they are: their outlines lose sharpness and the air, dust and fumes that come between them and the viewer cause them to lose tonal value – especially where wide vistas are concerned.

Tonal, or aerial perspective, takes into consideration these effects, and is based on the principle that the elements of a scene as they recede into the distance, close to the horizon, appear gradually lighter, more vague and somehow 'veiled' in relation to the objects in the foreground, the area near the viewer.

The adjacent diagram illustrates this principle. Bear in mind, too, that in a drawing you can create the feeling of depth, of regressing in space, not just by weakening the tones but also by partial superimposition of objects or elements of the scene.

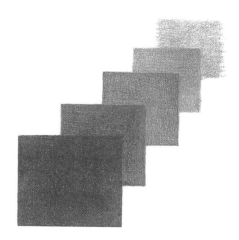

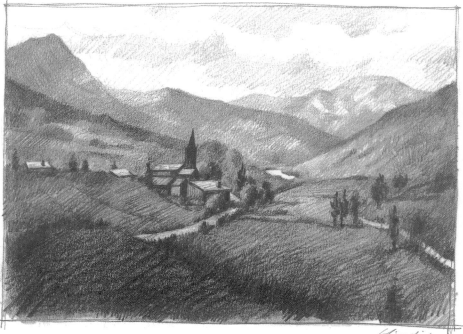

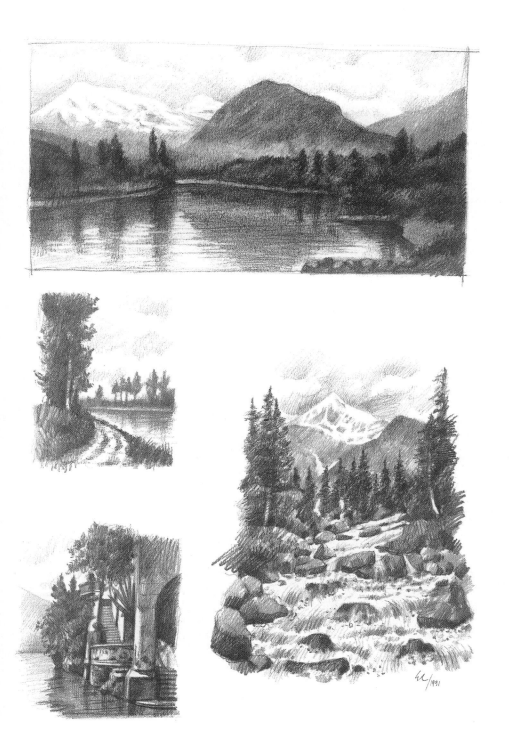

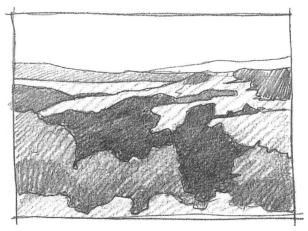

Study of top photograph, opposite.

Study of bottom photograph, opposite.

Try to find somewhere you can draw from life, or if this is not possible, take photographs similar to the scenes drawn or photographed in this book. Study the local tones carefully, i.e. the various shades of grey in different areas, and simplify them. To do this, choose only three or four shades between black and the white of the paper. You can use a very soft pencil and make the mark more or less dark by varying the pressure of your hand. A particularly useful exercise is to put a sheet of tracing paper on top of the photograph, then outline the areas that appear to have the same tonal intensity. You may find it quite difficult at first but observing and practising will improve your perception and make the choice of tones in your subsequent drawings easier and more confident.

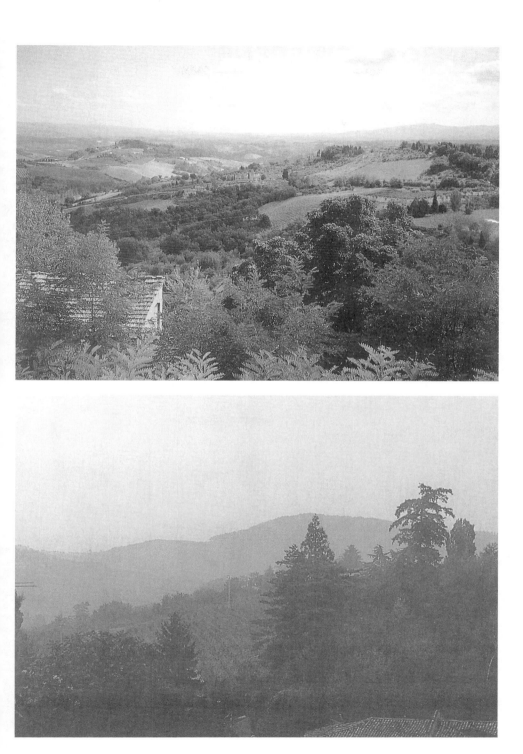

COMPOSING A SCENE

Composing a painting or a drawing means choosing and placing the expressive elements that are to be represented, and organizing the way they relate to one another on the drawing surface.

Composition depends to a great extent on the artist's intuition and 'visual' education, and is not bound by rules. It is possible, however, by observing works of art from the past or by experimental research, to work out a number of principles and tendencies which best suit our need for harmony and our perception of the environment.

The sketches shown on this page are made up of non-figurative elements (as used in research), and review some fundamental principles such as unity, contrast, harmony, convergence and dispersion, amongst others. At the bottom are some linear 'sequences' – horizontal, vertical, diagonal and wavy. Practise drawing similar sketches and try to check their emotional effect; some will inspire feelings of calm, and/or harmony, others tension, others still thickening or rarefying, and so on.

On the opposite page I have shown solutions which give better aesthetic results to a number of compositional situations. Bear in mind that these are just suggestions, not rules.

Avoid placing the subject at the centre of the drawing.

Avoid placing the horizon so it cuts the drawing into two equal parts.

Avoid dividing the image into two contrasting (black/white, full/empty, etc.) sections of a similar size.

Leave some 'space' around the subject.

Avoid creating rigidly symmetrical images.

Break the monotony of horizontal lines by introducing vertical elements.

Avoid lines which converge at the centre of the drawing.

Engineer 'lines of interest' which draw the viewer's eye to the inside of the drawing, rather than outside the edges.

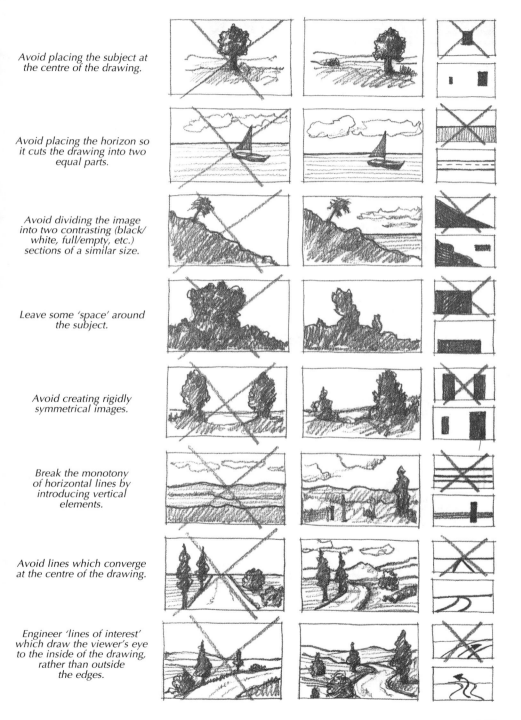

165

CHOOSING A COMPOSITION

When you start drawing scenery from life you first need to choose a composition, based on the observations in the previous chapter. Composing a scene means evaluating it from different viewpoints in order to understand it in its various aspects and represent it in the most appropriate and satisfying way. Below are some small preliminary sketches and, opposite, the viewpoint I have chosen for a more comprehensive study.

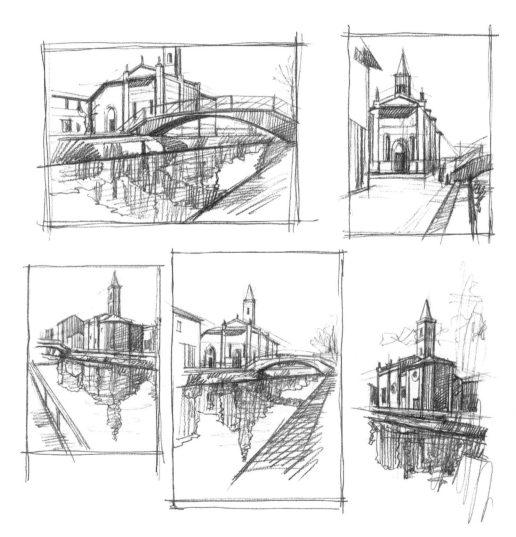

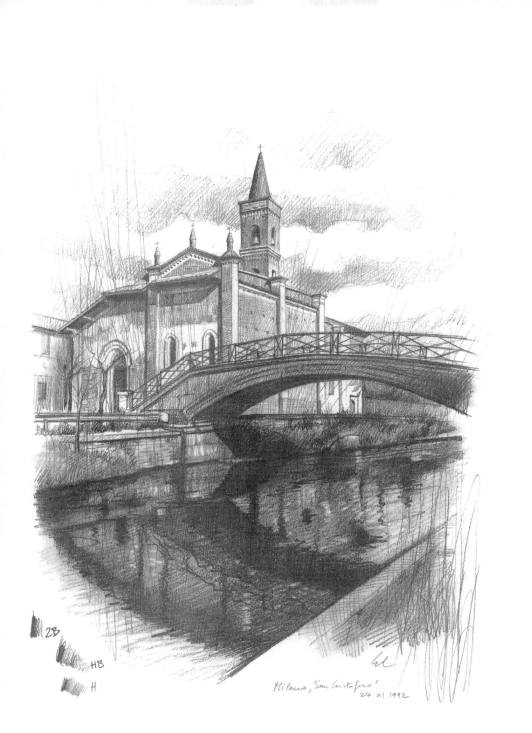

2B

HB

H

Milano, 'San Cristoforo'
27 XI 1992

Pencil on NOT paper, 33 x 48cm (13 x 19in).

DRAWING TECHNIQUES

FRAMING

Composing a scene is more than just choosing the right viewpoint. It involves deciding which elements should be put in the drawing, which to leave out or which to change in size or position. It also means 'cropping' the picture, that is choosing the size of the drawing, whether it should be portrait or landscape format and so on (see the diagram below as an example). You may find it easier to use a 'viewfinder' (a little rectangular window cut from a piece of card) through which, by moving it closer or further away from your eye, and holding it either vertically or horizontally, you can 'frame' the actual scene before deciding which view to draw. Many artists find it easier and more convenient to use an empty slide frame.

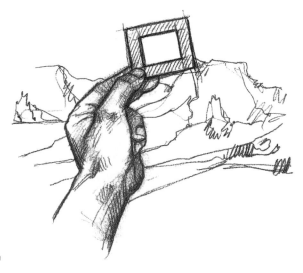

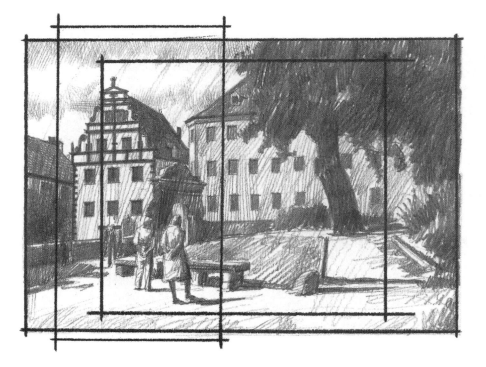

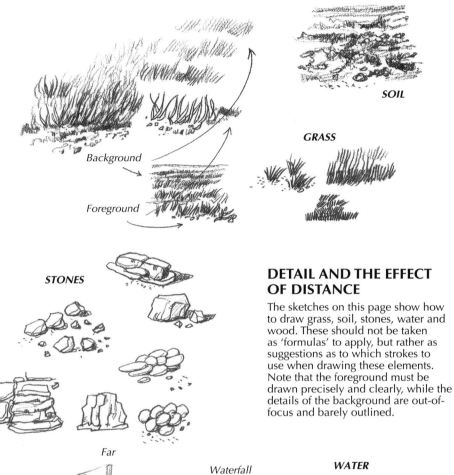

SOIL

GRASS

Background

Foreground

STONES

DETAIL AND THE EFFECT OF DISTANCE

The sketches on this page show how to draw grass, soil, stones, water and wood. These should not be taken as 'formulas' to apply, but rather as suggestions as to which strokes to use when drawing these elements. Note that the foreground must be drawn precisely and clearly, while the details of the background are out-of-focus and barely outlined.

Far

Near

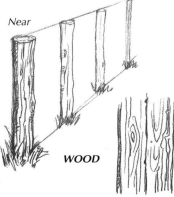

WOOD

Waterfall

WATER

Waves

Reflections

Splashes

LINE DRAWING

Line drawing can be used to 'build' a scene stage by stage. I start by sketching perspective lines, then outlining the individual elements. I then draw the most important tones and finally add more detailed tones. This is an analytical type of representation, suited to drawing with a pen or hard pencil.

On these two pages you can see the four stages of a drawing I sketched from life while on holiday in Germany, when preparing this chapter. The finished drawing is on pages 172–173.

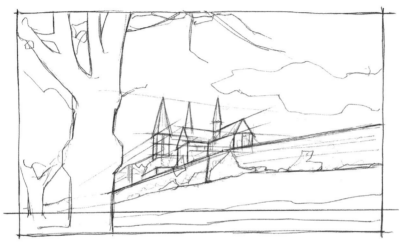

Stage 1 *Perspective lines sketched in.*

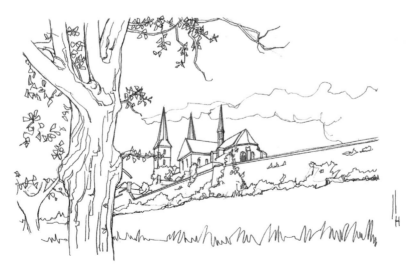

Stage 2 *Individual elements of the scene outlined.*

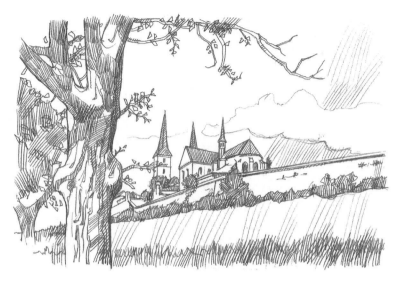

Stage 3 *The most important tones outlined.*

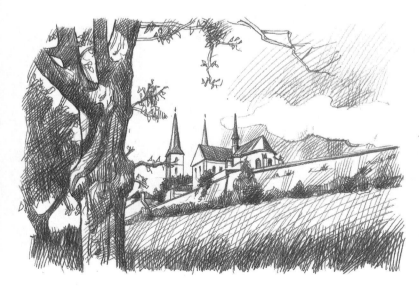

Stage 4 *More detailed tones added with cross-hatching.*

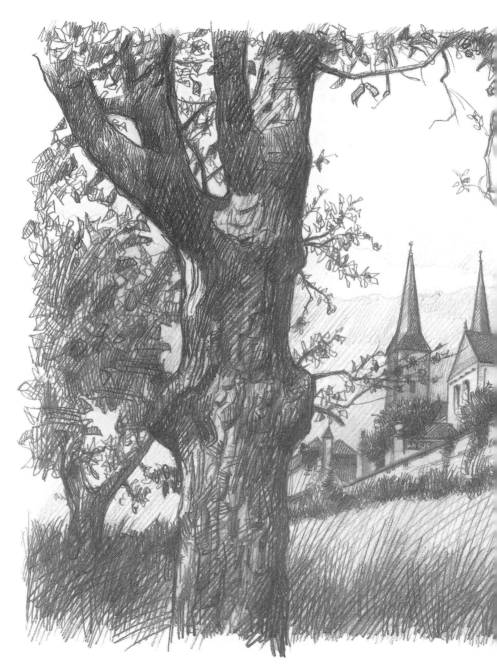

Pencil on NOT paper, 33 x 48cm (13 x 19in).

H

HB

Scivardi/ VI 92

TONAL DRAWING

Compared with the more 'graphic' line drawing approach, tonal drawing is definitely pictorial. It concentrates on representing the 'shapes' that make up a scene, with a unitary, structured approach which pays more attention to the interplay of tonal values than to minute detail. It is an approach that works well with soft graphite, charcoal, watercolours or mixed media, all of which are well suited to the tonal shading typical of aerial perspective.

To demonstrate this method I have, again, included four successive stages and, on pages 176–177, the finished drawing. My advice is to try both the linear and tonal approaches, regardless of which style you prefer, and apply them to the same scene, in order to weigh up their different expressive characteristics.

4B

Stage 1 Rough representation of the overall shape of the scene.

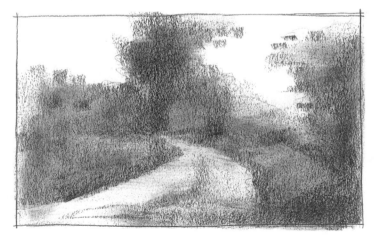

Stage 2 Tonal differences of some of the elements added.

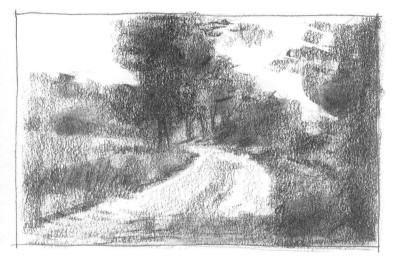

Stage 3 *More tonal 'depth'.*

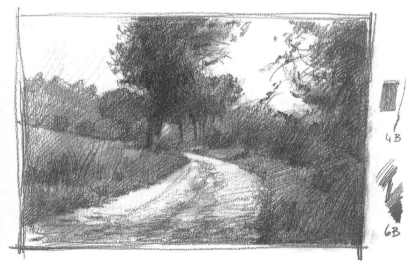

4B

6B

Stage 4 *Further tonal shading added.*

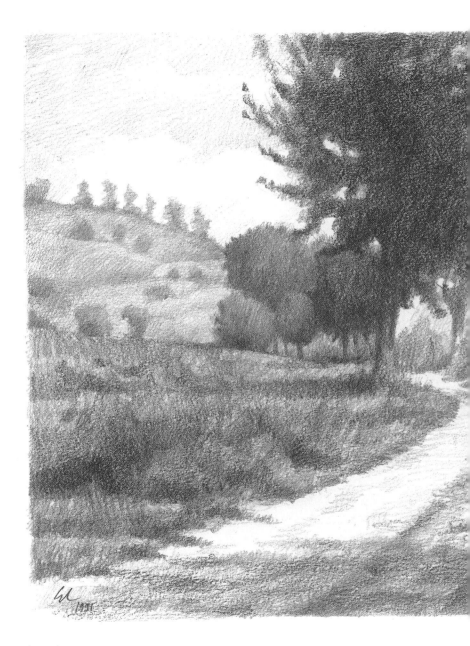

Soft graphite on NOT paper, 33 x 48cm (13 x 19in).

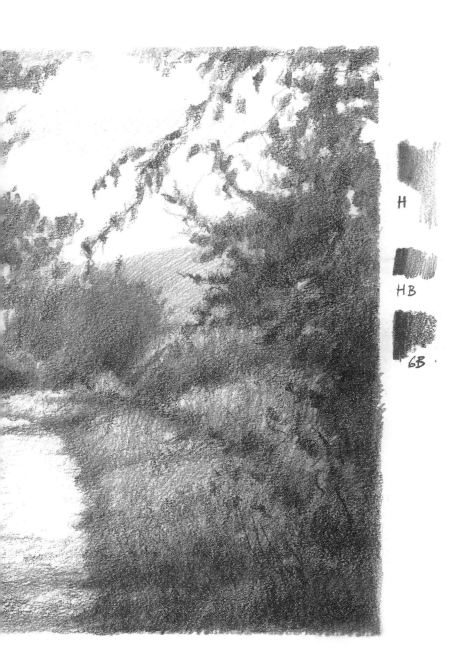

H

HB

6B

177

PRELIMINARY STUDIES

Drawing can be an autonomous means of expression, with its own intrinsic qualities and values, or it can be a clever tool to study reality, to make visual notes, and to solve compositional problems. It can be, in short, a 'preliminary' study, done as preparation for a more complex work, whether another drawing or a painting.

On this page I have put together some drawings sketched from life on a landscape theme. Note how I have 'moved around' the subject, looking for the most suitable viewpoint; how I have tried to replace, eliminate or move certain elements (houses and trees); how I have observed in more detail the architecture of a little cottage, and so on. When going on country walks, always carry a pencil and a pocket sketchbook and draw lots of sketches, as these will prove useful visual notes when you set out to paint or create complex scenes at a later time. Many artists also carry a camera which is indispensable for collecting a library of reference scenes and details – but remember that photography is a tool, not a substitute for drawing.

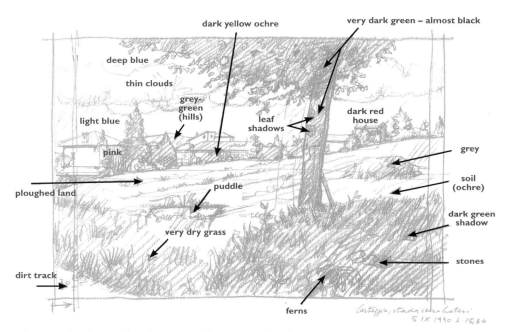

When you sketch a quick preliminary study in preparation for a painting, take down plenty of information on colours, details of the surroundings, the structure of complex elements, light and weather conditions, etc..

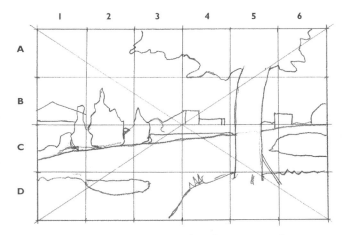

To enlarge a little sketch or photograph to the size wanted, you can use a simple tool called a 'grid of squares', which allows a quick and accurate transfer of the main outlines of an image. It is an intuitive process. Draw light parallel lines to subdivide the original surface into small squares and then transfer the same number of squares on to the canvas, or a bigger sheet, as indicated on the diagram on the right. It is easy to draw on each square the corresponding strokes from the original. The whole drawing will be enlarged in proportion.

DETAIL

If you have already experimented with drawing scenery, you will have realized that not everything you see lends itself to drawing. For instance, a large scene can be enchanting with regard to colour, yet look insignificant when we try to draw it. Or the opposite can happen, whereby an apparently unattractive landscape turns out to be unexpectedly interesting when we start drawing it. The same principles can in part be applied to photography. This is, in effect, an extremely complex problem to do with visual perception, psychology and artistic experience. The main difficulty, however, lies in transferring three-dimensional reality to a two-dimensional surface without losing the scene's feeling of depth.

Sometimes one or two elements from a large scene can be worked up into an effective drawing of their own. In the 'panoramic' drawing shown below, the foreground has limited prominence, is part of the total scene and even the sharpness of the detail is secondary to its tonal and perspective relationship with the other elements (rocks, sea, and so on). The same foreground (opposite), taken out of context, acquires an importance and graphic meaning of its own and requires a more detailed rendering.

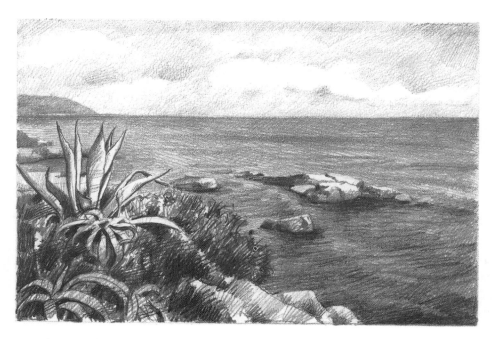

HB and 2B pencils on NOT paper, 28 x 19cm (11 x 7½in).

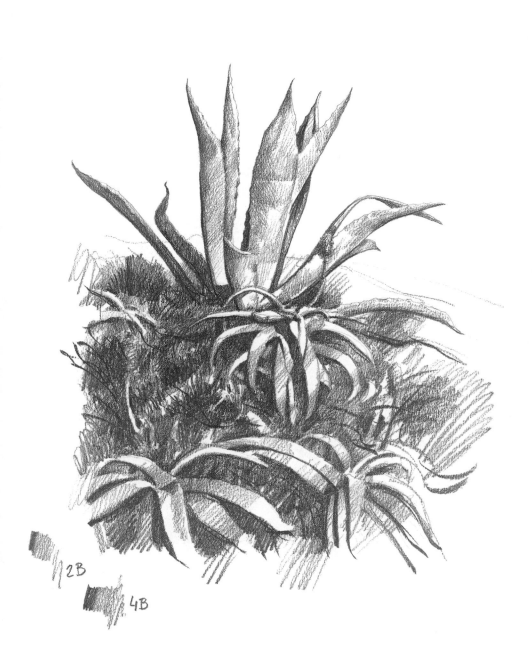

Soft pencils (2B and 4B) on NOT paper, 33 x 48cm (13 x 19in).

LIGHT

As light is of prime importance to the artist, you should pay a lot of attention to the sun's effect on a scene. The direction of the shadows varies according to the time of day, as shown in the diagrams below, and in the sketches on the opposite page. If possible, look at the same scene in different weather conditions – broad sunlight, dimmed by clouds, rain, snow, fog and so on.

Early morning　　　　　　　*Midday*　　　　　　　*Late afternoon*

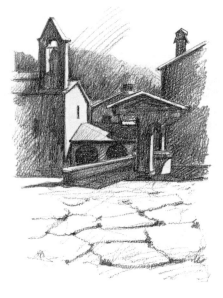
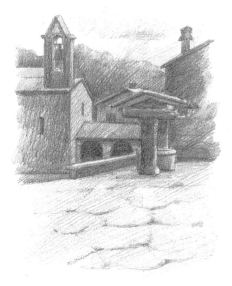

Direct sunlight with cloudless sky.　　　　*Indirect sunlight with cloudy sky.*

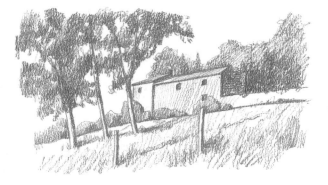

Hill scene sketched in autumn, in the first hours of the morning. At dawn, the sun is low on the horizon and creates long shadows with weak tonal contrasts as the atmosphere is bright and clear.

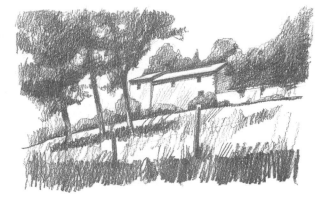

The same scene drawn at about midday. The sun is almost vertical and creates sharp shadows at the foot of the objects (houses, trees, etc.). The tonal contrasts are fairly strong; the whole landscape appears brighter and colours are at their most intense.

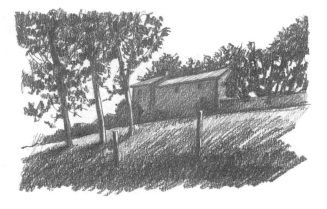

The same scene drawn in the late afternoon. At sunset the sun is again low on the horizon creating strong, long shadows and causing a strong tonal contrast between the sky (very bright) and the other elements of the landscape (dark because of the shade) silhouetted against the light.

WATER

Water can also be an important element of a scene. I have already mentioned the perspective problems of reflections (see pages 86–87 and 156–157) but here I suggest you simply study water in those situations which are of compositional interest: waves, boats in the harbour, ponds, fountains, streams, to name a few.

Waves are caused by wind and reach various heights. When they come close to the shore they look like those shown in the sketch below. The 'crest' juts out in front of the wave and then falls upon it, forming the characteristic breaker which dissolves into foam. When you draw the sea, do not attempt to compete with a photograph in its meticulous representation of detail, but rather suggest the feeling of perpetual movement by drawing short, sketchy strokes in a horizontal direction.

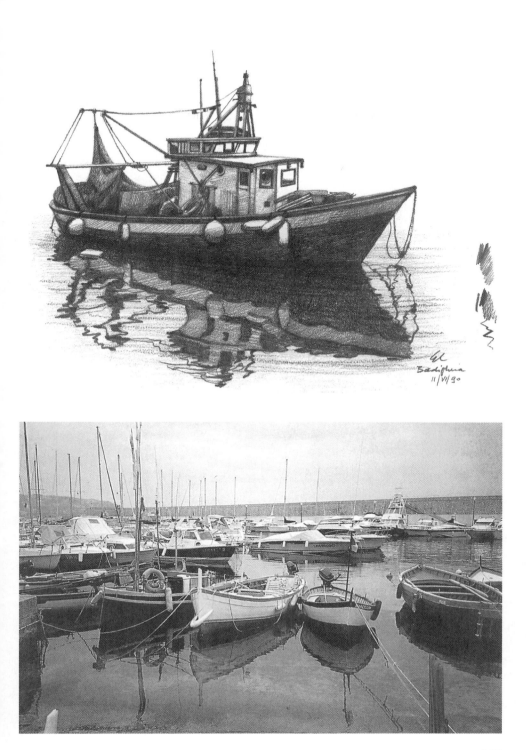

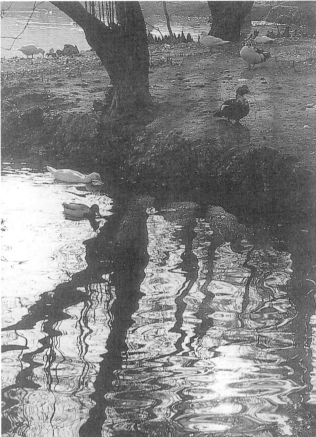

Small ponds and fountains in public parks and gardens are subjects that are both picturesque and easy to find. Practise interpreting these photographs using various media (such as charcoal, pencil and watercolours), enlarging them using the 'grid of squares' technique (see page 179), and then look for similar subjects in your own neighbourhood and draw them from life.

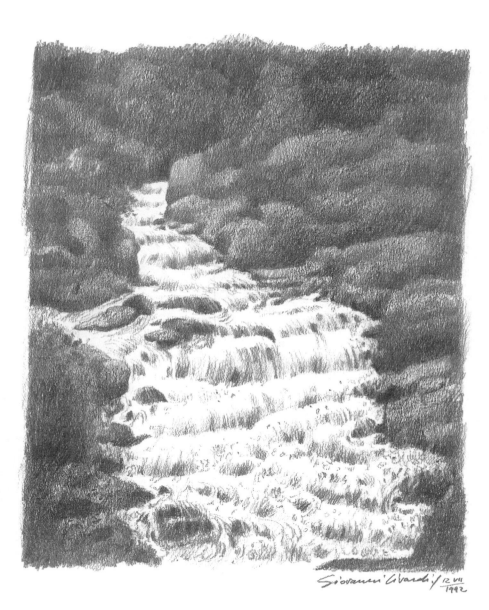

Little Stream. Pencil on NOT paper, 30 x 40cm (12 x 16in).

Short pencil strokes in the direction of the current are enough to suggest the waterfalls and the water breaking on the rocks.

TREES AND VEGETATION

In almost all landscape drawings you will have to represent trees, woods, shrubs and flowers. Vegetation is extremely varied and you need to study it carefully from life to be able to draw it convincingly. Here I have limited myself to a few suggestions.

When drawing a tree, notice first its general shape, especially its outline (see the sketches on the opposite page); try to understand the direction its trunk and main branches grow, and the structure of its bark and leaves. Then I suggest you follow these three stages: firstly, outline the profile; secondly, indicate the most relevant, yet significant, subdivisions of the foliage, and thirdly, sketch some of the foliage detail.

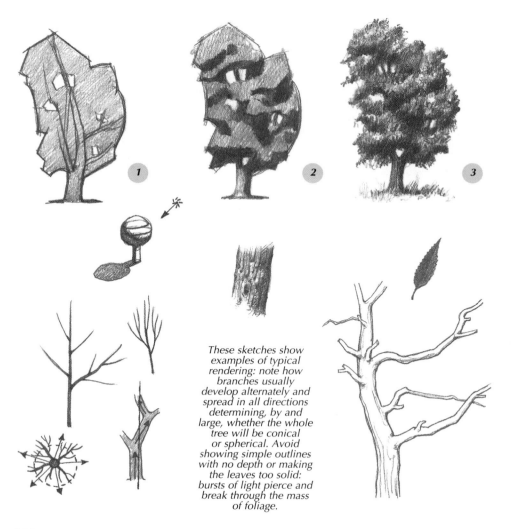

These sketches show examples of typical rendering: note how branches usually develop alternately and spread in all directions determining, by and large, whether the whole tree will be conical or spherical. Avoid showing simple outlines with no depth or making the leaves too solid: bursts of light pierce and break through the mass of foliage.

The characteristic outlines of some common trees (useful for identification).

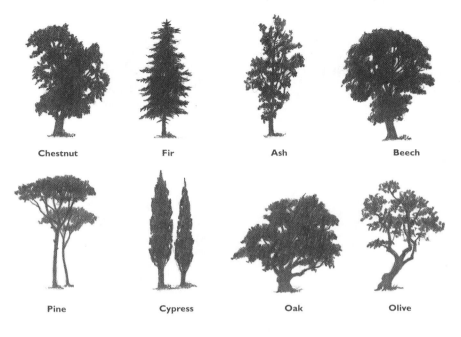

Chestnut　　　　Fir　　　　Ash　　　　Beech

Pine　　　　Cypress　　　　Oak　　　　Olive

The photographs below show the same tree taken in winter, after shedding its leaves, and during its spring blooming. Carefully compare the two pictures and notice the radical transformation which has taken place.

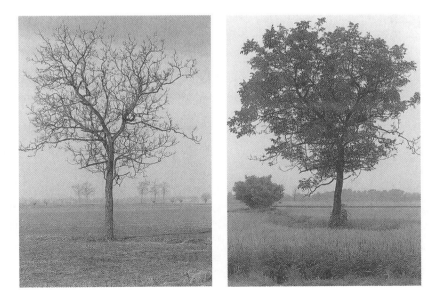

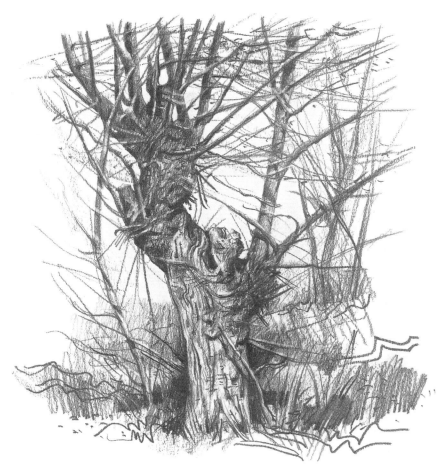

6B pencil on NOT paper, 35 x 35cm (14 x 14in).

Trunks are fascinating subjects to draw. Understand their structure and general direction, then examine the texture of the bark. Use soft grade pencil or charcoal.

Trunks and branches evoke almost abstract shapes.

Grasses and shrubs.

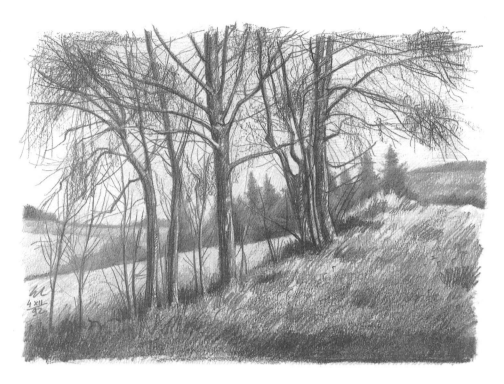

Trees on the Edge of a Wood. Pencil on paper, 25 x 30cm (10 x 12in).

Compare the drawing with the photograph below, which shows the subject from a slightly different viewpoint.

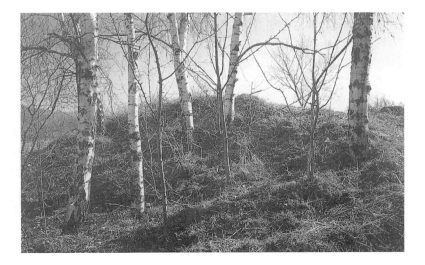

BUILDINGS AND STRUCTURES

It is rare to find a scene which doesn't feature something man-made, whether it is a house, bridge, road, or farm machinery. You will have to place these elements in your drawing. When drawing buildings, start with a thorough perspective sketch to highlight architecture, monuments and urban vistas. Buildings in the distance should be sketched in broad shapes, without much detail, while those in the foreground must be drawn precisely. Bear in mind the relative proportions of people to buildings. The adjacent diagrams show the relationship between a man's height and the door, window, and front elevation of a house.

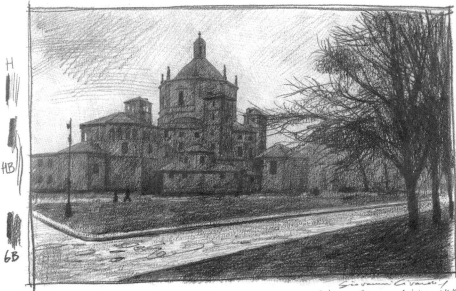

Practise drawing the details of buildings close up. This helps you to understand construction methods and to notice the characteristics of different materials (such as wood, brick, metal and stone).

dormer window

chimney

Door and small window of an old Tuscan house (right). The position of the window, which looks odd at first, makes sense when it turns out to be the skylight of a staircase. Study these curious characteristics from life – you will often come across them in old country houses.

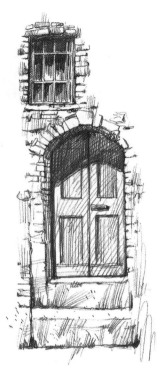

brick

Massive rock wall (left) and low stone wall (above). The materials of each are similar but the dimensions are quite different. In many cases it is necessary to introduce elements of scale (in this case, a man and a flower).

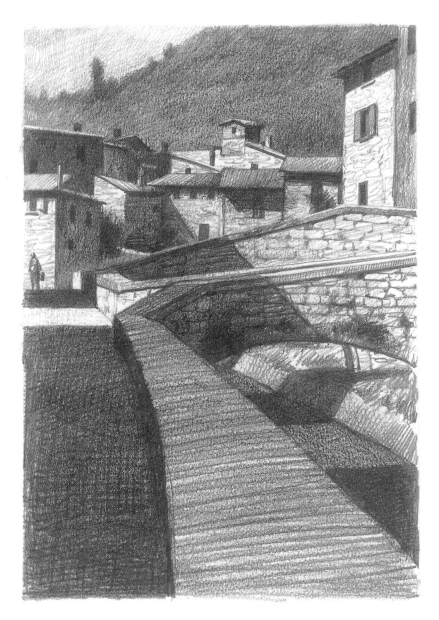

I sketched this little pencil study in a village in Tuscany, Italy. What appealed to me was the unusual perspective of the vista. The architectural elements are secondary to the geometric rhythm of the houses, and to the alternating of light and shade. The hilly background is rendered out of focus by finger-smudging the pencil strokes, while the other planes are defined more clearly as they get closer. You can see the texture of the stones in the wall of the little bridge, but I barely hinted at these details when drawing the walls of the houses in the distance. I cross-hatched with a soft pencil to achieve increasingly darker tones.

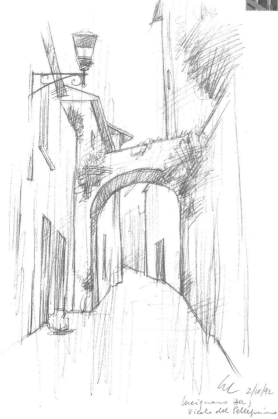

During walks in search of interesting urban scenes, take some photographs but, above all, draw plenty of sketches.

2/IX/92
Lucignano (AR)
Vicolo del Pellegrino

195

CLOUDS AND SKY

Clouds' shape, consistency and position change so rapidly that only by observing their natural appearance carefully can you work out how to represent them convincingly. The sketches below will help you recognize the various types of clouds and point out features useful for drawing. Draw close strokes in soft pencil using even pressure and blending well. Smudging is not necessary, except to achieve soft and misty effects, as it is better to keep a certain shape and structure to clouds.

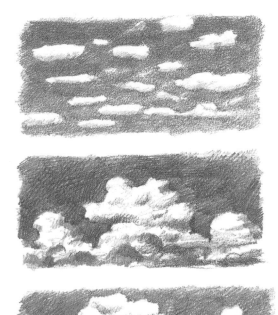

Cirrus have a stringy or necklace-like appearance. They are found at very high altitudes.

Cumulus appear as banks of partly superimposed clouds with a rounded outline. They are found at low altitudes.

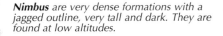

Nimbus are very dense formations with a jagged outline, very tall and dark. They are found at low altitudes.

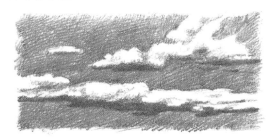

Stratus appear thin and elongated and are found at medium altitudes.

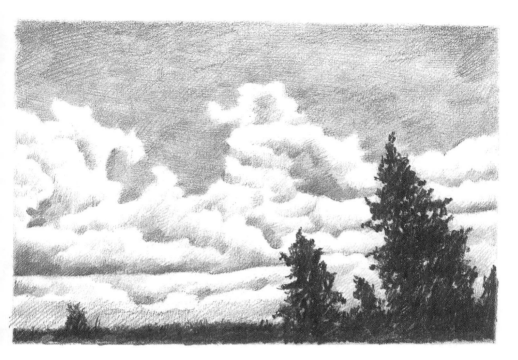

4B pencil on paper, 25 x 35cm (10 x 14in).

This study of a cloudy sky is partly based on photographs below but also on many sketches from life. It highlights the tonal contrast between the dark tree-lined foreground and the intensely bright sky.

REFERENCE MATERIAL

I mentioned on page 178 how useful it is to sketch lots of little studies from life while you are out and about in search of views to draw. I believe that drawing, even a quick sketch, has invaluable meaning for the artist. However, photographs can be useful for collecting reference material when we have limited time at our disposal or we need to capture fleeting images. Do not neglect, then, to take plenty of photographs. Bear in mind the drawings you will make from them and choose viewpoints and compositions accordingly.

Interno di giardino

Gondola a Venezia

San Gimignano in controluce

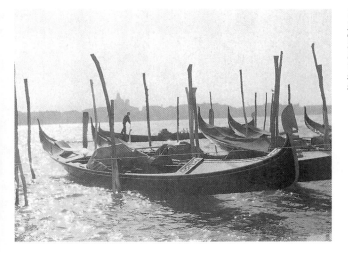

The sketches and photographs
you see on these two pages
come from my 'visual notes'
file in which, over the years,
I have assembled a large and
varied collection of themes and
subjects related to landscapes,
seascapes and buildings.

FIGURES AND ANIMALS

If you want to draw the surrounding environment and scenes of everyday life you will need to introduce figures and/or animals. I will go into greater detail with animals in the later chapters, on pages 272–400, but will mention them briefly here. These subjects are as fascinating as they are complex to draw. For the moment I would like to reassure you by saying that, in drawing scenes human beings do not usually need more attention than the other elements. You should pay particular attention to scale (note that the total height of a person corresponds to seven and a half times the height of their head); the overall look, and characteristics of the subject.

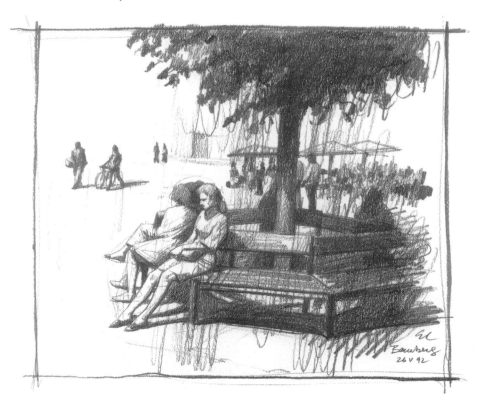

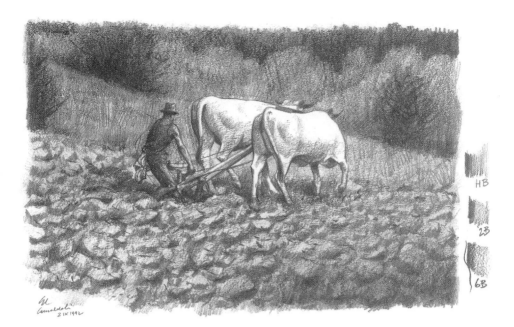

HB

2B

6B

When you need to add figures and animals to a scene you can, at least to begin with and to simplify any problems, refer to good photographs. Start with a detailed sketch, possibly with the help of a 'grid of squares' and use hard pencil on medium size paper. With practice, and once you feel fairly confident, you can move on to doing studies from life. On these two pages I have compared each sketch, drawn fairly quickly, with a photograph of a similar subject which has lots of detail, sometimes secondary or unnecessary.

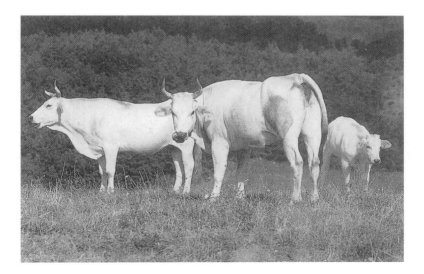

LANDSCAPES

Landscapes, with their wide open spaces, cultivated fields and gentle slopes, have always evoked in the artist and the viewer alike a feeling of natural peace and human industry. More than other terrains, they epitomize man's work on the land. Try, then, to portray in your sketchbook features that are characteristic of the rural environment: ploughed or planted fields; trees, isolated or in a row; hedgerows; farmhouses; little villages; and clouds in the wide expanses of sky.

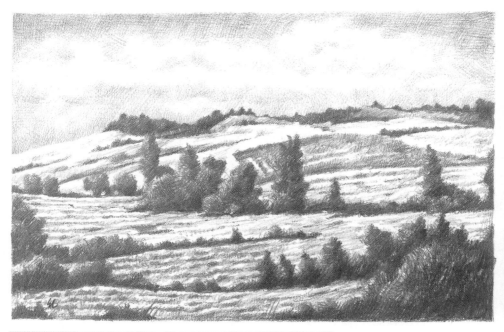

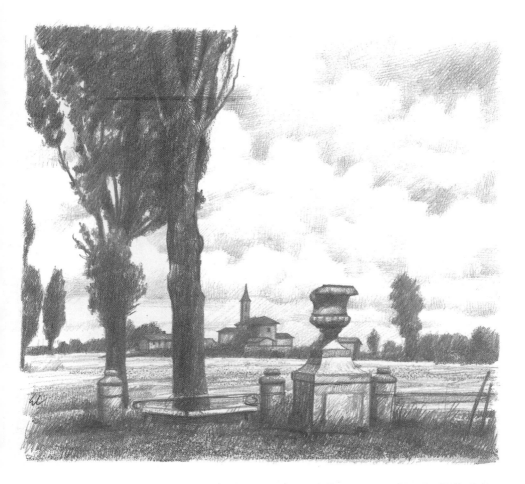

Pencil and charcoal are the ideal media for drawing landscapes as they allow you to portray their characteristics concisely, therefore maintaining the effect of spatial depth. The drawings on these two pages have been done with 4B pencil on NOT paper. Note the direction of the pencil strokes which suggest, at intervals, the terrain's uneven surface and the masses of vegetation. The photographs show other subjects you can take inspiration from.

SEASCAPES

The sea is the main subject of a whole genre of painting, the seascape, which also includes boats, ships, reflections, harbours and so on. Before you start drawing the sea, notice the direction and the formation of waves and how they break upon the shore (see also pages 184–185). On a sheet of paper leave just a little room for the sky and concentrate your attention on the watery mass. The distant waves should be sketched concisely, with short, horizontal strokes, not too blended together. The waves in the foreground, however, require a more accurate 'build-up' with short and well-defined strokes suggesting, by their direction, the shape of the wave. Soft pencils and charcoal are both suitable for drawing the sea but watercolours are best at capturing the 'liquidity' of the subject. Keep your drawing simple and concise, avoiding minute, photographic details which weaken the overall structure of the study.

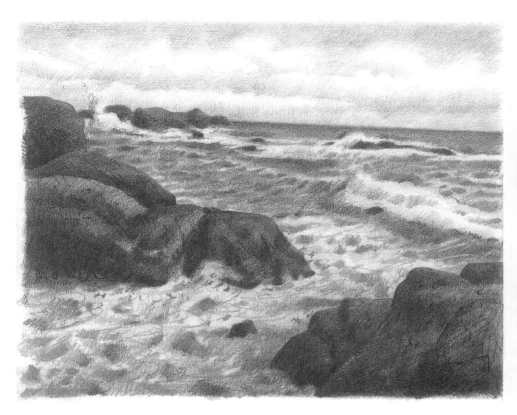

HB and 4B pencil on NOT paper, 30 x 33cm (12 x 13in).

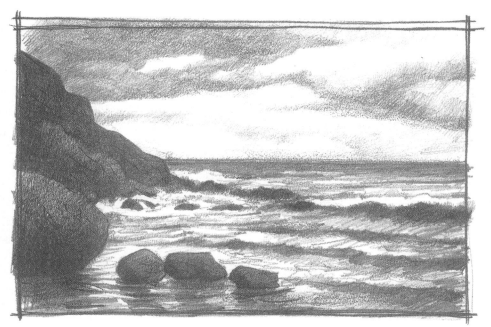

Study in preparation for a painting. 6B pencil on paper, 20 x 32cm (8 x 12½in).

MOUNTAINS

Only by visiting one of the bigger mountain ranges can you fully appreciate the impressiveness of mountains. The sculptural power of these masses of rock, the contrast between the brilliant white of the snow and the dark shadows of the crevices and the cracks, and the sloping woods and meadows, provide many potential scenes and call for clean drawing, rich in tonal contrasts. Use a soft pencil (charcoal and pen are less effective) and fairly rough paper, pay attention to aerial perspective, and make sure you deal with the various elements differently (such as rocks, grass, trees, snow and ice). For example, when drawing rocks, especially in the foreground, you need to hint at their rough, irregular texture with hatching or cross-hatching, dotting and the odd mark; short, vertical pencil strokes work well for meadows and trees; lit patches of snow can be suggested by leaving the paper white while strengthening some of the shadows to give thickness and texture to the mantle.

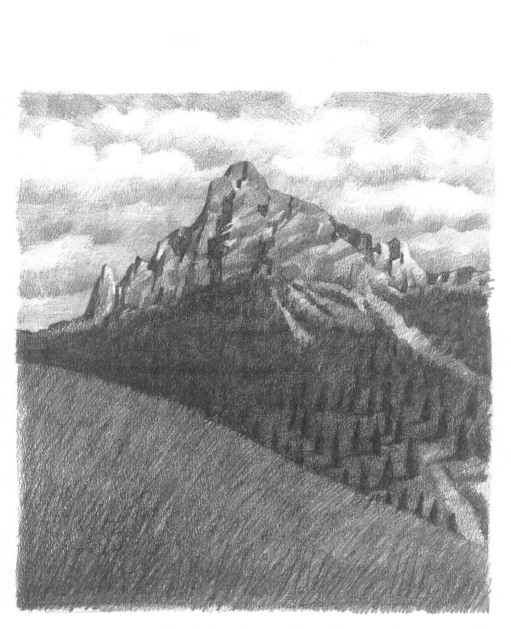

The Dolomites in Summer. Soft pencil on paper, 30 x 40cm (12 x 16in).

FLOWERS, FRUIT
& VEGETABLES

INTRODUCTION

So-called 'still life' has long been an important part of artistic expression, and flowers, along with fruit, vegetables and other food items, as well as articles of everyday use, are its preferred subject matter. Indeed, images of flowers, fruit and plants appear on early historical artefacts from almost every civilization including those of China and Japan. You will see them in the wall frescoes and mosaics of Ancient Rome and the botanical manuscripts of the Medieval and Renaissance periods, where they carried symbolic meaning.

The position of such subject matter as a separate genre did not come about until the 17th century in northern Europe, when what were at first details within more comprehensive paintings such as portraits and depictions of historic or religious scenes took on the status of subjects in their own right. Still-life painting became very popular and much sought after, partly because of the skill with which artists were able to render particularly complex forms. In the centuries that followed, this genre of 'silent nature', as some prefer to call it, has expanded and developed – think of the varied styles of Chardin, Monet, Van Gogh, Braque, Picasso, Matisse and Morandi, for example.

Flowers, with their great variety of colour and form, are one of the most fascinating subjects for painting, drawing and, above all, for engraving, which requires such a meticulous technique that the most intricate botanical details can be rendered. But other, more practical reasons recommend careful and continuous practice in depicting flowers as a subject of choice.

Like fruit, they can easily be found anywhere or can be bought at a reasonable price; they can be kept for a period of time (for long enough, at least, to be drawn precisely); they can be studied individually or grouped into complex compositions and they can be cut into sections for examination of their internal structure. In other words, flowers provide the artist with training in the skill of careful observation and practice in capturing different aspects of surface and structure. In addition, these subjects offer the artist limitless scope for creative and stylistic expression, for composition or for depiction using light and shade. They can contribute to laying down the technical basis required for tackling more complex and challenging subjects such as the human figure or face.

It is worth mentioning at this point that there are two fundamentally different approaches to drawing flowers and other plant life – two approaches which may, however, find ways of enriching each other. Scientific-style 'botanical' studies (as exemplified by medieval herbarium) have the main objective of providing a clear and simple description of the most striking physical characteristics typical of a particular plant. In contrast to this, in the case of purely 'artistic' drawings, the artist's overriding intention is to find inspiration in botanical subjects in order, through exploring its form, to express emotions or ideas, freely exploiting the subject's graphical, pictorial and aesthetic potential. Nonetheless, I would suggest that the route to artistic knowledge begins with careful observation, which, if it avoids deteriorating into sterile pedantry or imposing a suffocating straitjacket of rules, will form the foundation of an intelligent visual appreciation which can only empower an artist's ability to interpret freely and convincingly.

Corn on the Cob (study of Indian corn). Etching, 6 × 11.5cm (2³⁄₈ × 4½in).

GETTING STARTED

Although colour is one of the most striking characteristics of any botanical subject, and of flowers in particular, I have limited myself in this chapter to the best of all graphic mediums: pencil on paper. I have done this in order to help concentrate our attention on the observation of structure and form, rather than on attaining aesthetic effects through the use of colour. Nonetheless, I hope you will be able to supplement these studies with some written notes on colour, or, if preferred, with work using traditional media such as coloured pencils, pastels and watercolours, for example, which combine well with traditional pictorial techniques.

In short, when drawing these subjects, especially when working outdoors drawing directly from observation, the simplest and most common tools can be used: pencil, charcoal, pen and ink, felt-tip pens, ink wash and so on. Each of these mediums will produce different effects, not only due to the specific characteristics of each tool and technique, but also depending on the surface they're used on: smooth or textured paper, card, white or tinted paper, etc..

Pencil and graphite on paper Thanks to its characteristic properties – ease of use, expressiveness and precision – the pencil is the most widely used tool for any type of drawing. It can be used to create highly finished works or simple thumbnail studies and sketches for reference. Soft graphite pencils are especially suitable for the former while the finer leads of mechanical pencils are suitable for the latter. Graphite leads may be inserted in button-operated mechanical pencils or encased, as with traditional pencils, in easy-to-hold wooden sheathes. Leads are graded according to

hardness, from the very hard 9H, which leaves a fine, pale line, to the very soft 6B, which will create a large, dark mark on the paper with little effort.

Pen and ink There are many different types of pens and nibs, each creating distinct, characterful effects, including bamboo pens, fountain pens, calligraphy pens, technical pens (such as rOtring's Rapidograph), felt-tipped pens and ballpoint pens. Tonal variations are usually achieved by hatching pen strokes, worked closely or loosely and at various angles. For this reason it is advisable to work on a smooth paper or card with a sturdy surface that will not tear, resulting in irregular take-up of the ink. (See also Lavis, below.)

Charcoal With this very versatile medium, intensities of tone can be controlled with ease, while it is also possible to attain a high degree of detail. Charcoal should, however, be applied fluently, aiming at an overall rendering of tonal masses and structural volume – an approach that brings out the best qualities of this agile and evocative medium. The choice is between compressed charcoal, which has a compact consistency that offers bold, vigorous lines, and natural charcoal in the form of soft, brittle sticks of carbonized willow. In either case, care must be taken not to leave smudge marks on the paper. Charcoal lines can be built up or subtly shaded off (using your finger, for example) and shading can be made lighter by dabbing with a soft eraser (a putty eraser). The finished drawing should be protected with a coat of spray fixative.

Lavis (monochrome or 'half-tone' wash) When suitably thinned down with water, watercolours, water-soluble inks, tempera or Indian ink lend themselves very well to

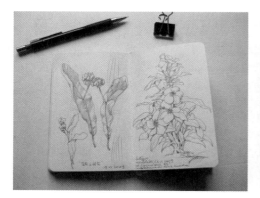

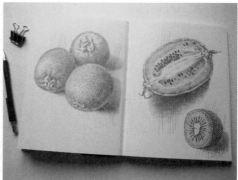

flower or botanical studies in general. These mediums are, however, more closely related to painting than to schematic drawing as they are applied by brush and require concise, expressive shading. For rapid studies from life, water-soluble graphite sticks or pencils (black or coloured) can be used. Marks made with these pencils can easily be dissolved by running a wet or moist brush along them. For this kind of work, watercolour paper, heavy card or pasteboard is preferred to avoid puckering of the paint-bearing surface.

Mixed media This means combining different drawing media, often with the intention of creating an unusual or elaborate effect. These are still 'graphic' media but combining them calls for familiarity with the tools used as well as with the principles of painting, otherwise the results will appear confused and have little aesthetic appeal. Mixed media can be very effective when applied on coloured, textured supports, which should ideally be dark in tone.

WHERE TO FIND YOUR SUBJECT

At the right time of year, fruit and vegetables can be found in allotments, gardens and farmers' fields. If you do not live in the countryside, fruit and vegetables are easily obtained in markets or shops. In either case, it is advisable to select examples displaying all of the typifying traits of the variety (shape, colour, ripeness, etc.) but which also display interesting individual features (in the stalk or the leaves, for example). Flowers are even easier to obtain: interesting subjects can be found and studied directly in their wild habitats where they grow spontaneously, but also (which may be more convenient for city dwellers) in private gardens and public parks, in botanical gardens, greenhouses, or in pots or as cut flowers as they are sold in many commercial outlets.

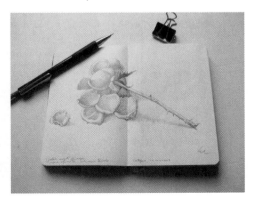

Cultivated flowers can now be found at just about any time of year, irrespective of whether they are in season. Such specimens are often highly pleasing aesthetically. Of course, cut flowers will wither more quickly than those with roots and therefore need to be drawn or painted rapidly before irreversible deterioration sets in as petals fall and stalks begin to wilt. There are simple tricks that help slow down this process of decay: for example, keep cut flowers in a cool, well-lit and humid environment; change the water in their container frequently and add nutrients to it; cut off a short section of the stem each day; or spray with a finishing spray. In the absence of natural fruit or flowers to serve as your subject, artificial substitutes could be used, but I think this is a practice best avoided because, even with perfect reproductions, that element of empathy with the subject, which is part of the process of observation, will be denied, not to mention the difference there will be in the physical structure. And flowers, when they have dried or even withered and faded, may still provide a source of interest, particularly with regard to their structure and texture.

HOW TO STUDY BOTANICAL SUBJECTS

Drawing from life is, without doubt, the best and most rewarding method of portraying flowers or fruits because it requires direct and careful observation and provides a concrete object for your artistic response. Even a quick sketch – a form of visual note taking that functions as a simple reminder of an object – may turn into the first draft of a more carefully elaborated drawing. With this in mind, we should always carry a pocket sketchbook and pencil with us, as interesting subjects tend to present themselves when least expected and in unrepeatable circumstances.

Drawings can also be very complex and highly finished, depending on the artist's intentions and purposes. As we shall see on page 220, scientific botanical drawings require precision and clarity in the way they represent the overall form of the subject and its structural features (stamens, petals, stems, leaves, phases of development, etc.) so that the species or variety can be identified. These visual records can be accompanied by written captions conveying further information and references to colour that supplement and clarify the description. The 'artistic' drawing, which is closer to our focus of interest, has very different – exclusively aesthetic – goals and with them different approaches to interpreting the subject.

In this case, although still indebted to the actual form and function of the subject, the artist's emotional response will direct the drawing towards presenting the subject in a way that satisfies the artist's intention and stylistic needs. Having said that, it is clear that the borderline between the botanical approach to drawing and the artistic one is not static: each approach contains, to varying extents, a part of the other both in terms of the ways in which forms are perceived and the ways in which they are rendered. As well as being precise, a scientific study can be a beautiful thing that arouses the emotions, while it is possible for an 'artistic' drawing to be dry and devoid of meaning even though it is imaginative.

Should you lack the time needed to carry out studies directly from life or if you wish to collect documentary material that you can study later on at your ease, photography is an option. Digital images have the fascinating advantage that they can be greatly enlarged on the computer screen, allowing you to perceive (while being careful not to fall prey to optical illusions) minute details or short-lived effects that normally elude the eye even of an attentive observer.

When taking photographs of flowers or of reasonably small edible vegetables, there are some good technical tips to ensure that you produce images which provide a suitable resource for later study:

- Do not simply photograph the flower or the fruit alone, but, if possible, include the whole plant in its natural growing environment.

- Keep your back to the light or have it angled from the side in order to throw the lumps and bumps of structural detail into relief along with the volumes and surface details.

- Take a close-up shot of the whole subject, including its most important details, bearing in mind the inevitable distortions produced by perspective.

- Experiment with taking some shots from unusual angles.

- Draw a diagram of the subject and note down its significant features.

HOW TO OBSERVE

Whether your subjects are flowers, fruit or vegetables, the method of learning to see (which is not as easy as just looking) is always the same: observe, understand and interpret. For the artist, observation means visually investigating the subject and following your curiosity for what is unusual or exceptional; understanding means learning about a subject in a scientific way but always from a sensitive and artistic slant; and interpreting means rising above your emotions to communicate creatively.

PRACTICAL TIPS

Here are some practical tips for drawing botanical subjects (but with the accent on flowers), many of which will be developed later in this chapter:

- First identify the overall form and the essential structural lines of the subject by looking at it from different viewpoints and then choosing the most suitable angle from which to represent it.

- In order to transfer the subject's three-dimensional volume on to flat paper, first reduce the forms to simple geometric shapes or elementary solids (squares, circles, ellipses, cubes, cylinders and so on). This will make it easier to judge the effects of foreshortening when applying the elementary rules of linear perspective.

- After the initial overall assessment of the whole subject, you can begin to develop the minor forms and details. It is not necessary to draw everything you see: it is a good idea to simplify and leave out insignificant details as part of the 'good housekeeping' of your drawing. However, as an exercise in observation, you can try reproducing every last detail in a flower, for example, exploring the relationship between one example and another.

- In any case, it is important to avoid considering every single detail in isolation, but instead see it as part of the whole structure.

- Evaluate the relationships between the positive shapes (leaves, stems, flowers and so on) and the negative spaces (the gaps between and within objects).

- When organizing a composition (whether it involves one or more items), it is advisable to select elements that create contrasts of tone, scale, form and/or surface texture. For example, flowers can be arranged in a vase, keeping an eye on their height, the angle at which they stand or the direction in which their flower heads and leaves are facing (face on, in profile or foreshortened). An overall impression of spontaneous, but non-random, simplicity can be created and the arrangement will be rich in details to explore. It is important that the positions of the main elements of a composition are set at the outset or early on and that they are treated in the same way as neighbouring elements.

- There is more to a flower than just its petals, although it is these that attract our gaze. Plants are complex in structure and the stem and leaves are equally important. Does the stem bear a single large flower or a sequence of blooms? Are the leaves simple or complex? How are they attached and how are they arranged on the stem? What is the pattern of the leaf veins? Is the corolla (all the petals) mainly circular in shape or is it a polygon, sphere or cylinder? A drawing made as a study should concentrate not just on graphic and aesthetic qualities, but also on portraying the typical and essential characteristics of the flower.

- A lot of attention should be paid to the lighting conditions, especially the intensity and direction of the light. Flowers are characterized by their surface structures and their many subtle graduations of tone, which are essential for conveying an effect of volume.

- The structure and internal forms of botanical subjects may easily be viewed by cutting through them, either along their length or in cross section. Cutting a flower is not so easy because it is soft and prone to collapsing and may be squashed by the pressure of a knife. This can be overcome by putting the flower head and a part of the stalk into a freezer for about twenty minutes and then slicing through it using a fine, serrated blade.

PERSPECTIVE

Linear perspective (see also pages 50–79) creates an effect of spatial distance through the progressive reduction in size of the objects portrayed as they move further away. By following these basic principles, the artist will be able to correct and understand 'intuitive perspective' – perspective as it is perceived by the eye.

In linear perspective, a sense of depth is produced by tracing the apparent heights of objects on to one plane and gradually reducing these heights as they recede from the observer. When drawing small natural forms, such as some flowers or fruit, the perspective effects may not be very apparent – although they still exist – and it is necessary to have a good understanding of how perspective works in order to accentuate or reduce its effects in the interests of creating a realistic drawing. It is particularly important to consider the way that perspective distorts not just linear forms such as leaves and stalks, but also cylindrical shapes (a container holding cut flowers, for example) and circular shapes (such as the large corolla of a flower) as these are items that occur again and again in this type of art.

Angular linear perspective, also called oblique perspective (see also pages 104–105), uses two vanishing points (VP1 and VP2), which are located towards the opposite ends of the line representing the horizon (H). Its effects (which, for simplicity's sake, I've illustrated through simple geometric shapes in the diagrams below) are evident in an edge-on view. All the vertical lines stay vertical, but their heights are reduced as they approach the horizon and appear to recede into the distance. The horizontal lines, on the other hand, converge on one of the two vanishing points, creating a 'foreshortened' view of the objects.

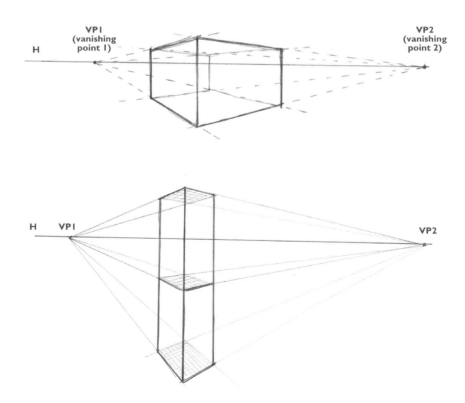

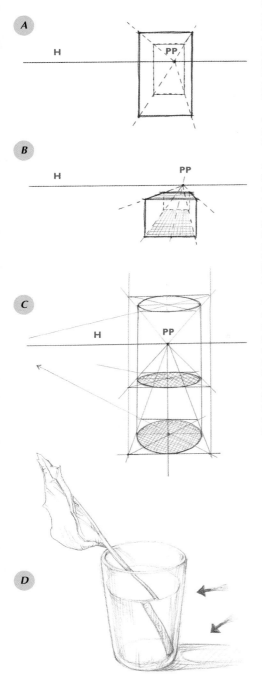

Central linear perspective (or one-point perspective – see pages 54–59) is based on the principle that the non-vertical lines of the object converge on a single point, called the **principle point** (PP) on the horizon line (H). The side of the object directly facing the viewer, its horizontal lines are parallel to the plane of the perspective frame, known as the **picture plane** (see diagrams **A** and **B**).

In either case, the line of the horizon always corresponds to the observer's eye level and is determined by the viewpoint, i.e. the position from which the object is being observed.

The top and bottom faces of a cylinder are circles (as are any parallel intersections or cross sections), and the effect of perspective on these circles will vary in relation to the horizon: they 'turn' into ellipses that are more and more 'squashed' as they approach the horizon line, and become progressively wider as they move away from it, depending on the viewpoint (see diagram **C**). It is essential to bear these processes in mind when drawing a flower vase, for example, or vegetables such as courgettes/zucchini, carrots, parsnips and so on.

When drawing cut flowers with their stems visibly standing in the water of a transparent container, do not overlook either the optical effect of refraction or the 'magnifying-glass' effect (see diagram **D**). These phenomena are described by the laws of physics and can be calculated precisely using optical formulae (which take the differences in density between air and water into account, among other things). Working by eye, pay special attention to the positions and changes in dimension of the various segments or the differences in intensity in the shadow cast by the object.

COMPOSITION

With drawing, as with painting, composition
consists of choosing the figurative elements you
wish to depict and organizing them in relation
to each other and in relation to the edges of
the paper or other support. The composition
will, to a large extent, depend on the artist's
intuition and 'visual education'; there are no
hard-and-fast rules. It is possible, however, to
refine our understanding of composition by
studying works of art from the past and present
and by looking at some of the experimental
psychological research that has been done
into visual perception. Some general human
tendencies emerge along with information
about how best to fulfil our requirements
for harmony based on our perception of the
environment and of spatial organization. For
example, some principles (of unity, contrast,
balance, convergence and dispersion) have
been formulated which can enhance the way
a work of art conveys such feelings as calm,
stability, tension or conflict.

In normal situations, when you are not trying to create specific effects, practical experience suggests that there are some compositional layouts that are best avoided because they usually cause an impression of monotony or a sensation of visual awkwardness.

For example, avoid positioning objects just along one side of the support (**1**), or in the absolute centre (**2**); avoid arrangements that are perfectly symmetrical (**3**) or in which the profiles of adjacent objects come into contact (**4**); avoid positioning the subject on the bottom edge of the support (**5**) or right down the middle (**6**); and avoid filling all of the available space (**7**).

1 2 3 4 5 6 7

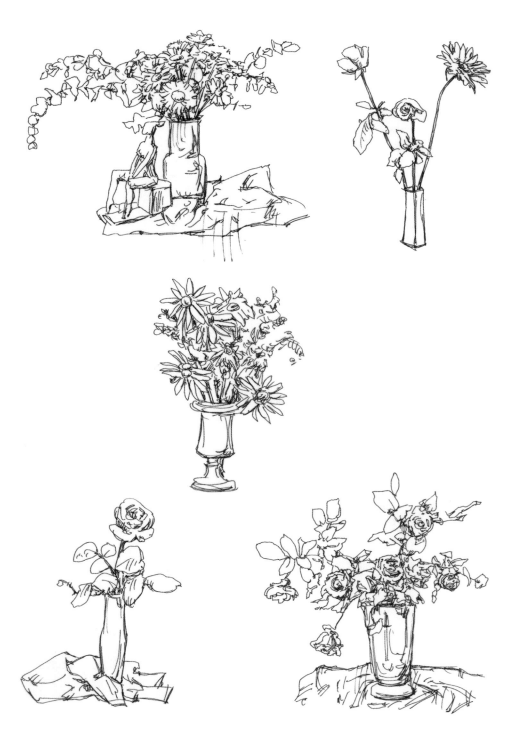

The art of flower arranging is timeless, but when drawing it is perhaps better to avoid over-elaborate or excessively complex set-ups. If your aim is to attain simple and effective results, study the examples illustrated throughout this chapter and bear in mind the following compositional guidelines:

• Position a single flower, piece of fruit or vegetable so that it is seen from its most suitable and significant angle.

• Arrange groups of flowers or fruit or vegetables in a way that creates a variety of shapes and tones.

• Arrange objects and containers in mixed groups (flowers with fruit or fruit with vegetables, for example) for an interesting composition.

• When making the arrangement for a still life, think about contrast, depth and the relationships between objects in terms of their shapes, colours and tones, and use these to guide the viewer towards a central focus of interest.

BOTANICAL ANATOMY

For the artist, drawing from life is an essential way to sharpen the skills of observation and visual perception. The diligence and attention required for this activity will, in fact, bring about a new way of seeing, whereby you find yourself exploring even the most familiar and ordinary objects. It will also help you gain greater insight into the relationship between overall form and individual detail.

It is by no means necessary to study botany in order to be able to draw fruit, vegetables or flowers, nor do you need an in-depth knowledge of plant anatomy and morphology. However, some information relating to the basic structures, at least of flowers and leaves, can prove very useful in helping to identify and understand the specific characteristics and details that differentiate one variety from another.

In the flower diagram, bottom left, you can see some of the main parts on a flower and its stem: the corolla, which comprises all the petals (1); the stigma (female part) which catches incoming pollen (2) – the pollen-bearing stamens (male) are often lower and not always seen from this angle; the sepals (3), which protect the flower when it is just a bud, with the receptacle sometimes apparent as a bulge; the bud (4); the node on the stem from which

leaves, flowers and so on grow (5); the stalk (6); the leaf (7) and the peduncle or stem of an individual flower or inflorescence (8).

Flowers contain the plant's reproductive organs and after successful pollination they bear the fruit(s) or seeds. In the case of a fruit, the pericarp surrounds the seeds, pip(s) or stone. The pericarp consists of three layers, which vary according to the fruit type. In the case of nuts, the exterior layer is hard and woody; in the case of fleshy fruits, the two innermost layers are succulent or fleshy – the part we eat.

The leaf is the main site of a plant's photosynthesis, respiration and transpiration (giving off water vapour). Nearly all are fairly flat, but shapes, profiles and sizes vary enormously and are mostly designed by nature for the conditions in which the plant grows – desert, alpine regions, temperate climates and so on.

The diagram bottom right shows the basic parts of a leaf: the node (1); the stipule, which is only present on some leaves (2); the petiole or leaf stalk (3); the veins, with the midrib down the centre (4); the margin, which is the very edge of the leaf (5) and the blade or lamina, which is the main body of the leaf (6).

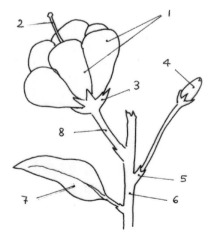

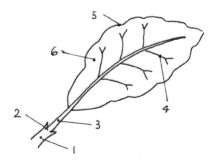

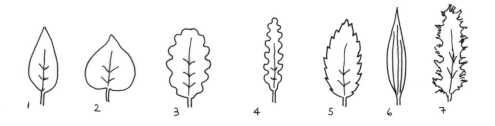

Here are examples of some common leaf shapes: ovate, which is egg shaped
(*1*); cordate, which is heart shaped (*2*); lobed ovate (*3*); lobed (*4*); elliptic,
here with a dentate margin (*5*); linear (*6*) and elliptic with a spiny margin (*7*).

Leaf margins (edges) vary and include:
smooth (*1*), sinuate (*2*) and dentate (*3*) forms.

Venation (the pattern of veining) can be
equally varied and includes the common
pinnate (*1*) and also parallel (*2*) forms.

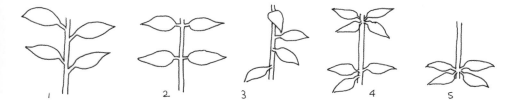

Notice the way that leaves are borne on the stem. They may be alternate (*1*),
opposite (*2*), spiral (*3*), whorled (*4*) or basal (*5*).

STRUCTURE

The external form of an object (in our case, a botanical object) reveals each aspect of its surfaces and volume but only hints at the internal architecture that provides the object with its 'structural scaffolding'. This interior arrangement can easily be revealed by cutting the fruit or flower under observation, either along its length or across the middle. Often, the inside of an object interests us more than its exterior and is more stimulating.

It is also a good idea, especially when starting the study of a particular flower or other object, to make a quick, perhaps geometrically simplified, diagram of it. For example, on pages 223–224 I have drawn some overall views of a gerbera and a cyclamen, as well as some of their details (a leaf, a petal, etc.)

Analytical and comparative studies help in the methodical observation of plants, enabling us to distinguish between their essential and characteristic parts and between features that are general and those that are particular to the specimen in question. Far from being hampered by this approach, artistic drawings will improve, both in simplicity and in precision.

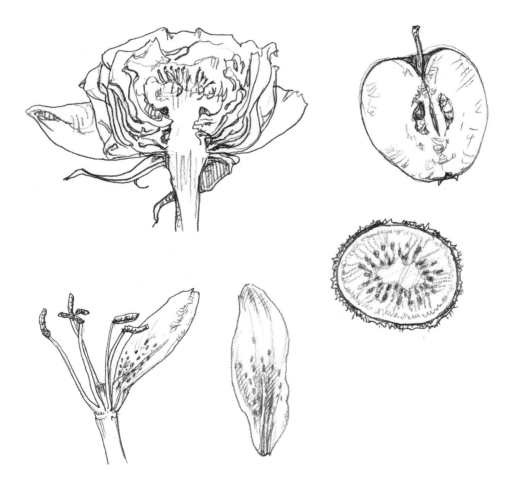

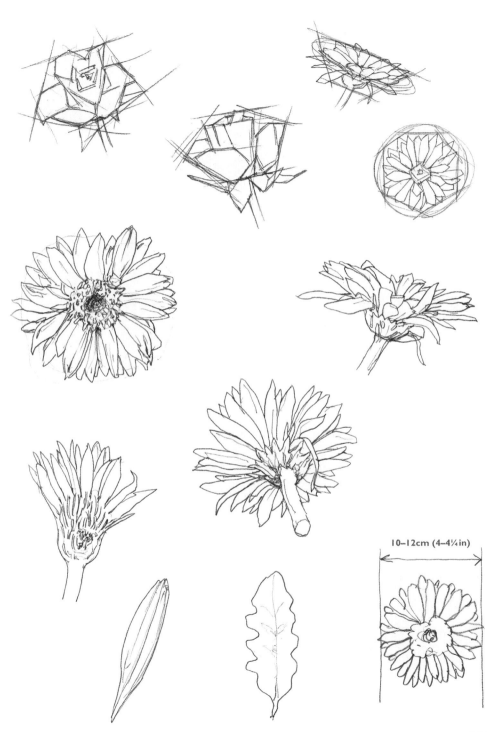

10–12cm (4–4¼in)

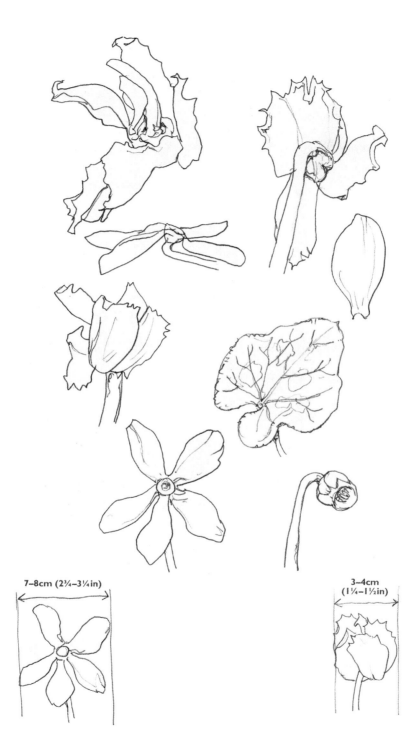

7–8cm (2¾–3¼in)

3–4cm
(1¼–1½in)

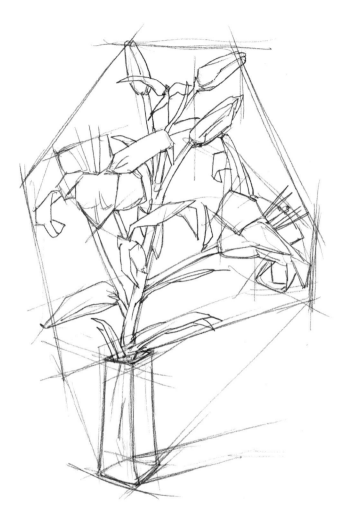

Investigations into the structure of your subject will reverberate throughout the drawing, extending as far as its geometrical structure. There will be a trend to simplify outlines and volumes and reduce them to basic geometric shapes and solids (squares, circles, cubes, spheres, and so on). This process enables you to convey solidity and volume more effectively, aiding you in locating those 'load bearing' structural lines that account for the appearance of substance and depth.

Look at the sketches on this page, for example, and see how the geometrical guidelines and a few intersecting straight lines help to segment the space and facilitate our understanding of the dominant structural tensions within the composition; they also help define the different proportions of each element and of the object as a whole.

LIGHTING

The effects of light and shade created by a source of illumination allow you not only to suggest an object's volume and depth, but also to highlight the various surface characteristics displayed by different flowers, vegetables and fruit, which facilitates their portrayal in drawings and paintings. When making a study of a complex object, such as a group of flowers or unusual vegetables, which requires slow, patient drawing, it is advisable to use artificial lighting (although avoiding multiple light sources), because artificial illumination remains constant over time and is not as variable as sunlight, especially direct sunlight. It is also a worthwhile exercise to study the same object under direct illumination from a single light source while varying the angle from which it is viewed in order to observe the play of light between self-shadow and shadows cast by other objects. For more information about light and shade, see the chapter *Drawing Light & Shade* on pages 92–147.

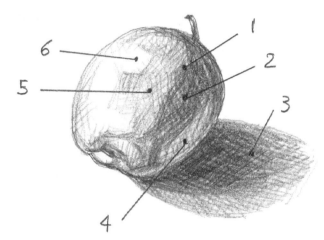

It is helpful to understand the following terms: shadow line, meaning the edge of the shadow (1); self-shadow, which is the shadow cast on an object by itself (2); cast shadow, which is a shadow cast on to another object or surface (3); reflected light (4); penumbra, which is the area where only part of the light source is blocked, the dark part being the umbra (5), and reflection (6).

It is helpful to break down an object into its main tonal 'planes'.

Gradual tonal shading can be simplified by choosing a limited range of tones, (light, mid and dark), which will be sufficient for effective depiction. Head-on illumination is less suitable for 'artistic' drawings, as it flattens out solid forms, but it is an effective form of lighting for the careful study of profiles.

Experiment by viewing the same subject under different lighting conditions:

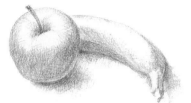

Diffused daylight.

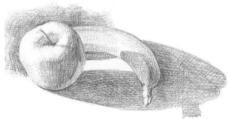

Direct, lateral sunlight (or artificial light).

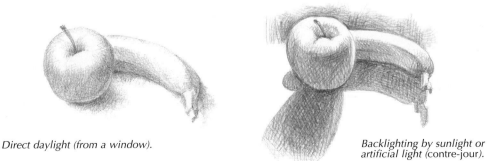

Direct daylight (from a window).

Backlighting by sunlight or artificial light (contre-jour).

STAGES OF A DRAWING

A drawing can be made in various ways and with different intentions or purposes in mind. In terms of the method used, a drawing can be executed using only lines (when setting out to explore nothing but the outlines or contours); using only tones (conveying form and volume solely through tonal graduations between light and shade); or it can combine lines and tones to varying degrees.

In terms of intentions or purposes, a drawing may investigate a subject scientifically, as for a botanical or naturalistic study, or express an emotion or an aesthetic feeling, as in the case of an 'artistic' drawing. The choice of technique, style and depth of analysis depend on the artist's personal style and taste. Nonetheless, out of the many available methods, I suggest a basic and traditional way of proceeding through the stages of a drawing on pages 229–230. This method has proved useful because of its huge, almost intuitive simplicity.

Line drawing.

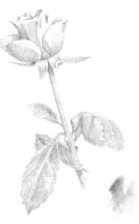

Tonal drawing.

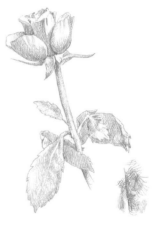

Combined drawing (shading added to a line drawing).

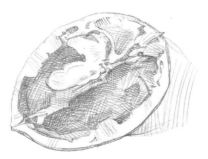

Brief drawing.

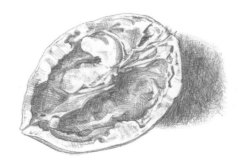

Analytical drawing.

MAKE A DRAWING

1 Sketch a basic structural outline of the subject using light construction lines. You could start by indicating the maximum height and width of the subject (the overall space occupied by the entire composition), followed by a geometric breakdown of the most important features. Although this initial stage may be brief and spontaneous in appearance, it requires great attention because it prepares the basis for the stages that follow, which will result in a more successful execution with the final drawing.

2 Define the shapes inside the 'structural scaffolding' using segmented lines, paying attention mostly to setting out the exact dimensions, the correct relationships between the individual elements of each flower, and the perspective view of the vase.

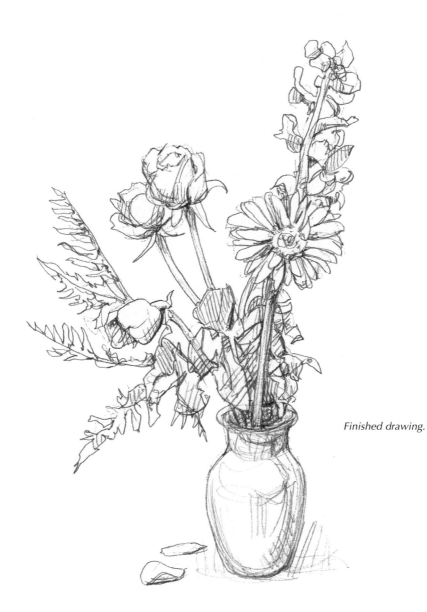

Finished drawing.

3 Working across the whole of the composition simultaneously, build on the structural sketches of the previous stage with the actual forms of each flower and leaf, paying careful attention to proportion. Add the larger, deeper areas of shade. After this, you could go on to elaborate the detail further and work on the tonal differences, depending on your style, until you are happy with the final effect. Any unnecessary structural pencil lines can also be erased.

When you draw very simple, compact shapes, the benefits of starting with steps 1 and 2 (see page 229) become more evident, particularly in the case of large fruits. The linear, construction stage, which is based on a cognitive treatment of the object, can be developed to provide an investigation into the form's 'architecture'. Alternatively, the construction stage can be developed into a tonal drawing, perhaps combining visual realism and emotion, in which case the linear drawing provides the underlying support of the finished work.

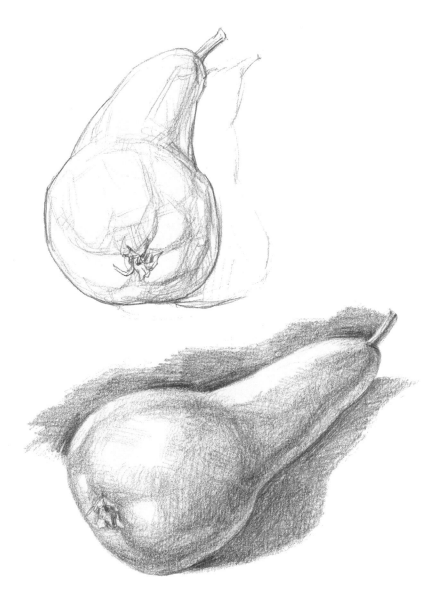

BOTANICAL SKETCHBOOK: FLOWERS

In these final three sections I have gathered many pages from a sketchbook of mine, which I recently dedicated to botanical subjects that are easy to come across in our daily lives. These drawings have been executed quite quickly and fairly freely, and I have concentrated on the form and the overall characteristics of the object concerned – a flower, fruit or a vegetable – as well as on some of its more important details, or simply on details that I found interesting. Some of these explorations have been conducted from unusual viewpoints.

I used a sketchbook measuring 15 × 18cm (6 × 7in) with pages of fairly smooth, white paper and a mechanical pencil with a fine 0.5 HB lead.

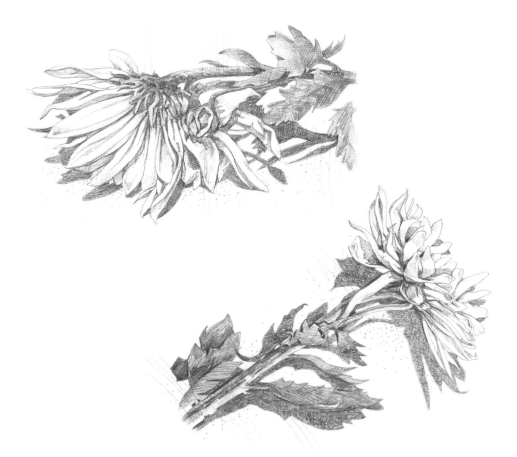

Here, the flower's shadow, cast on to the surface underneath, creates a densely packed, maze-like pattern made up of tiny patches of light and shade. This provided an opportunity for a somewhat unusual graphic study (which, at first glance, may be a little difficult to interpret).

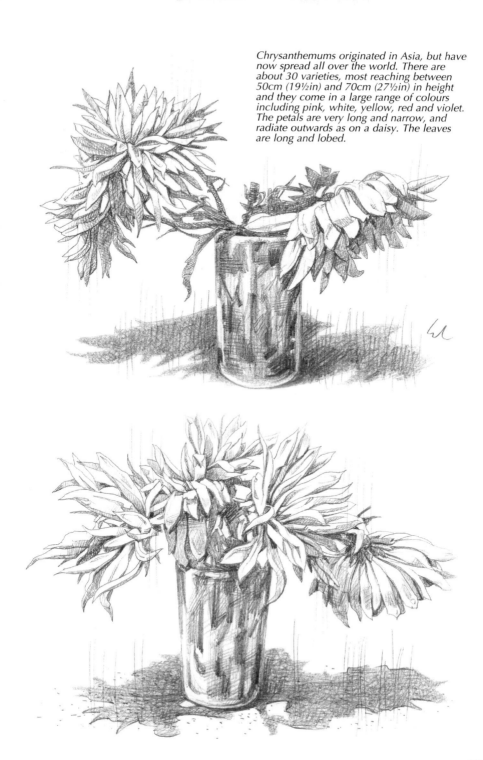

Chrysanthemums originated in Asia, but have now spread all over the world. There are about 30 varieties, most reaching between 50cm (19½in) and 70cm (27½in) in height and they come in a large range of colours including pink, white, yellow, red and violet. The petals are very long and narrow, and radiate outwards as on a daisy. The leaves are long and lobed.

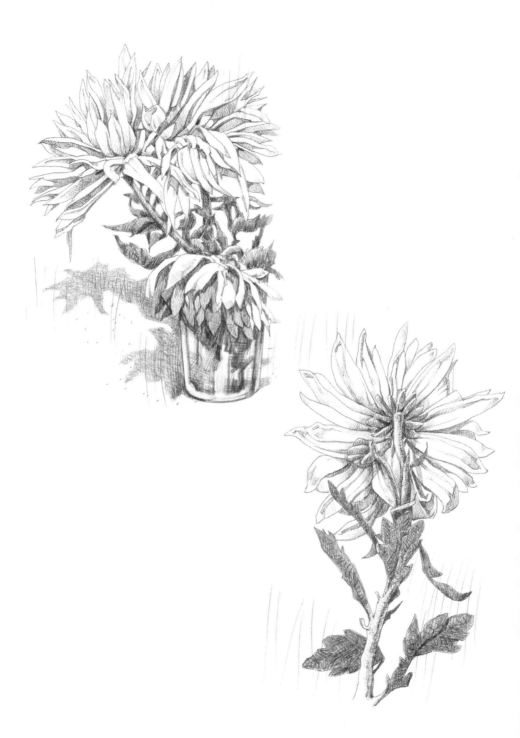

The aptly named Bird of Paradise plant (Strelitzia) originates from South Africa. Its horizontal flowers have three small orange-yellow sepals and three large grey-blue petals, two of which are fused together. Two or more flowers are held in each highly coloured, canoe-like bract. The leaves are very large and long. This flower has a complex form (which also presents challenges in rendering the effects of perspective) but, despite this, it is a pleasure to study and investigate close-up or from different viewpoints.

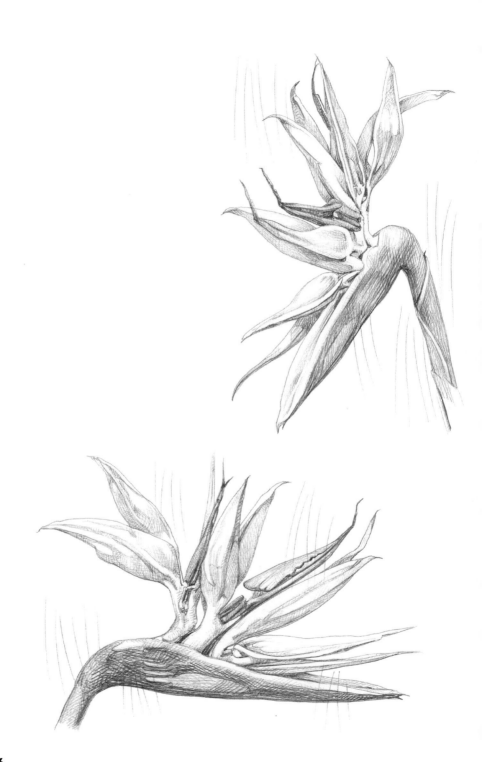

The Tiger Lily, which originated in the Far East, is unmistakable because of its eye-catching orange coloured blooms with black speckles on each of the six petals and the heavy masses of pollen proffered on a collection of high-reaching, protuberant stamens. The lily species offers a wide range of colours including white, yellow and red.

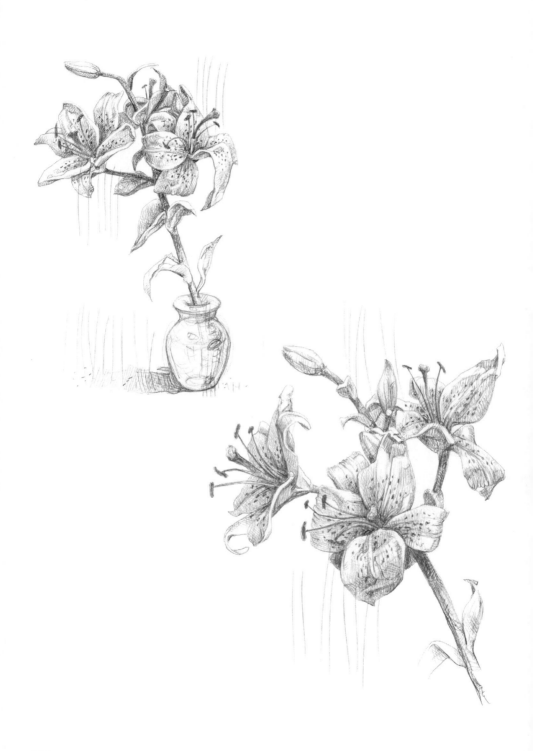

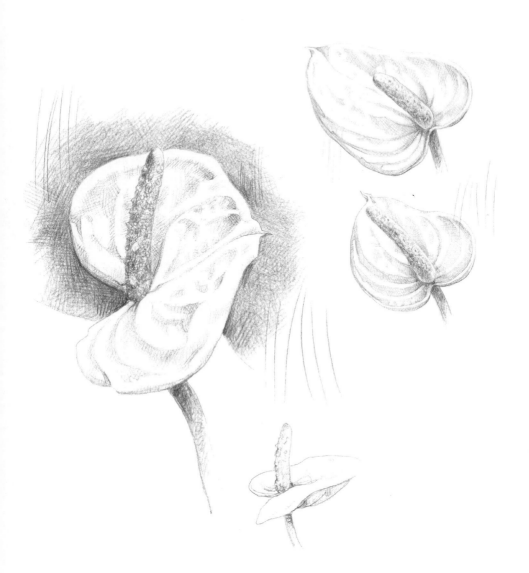

The Flamingo Lily (Anthurium), *which originates from tropical zones, is a bloom that is divided into two parts: the smooth, waxy, heart-shaped and flattened spathe (a bract or leaf that encloses the flower before it blooms), which can be white or red in colour and is fairly bulky in its proportions, and the spadix (a spongy-looking cylindrical structure which forms a continuation of the stalk and where, believe it or not, the real flowers grow). It is a flower that has the appearance of being almost artificial, as if it were made of plastic, and this characteristic makes it well suited to graphic studies of its various surfaces and their reflections.*

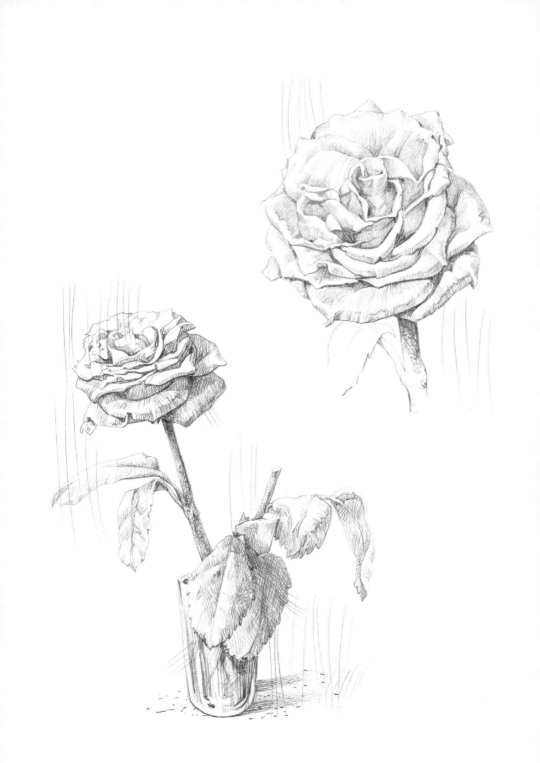

There are hundreds of rose varieties,
encompassing many forms and colours,
each one of them making an extremely
interesting subject for drawing. The
complex interweaving of the petals,
the velvety appearance of the surface
(especially in contrast to the spiky
thorns), the colour and the fragrance
all combine to make a flower rich in
symbolic suggestiveness that has found
full expression over time in the arts and in
social relations. On pages 240–245 I have
drawn two varieties of rose: a red rose with
thickly packed petals forming a full corolla,
and a white rose with a more compact and
cylindrical structure.

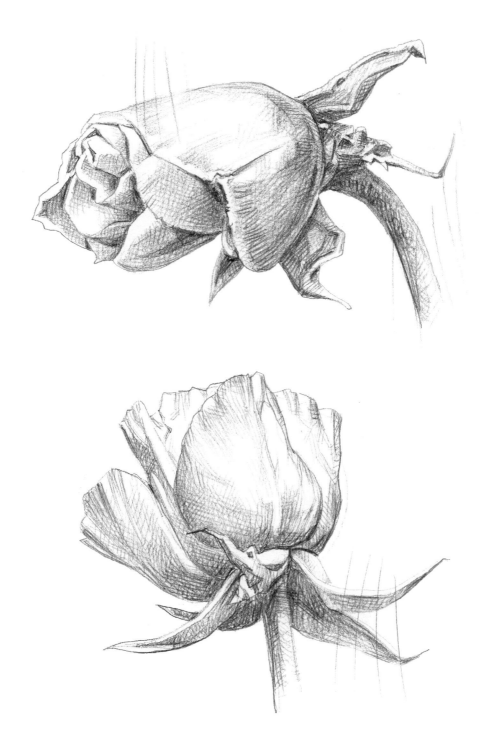

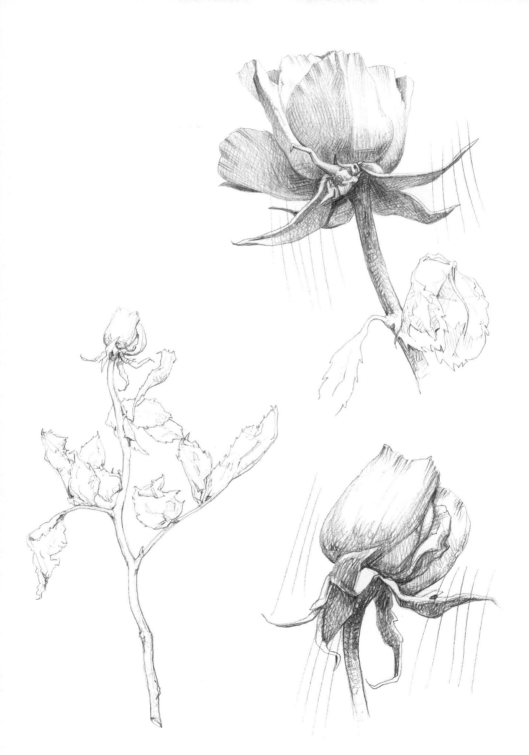

The drawing of a rose against a contrasting background (top right) demonstrates the different perceptions of tonality with which the object has been depicted, according to whether it was seen against a light or a dark background.

A traditional rule in academies of art used to state that we should create contrast: light against dark and dark against light.

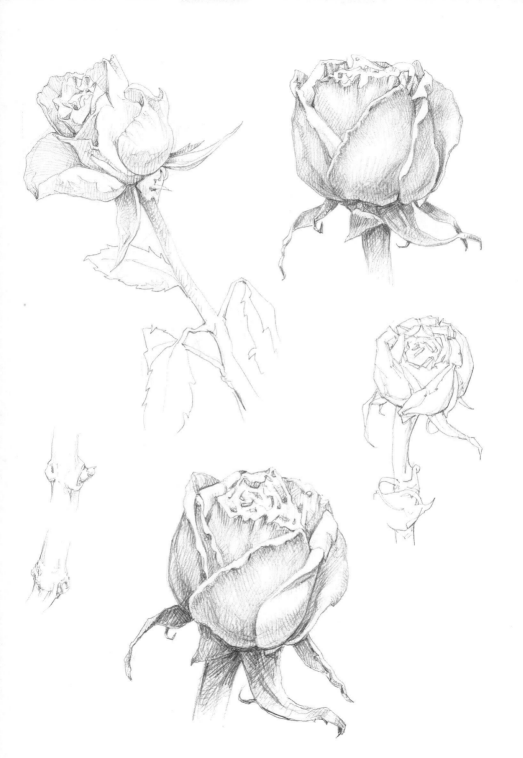

The gerbera originates from South Africa and looks rather like a large daisy. Its colours vary from white to yellow, pink and red. It has a stiff, sturdy stem and lobed leaves. The complexity of its petal arrangement may be seen as a chance to practise a linear treatment.

It is a good idea to avoid having the outlines of the stems meeting precisely at a tangent: it is preferable to have them either apart or to have them meet with a moderate amount of overlap.

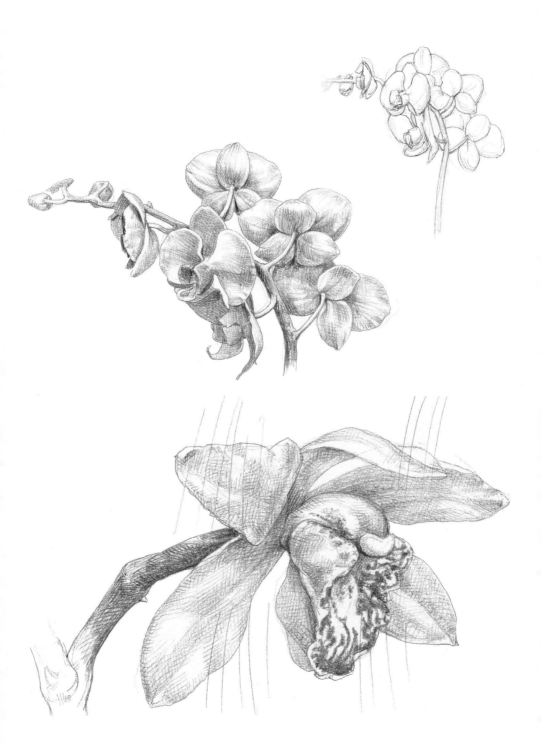

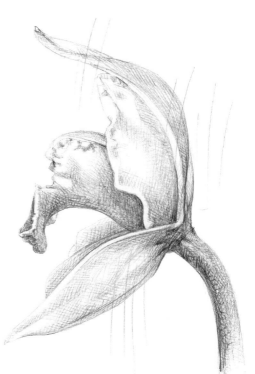

The orchid, which originated in Central and South Africa, has many beautiful varieties. In the drawings at the top of the opposite page I have shown a type of orchid with a small corolla. The flower comprises three sepals and three petals which resemble each other in both shape and size, with the exception of one (the labellum), which looks strikingly different.

The corolla is borne on a sturdy stalk (see above) and it is turned through 90 degrees, so that it faces out horizontally.

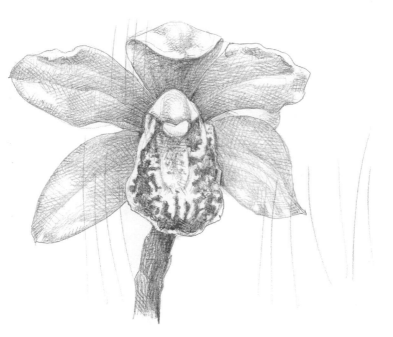

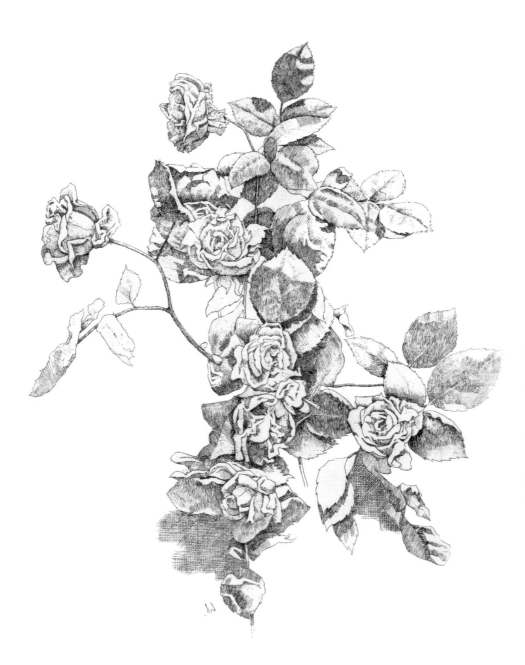

Roses from my Garden. Etching, 23 × 29.25cm (9 × 11½in).

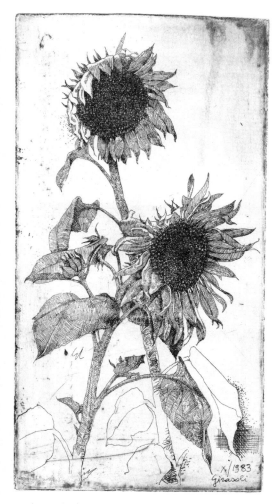

Sunflowers. Etching, 11.5 × 23.5cm (4½ × 9¼in).

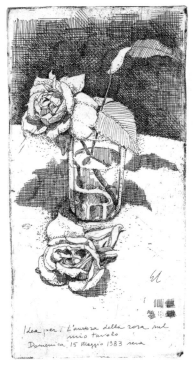

The Shadow of the Rose on my Table.
Etching, 9.5 × 19.75cm (3¾ × 7¾in).

The Bread and the Rose. Etching,
7 x 15.25cm (2¾ × 6in).

BOTANICAL SKETCHBOOK: FRUIT

A fruit results from the development of what was the female portion of the flower as it envelops the seeds. Fruit may be divided into two groups: dry and fleshy. The latter are rich in soft or juice-laden flesh and can be further divided into categories such as berries, drupes (stone fruit such as plums) and others. Dry fruits have a hard outer wall and may also be sub-divided into two further groups: dehiscent, in which the fruit splits open as in legumes such as peas, and indehiscent, in which the fruit does not split as with nuts and grains. Unless your interest lies in making scientific drawings, you will not require an in-depth knowledge of botany in order to draw these subjects, but it is a fascinating and appealing subject that will complement your general education. These pages focus on the variety of structures, shapes and colours displayed by some of the more common fruits that are found on our dining tables. In fact, most of the drawings that follow were made either during or after a meal.

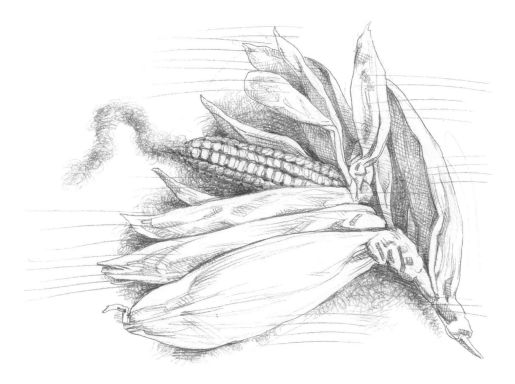

A cob is the ripened female flower of the maize plant. It produces grains in the form of many compact little yellow or white fruits or kernels – the corn – that can be ground into flour. From a graphic point of view, the complexity and arrangement of the leaves and the play of light and shade produced by their overlapping forms are particularly interesting.

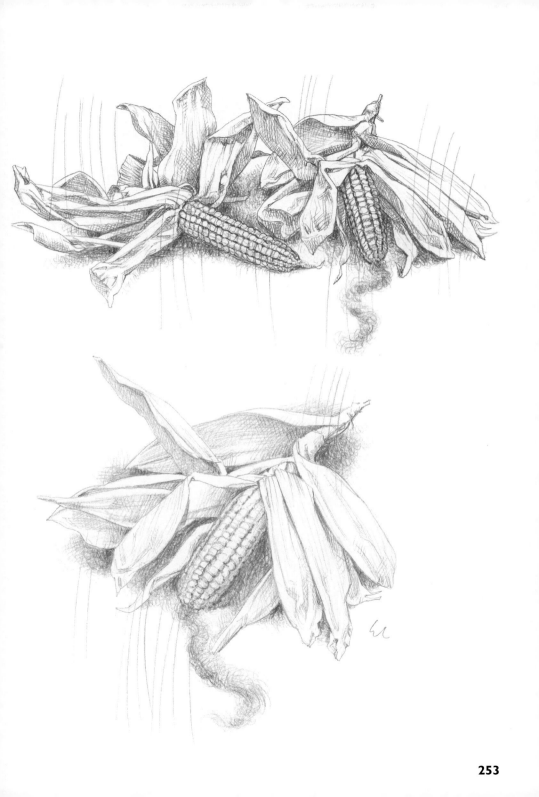

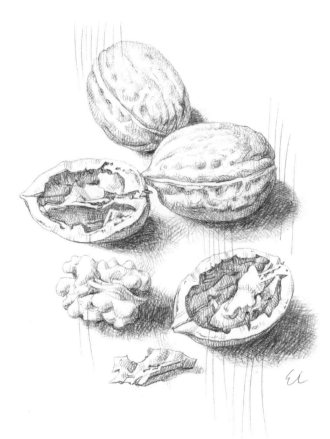

Here, and on the following pages, are a number of drawings of common fruits. They are listed here in the order in which they are shown: walnuts, pomegranates, mandarins, kiwi, chestnuts, pears, grapes and bananas. I studied the overall shape as well as particular details of each one, its internal structure, etc., concentrating in particular on the various characteristics of the external surface (whether it is smooth and shiny, gnarled, granular, furry and so on), and on the details of the interior organization as revealed when the fruit is cut open. When carefully observed from close up, these fruits take on forms of unsuspected complexity and beauty.

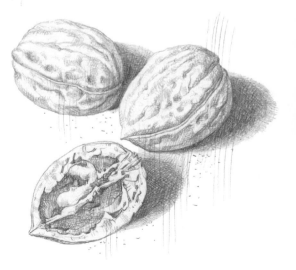

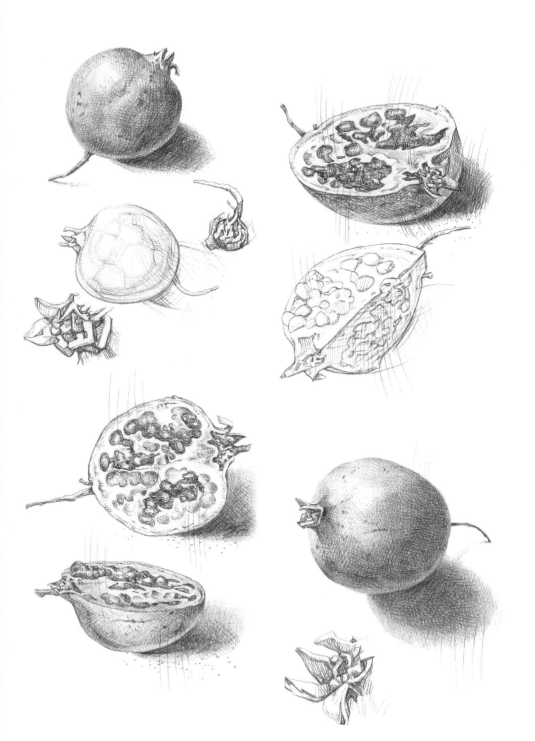

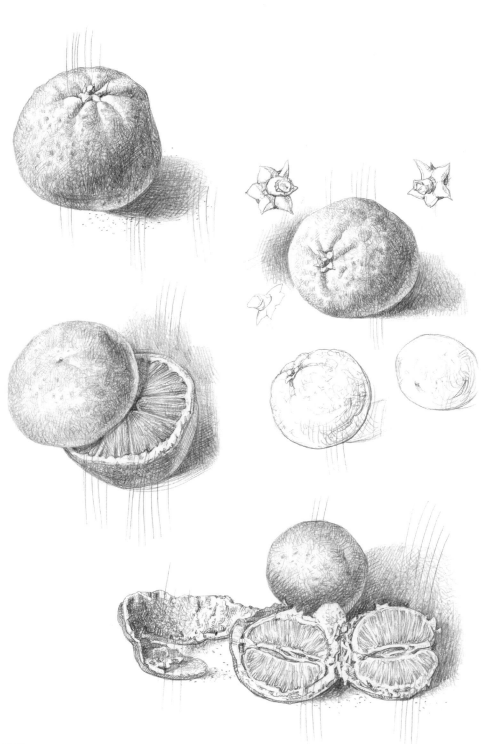

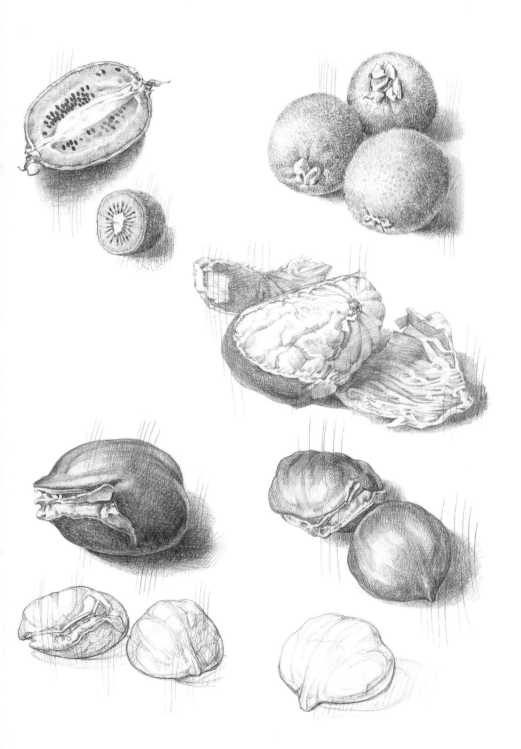

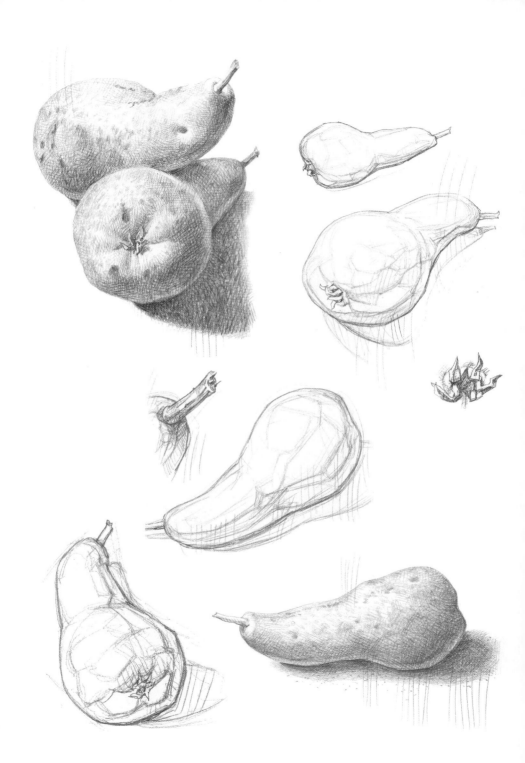

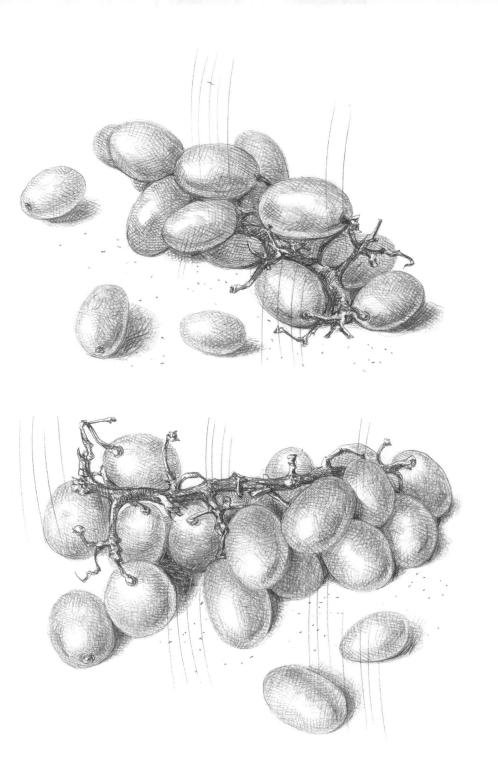

259

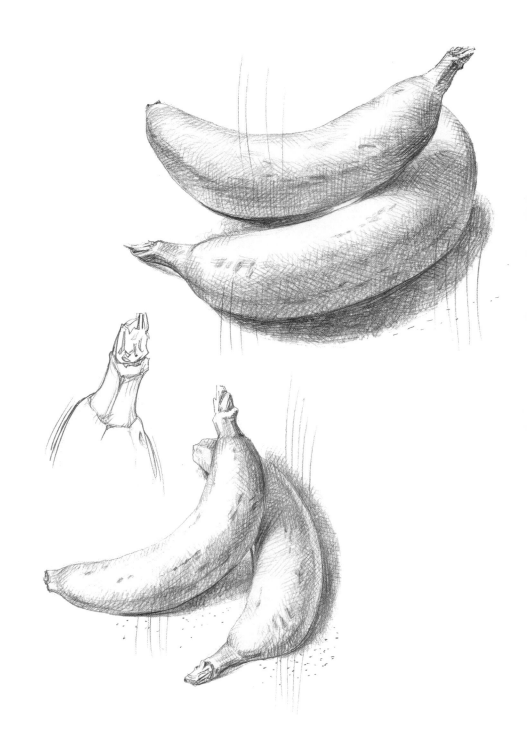

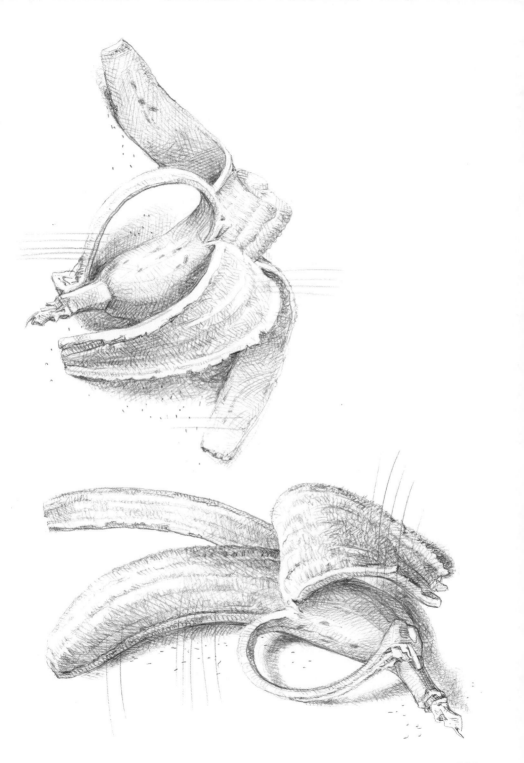

BOTANICAL SKETCHBOOK: VEGETABLES

In this final section, I have portrayed some easily available vegetables that are well known to us all. 'Vegetables' is the general term for herbaceous plants that are cultivated for their edible leaves, roots, tubers, bulbs, fruit or seeds. There are numerous varieties of each, all of them rich in graphic or sculptural interest due to shapes that are often complex and surprising. Even more so than the fruits examined in the previous section, vegetables offer many opportunities for making either rapid sketches or an elaborate study.

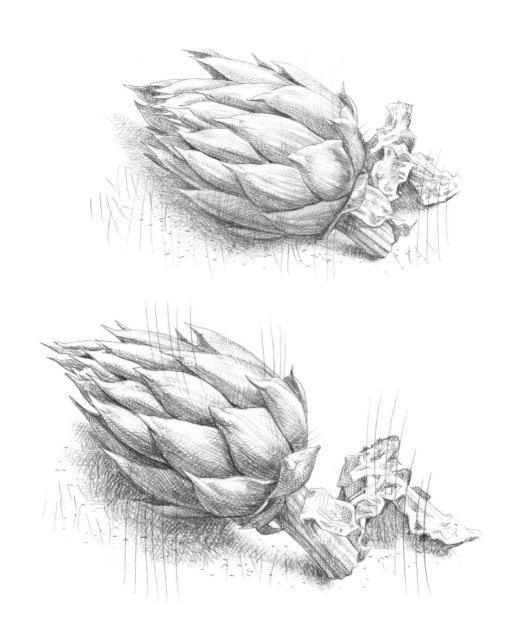

The spiked 'leaves' of the globe artichoke are almost geometrically arranged, overlapping like tiles on a roof. They are somewhat convex in form, which means each one of them produces a play of light, shade and reflection which, although subordinate in effect to that of the overall form of the vegetable, should not be overlooked.

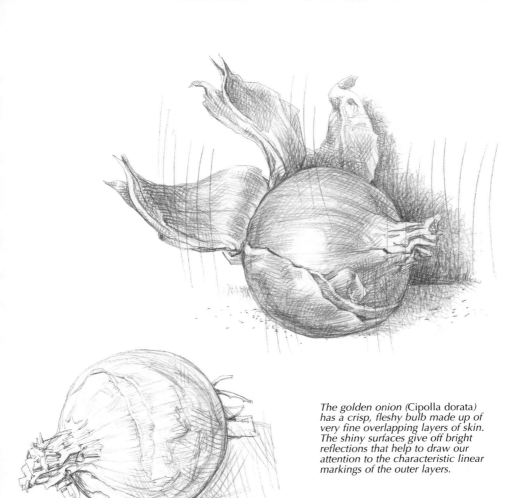

The golden onion (Cipolla dorata)
has a crisp, fleshy bulb made up of
very fine overlapping layers of skin.
The shiny surfaces give off bright
reflections that help to draw our
attention to the characteristic linear
markings of the outer layers.

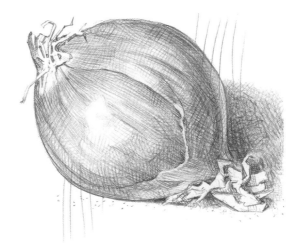

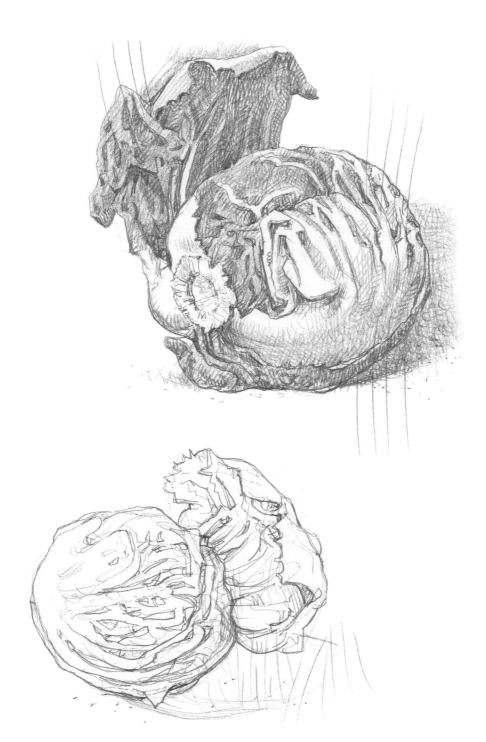

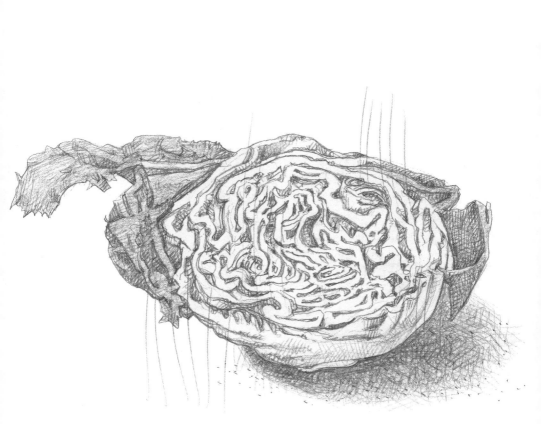

Red chicory (Radicchio) is a roundish, compact, richly veined
plant with closely overlapping layers of leaves whose intricate
labyrinthine arrangement becomes fully apparent when it
is sliced in half. When you draw this kind of interweaving
pattern, it is important not to get confused or lost in the
complex twists and turns. Ideally, patiently follow the path
of one meandering line at a time, and compare it along
the way with its neighbour. This operation becomes
easier if you begin from the central area and work
outwards towards the perimeter. As long as you
work conscientiously, and faithfully depict what is
in front of you, there is no need to draw absolutely
everything that you see.

267

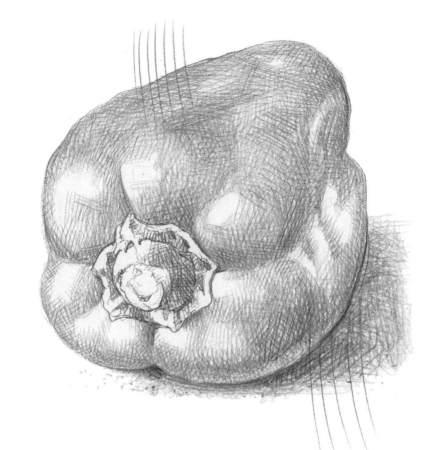

The smooth, glossy skin of a yellow sweet pepper is a source of bright, highly localized reflections. This vegetable also has rather thin partitioning walls that are easy to study in longitudinal section. Under strong lighting, this characteristic leads to some areas of the fruit becoming translucent.

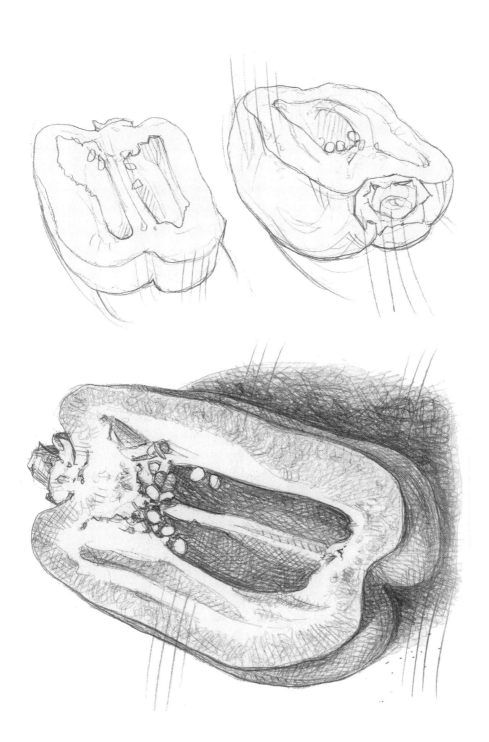

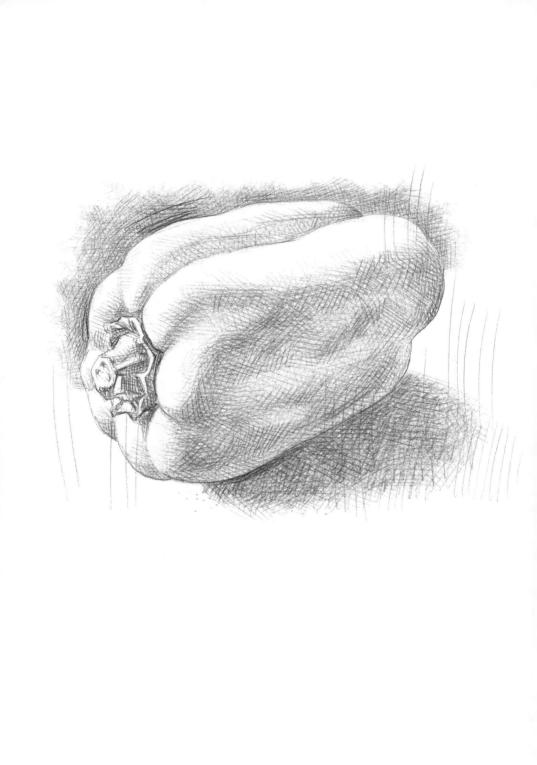

PROPORTIONS

It is useful to note down some approximate overall measurements of the fruit and flowers you are drawing. This will help you become accustomed to assessing proportions of various diverse features when you come to draw a mixed composition. Note that the drawings below are not to scale.

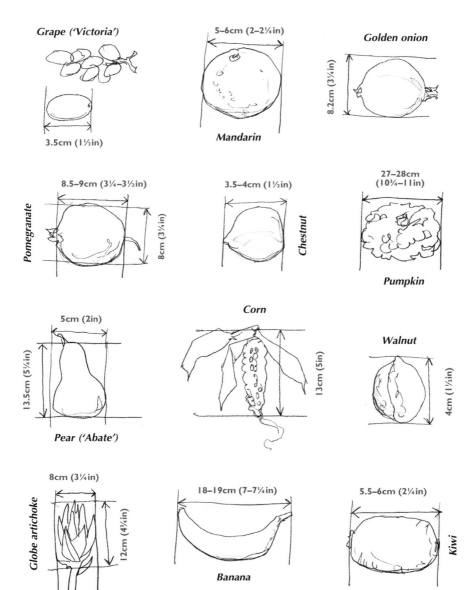

Grape ('Victoria')

3.5cm (1½in)

5–6cm (2–2¼in)

Mandarin

Golden onion

8.2cm (3¼in)

Pomegranate

8.5–9cm (3¼–3½in)

8cm (3¼in)

3.5–4cm (1½in)

Chestnut

27–28cm (10¾–11in)

Pumpkin

Pear ('Abate')

5cm (2in)

13.5cm (5¼in)

Corn

13cm (5in)

Walnut

4cm (1½in)

Globe artichoke

8cm (3¼in)

12cm (4¾in)

18–19cm (7–7¼in)

Banana

5.5–6cm (2¼in)

Kiwi

DRAWING PETS

INTRODUCTION

'Everything that is great happens in silence.'
– Giovanni Civardi

Drawing animals is just as fascinating as drawing the human figure: both activities involve portraying living beings, each with their own character and personality, their own particular temperament and physical characteristics. The key to producing a good drawing of an animal is knowledge and understanding – not only of its physical structure but also of its habitual behaviours and instinctive reactions, allowing you to show not just the physical characteristics of a species, but also the idiosyncratic character of the individual animal being drawn.

Artists who dedicate themselves to the study of nature, and in particular to the portrayal of animals from life, do not need to travel to distant locations in order to track down and observe animals in the wild – they can easily turn to those in their local environment, such as household pets – cats, dogs and birds – and the animals reared on farms or those housed in zoos and in wildlife parks. Another starting point for your first steps in practising the drawing of animals could also be the natural-history department of a museum (see pages 322–333).

When drawing a domestic animal from life, it is best to do so from a distance. There are several reasons for this: the whole of the animal will be visible; perspective distortions will be avoided; the animal's overall form can be appreciated, whether in movement or at rest; and the subject will not be disturbed by your presence, which may happen if you meet the animal's gaze and stare directly into its eyes.

Drawing plays an important role in the scientific study of nature, and some drawing techniques are ideally suited to naturalistic or anatomical study, for describing the subject and analysing its form and structure. There is also the 'artistic' approach, which focuses on the expressive aspect of an animal's behaviour and movements, and on its bodily appearance.

The history of the artistic representation of animals goes back a long way. Cave paintings from prehistoric times are the oldest surviving drawings and they often depict animals. Since then, particularly in painting but more frequently in sculpture and decoration, the art of every civilization has seen animals as subjects of great symbolic power and fascination. There is even a great tradition in the art of animal portraiture, which is still very much alive, and represents a significant part of the activity of professional 'animal artists'. Animal owners, especially the owners of thoroughbred horses or pedigree dogs and cats, are very fond of having portraits of their loved ones on show.

Pages from sketchbooks dedicated to the study of natural history.

SOME PRACTICAL CONSIDERATIONS

'It is much easier to draw a fragment than the whole. Perhaps a part is already an entirety and what seems incomplete is already finished.' – Giovanni Civardi

TOOLS, MATERIALS AND TECHNIQUES

As with any other subject matter, the simplest and most obvious tools can be used for drawing animals, especially when working out in the open, directly from life: pencils, charcoal, pen and ink, felt-tip pens and ink-wash, to name a few. Each of these materials will produce its own effects when its associated techniques combine with the characteristics of the working surface, be it smooth or textured paper, card or tinted paper, for example. For the pictures in this chapter, I have restricted myself to that classic drawing combination, pencil on paper, in order to help me concentrate on observing each organism's form and structure. I used a mechanical pencil with a 0.5 HB lead and a 15 × 21cm (6 × 8in) sketchbook. You may also wish to explore the chromatic qualities of animals' coats using techniques that combine drawing with coloured media such as coloured pencil, watercolour or gouache.

WHERE TO FIND YOUR SUBJECTS

While wild animals should be studied in their natural habitats or, failing that, in wildlife parks or zoos, domestic animals can, of course, be observed from life in a variety of everyday locations and circumstances. Cats and dogs, for example, can be found just about everywhere, whether you are in the countryside or in a town. It may be a little more difficult to find horses, cattle, donkeys and other 'farmyard' animals but riding stables or livestock farms are usually easy to find, and a visit to them will help any artist. There are also regular seasonal events, such as county fairs, pet shows and sporting events, which feature various species and breeds of dogs, cats, horses or birds.

A visit to a natural-history museum will provide an opportunity for a more scientific type of study, which will prove useful for acquiring a detailed understanding of anatomical structure, the details of external forms and of the comparative differences between kindred species. If this is your chosen location, pay attention to the accuracy of anatomical proportions, as the animals on display in museums are usually a product of the taxidermist's art, and artificial aids or dodges may have crept into the preparation of bone structure and musculature that may not be obvious beneath the feathers, fur or skin.

HOW TO STUDY ANIMALS

The greatest challenge to an artist attempting to draw living animals is the unpredictability and speed of their movements. Human subjects can voluntarily hold a pose for the amount of time it takes to depict them, but animals, whether domesticated or wild, cannot be made to hold completely still. It is, however, possible to makes studies of them while they are asleep, while they are eating or engaged in gentle play. It is always a good idea to spend time just observing an animal's movements from a distance and trying to learn the cyclical pattern of behaviours by guessing the direction and nature of the next movement. You will then find that you can draw during the repeated phases of relative stillness. Luckily for the artist, much of the behaviour of domestic animals is repetitive and, with a little patience, you can turn this to your advantage by discovering how they always return to a few typical positions.

There is no doubt that drawing from life is the best way to portray animals as it forces the artist to observe directly and carefully and to give physical form to their aesthetic feelings. Artists can make drawings from life that are highly detailed and faceted or, at the opposite extreme they can make quick sketches as a means of simple visual note taking, which can later serve as a reminder and be a starting point for a more complex and highly finished work. It is a good idea to keep a pencil and a pocket sketchpad at hand because the best opportunities for making rapid studies tend to come when we least expect them, and such opportunities may not be repeated.

If the subject's constant motion prevents you from making even the most rapid and cursory sketch from life, or if you are looking for other sources of recorded images for a work to be executed later, photographs, film or television documentaries could prove useful. Today, technology allows us to 'freeze' animal movements, which offers a faithful record of animal behaviours and habitats. If you decide

to take photographs yourself for this purpose, pay careful attention to possible distortions created by the camera lens and consider how a photographic image can alter an object's proportions, especially in three-quarter view and in close-up.

HOW AND WHAT TO OBSERVE

Drawing is a way of seeing. Whatever subject matter you intend to depict by means of lines on paper (in this instance, domestic animals) the most effective approach is to move from observation to understanding and then to interpretation. In the text that follows, you will find practical ideas to help when drawing pets, many of which are explained in more detail later in this chapter.

The first lines to be drawn should delineate the animal's overall form. Various techniques can be used to do this: for example, reduce each form to a simple geometrical shape such as a square or a circle; outline the large bodily masses using a few lines; or make a schematic diagram of the main skeletal shapes – the cranium, the spinal cord, the pelvis and so on.

There is no ready formula, of course, for bodily proportion and anatomical layout that can be applied like a template to each and every animal, but there is a general structural scheme for each species, and it is possible to outline the main construction principles shared by all quadruped vertebrates. However, remember the variations within each species (i.e. all the different breeds of horse or dog), as well as individual differences.

It is a good idea to acquire a sound theoretical knowledge and take a methodical approach. When drawing animals, you should concentrate on developing one or two specific skill sets to help you interpret and combine the data observed in the creature to make a coherent representation on paper. Examples of areas to consider and develop through your drawing could include the following: anatomy; the ability to analyze form, structure, movement and balance; knowledge of a species' characteristics – its behavioural habits and physical traits, such as the way its skeleton, musculature and body form have adapted to suit its environment; the characteristics of an individual animal; diversity of size and form in relation to sex and age; typical postures and behaviours; and characteristic mannerisms.

The complexity of the issues involved when drawing animals, and the need to avoid giving these a superficial or unconsidered treatment, have caused some artists to specialize in observing only one particular species (e.g. dogs, horses, birds, etc.). This enables them to concentrate on understanding the general way in which these animals move, their habitual behaviours and reactions, in order to be better able to give a fully nuanced artistic treatment of each individual.

Birds are anatomically designed for flight: their bones are hollow, making them light, while the wing-impelling muscles are strong and solidly built, with firm anchorage to the bones of the chest. Birds' bodies also have an overall 'teardrop' aerodynamic shaping, which offers the least resistance to the air (see also page 296).

PERSPECTIVE

Perspective is used to represent spatial depth on a flat surface. These pages provide an overview of the basic geometrical principles of linear perspective, which creates an effect of spatial distance through progressive reduction in size of the objects portrayed. By following these basic principles, you will be able to correct and understand 'intuitive' perspective as it is perceived by the eye. In linear perspective, a sense of depth is re-created by tracing the apparent heights of objects on to one picture plane and gradually reducing these heights as they recede from the observer. (For more information, see the chapter *Understanding Perspective* on pages 38–91.)

Perspective plays a particularly important role when drawing large animals, such as a large dog, a cow or a horse. When drawing such animals, the artist is often confronted with problems of foreshortening and of keeping the nearer and farther portions of the body in proportion. Single parts of the body, such as the animal's head, its legs or its tail will present themselves obliquely and in such a way that requires applying the rules of perspective – not necessarily in an unbending way, but adapting them to obtain an aesthetically acceptable likeness. What goes for individual animals (and the shadows they project) also applies to groups of animals spread over a large area: it will be much easier to depict the size relations between one animal and another if careful attention is paid to the rules of linear perspective.

Two types of linear perspective may be of interest: central and two-point perspective. Central linear perspective is not often needed in the depiction of organic forms, as it uses a single vanishing point on the horizon towards which all of the object's non-vertical lines converge. It is used when the object presents itself with one side parallel to the picture plane.

Two-point linear perspective can be applied to many of the positions animals typically present in relation to the observer's viewpoint. The diagrams shown here are, I think, reasonably self-explanatory in their presentation of the most basic application of two-point perspective, but note the following:

- Two vanishing points (VP1 and VP2) are taken into consideration, located towards the ends of the horizon line.

- The horizon line (H) always corresponds to the eye-level of the observer, as determined by the observer's viewpoint, i.e. the position from which the object is being studied.

For the sake of clarity, the object shown in the diagram below is a simple geometrical shape. This type of perspective is applied when an object is viewed corner-on, with one of its upright corners being the only facet of the object that is parallel to the picture frame of the perspective view. All of the object's vertical lines remain vertical but they reduce in height as they get nearer to the horizon and appear to recede into the distance. This recession or foreshortening is determined by the way the object's horizontal lines converge towards one of the two vanishing points.

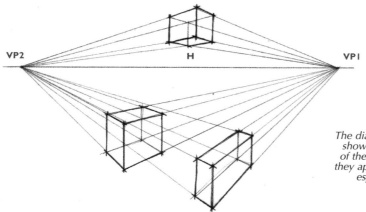

VP2 H VP1

The diagrams left and opposite show the main applications of the rules of perspective as they apply to drawing animals, especially large ones.

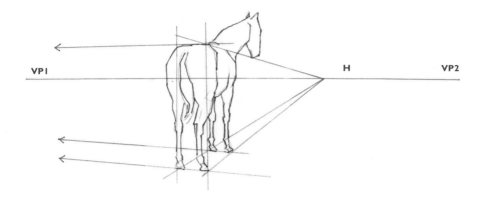

VP1 H VP2

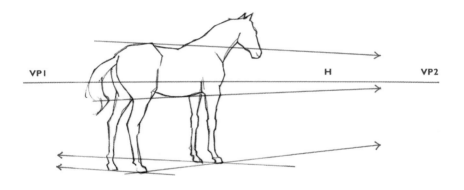

VP1 H VP2

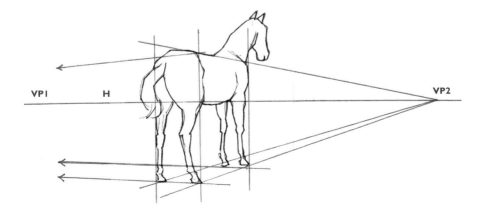

VP1 H VP2

277

ANATOMY

'Art involves craft as well – and craft imposes its own harsh discipline.'
– Giovanni Civardi

Artistic representation requires the application of the intellect and emotions influenced by reasoning and analysis. Being more closely related to the analytical side, the study of the anatomy of animals (comparative or zoological anatomy) is very useful for acquiring a sound knowledge of the basic structures of animals' bodies and, in particular, their bone structure. This knowledge will become important especially when attempting to portray constantly moving creatures from a distance or in complicated positions.

The pets and other domesticated animals I have depicted in this chapter are all vertebrates (mammals and birds) but obviously the various species are all very different: cats and dogs are carnivorous mammals; horses and cows are both hoofed (ungulate) mammals, although the horse belongs to the family of odd-toed hoofed mammals (perissodactylous ungulates) while the cow is an even-toed (artiodactylous) ungulate. The chicken belongs to the galliform order of birds.

It is of fundamental importance to have an anatomical understanding of musculature in order to produce accurate likenesses of the way animals move and to convey their pent-up energy. While the muscles determine an animal's exterior bodily form, their influence is often masked by the thickness of the skin or the shaggy mass of the animal's coat. An analysis of muscle anatomy when starting out with drawing animals is very useful. The ability to combine careful observation of animals from life with a sound understanding of the body's system of support – its bones – is also essential.

A BRIEF OVERVIEW OF ANIMAL ANATOMY

The skeletal structure of the animals described in this chapter consists of an axial section (the cranium and spinal column) and appendicular sections – the limbs. These two groups are linked together by the pelvic and thoracic girdles. The shape of the backbone reflects the fact that, unlike humans and birds, quadrupeds walk on four limbs and support themselves on the ground with the equivalent of their fingers or toes alone. (These animals are known

as digitigrades.) Instead of consisting of a succession of curves (the kyphosis and lordosis, or convex and concave curves of the human spine), which typify animals whose customary stance is an upright one, the backbones of quadrupeds are more regular in shape, resembling the arch of a bridge (whose function is in some ways similar) as it extends from the cranium (skull) to the pelvis (hip), with an extension along the tail.

The cervical (neck) portion of a quadruped's spinal column always consists of seven vertebrae, with the overall length of the neck depending on the varying sizes of these individual components. The dorsal parts of the column: the thoracic (chest), lumbar (between chest and pelvis), sacral (pelvic) and caudal (tail) sections have varying numbers of vertebrae in different animals. For example, the thoracic section of a horse's spine consists of 18 vertebrae, while that of a cow has 13. The lumbar section comprises six vertebrae in a horse or cow, but seven in a dog. With birds, the cervical section is much longer and more mobile, having between 12 and 25 vertebrae, while the thoracic section is more compact, having only seven to nine. These variations correspond to the distinct body lengths of different species and to the relative lengths of trunk and limbs.

One important difference between quadrupeds and humans is that the former have no collarbones – the front limbs are connected to the trunk simply by strong, sturdy muscles. Another notable difference is the presence of long apophyses (anchor points for muscles) along the quadruped spine to provide the bearings for a complex system of ligaments such as the nuchal ligament which, attached to the nape at the back of the cranium, helps hold the head and neck erect without the need for muscular exertion.

The diagrams here and on the following pages provide a basic introduction to the bone structures and surface musculature of the animals depicted in this chapter. In order to follow up this introduction with a study of anatomy in much greater depth, it is a good idea to consult specialist publications and to examine animals' bodies.

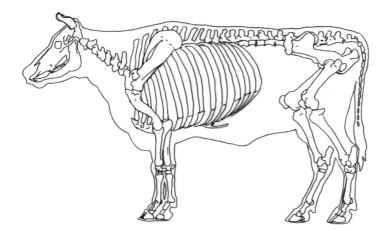

Cow's skeleton

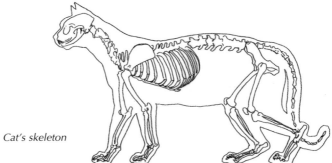

Cat's skeleton

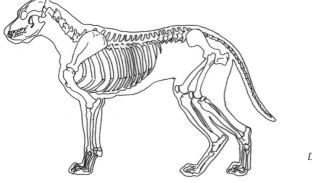

Dog's skeleton

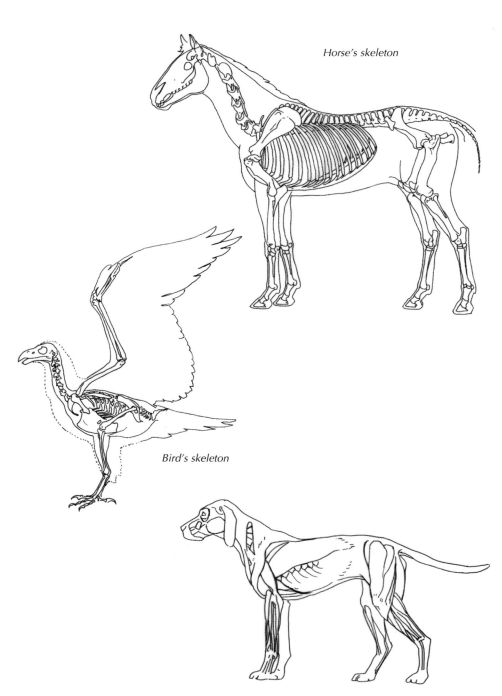

Horse's skeleton

Bird's skeleton

Superficial muscles of a dog

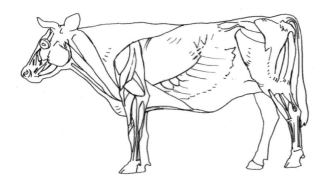

Superficial muscles of a cow

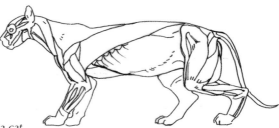

Superficial muscles of a cat

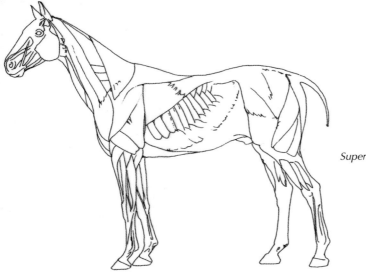

Superficial muscles of a horse

FORM, STRUCTURE AND MOVEMENT

'The voice of beauty speaks softly...' – Friedrich Nietzsche

Drawing simple structural lines is necessary and sufficient for rendering the overall shape, mass and bearing of an animal's body (quadruped vertebrate), as with any organic form or object.

Begin with a rough but accurate sketch showing the elements of the essential skeletal structure (the backbone and the trunk, the cranium, pelvis and limbs) in their correct proportions, as shown on this page, top right. These lines lay the foundations for the drawing and they help characterize the typical structure of the species to which the animal belongs. For this reason, they can only be drawn after carefully analysing the subject, identifying its most important bodily masses and its most significant points of articulation.

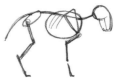

A further stage of the sketch could go on to summarize the body masses in terms of simple geometrical shapes combined with accurate observation of the body's axes, its slants and tilts, and the angles at which the different segments (the trunk, neck, limbs, etc.) meet. A later stage of working through the drawing will involve giving definition to the shapes of individual features – the eyes, nose, paws and hooves, and so on – as well as adding effects of light and shade to convey the characteristics of the animal's coat and posture.

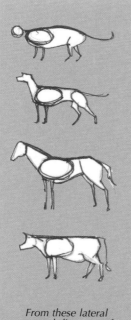

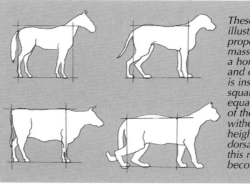

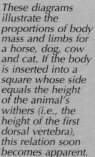

These diagrams illustrate the proportions of body mass and limbs for a horse, dog, cow and cat. If the body is inserted into a square whose side equals the height of the animal's withers (i.e., the height of the first dorsal vertebra), this relation soon becomes apparent.

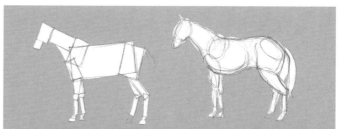

From these lateral structural diagrams of a cat, dog, horse and cow, it is obvious how each animal's spinal column describes a different path and how the animal's head stands in relation to it.

An animal's basic structure can be indicated either by 'geometricizing' its forms (above left) or simply by using free-flowing strokes of the pencil (above right). It is up to each artist to decide which of these approaches is preferable: the first method helps to 'construct' the form by spelling out the positions of each jointed segment in relation to the others and helping to establish proportions, while the second better conveys the dynamic and unified character of the organism.

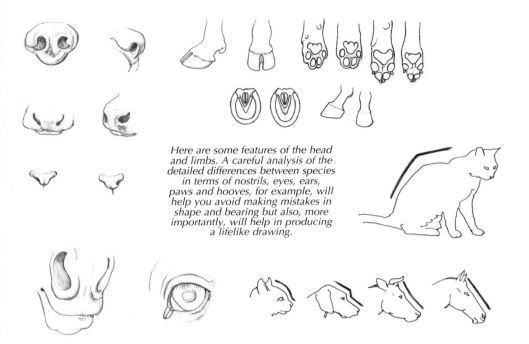

Here are some features of the head and limbs. A careful analysis of the detailed differences between species in terms of nostrils, eyes, ears, paws and hooves, for example, will help you avoid making mistakes in shape and bearing but also, more importantly, will help in producing a lifelike drawing.

Diagrammatic representations of the mechanics of locomotion (or gait) for the horse, dog, cat and cow. These diagrams are taken from the photographic sequences produced by Eadweard Muybridge around 1887, which are still of inestimable value for the study and understanding of animal movement.

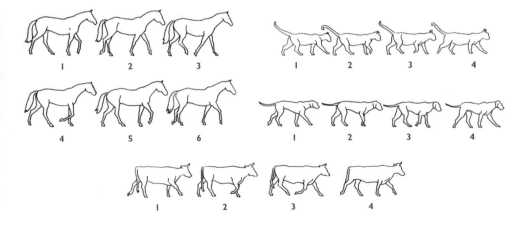

DRAWING TECHNIQUES

'The best outcomes (not only in drawing) are achieved in the final moments.'
– Giovanni Civardi

A drawing can be approached in a variety of ways, with different aims and for different purposes. For example, there is the purely linear drawing of the subject only or, at the other end of the spectrum, a purely tonal drawing in which form is created using tone, not line. Finally, of course, there are drawings that combine the two approaches to varying degrees. Some examples of aims and purposes include the drawing of an animal in order to carry out a 'scientific' investigation of its physical structure (an anatomical illustration), or to depict its typical habitat (a naturalistic illustration), or a drawing in which the aim is to express an aesthetic feeling (an artistic drawing). Of course, whatever the technique and procedure used, the extent to which it is elaborated and 'finished' can vary greatly – anywhere between the rapid sketch for gist, (or a 'gestural' sketch, which is even more bare and fluent), to a complex analytical study.

Linear drawing

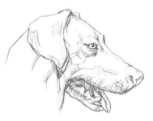

Structural drawing

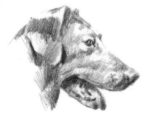

Tonal drawing

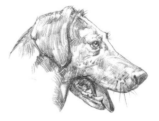

Analytical drawing

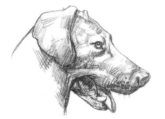

'Mixed' drawing
(a combination of line and tone)

'Gestural' drawing

The choice of technique and style, and the depth of the study, is always left up to the artist's preferences or to professional demands. That said, it might be of use to suggest an elementary, traditional approach, which represents just one of many possibilities, but which has proven useful because of its great simplicity and intuitive ease. See the three-stage process set out below.

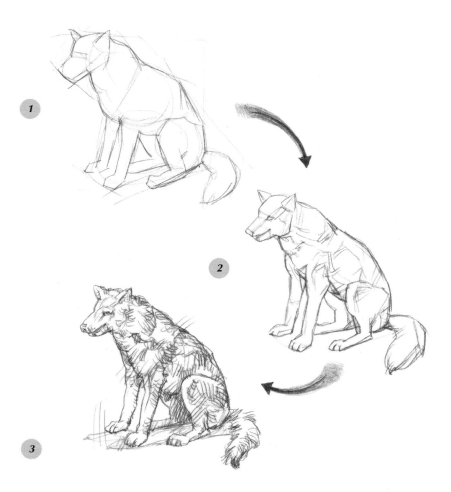

Step 1 *Start with basic, overall indication of the whole subject using lightly drawn construction lines.*

Step 2 *Block in the interior forms of the structure.*

Step 3 *Gradually work through and build on the various bodily forms and the details of the features by defining tonal areas, picking out structures, light and shade, etc..*

SKETCHBOOK: DOGS

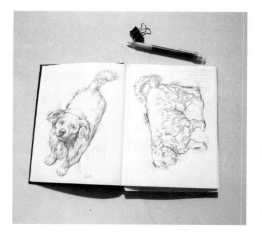

The dog is one of the most expressive, affectionate and lively of animals, much loved by nearly everyone. The origins of the domestic dog are lost in pre-history, but its roots have produced a great variety of breeds (including hunting dogs, working dogs, guard dogs, racers and 'best friends') with wide variations in size and bearing between them.

Dogs can be found in most environments, and can be portrayed quite easily in their habitual positions of rest or when being fed. Dogs can also be trained to perform specific actions. It is not so easy, however, to depict them while they are playing or running or when they adopt unusual stances. In these cases, it is necessary to draw from memory, having carefully observed the actions when they occurred, or to make some very rapid sketches and then complete them, perhaps with the help of photographs. (If photographs are used, they should be taken from a suitable distance and angle to avoid distortions of perspective and proportion – see page 43 for more information about this.)

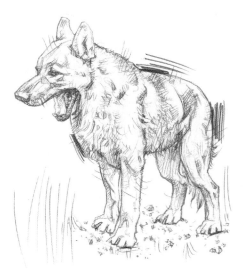

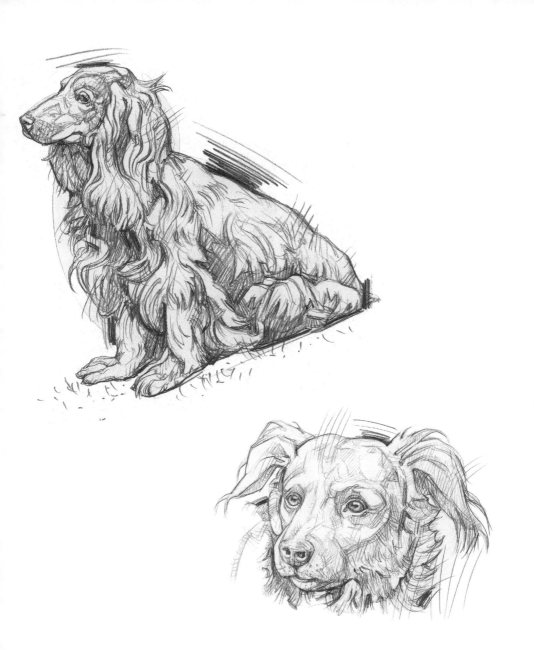

Drawings of short-haired breeds are essentially focused
on variations of light and shade, rather than on following
the interweavings and patterns produced by the hair.
But when a dog has a long, thick coat, it is important
to assess the direction in which hairs lie and the places
where locks of hair part or come together. Pay particular
attention to the underlying anatomical structure, which
can still be recognized beneath a dog's fur.

A dog's head is the most mobile part of its body, and is always alert and full of expression. The facial features – its nose, eyes and ears – should be drawn with particular care as they vary from one breed to another and from individual to individual.

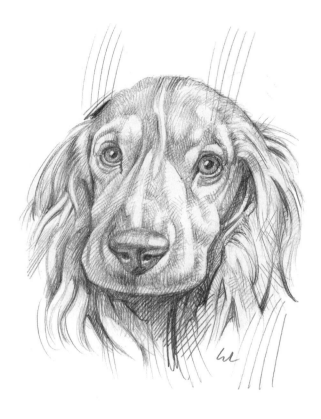

Mouth closed, with the jaws clamped tightly together – this is the way underdogs present themselves to their superiors, a fact worth considering when portraying a dog's head.

Before beginning a drawing of a dog (or of any other animal), it is a good idea to make a thorough analysis of its basic structure and skeletal framework, at least in your mind, if not on paper. Pay particular attention to the directions followed by the spinal column, the positions of the shoulder blades and pelvis, the orientations of the legs and also the head.

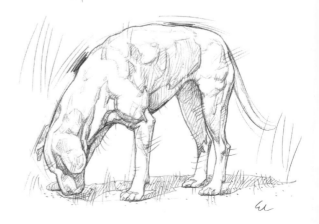

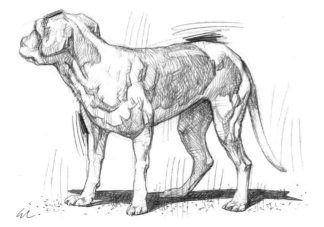

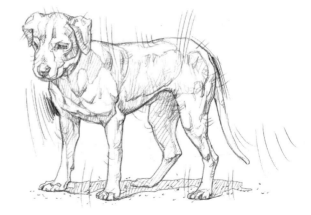

A dog's bone structure is generally better adapted to rapid, agile movements than to carrying or pulling loads, and accordingly its bones are quite fine and its neck rather short. The back muscles, those of the hips and the limbs are particularly well developed.

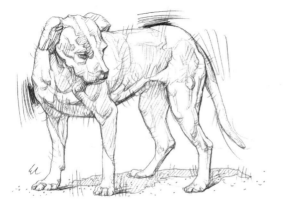

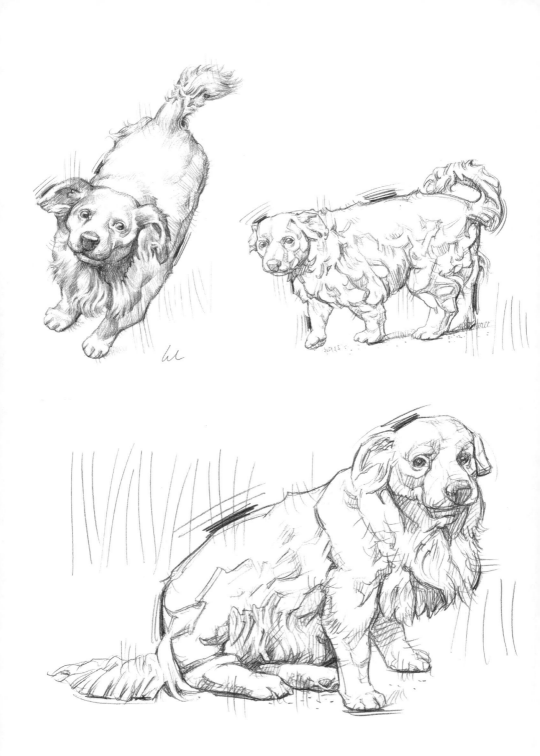

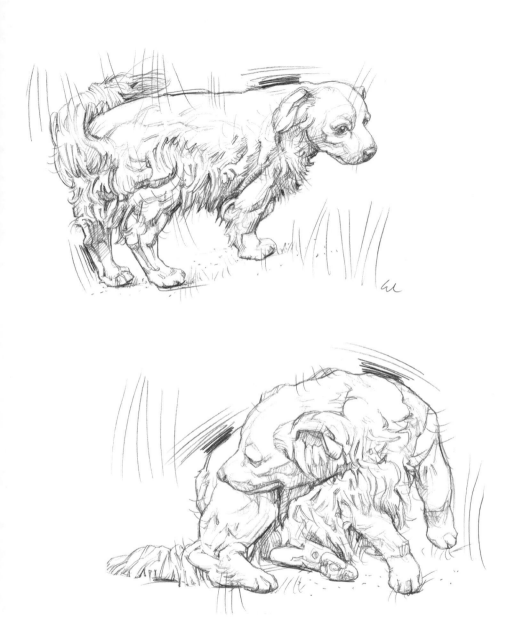

Each paw has four toes plus a rudimentary back toe (or spur), which may be quite prominent. When a dog's paws are resting on the earth, the cushioning effect of the soft pads at their base means that its claws are raised slightly from the ground.

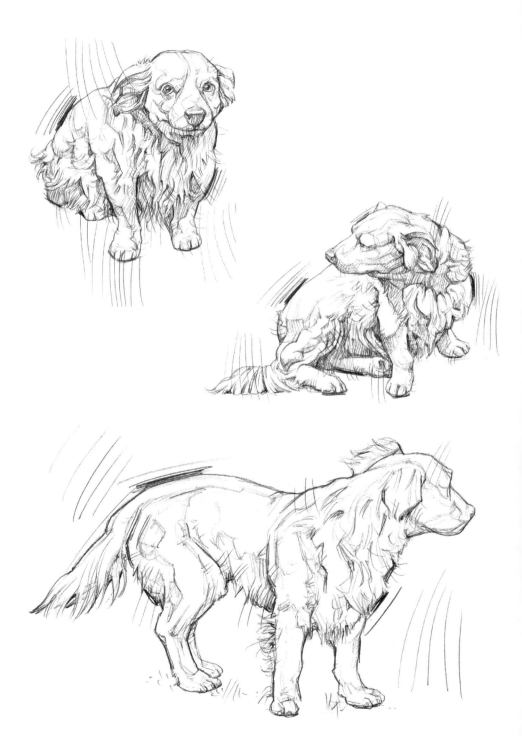

A dog has a characteristic fold in its skin between belly and thigh, corresponding to the joint of its hind leg. This will be in evidence to a greater or lesser degree depending on the length of its coat.

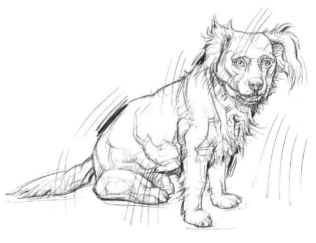

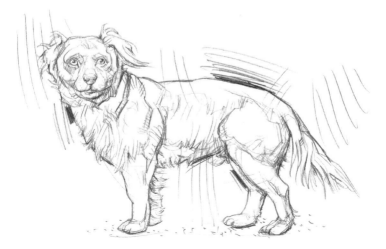

SKETCHBOOK: CHICKENS

Birds are vertebrates adapted for flight. The ovoid shape of their bodies is aerodynamic and their skeletons have also evolved for flight, being very light due to their air-filled bones. The breastbone has the shape of a boat's keel and is fused solid to the collarbones. The muscles are sturdily built and massed around the breast and back, but they are not visible, being completely covered with feathers and down.

There are two main feather types: down feathers, which are small, soft and insulating, and vaned feathers, which cover the body and the down. The remiges (flight feathers of the wing) and rectrices (flight feathers of the tail) are long and rigid vaned feathers, and are laid over the body in overlapping scale-like layers. These flight feathers serve as 'oars' during flight. Of course, when on the ground, birds walk on their hind limbs, as the front ones have evolved into wings.

There is a long tradition of the patient study of birds, which now uses the camera as its tool of choice. This has supplied us with a vast and highly useful stock of reference images, but in this small section I have limited myself to drawing the chicken, or domestic fowl. I have done so because it is relatively simple to find examples of these birds in the countryside. On poultry farms, behind fenced enclosures, the hens, cockerels and chicks rummage about for food, and it is not difficult to single out an attractive specimen and draw it while this semi-flightless bird is busy pecking at food and scratching the soil. There is little variation in a chicken's behaviour, and the birds soon get used to the presence of a strange person in their territory. Apart from chickens, other domesticated birds that provide similarly compliant models, such as geese, swans and ducks, can be studied in their countryside habitats or in the ponds of city parks.

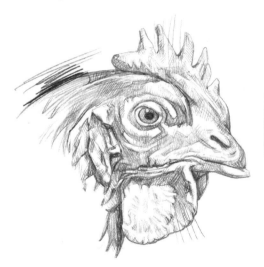

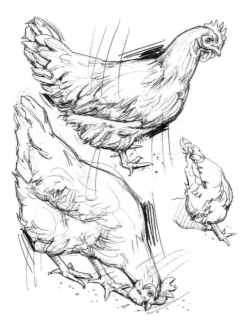

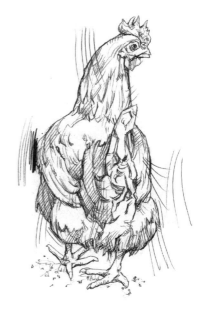

The plumage of the cockerel, or rooster, tends to be boldly coloured: his head is decorated with a large comb on top, with wattles below the beak; his feet are equipped with spurs – a horny conical growth pointing upwards from the back of the foot above the fourth toe.

The hen is smaller and weighs less than the cockerel of the same species; her comb is usually more modest, or sometimes completely absent, and her wattles are often less developed. In both sexes, the eye has a flattened, lenticular shape and is set in the side of the head; there is no external ear and the auditory canal is covered over by feathers and folds in the skin; and each foot has four toes: three pointing forwards and spread out fan-wise, and one backward-facing. The toes are armed with sharp claws and have a covering of scaly skin.

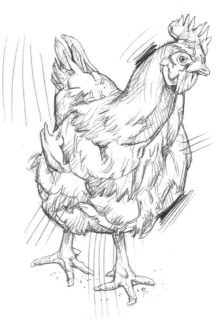

SKETCHBOOK: CATTLE

The term 'cattle' is generally used to refer to domesticated bovines raised for milk or meat production. The castrated males, especially those used as beasts of draught, are widely known as oxen; the uncastrated male of the species is called a bull, the female is a cow and the young animal is a calf.

Cattle have long been used as beasts of draught and utility for human populations in an association that reaches back to remote antiquity. Bovines are artiodactyla (even-toed); ruminants (regurgitating semi-digested food – the cud – to chew it a second time); and ungulates (hoofed animals), having two toes on each cloven, conically shaped hoof. They are ponderous, massive animals whose build is better adapted to steadiness than to fleetness of foot. The trunk of the body has the shape of a flattened cylinder, and the head is large and pyramidal in shape with a long muzzle.

Cattle have forward-pointing horns that are present throughout the year and whose length varies with breed. Their necks are particularly sturdy and, together with the back, give the animal a continuous, horizontal and straight upper profile, although in some species this line is interrupted by a hump. Cattle are easy to draw because they rarely make sudden movements or engage in energetic behaviour, preferring to spend most of their time with their heads to the ground, intent on grazing.

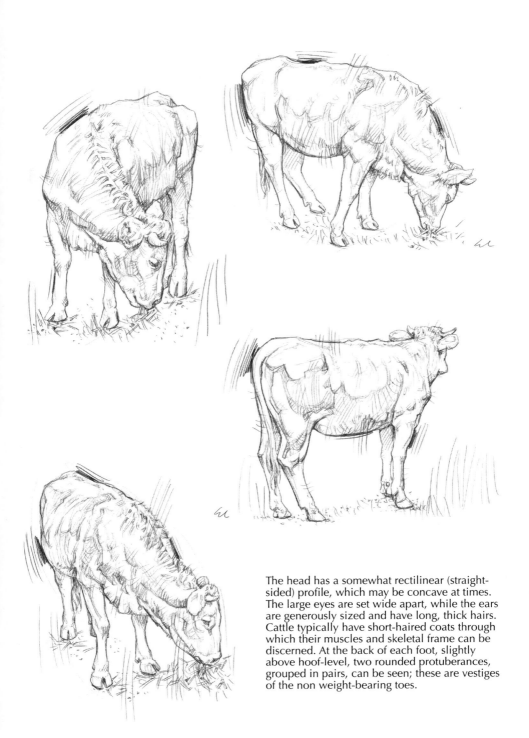

The head has a somewhat rectilinear (straight-sided) profile, which may be concave at times. The large eyes are set wide apart, while the ears are generously sized and have long, thick hairs. Cattle typically have short-haired coats through which their muscles and skeletal frame can be discerned. At the back of each foot, slightly above hoof-level, two rounded protuberances, grouped in pairs, can be seen; these are vestiges of the non weight-bearing toes.

SKETCHBOOK: CATS

Everybody knows what a large variety of cat breeds there are, and we are all familiar with the supple, nimble movements and the dignified, independent character of the domestic cat. But despite their capacity for swift movement, cats will often assume placid, static poses and hold them for long periods. Cats love to sleep curled up in a ring, or splayed out on one side; they may often become engrossed in grooming themselves or in intently observing their environment while sitting neatly on their hind legs. They also enjoy toying with small objects. These are moments during which you will be able draw a cat in an unhurried way. It is the cat's lightning-fast dynamism that attracts our attention the most and which displays the

greatest variety of movement. This aspect can only be captured in brief, bare sketches and the best strategy here is to focus on observing the way the animal's actions develop in real time – such movements may often be repetitive ones – and then to get the sketch down on paper after the event, trying to retrace the entire action sequence. Of course, you can make use of photography for this purpose and, indeed, this may even prove indispensable, or you can freeze-frame sequences from films or documentaries. However, if you do this, beware of making an overly detailed drawing as this can make the image appear static and can rob the movement of its vitality and flow.

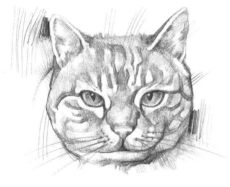

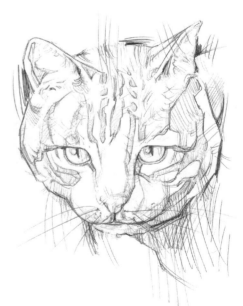

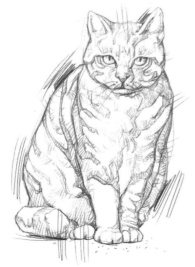

NOTABLE FEATURES

As well as the cat's whiskers on each side of its nose, other extra-long, stiff hairs also grow on the cat's face above its eyes and in front of its ears. These long hairs, including the whiskers, are technically known as vibrissae and function as organs of touch. The cat's outer ears (or pinnae) have a concave, triangular shape and are extremely mobile and velvety in texture. Cats have long, curved canine teeth, which are conical in profile and also very sharp. The pupil of the eye opens to a full circle in complete darkness but in the presence of light it closes to a vertical slit, which narrows as the light intensifies. When a cat is ill or out of sorts, the 'third eyelid' (the nictitating membrane) will cover part of the eyeball.

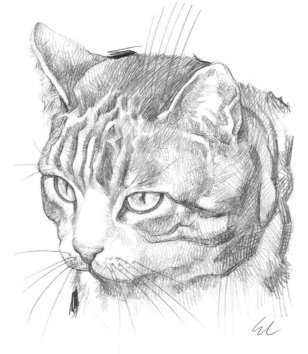

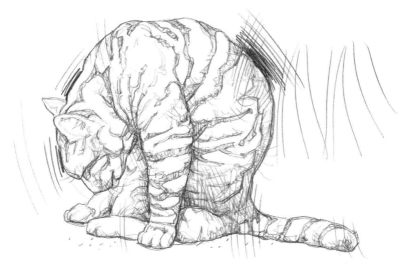

UNDERSTANDING
THE STRUCTURE

Cats have small heads with a short
face, but their bodies are elongated.
It is difficult to discern clues to the
build of their muscles and their
skeletal framework as these are
hidden beneath a thick coat of hair.
It is often only through the delicate
play of light on surface planes,
or by means of the wave patterns
of an animal's stripes, that the
underlying structures may
be recognized and their
volumes indicated in the
drawing. Concentration
is required to draw the
bodily structure of a cat
in its correct proportions.

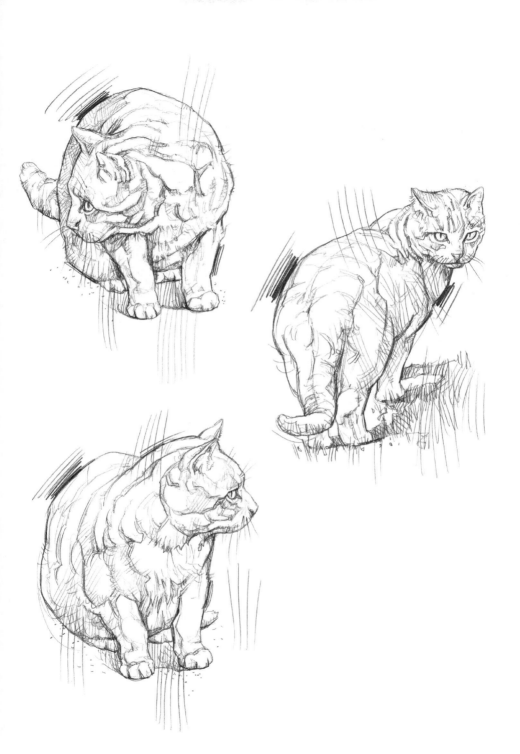

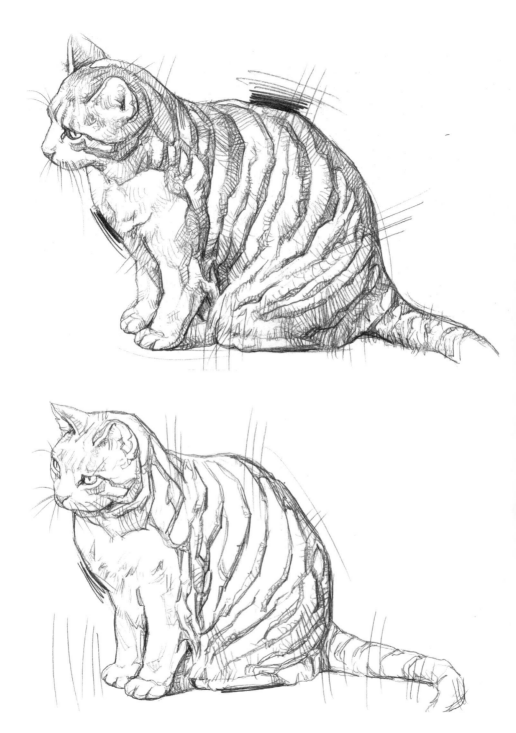

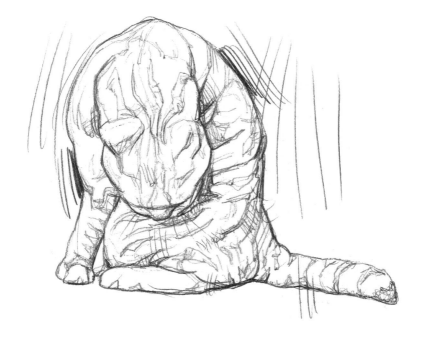

A cat's body is very supple and its limbs are adapted for quick pounces and unexpected springs, for running and for climbing. Soft pads give its paws their steady footing and a soft, silent tread. A cat's strongly fashioned, curved claws are retractable, and are exposed voluntarily when required for assault, for climbing or for clinging, for example.

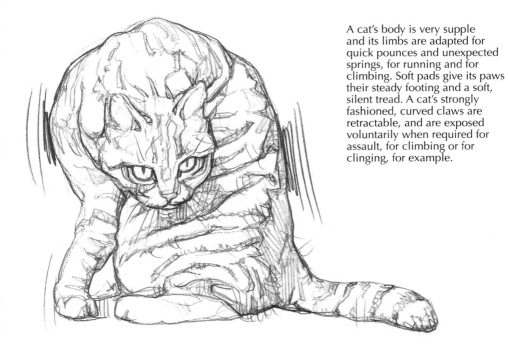

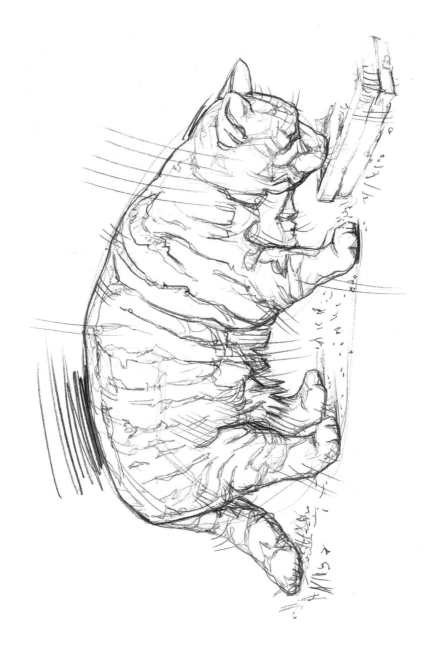

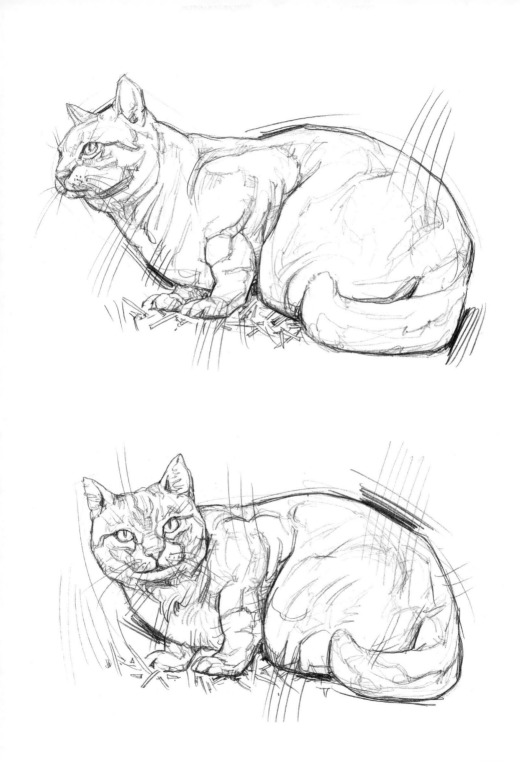

SKETCHBOOK: HORSES

The practice of keeping sketchbooks is indispensable for keeping your hand well trained for drawing. As the Ancients said: *'nulla die sine linea'* ('never a day without a line'), and a small notebook for visual note taking is something that should accompany an artist wherever he goes. Sketching from life will sharpen your observational capacities, help you to notice interesting details and at the same time teach you fluency of line. However, you will also assemble a stock of visual records that you can call on when attempting more highly finished work.

The following sketches were made over a period of months during which I was an unfailing visitor to certain stables and riding schools. A degree of discomfort had to be endured in terms of working conditions, but this was more than compensated for by my pleasure in the work. Horses are such beautiful and fascinating creatures and they fully deserve a course of study in their own right (one which I have undertaken summarily in my book,

Drawing Animals Using Grids (Search Press, 2021)). Here, I shall limit myself to putting my visual notes on display in the hope that they will stimulate other artists to imitate my habit – and passion – for keeping life-study sketchbooks.

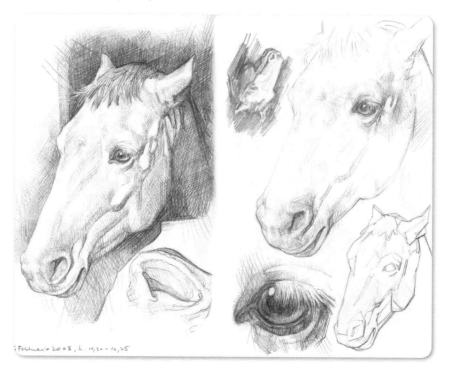

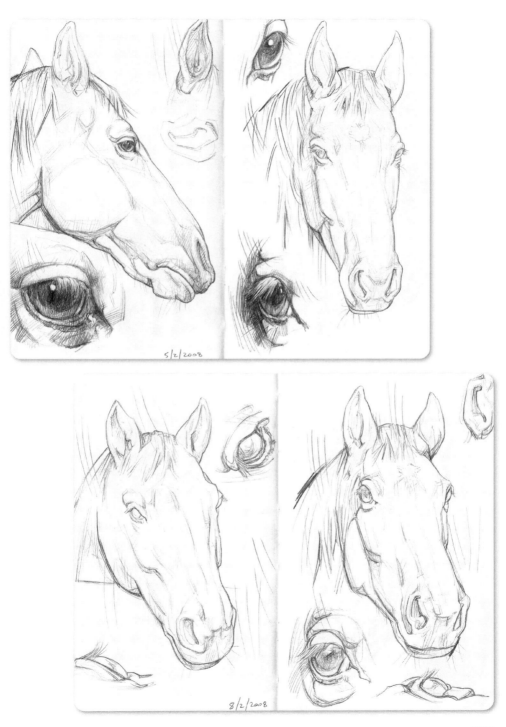

5/2/2008

8/2/2008

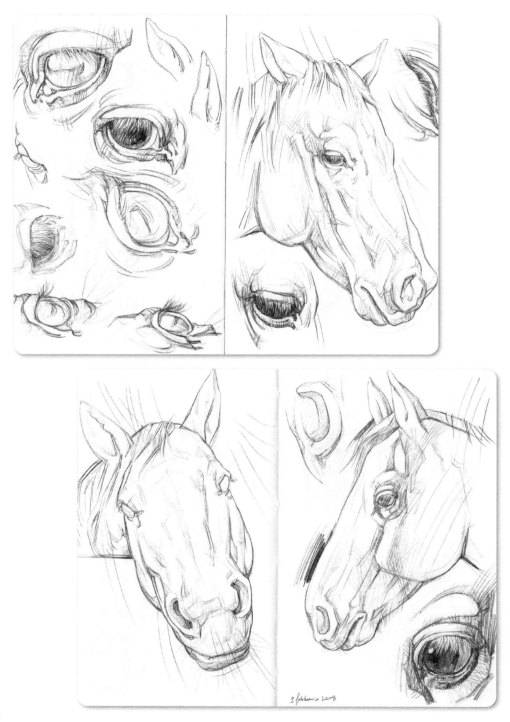

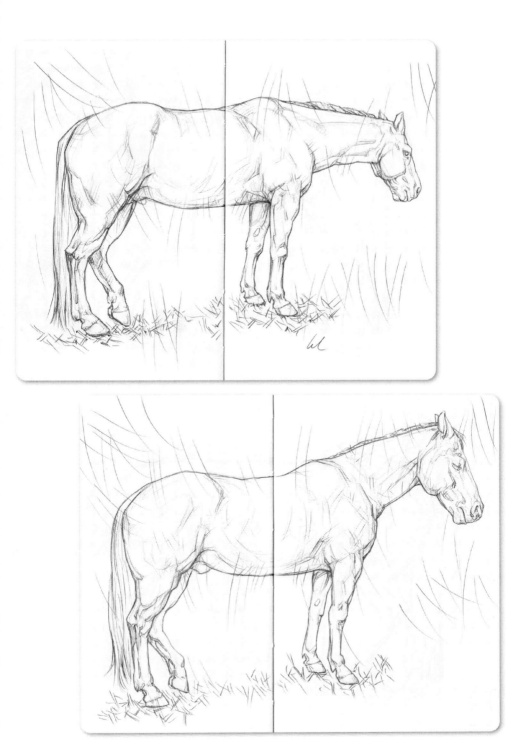

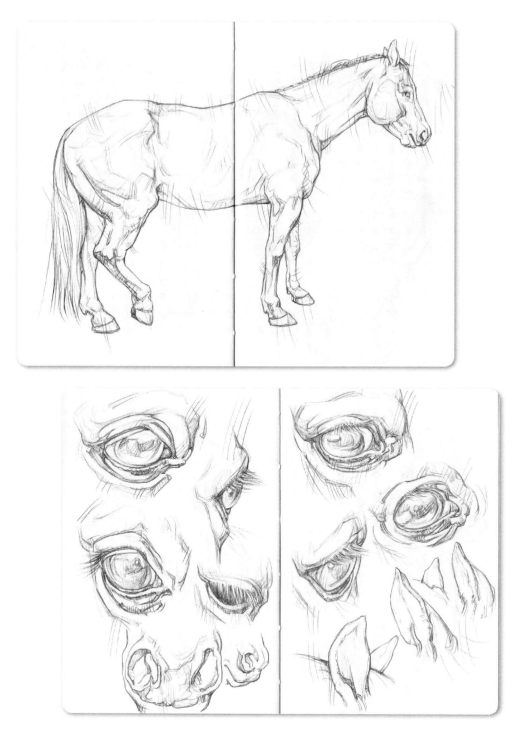

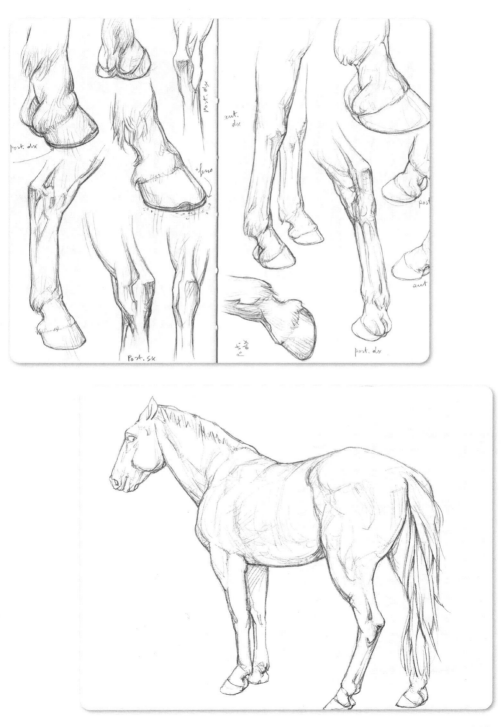

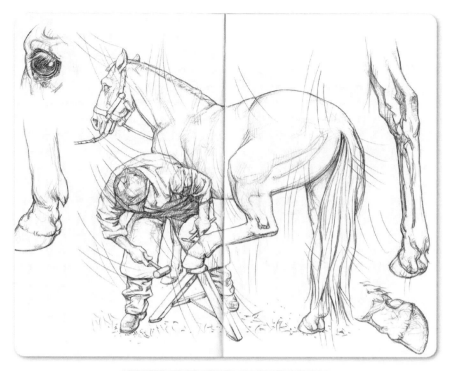

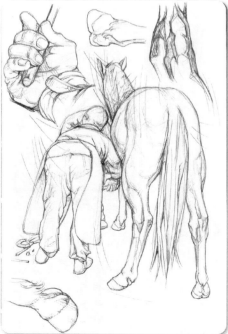

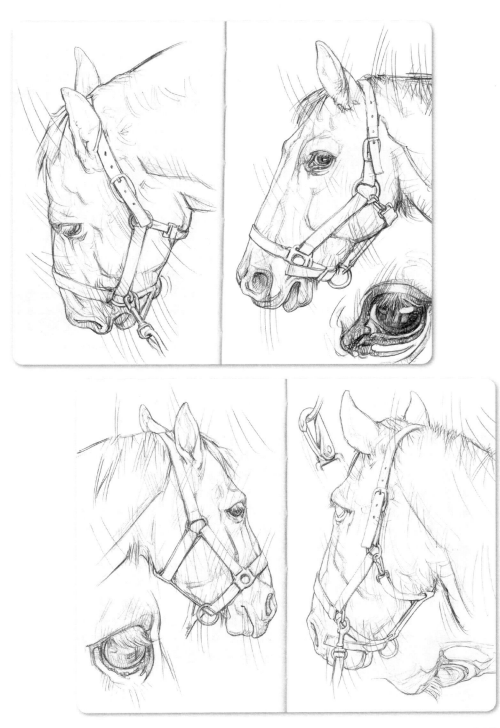

315

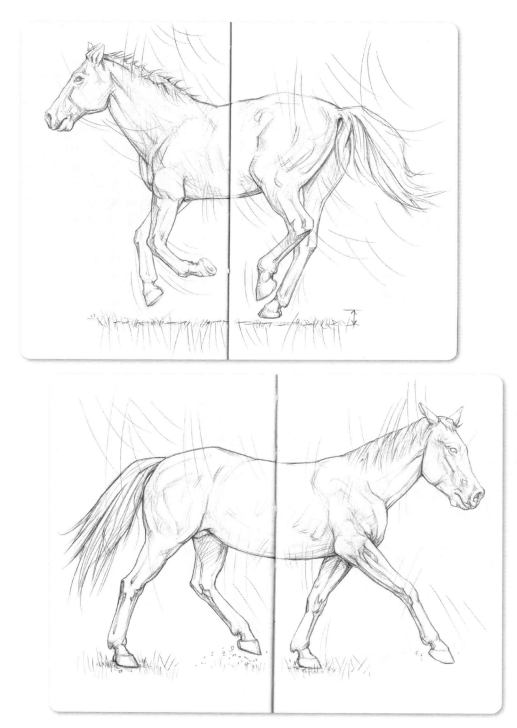

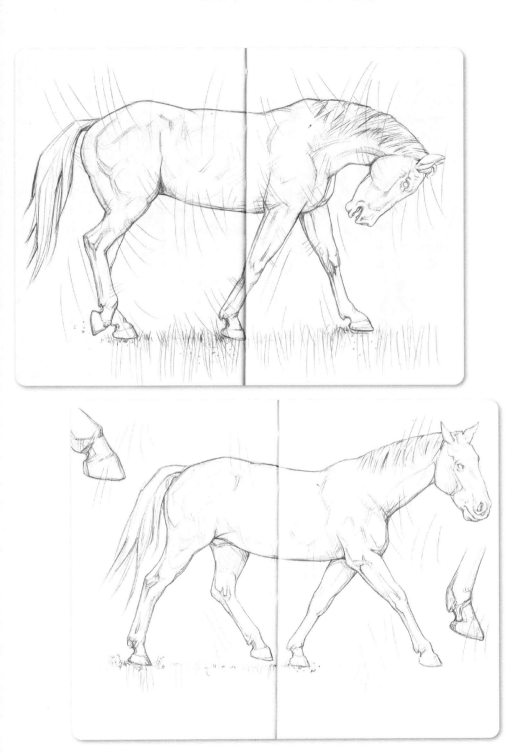

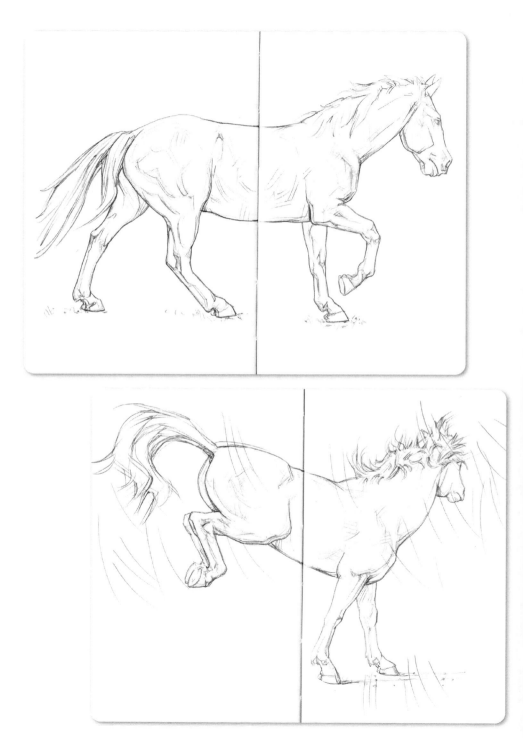

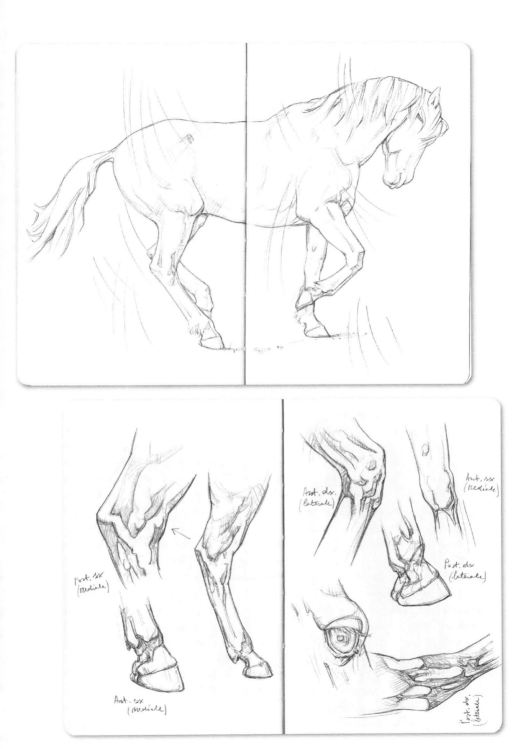

Post. sx
(Mediale)

Ant. sx
(Mediale)

Ant. dx
(laterale)

Ant. sx
(Mediale)

Post. dx
(laterale)

Post. dx
(laterale)

319

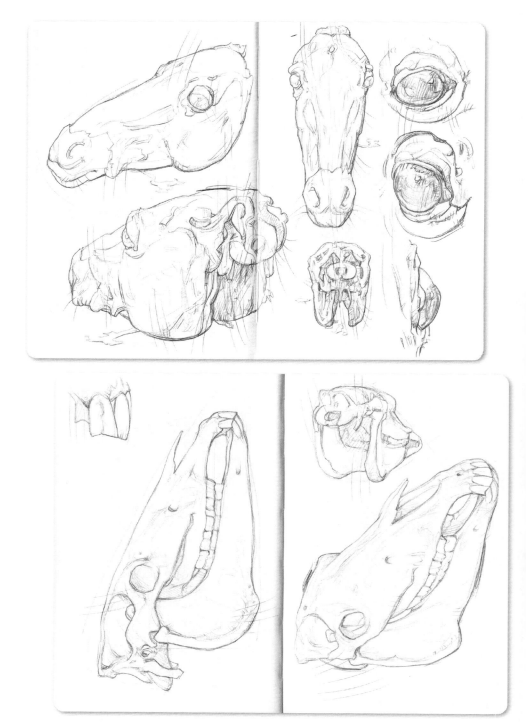

WILDLIFE SKETCHBOOK

(DRAWINGS FROM THE NATURAL
HISTORY MUSEUM, MILAN)

In this final section, I would like to
show a few pages from another one
of my sketchbooks. We do not often
get the opportunity to draw wild or
exotic animals from life, and this is
the reason why I have limited myself
so far in this chapter to drawing only
some of the more common domestic
animals. However, natural history
museums (which can be found in
many larger cities) offer another great
opportunity to the artist. In these
museums, animals are displayed
according to strict scientific and
didactic criteria, having undergone
a complex process of taxidermy. This
work is usually performed by highly
competent and qualified experts
so that the preserved animals are
displayed in a very faithful manner
that is as true to nature as possible.

Ideally, it would be useful to
follow up your depiction of these
examples with a study made of the
animal in the wild, incorporating its
habitats and its typical behaviour,
or you could perhaps refer to the
wildlife studies of experts. Even
without this, time spent sketching in
a natural-history museum can be a
significant exercise in its own right,
as it allows you to examine the whole
animal from close up and to note
even the tiniest of details.

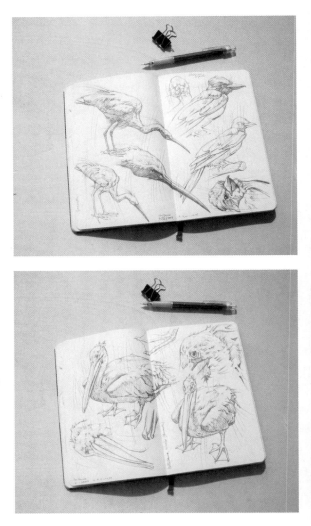

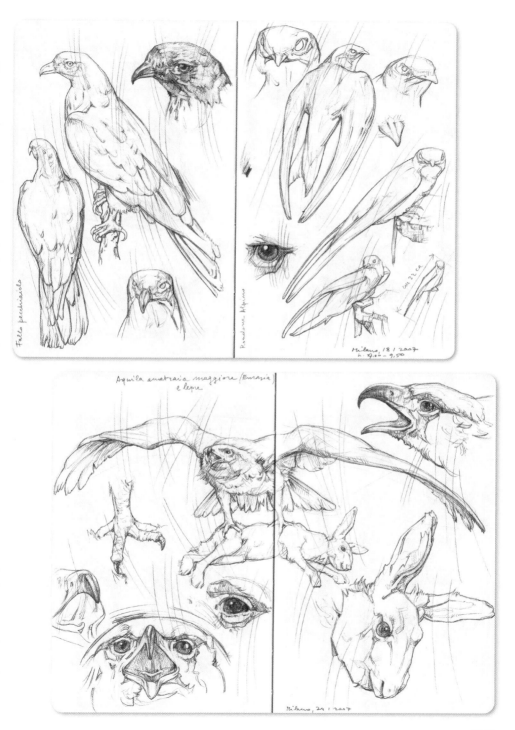

Falco pecchiaiolo

Rondone Alpino

Aquila anatraia maggiore (Eurasia)
e lepre

Milano, 18 / 1 / 2007
h. 9.06 - 9,50

Milano, 24 / 1 / 2007

323

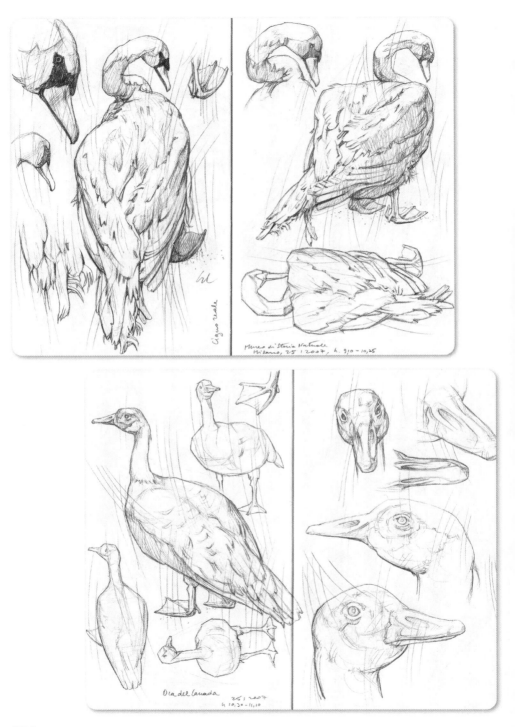

Cigno reale

Museo di Storia Naturale
Milano, 25 I 2007, h. 9,10 – 10,25

Oca del Canada 25 I 2007
h 10,30 – 11,10

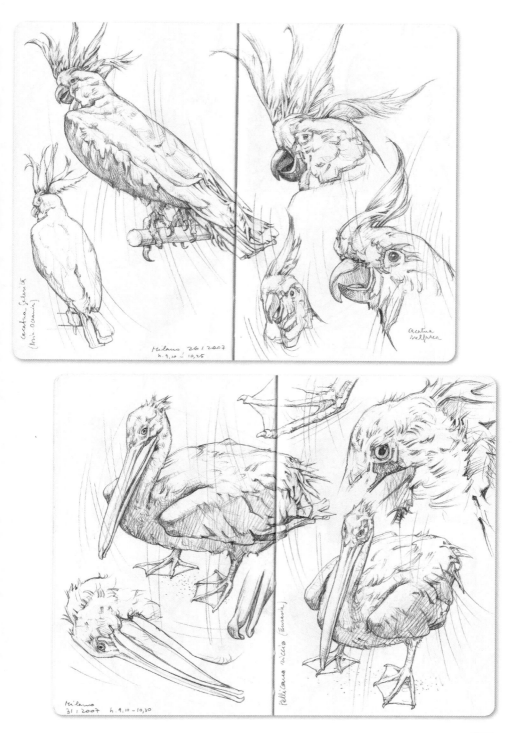

Cacatua galerita
(Mar Oceania)

Milano 26 i 2007
h. 9,10 - 10,25

Cacatua
sulfurea

Milano
31 i 2007 h. 9,10 - 10,30

Pellicano onocro... (Eurasia)

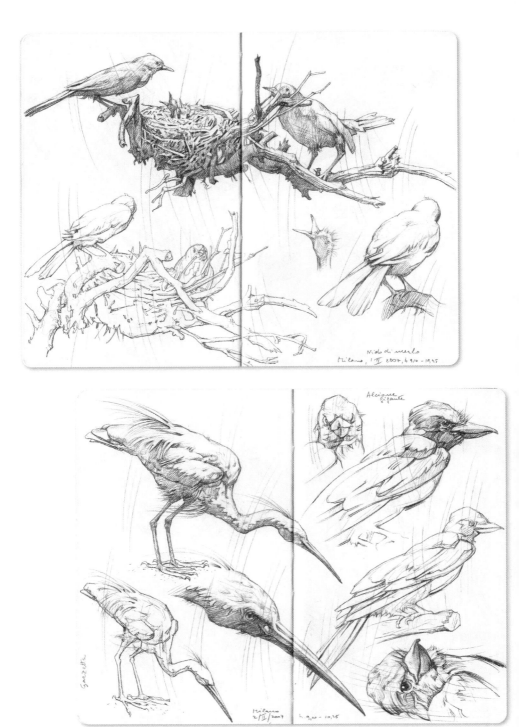

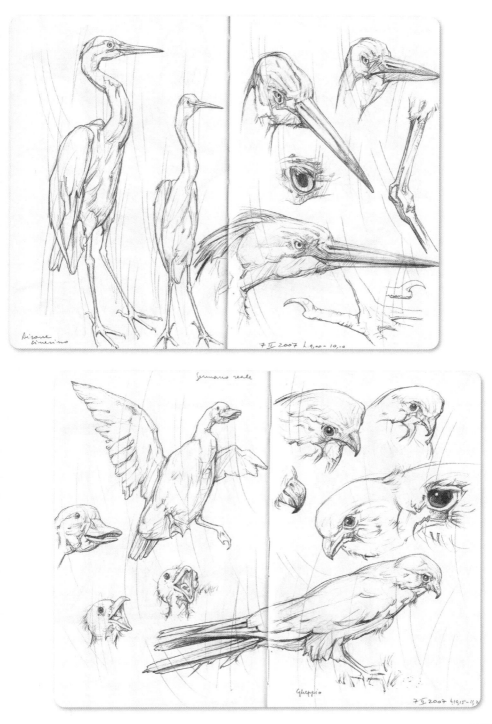

Airone
cinerino

7 II 2007 h 9,00 – 10,10

Sermano reale

Gheppio

7 II 2007 h 19,15 – 11,7

327

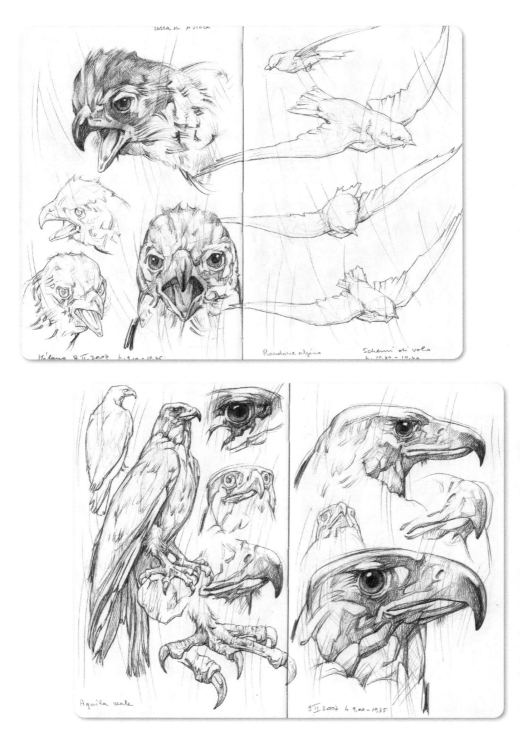

testa di pizeca

Milano 8 II 2007 h. 9.10 - 10.25

Rondone alpino

Schemi di volo
h. 10.30 - 10.40

Aquila reale

9 II 2007 h. 9.00 - 10.35

328

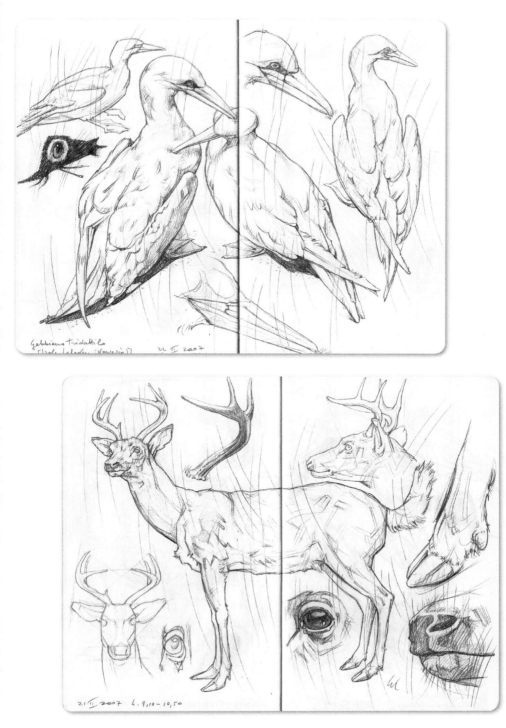

Gabbiano tridattilo
Isole Lofoten (Norvegia) 22 II 2007

21 II 2007 h. 9,10 – 10,50

329

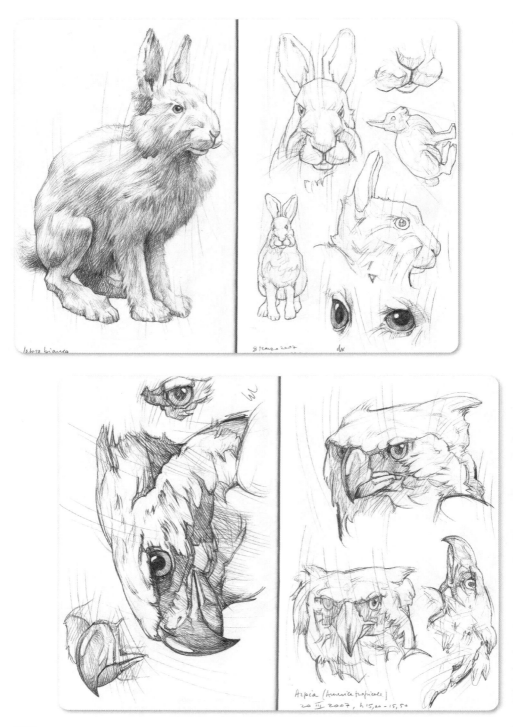

lepre bianca

8 marzo 2007 dx

Arpia (America tropicale)
20 III 2007, h 15,00 - 15,50

330

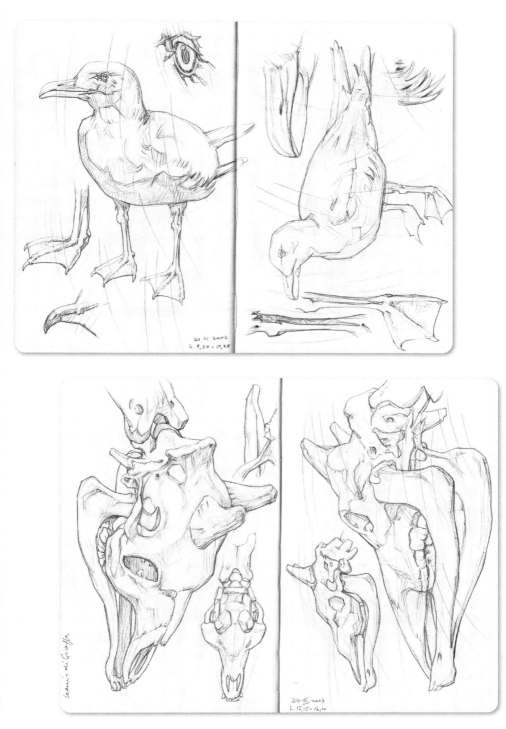

331

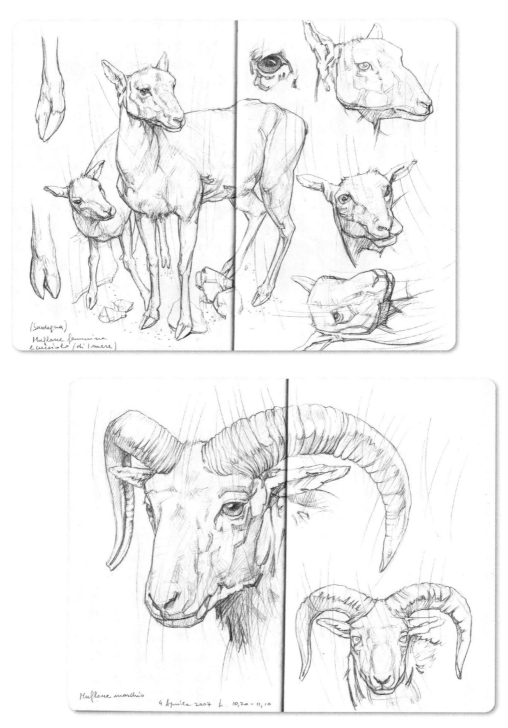

(Sardegna)
Mufloue femmina
e cucciolo (di 1 mese)

Mufloue maschio

4 Aprile 2007 h. 10,20 - 11,10

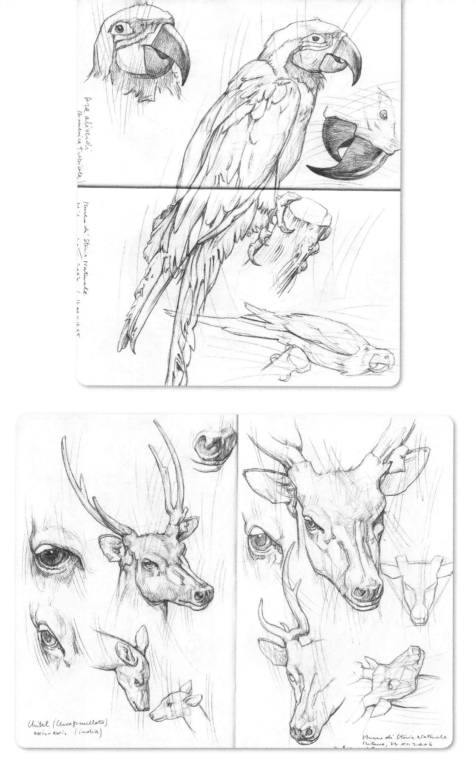

Ara ararauna
(Psittaciformes)

Museo di Storia Naturale
Milano

Chital (Cervo pomellato)
axis-axis (India)

Museo di Storia Naturale
Milano, 22 XII 2006

333

WILD
ANIMALS

INTRODUCTION

We know that animals have always fascinated humans because we have found cave paintings of animals dating back to ancient times. Indeed, since the practice of art was established, there hasn't been a civilization, culture or historic period that did not explore this theme in various forms and for a multitude of reasons. In the previous chapter I focused on drawing the most popular pets, but I believe it would be equally exciting – if not more so – to observe and draw wild animals. I have only selected a handful, all of which are mammals that we can see in the flesh at the zoo or nature park, albeit sometimes with a few difficulties (see page 336). Of course, it would be better to see these animals in large reserves in Africa, Asia or the Americas, if the opportunity arises.

These days, there are also other avenues open to the would-be wildlife painter. For example, you can observe wild animals, conveniently and in detail, by watching wildlife documentaries, by studying specialized photographic magazines or by visiting natural-history museums. You may wish to start with these anyway while you gain confidence and then move on to the living animal. But no matter where or how you view your chosen animal, the process of drawing it is the same: careful observation followed by drawing. In this way we see that drawing is a method of discovery as well as a form of communication.

As described in the previous chapter, drawing wild animals is an interesting, enjoyable and useful exercise for any artist because the required study does not just extend to the physical characteristics of a species and specific individuals, but includes their posture, typical manner, behaviour and relationship with the environment. You will quickly notice that even if you draw the details of an animal correctly, if the posture is incorrect, it simply won't 'work' as a drawing.

An animal drawing can be all about expression and artistic feeling or it can be an objective, detailed, accurate and thorough analysis in the style of a scientific drawing; mostly, a drawing falls somewhere in between these two extremes. No matter what your style, intention, skill or artistic sensitivity, the drawing of animals (particularly, wild animals), when carried out with affectionate passion, attention and detail, can provide very fruitful and satisfying professional results. Illustrative drawings, for example, could work well in a journal or child's book; scientific drawings would be ideal for encyclopaedias, documents, exhibitions and textbooks while purely artistic creations will be appreciated in their own right. Even today, when photographic images are so advanced and readily available, drawing has a role to play in highlighting particular aspects of the subject more clearly than any photograph and through its employment of aesthetic perception and human emotion. Any form of visual recording is also poignantly important in a world in which flora and fauna are increasingly forgotten, overlooked, despised and even threatened with extinction.

PRACTICAL CONSIDERATIONS

EQUIPMENT, SUPPORTS AND TECHNIQUES

When drawing animals from life, you have only a short time to capture the essential details and you may also be restricted in terms of your own comfort and convenience. For these reasons, use whatever tools and materials suit your style and the conditions: pencils of any sort, pastels, charcoal, pen and ink, felt-tip pens, monochrome watercolour (ink-wash painting) and so forth. Each of these tools produces different effects and requires a suitable support to bring out the best of the medium, be that smooth or rough watercolour paper, board, white or coloured drawing paper, and so on.

For the drawings in this chapter, I chose what I believe to be the best tool: lead pencil. I prefer an HB (medium-hard) lead pencil and standard white paper in sketchpads (preferably with single, loose sheets). I like the paper to be slightly rough, weighing around 200g/m² (120lbs), and with convenient dimensions such as 15 x 20cm (6 x 5in) or 25 x 35cm (10 x 13¾in). This combination of pencil and paper makes the drawing easily manageable, plus the precision of the tool means that the drawing can be highly accurate. As time is short, I tend to focus on observation of form, movement and the structure of the animal.

Of course, we must also consider the colour of animal coats, which are particularly rich and often combined with camouflage patterns. To capture these you could add coloured pencils, pastels, watercolours or even gouache to your pencil drawing, and for more complex works even use oil or acrylic. For the purpose of this chapter, I have not added colour to any of the drawings in this section.

Additional requirements depend on your choice of mediums. You will probably need some sort of bag or case for your equipment and perhaps water jugs, easel, cloths and metal clips, fixings, etc.. Remember to consider your location in your planning. Obviously when working from a magazine picture you can make yourself comfortable with all the tools you want, whereas when working in the field you should restrict yourself to what is truly practical.

WHERE TO FIND SUBJECTS

The types of wild animals I am covering in this chapter, namely large mammals, may only be studied in the wild, in wildlife parks or in places like zoos. The opportunity to study them in the wild is rare and can be both expensive and time consuming, so for most people a wildlife park is the next best option for witnessing the animals in a natural environment. But this has its own difficulties, as it isn't always easy to see the animals closely, let alone photograph or draw them comfortably. Animals that are tamed and remain still can be a little lazy, and do not act in the manner we expect from wild animals. Meanwhile, wild animals are constantly alert, and can sense human presence even from a great distance; they can be alarmed, escape and hide or react aggressively. Thankfully, well-run zoos abound, and here, with sufficient patience and luck, it is possible to approach and observe, draw and photograph these animals in safety.

Although drawing the living animal is ideal, there is much to be gained too from studying anatomically correct sculptures and the stuffed animals in natural-history museums (see pages 322–332 and page 384). From these you can make a fairly analytical study, useful for understanding the anatomical structure accurately, work on details of the outer form and make a comparison with similar species. In such a case, do check the accuracy of anatomical relationships as the examples exhibited may not be totally true to stereotype, may have been injured or modified for some reason.

HOW TO STUDY WILD ANIMALS

The greatest difficulty when drawing live animals is the unpredictability and speed of their movements. To begin with, it would be wise to study them while they are eating or sleeping. It is always wise to observe their movements from a distance and at length (where circumstances allow) looking to identify the cyclic nature of their habits, as when pacing or stalking prey, attempting to foresee or steer the possible subsequent movements and draw during these stages of relative stillness.

Life drawing is definitely the best way to depict animals because the artist has to observe directly and attentively as well as provide substance to aesthetic emotion. It is therefore possible to draw a rough sketch in the form of a simple visual pointer, which serves as a memo or an initial idea on which the more complex and elaborate drawing is based. For this reason, artists should always carry a pocket sketchbook

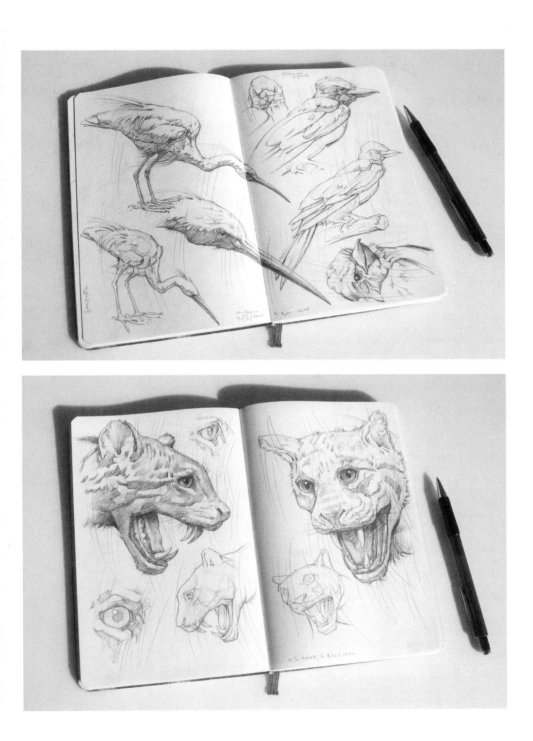

337

and a pencil with them, as the most interesting opportunities present themselves at the most unexpected times and some are once-in-a-lifetime events.

REFERENCE DOCUMENTATION

If it is not possible to create a drawing from life, not even a quick outline sketch, owing to the constant movement of the subject, documentary materials can be collected which can be used at a later date. For example, use photographs, video or television documentaries.

Today's equipment, which focuses on digital technology, offers opportunities that were unimaginable in the past. For example, you can enlarge a digital photograph on a computer screen to view specific details that may not have been visible in standard print and then use this to help you understand the animal more accurately. With videos online or on television, you can pause the animal's movement and witness its behaviour repeatedly.

When taking your own photographs, take the following into consideration:

- **Foreshortening** – the apparent distortion of the subject's form due to the artist's viewpoint.
- **Blur**, owing to the use of a telephoto/zoom lens or hand tremors. Here a tripod may be of assistance, or (if you are using a certain smartphone or tablet) a setting that helps to counter shakiness and steady the camera.
- **Contrast issues** with photographs, which often means that details in shadow are lost while areas in full sun can be bleached out. (Taking a series of bracketed photos helps here if your camera has the ability.)
- **The need to blend into the environment**, possibly with the use of a hide or camouflage, making it more likely that the animal will act naturally.

If your own photographs let you down, you can compensate by carefully studying many images of the same subject and also familiarizing yourself with the anatomical characteristics of the species, then adapting as needed.

In many circumstances, film recordings are a more effective form from which to extract the most suitable images, although good photographs are a wonderful resource if you can take them.

Other resources include the wealth of photographs published in books, journals, newspapers and encyclopaedias as well as television documentaries and wildlife programmes. In such cases, they should be regarded as useful for analysis and reference but they should not be fully copied as they may be protected by copyright. Remember, too, that colours in other people's photographs and films may have been manipulated or enhanced and not be true to life.

HOW AND WHAT TO OBSERVE

See drawing as a way of looking. Regardless of the subject of the drawing (in our case, wild animals), the most effective and fruitful system of drawing is first to observe and understand and then to interpret what we see. Bear this in mind as you work. The following pointers should also help you on your journey as an effective artist:

- Start with the overall form first. This is true of any subject but is especially true of animals as the proportions are critical. Various processes can be used: you can simplify down to basic geometric forms such as cones and rectangles, start with a few sketchy lines depicting the main body forms or begin with a schematic drawing of the main skeletal parts (skull, spinal column, pelvis, limbs, etc.).

- Details, such as expressions, eyes or fur patterns can be very eye-catching, but they should come after the main body forms. Also, body markings should enhance rather than confuse the body form: these must be firstly studied as they characterize each animal species and each individual. Once everything is technically correct then you can add specific elements in order to uphold an artistic approach, to produce a drawing that is not simply scientific.

- Do not try to start with a 'standard' body form for any four-legged creature. There is no one rule governing proportions of all animals. With four-footed vertebrates, for example, it is possible to trace shared construction principles and produce a generic structural diagram for each species but many variations exist within individual species and between individuals.

- When drawing any animal, it is always wise to consider the basics: be aware of the anatomy and accurately observe the form, structure, profile, movement and balance of the subject; identify the characteristics of the species (behavioural and physical traits) as well as individual features; assess the different forms and sizes attributable to the sex and age of each animal; identify

seasonal trends (hair shedding, etc.); examine the typical positions and behaviours as well as characteristic movements and aim to memorize what you are drawing. All this will be easier if you research your animal in books or online, for example, before attempting to draw it.

- Consider specialization. The complexity of the issues associated with drawing animals leads some artists to dedicate themselves to one species in all its varieties. This enables them to see and depict subtle differences between individuals. If you want to draw, say, a lion really, really well, you need to draw lions as much as possible. It's as simple as that.

PERSPECTIVE

There is a convention for creating accurate perspective across a flat surface and for giving the impression of depth. In Western culture this is based upon geometric principles (illustrated below), and these ensure accuracy of depth perception as suggested by our natural vision. I have outlined some basic perspective methods briefly here; for more information, see *Understanding Perspective* on pages 38–91.

When completing naturalistic drawings, especially when drawing large or medium-sized animals, understanding the basics of perspective rules is useful for a number of reasons: to draw animals and their surroundings so they are believable (ranging from the entire form to its relative parts); to correct or adapt details taken from photographs (see page 338) and to construct from memory the form or behaviour of an animal. We can use two fundamental methods of creating perspective: 1) linear perspective, when an object or its parts reduce in size the further they are away from us and converge towards a single or multiple vanishing points, usually located on the horizontal line; 2) aerial perspective, which refers to the representation of tonal values, when objects appear fainter and bluer in the distance, for example.

Diagrams A and B: examples of linear perspective. Here the horizon line is marked as H and the two vanishing points visible from this angle are marked as VP1 and VP2. Notice how the edges of the objects (in this case, simple boxes) converge and appear to narrow as they get nearer to the appropriate vanishing point. In diagram A, all the boxes are conveniently placed to align with the same vanishing points. In reality, each object would have its own vanishing points, as shown in the second diagram, unless your subjects are aligned, as might be the case with a column of elephants, for example.

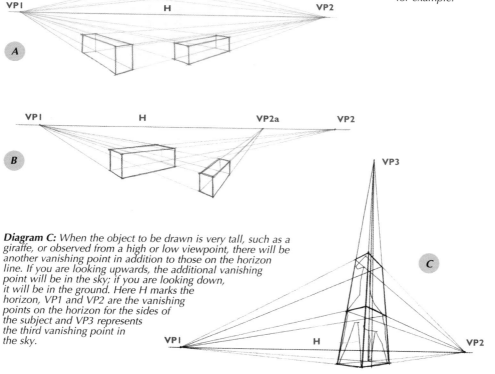

Diagram C: *When the object to be drawn is very tall, such as a giraffe, or observed from a high or low viewpoint, there will be another vanishing point in addition to those on the horizon line. If you are looking upwards, the additional vanishing point will be in the sky; if you are looking down, it will be in the ground. Here H marks the horizon, VP1 and VP2 are the vanishing points on the horizon for the sides of the subject and VP3 represents the third vanishing point in the sky.*

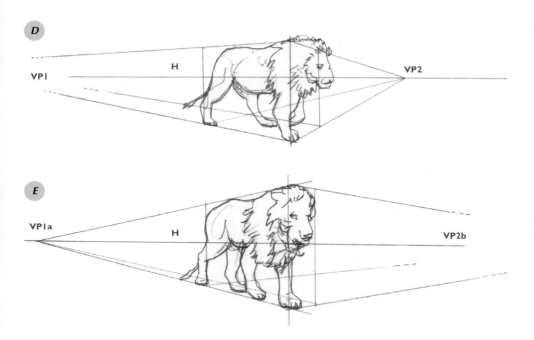

Diagrams D and E: *A complex subject, such as an animal, can be more easily 'placed' in perspective when it is drawn within the sides of a simple solid geometric shape (such as a parallelepiped or a cube). I recommend beginners draw in this geometric shape first, but with experience this can be imagined.*

Rules of linear perspective should not be too strictly applied, however, because this could lead to unacceptable aesthetic results. For example, exaggerating the size of body parts that are close to the observer and reducing proportions for those further in the distance. Note that the same issue applies to a photograph: both linear perspective and photographs are based on the vision of a single, monocular view while natural vision is binocular.

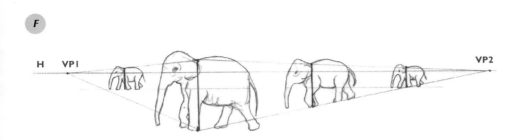

Diagram F: *Wild animals nearly always live in groups – prides, herds, troops, etc. – and it is uncommon for individuals to live alone. In order to maintain an effective and correct sense of proportion when animals of the same species and size are spread apart, a common size must be identified (the height of the withers for example) and this must be graduated in depth, as demonstrated above.*

ANATOMY

A basic knowledge of the structure and body systems of mammals is useful for artists in order to be able to observe better and to draw the chosen subject more effectively. This will help you understand proportional relationships and get an idea of expected movement or common behaviour. The bone structure is the most important, even more so than the muscle-mass arrangement, as our view of the latter is almost always influenced or even completely concealed by the thickness of the fur. All the animals I have drawn for the purpose of this chapter are mammals, and therefore share many structural elements that can be compared to those of humans, as can be seen in the generic diagram below.

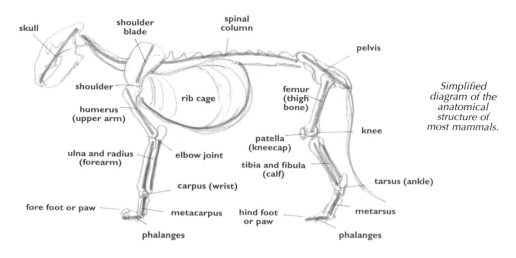

skull

shoulder blade

spinal column

pelvis

shoulder

rib cage

femur (thigh bone)

humerus (upper arm)

knee

patella (kneecap)

ulna and radius (forearm)

elbow joint

tibia and fibula (calf)

carpus (wrist)

tarsus (ankle)

fore foot or paw

metacarpus

hind foot or paw

metarsus

phalanges

phalanges

Simplified diagram of the anatomical structure of most mammals.

Naturally, every species has anatomical features which are specifically suited to its environment and relative lifestyle, such as the number of backbones and ribs, the shape of the teeth, the way the limbs offer support on the ground, the specific muscle development, the markings of the coat, to name a few. The fundamental and essential skeletal structure for all mammal species (which are vertebrates) is shown here, starting with the spinal column to which the skull, ribcage and the limbs (via the pelvis and shoulder girdle) are attached. It is useful to consider that with four-footed animals, the hind limbs are primarily effective when jumping, while forelimbs (located under the front part of the torso) support most of the body weight. The head faces forward and is fully subjected to the force of gravity, which is in contrast to the neck muscles, which are particularly strong and stabilized by a solid ligament. The head and neck are an important factor in terms of the animal's balance, both when still and when in motion.

Anatomical and ethological (behavioural) information on animals is available from many sources, primarily from scientific books and articles. To help with research, sometimes it is not enough to refer to the common name of the animal. It is useful to be aware of the scientific name and the relative category to which it belongs based upon shared classification criteria. Taxonomy, the practice and science of classification, includes nomenclature formed of two names (usually in Latin); the first denotes the class while the second identifies the species. In a broad sense, an animal is assigned a series of related categories ranging from the most extensive to the most limited of groups: the type, class, order, family, category and species. For example, the mammal class is divided into orders – primates (e.g. monkeys), artiodactyla (such as giraffes), perissodactyla (such as the zebra), proboscidea (elephants), carnivores (e.g. lions), marsupials (e.g. kangaroos and koalas), etc.. Each of these is further subdivided until we get down to species. For example, in reverse order, the lion (species) belongs to the Felidae or cat family and the carnivore order.

Scientific names are useful to help you identify anatomical or behavioural features common to all the animals within a broad category (order, etc.). For example, ungulates are basically hoofed animals and include artiodactyla (which are even-toed, with two or four toes) and perissodactyla (which have an odd number of toes i.e. one or three). Carnivores, who are the predators, include Felidae (cats, lions, tigers etc. ...), Canidae (dogs, wolves, jackals and so on), Ursidae (bears) and others.

It is useful to be aware of the approximate and average sizes of the animal species you are drawing as this information can be used to place the subject correctly in its environment in proportion to, say, trees or shrubs, other animals or people. In the case of four-footed ungulates (and sometimes, carnivores), the height of the withers (measured from the base of the foot to between the shoulder blades) is important, and consequently also the distance between the ground and the base of the neck and between the base and upper edge of the neck. In the case of other animals, it is more common to refer to the length of the head and neck as a unit of measurement. Although there are exceptions, the female body is usually smaller than that of the male.

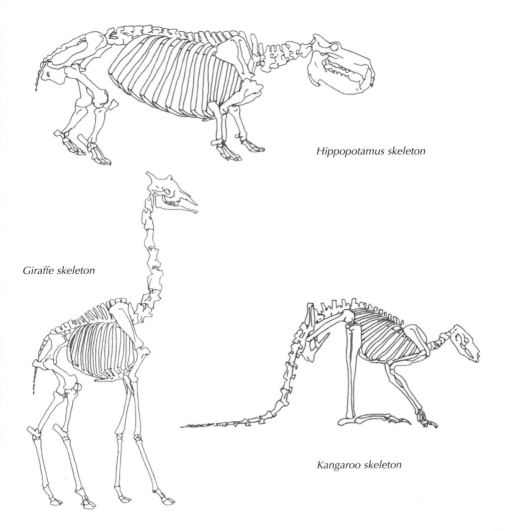

Hippopotamus skeleton

Giraffe skeleton

Kangaroo skeleton

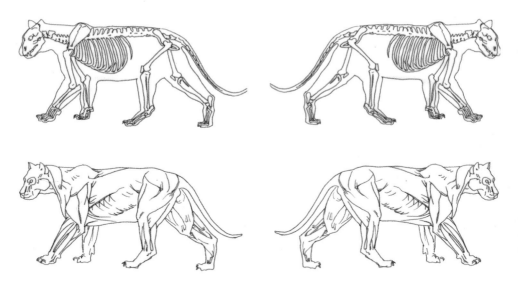

Bone structure and muscle mass of a feline (tiger)

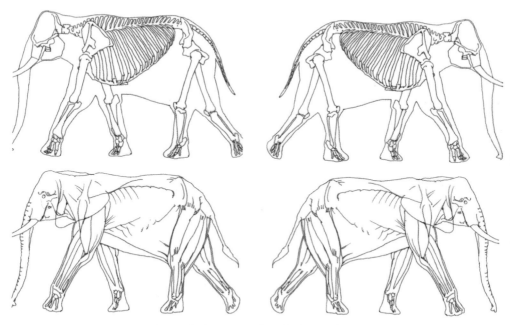

Anatomical structure of an elephant (African)

It is useful when drawing or sculpting any animal from memory to refer to images or sketches showing the anatomical projection of both sides of the animal. Study the bone-muscle structure and adjust your drawing accordingly to ensure accuracy. This speeds up the procedure and reduces the risk of uncertain interpretation.

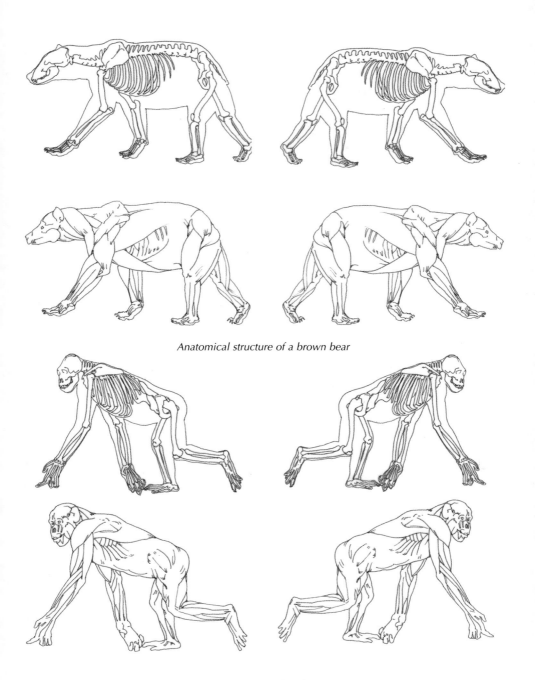

Anatomical structure of a brown bear

Anatomical structure of a chimpanzee

FORM, STRUCTURE AND MOVEMENT

The heading here indicates how you should approach the drawing of your subject in stages. First it is the form, which is so varied between species that we can often even identify a species by its silhouette. Next, the structure: give some attention to the osteoarticular system (bones and joints) and the myological system (muscles) of your chosen animal. Now tackle movement: practise drawing the animals from life or from good photographic images or videos (refer to pages 336–339). At the same time, try to identify proportional relationships between the parts of the body and between the animal and its environment; then make accurate studies of form and structure, skin characteristics, the differences in form associated with sex, age and varieties of species. The following diagrams highlight some elements that should be observed and suggest methods of further study.

 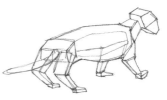

Stage 1 *The skeleton* **Stage 2** *Analysis of volume* **Stage 3** *Identification of body planes*

The study of form can be completed in more than one stage. For example, first identify the main form of the simplified skeleton (stage 1 above); then, flesh out with the body volumes in the form of basic cylindrical or ovoid forms (stage 2); lastly, identify the various planes of the body surface so that you can accurately predict tones and shading in relation to the light source (stage 3).

It is extremely important to consider the size and proportions of the animal body by creating drawings depicting the profile from above (or the transverse profile), as shown left. It is interesting to see where the main body masses are, as here comparing a lion and an elephant.

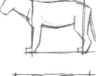

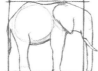

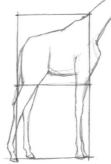

Simple geometric shapes can be combined with body outlines to show proportion very effectively. Notice, for example, that the giraffe is twice as high to the withers as it is wide. Such diagrams are also useful for depicting stance. Here we see a bear, lion, rhinoceros, African elephant and giraffe.

HAIR AND SKIN

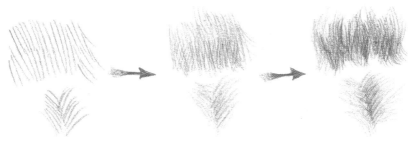

When drawing a medium-length coat, first identify the main direction of the hair then identify the sectional colour shades and finally add the details.

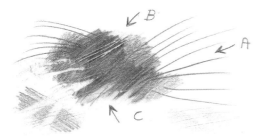

Hair which emerges from the body profile can be can be added with subtle yet decisive pencil strokes when it is against a light background (**A**), or scraped out with a sharp point when against a dark background (**B**). Before completing this final operation, practice must be carried out in order to judge the pressure needed to avoid tearing the paper. The use of an eraser (cut into a wedge) is less effective when you are trying to add fine strokes (**C**).

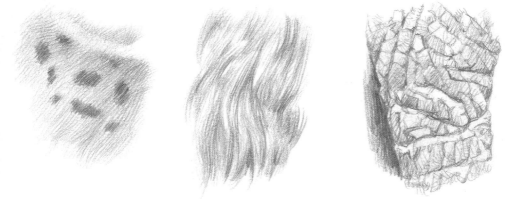

The direction of the pencil strokes and the pressure to be applied depends on the type of skin or hair you are drawing. These examples show short spotted hair, long curly hair and thick coarse skin.

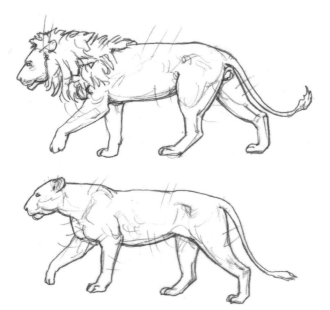

DIFFERENCES OF SEX AND SPECIES

Body size is a valid first indicator of whether an animal of a particular species is male or female. Usually, the female is smaller overall than the male, although there are exceptions and it is useful to consult scientific manuals with diagrams for accurate details. Some species have other distinct physical differences specific to the sex. For example, the male lion has a mane unlike his mate.

Physical differences associated with the sex (known as sexual dimorphism).

There can also be significant differences between members of the same species or closely related species that come from different environments. Asian and African elephants, for example, are closely related species that have a number of physical differences. For example, the Asian elephant (**A**) when compared to the African elephant (**B**) is smaller overall, has smaller auricles (ears) and shorter tusks, the back profile is regularly convex, and the trunk has just one finger (**C**).

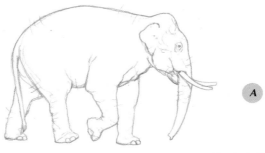

A

Physical differences associated with the species.

C

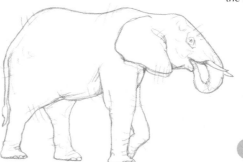

B

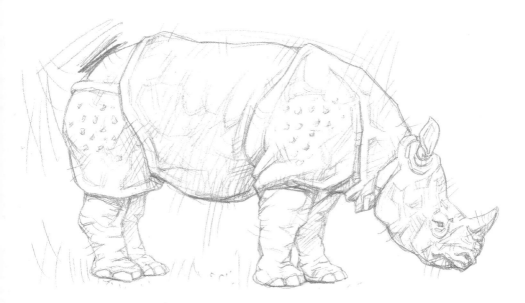

In the same way, the Indian rhinoceros is single-horned and 'armoured' (see the drawing above) while the 'black' (pointed upper lip) and 'white' (straight upper lip) African rhinoceroses (see drawings below) both have two horns.

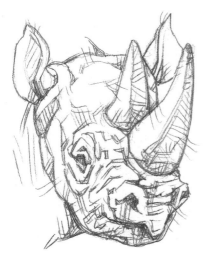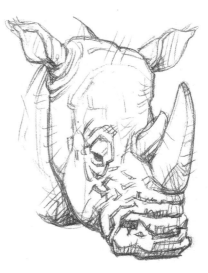

PHYSICAL DETAILS

Many beginners concentrate on the major characteristics of the species they are drawing without giving full attention to the smaller details. But often-overlooked features such as the ears, feet and noses are important too. Not all mammals' noses are the same! These diagrams give examples to show how subtle or how vast the differences can be.

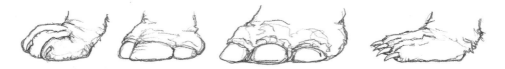

Animal feet: lion, rhinoceros, elephant and bear.

*Big cats (Felidae) noses in front view (**A**) and oblique projection (**B**).*

A *A* *B*

lion

tiger

Ear shapes: lion, bear, rhinoceros and hippopotamus.

The foot of the elephant (like that of the rhinoceros and hippopotamus) is able to support great weight without sinking into the ground because the support surface is vast and the toes are arranged on a type of fibre-adipose tissue cushion, suitable for evenly distributing the weight and not leaving very heavy footprints.

A *B*

The ungulates are divided into: artiodactyla (**A**) – animals with an even number of toes (for example, the giraffe) – and perissodactyla (**B**), animals with an odd number of toes (for example, the rhinoceros).

350

MOVEMENT

You need to understand a few basics of anatomy in order to draw your animal correctly. The area of the autopod, which in humans denotes the hand or the foot, is particularly important because it provides support on the ground and enables the animal's locomotion.

Although animal movement is usually quite fast, it can be easily studied using photographs, film and other identification and recording tools (see pages 336–338). Alternatively, careful and repetitive observation of the behaviour of the animal may be enough. In this way it is possible to note that movement across many similar species features shared characteristics as well as some characteristics specific to each species.

Movements can be carried out without repositioning (for example, sitting down, getting up, laying down, rolling over, etc.) or by moving across the ground (for example, walking, running, jumping, climbing, crawling, etc.). The movement is carried out using a series of alternate stages of balance and imbalance of the body caused by the movement of the centre of gravity in relation to the support area: four-footed animals usually move the right front limb and the left back limb, and then the left front and the right back limb. There are, however, some exceptions: the elephant, giraffe and camel, for example, amble, hence the limbs on the same side move forward at the same time, whilst the other two remain still to support the body weight. Their movement can be easily observed, particularly if you are studying an animal in a zoo, as animals in captivity tend to repeat the same movements frequently.

Simplified diagram of the structure of a limb (hind) of a generic mammal:

1. pelvic girdle
2. stylopodium
(thigh or upper arm in humans)
3. zeugopodium
(forearm or calf in humans)
4. autopodium
(foot or hand in humans) –
A. carpus/tarsus; B. metapodium
(metacarpus or metatarsus);
C. acropodium (phalanges)

Diagrams of the distal region (autopod) of a forelimb:

1. unguligrade (hoofed)
2. plantigrade, i.e. walking on flat metatarsals (bear, monkey, human, etc.)
3. digitigrade, i.e. walking on the toes, AKA digits (lion, dog, etc.)

DRAWING METHODS

Drawing enables you to interpret reality. All artists gradually attempt to find a personal style that fits their temperament, their aesthetic sensibility and their culture. At the beginning of your artistic adventure, one of two well-established traditional approaches can be employed: starting with line drawing or with tone (and naturally, also with something in between). While linear drawing is primarily completed using pointed instruments (hard pencil, pen and so on), tonal drawing is more easily done using softer drawing tools (charcoal, pastel, brush and wash, etc.). However, it is wise to remember that the distinction is not based upon the type of instrument used, but the way you handle it and, primarily, the visual character adopted.

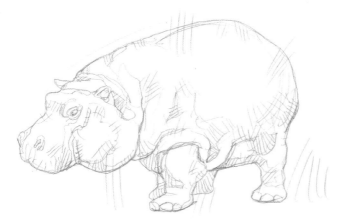

Purely linear drawing consists of the depiction of an object using only lines that can be thick, thin or a combination, and which conventionally are used to describe the outline of shapes, the development of structural elements or tonal areas. This type of drawing requires precise and clear markings, the result of a rational, analytical and structural vision of the image. At the same time you have plenty of freedom for interpretation and for decorative elements.

Purely tonal drawing, instead, does not directly resort to the line, but is upheld by the contrast between different contiguous tones that together denote the size, volume and external shapes of the object. This type of drawing is closer to a painting procedure, producing a representation which is both delicate and strong, unconcerned with unnecessary details. It can be difficult to begin with, however, for those of us trained from infancy to start with line.

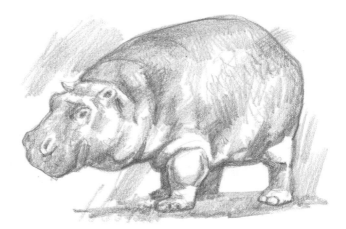

GENERAL DRAWING PROCEDURE

Below is a step-by-step example of standard drawing procedure, from the first strokes to the details. This system is one of the simplest and most common teaching methods and is very useful when studying complex forms, such as those of animals.

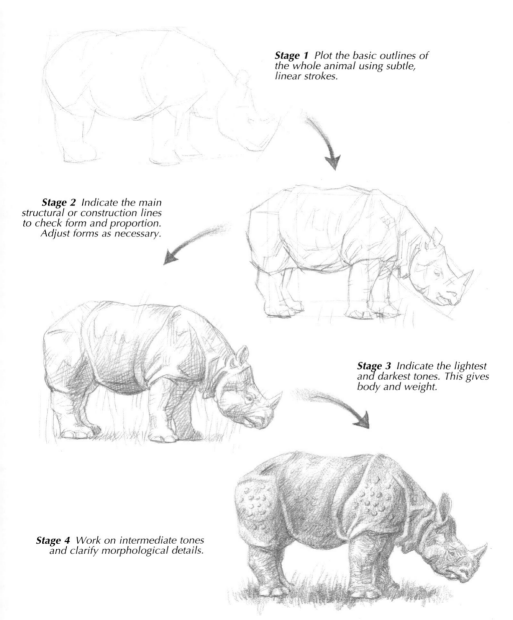

Stage 1 *Plot the basic outlines of the whole animal using subtle, linear strokes.*

Stage 2 *Indicate the main structural or construction lines to check form and proportion. Adjust forms as necessary.*

Stage 3 *Indicate the lightest and darkest tones. This gives body and weight.*

Stage 4 *Work on intermediate tones and clarify morphological details.*

TWO QUICK-SKETCH PROCESSES

Sketching wild animals from life requires great speed. The reason for this is
evident and results from the animal's continual and unexpected movement,
which is much sharper, more sudden and uncontrollable when compared to that
of many pets. Used as a simple observation exercise and using the photographic
documentation as effectively as possible, animal artists resort to two common
drawing processes – gesture and scribble – which are explained below.

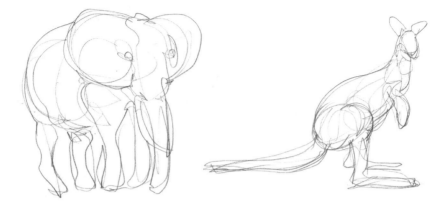

Gesture drawing is carried out quickly, and attention is given to the continual
observation of the subject rather than the rendering of details – don't look at your
paper, just draw. Such drawings are exclusively linear and continuous, almost
tangled; they tend to envelop the overall forms of the animal and are useful for
capturing posture or power of movement.

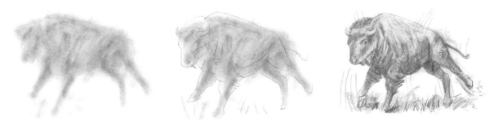

Stage 1 *Stage 2* *Stage 3*

Scribble drawing is also carried out rapidly, employing the following stages:
Stage 1: Indicate the overall body mass using, say, wash and brush or fingers and
charcoal/graphite powder.
Stage 2: Using a mid-to-soft pencil (HB or B) plot the outlines.
Stage 3: Using a very soft pencil (4B, 6B) add tones and detail. A wedge-shaped eraser
is useful for lifting out lighter areas of the body.

The two processes can be combined for a more dynamic drawing. Here are a few simplified structural drawings made using a mixture of gesture and scribble drawing.

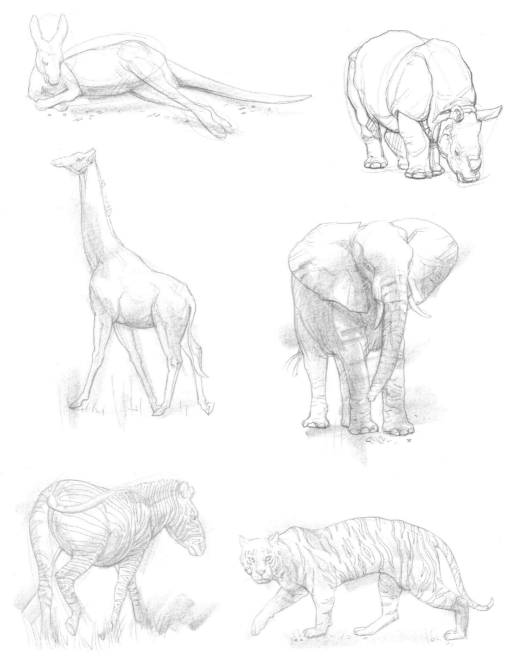

GIRAFFE (*GIRAFFA CAMELOPARDALIS*)

The giraffe is a remarkable and striking animal that lives in Central and Southern Africa. Its familiar reticulated markings make it easy to camouflage itself amongst the vegetation. It is the tallest of the mammals (exceeding 5m/16ft) yet is proportionally the shortest in terms of body length (approximately 2.5m/8ft). It is roughly 3m (10ft) to its withers but the hind limbs are much shorter than the forelimbs, so there is a significant inclination to the spine. Some subspecies exist: they all have two horn-like protuberances (ossicones) but some have a third, rounder horn-like protuberance on the top of the head on the forehead, the median lump, which is more pronounced on the males.

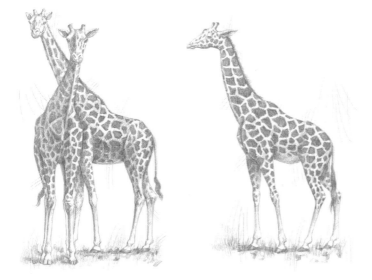

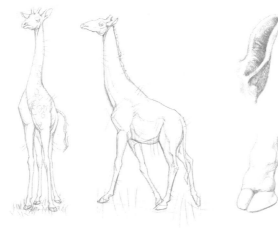

The giraffe is an even-toed ungulate with two toes and its ears are expressive and pointed.

Almost all giraffes have a coat pattern that is yellow to reddish brown in colour, with an almost rhomboidal-shape pattern. However, differences to the edges of the pattern shapes enable the identification of different giraffe subspecies: these can be consistent, quite soft or very jagged.

The giraffe's face is very elegant, long and slim, with soft, protruding, very flexible lips that are not sensitive to thorny shrubs; using their tongue, they are ideally suited to picking the leaves and sprouts on which they feed.

The eyes are large, wide set and heavy lidded and they have long eyelashes. The neck, despite being extremely long, is formed of seven cervical vertebrae, as is the case with almost all mammals.

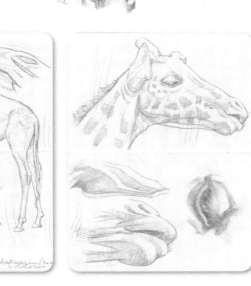

ZEBRA (*EQUUS ZEBRA*)

The characterful zebra lives in Eastern, Central and Southern Africa, from grassland to savannahs, woodland and mountains. It has a build somewhere between that of a horse and that of a donkey and is approximately 1.3m (4¼ft) to the withers. The zebra forms part of the Equidae family and its anatomical structure is the same as that of a horse, although proportionally it has a wider head, shorter neck and shorter limbs. There are three surviving species: mountain zebra (*Equus zebra*), plains zebra (*Equus quagga*) and Grevy's zebra (*Equus grevyi*).

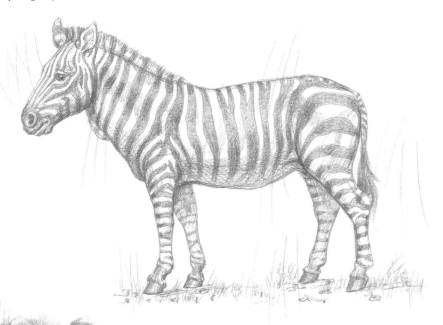

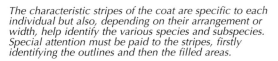

The characteristic stripes of the coat are specific to each individual but also, depending on their arrangement or width, help identify the various species and subspecies. Special attention must be paid to the stripes, firstly identifying the outlines and then the filled areas.

Note also how the shapes of the stripes help to reveal the anatomical shapes in accordance with your viewpoint. To get this right, it is essential to resort to a photograph, as, in the flesh, it is almost impossible to follow the exact progression of lines. It is usually preferable to add the stripes after you have placed the essential tones to describe the volumes of the body, effectively laying the stripes over the tones.

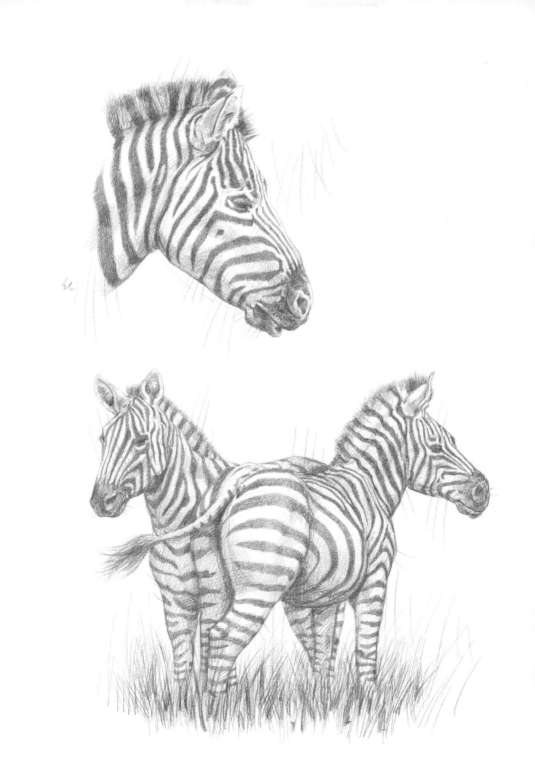

BROWN BEAR (*URSUS ARCTOS*)

The brown bear is one of the largest land-based predators on earth and can be found in Northern and Eastern Europe, Central Asia and North America. Its height up to the withers is approximately 1.3m (4¼ft), it is about 2.3m (7½ft) in length. When it stands on its hind legs, it can reach a height of 2.5m (8¼ft). It is a solitary animal and it walks with the toes and metatarsals flat on the ground (plantigrade locomotion). The feet are wide and flat, with five long claws, one for every toe. The thick fur, which also covers the paws, conceals the anatomical details of the toes and the entire limb, so to draw it effectively, it is necessary to resort to other documentary sources which could provide clear perspective.

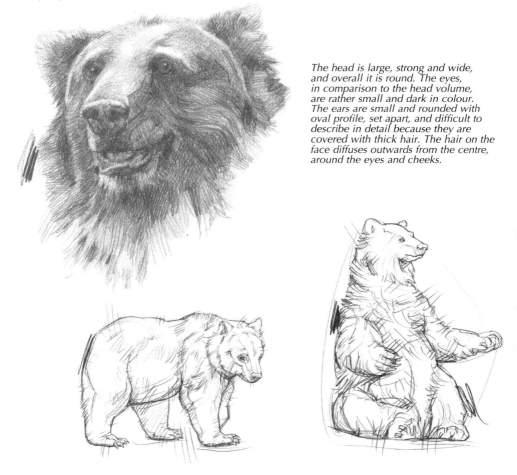

The head is large, strong and wide, and overall it is round. The eyes, in comparison to the head volume, are rather small and dark in colour. The ears are small and rounded with oval profile, set apart, and difficult to describe in detail because they are covered with thick hair. The hair on the face diffuses outwards from the centre, around the eyes and cheeks.

The overall form of the bear is stocky and strong, larger across the back area of the body. All bears, of any surviving species, walk on four paws, but can also fully stand or stay seated, assuming, at times, amusing, human-like positions, in which the bear nearly always stays still for enough time to complete an accurate drawing.

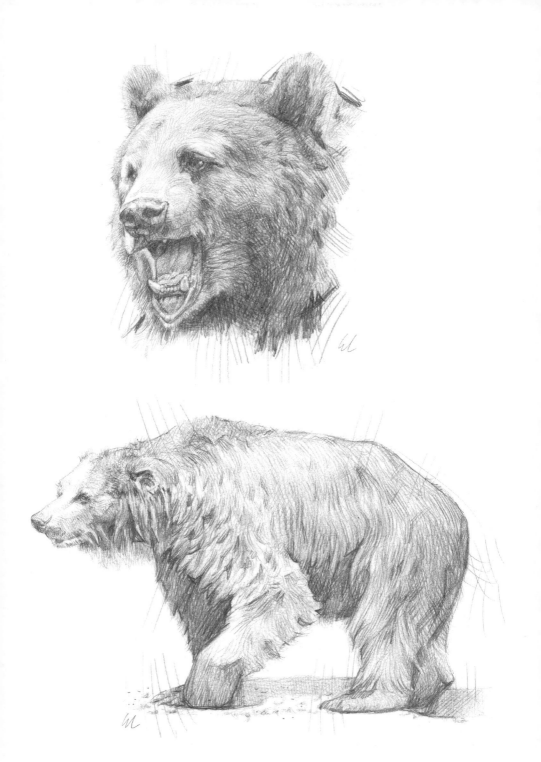

TIGER (*PANTHERA TIGRIS*)

The charismatic tiger is the largest of the felines: it is almost 3m (10ft) long and its height up to the withers is approximately 1m (3¼ft). It is found in Southeast Asia, and includes six subspecies, which vary in terms of body size and coat colour as well as the arrangement of the stripes. The body is very slender and no part of the body is wider than the head.

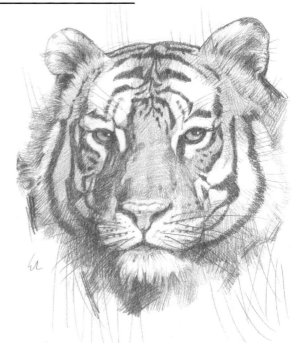

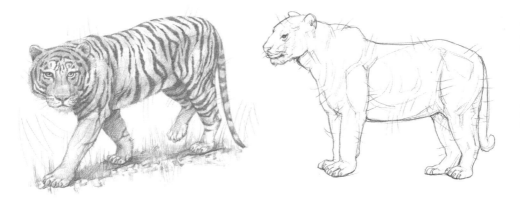

When drawing the tiger, as with all animals that feature markings or stripes on the coat, it is wise to define the anatomical structure and add the main tonal areas of the body mass before adding the markings. The arrangement and structure of the stripes is common to all tigers, even if every individual has specific characteristics. On the head, big spots outline the face and eyes; the stripes run across the neck and from top to bottom on the torso, and also they run horizontally across limbs (particularly hind limbs) and the tail.

Felines have very small incisors (six on each arch) while the canines are long and sharp. The bottom canines are closer together than the top ones and, when the mouth is closed, they sit alongside and overlap. The lip edge is very dark while the tongue is very long and flexible. The pupils (as with most large feline species) are circular. The face features plenty of sensitive hair: on the top lip (whiskers) and on the supraorbital ridge (the eyebrow in humans) towards the auricle (ear).

LION (PANTHERA LEO)

In ancient times, the lion was widespread in Europe and Asia, but presently it resides only in Sub-Saharan Africa and in Asia. It is almost 2m (6½ft) long, it has a tail of approximately 90cm (35½in) and its height up to the withers is approximately 90cm (35½in). Unlike the tiger and other felines, it is a social animal guided by gregarious behaviours that favour the establishment of prides, the members of which live and hunt together. The female is smaller than the male, with a stronger predatory instinct, and typically the females of the group hunt together.

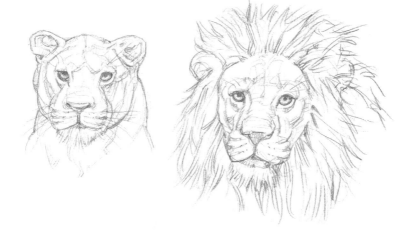

The differences between a lion and lioness are notable: the male, for example, is larger, weighs more and has a mane formed of long thick hair on the head, back, neck and chest. The female is more agile, slimmer and is more involved in hunting and raising cubs. In the case of both sexes, the tail is hairless and the tip features a dark, hairy tuft. The hair on the rest of the body is rather short, which makes it easy for us to see the strong, muscular body and how it moves.

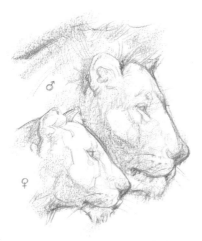

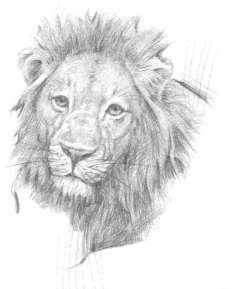

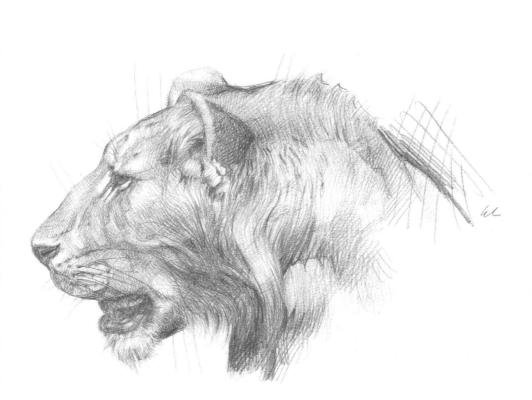

From an aesthetic viewpoint,
a lion's head appears beautiful
and intelligent, it is wide
and regularly symmetrical,
with alert, wide-set eyes. The
pupils are circular and the
eyebrows are embedded by
a few vertical folds, which
can give the impression of
an attentive and authoritative
gaze. The shape of the nose
is similar to that of all large
felines (see also page 350),
but the lion's nasal septum
(middle vertical section) is
finer than that of the tiger.

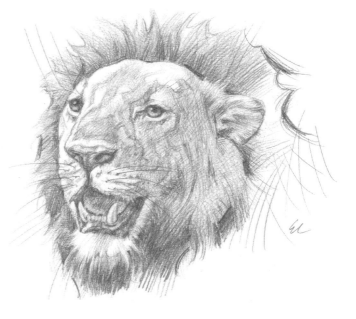

JAGUAR (*PANTHERA ONCA*)

The jaguar lives in the forest and woodland of Central and South America. It is smaller than the tiger and the lion at around 2.5m (8¼ft) long, 1m (3ft) of which is the tail, and its height up to the withers is approximately 80cm (31½in). The coat is formed of short hairs and is a yellow-reddish colour across the back and sides, while the stomach and paws are whitish. It is covered with black, roundish, characteristic markings: they are large with a rosette pattern arrangement on the sides and back with one or more small markings on the tail (a feature which distinguishes the jaguar from the leopard), along with plenty of rather small markings here and there.

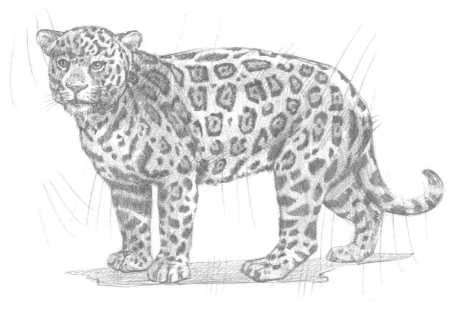

The jaguar has a comparatively large head, which is a roundish shape, and it has small eyes, a wide chest and quite short paws. The head is nearly always more significant or expressive than the body, however the animal must be studied in its entirety.

Upon deciding to extract a part of the subject, it must be remembered that the drawing must not depict an 'amputated' part but a part of a living organism.

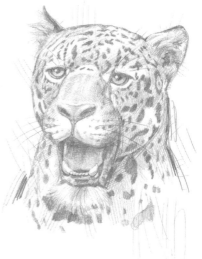

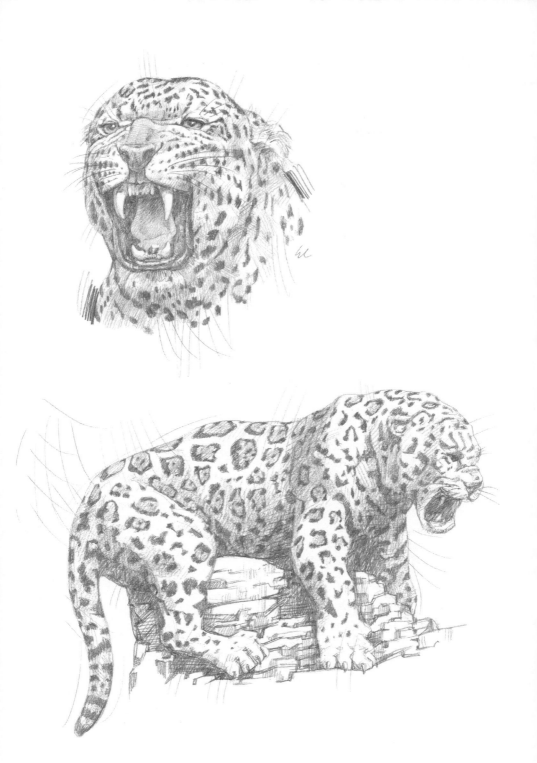

MEERKAT (*SURICATA SURICATTA*)

The meerkat belongs to the mongoose family (Herpestdae). It is a small animal that is very energetic and inquisitive and eats a variety of food from small lizards and insects to fruit. It lives in large groups in extensive burrows with systems of tunnels and rooms. It is approximately 35cm (13¾in) long (excluding the tail which is approximately 25cm (9¾in)) and has thick grey-brown hair with dark horizontal stripes across the back. It resides in Southern Africa and some areas in Asia.

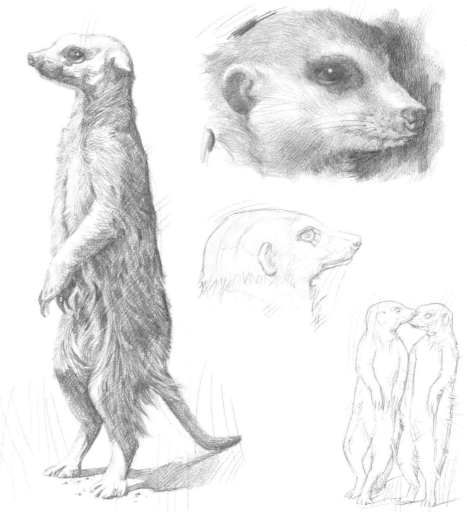

The meerkat happily warms itself in the sun or forages while others do sentry duty, often standing on hind legs for a better view. It has four-toed feet and claws that enable it to dig at a great rate. It also sits on its hips, with the body erect, looking out for danger using its excellent senses of smell and sight.

In addition to the stripes across the back, a meerkat has other very dark areas of hair around the eyes, ears and at the end of the tail. The head, including the face, is decidedly oval and elongated; the eyes are quite small, round and very dark; the ears are placed at the sides of the head and are small and semi-circular, and have evolved to permit closure of the ear canal to prevent dust or sand from entering the ears.

RHINOCEROS

There are two surviving species of the African rhinoceros, the so-called black rhinoceros (*Diceros bicornis*) and the white rhinoceros (*Ceratotherium simum*). There are also the Sumatran, Javan and Indian rhinos. Presently, all species are endangered.

Although different sizes and with different morphological details, all rhinos share the same head, which is very elongated with one or two horns, and have a very short neck, short paws and very thick, hard skin. On average, its height up to the withers is approximately 1.7m (5½ft) and it is 3.5m (11½ft) long. The Indian species (*Rhinoceros unicornis*) differs from the African species as it only has one horn, and the skin is scored with large folds and sprinkled with round relief sections.

Despite their names, both African rhinos have grey skin. The white rhino is slightly taller with a bigger head and longer neck, and the lip of the white rhinoceros is straight, while the lip of the black rhinoceros protracts in the centre to form a small extension (see also page 349). In fact, 'white' here was thought to be a mistranslation of the Dutch *weidmond* meaning 'wide-mouthed'. Both African rhinos have two horns; the front horn is much larger (it can be over 1m/3ft), while the other horn behind is chunkier and a lot smaller. The horn is actually thickened skin and does not include supporting bone.

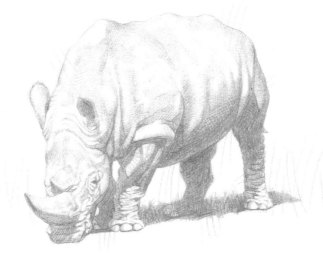

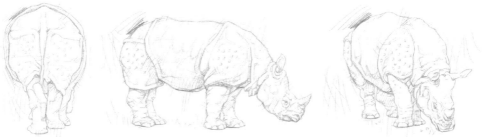

Rhinoceros unicornis

The head profile is concave and the neck, compared to the huge head and torso size, appears very short. The back of the black rhinoceros is concave while the back of the white rhinoceros features slight convexity in the middle section.

Each foot has three toes with hard toenails: the middle one is larger than the ones either side. The auricle cartilage (ear) is cylindrical at the base and opens up to form an oval outline, the top of which features a tuft of coarse hair.

The rhino's body is massive and its feet are stocky, but when spurred by aggression or the defence instinct, it can reach speeds of up to 45kmph (28mph) over short distances.

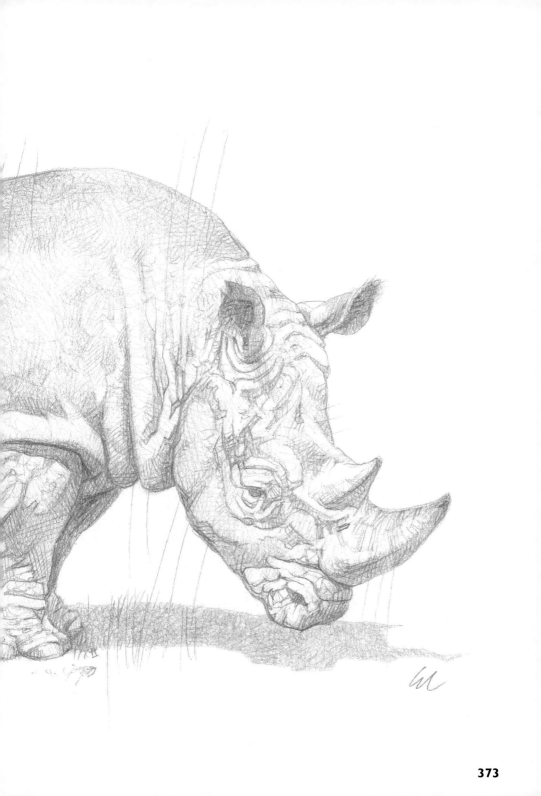

ELEPHANT (*LOXODONTA AFRICANA* AND *ELEPHAS MAXIMUS*)

There are two main elephant species: the African and Asian elephant, although there is a suggestion that there are actually two species of African elephant. The African elephant is the largest land mammal on Earth, and is found in Central and South Africa. Its height up to the withers is almost 4m (13ft) and it is about 5m (16½ft) long. The Asian elephant lives in South Asia and is smaller than its African counterpart.

The two species have many shared characteristics such as the extremely elongated nose (the trunk), the sharp top incisors (the tusks) and wide and mobile auricles (ears). Equally they have characteristics that help us tell them apart (see also page 348). The African elephant's front legs have four toenails and the back legs have three; the auricles are quite broad and have a triangular outline; the tusks are very long; the end of the trunk is equipped with two short finger-shaped extensions; and the back profile is concave across the middle section. The Asian elephant's front legs have five toenails and the back legs have four; the auricles are medium sized; the tusks are rather short; the trunk has only one finger-shaped extension; the forehead protrudes; and the back profile is regularly convex.

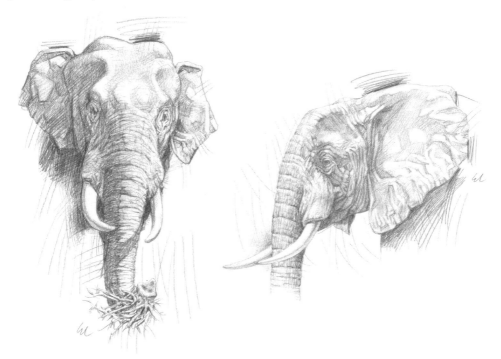

The tusks (which can be lacking or very small depending on sex and subspecies) are actually incisors and are deeply set into the skull. At times the skin layer over these appears to reach almost to the eye and cheek, creating a deep cavity. The African elephant has a flat forehead, protruding supraorbital ridge and very large eyes. The Asian elephant, instead, has a centrally concave forehead, longer trunk and two large front convexities at the brow.

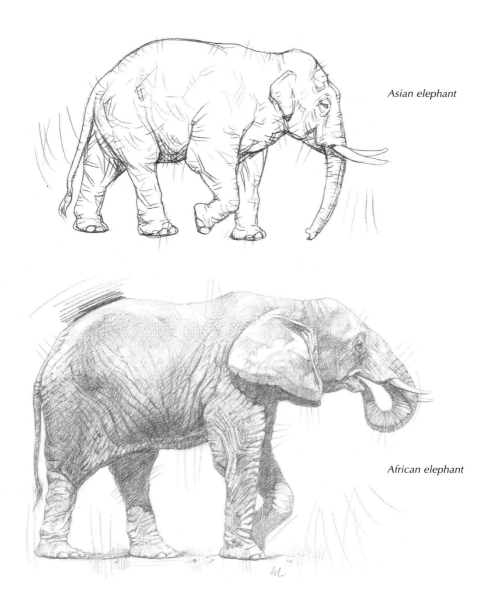

Asian elephant

African elephant

All elephants have a smooth, hair-free tail, with the exception of the short end section, which features a small tuft. The trunk, the extremely flexible transformation and extension of the nose and upper lip, carries out multiple tasks: in addition to a respiratory function, it is useful for smelling, sucking up water (or dust for a sand bath), feeling objects and grasping food. It has many horizontal skin folds, which gradually become closer together and fainter towards the free end. The auricles are large, smooth, slim and extremely mobile. The surface area also regulates the temperature and is therefore cut through by relief parts of the wall veins. The outer edges on old elephants may be corroded or jagged as the result of trauma and they may also be wrinkled.

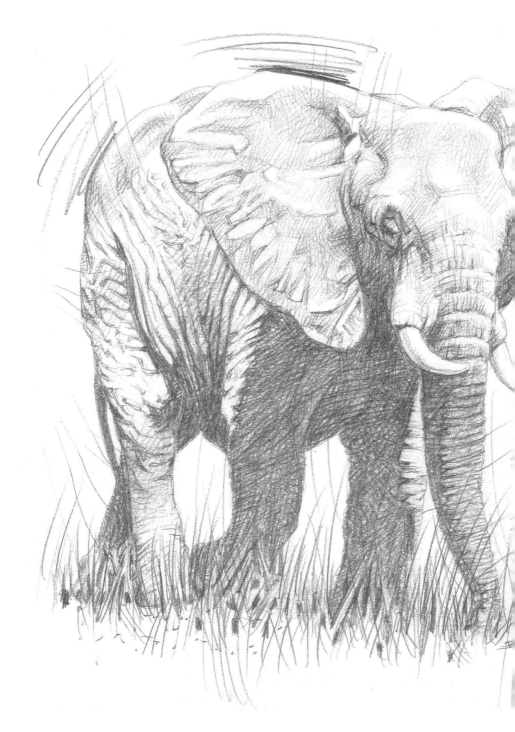

Young elephants, called calves, are reared by the mother or family group for a comparatively long period. They have no tusks, which grow over time, and their skin is rather smooth or slightly scored. The typical folds and rough skin are established upon reaching adulthood at about 15 years of age. The head appears quite large in comparison with the overall body proportions.

KANGAROO (*MACROPUS GENUS*)

The kangaroo a marsupial with such long feet that it cannot walk like other animals and so either hops or crawl-walks. It lives in Australia, Tasmania and their surrounding islands. The back legs are very strong, enabling it to move quickly over great distances. There are various kangaroo species but the red kangaroo (*Macropus rufus*), which is the largest marsupial in the world, is the most well known. It is 1.6m (5¼ft) long in addition to its strong tail, which is almost 1m (3ft) long. The forelimbs are half the length of the hind limbs, and they have four toes – some fused together – that are finished off with very strong claws.

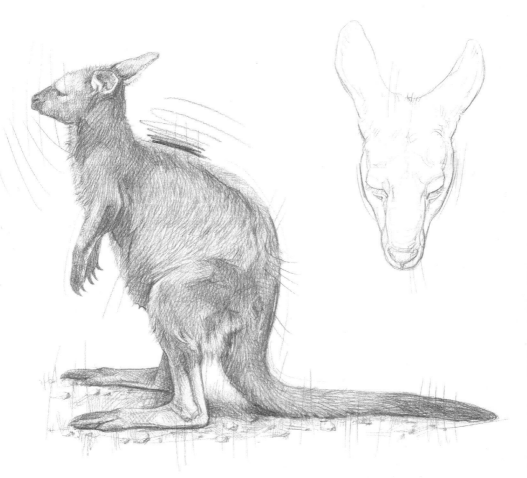

The kangaroo, when in the seated position, rests on the entire foot and not just the toes of the hind limb. The tail offers support, but also helps with jumping, running and balance.

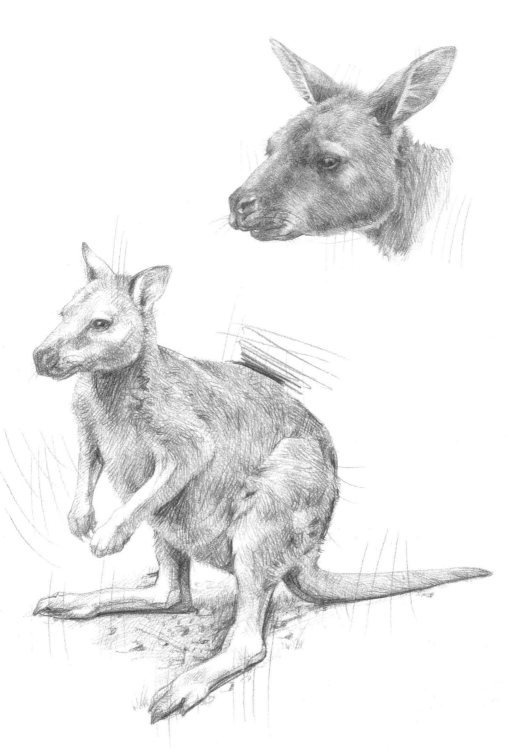

CHIMPANZEE (*PAN TROGLODYTES*)

The common chimpanzee (which is a primate) is a species of great ape. It is found in equatorial Africa, in diverse habitats from savannahs to forests, where it lives in groups of numerous individuals. It has no tail. It moves on four legs on the ground, resting on the toe knuckles, but it is not uncommon for the chimpanzee to assume an erect position. In this position, the male can reach up to 1.6m (5¼ft) tall while the female is smaller.

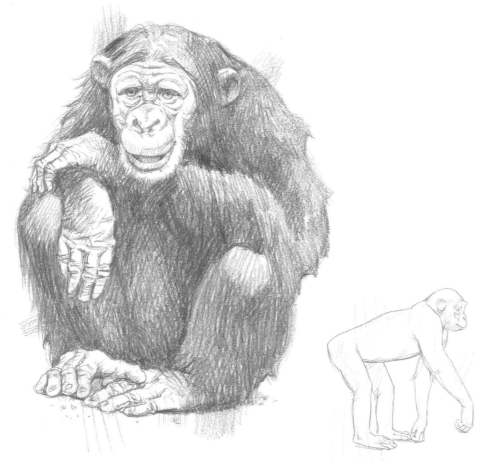

The skeleton and muscle mass of chimpanzees are very similar to those of humans; however, chimpanzees use arboreal locomotion and therefore brachiation, swinging through the trees, primarily using their arms, which is why their upper bodies are extremely developed and the forelimbs are very long when compared to the hind limbs. When moving on the flat, as when on the ground, movement is quadrupedal, using hands and feet, on their knuckles, but chimps also move across short distances walking upright.

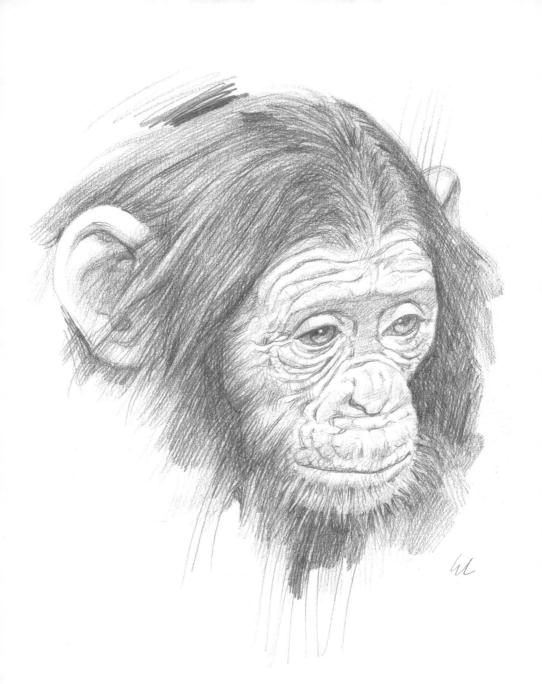

The head is somewhat round and the eyes are small with brown around the irises, the face is bare of hair, the forehead has deep transverse creases, the lips are thin and the nose is flat. The skin on the face is pinkish, although it tends to darken with age, with darker thickening around the eyes. The ears are large, protruding, rounded, hairfree and do not have lobes. The bottom lip, in both sexes, sometimes features a type of thin and white 'beard'.

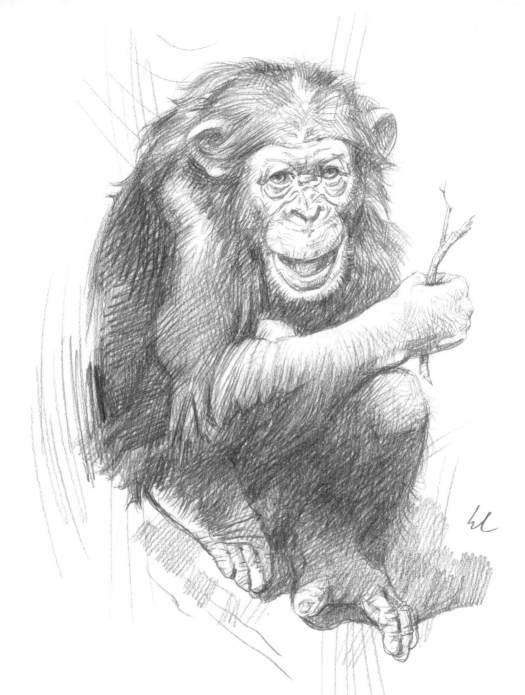

A chimp's entire body, with the exception of the face, the fingers and palms of the hands and the toes and balls of the feet, are covered with thick, straight, hair, which is black and shiny. The thumb and, to an extent, also the big toe are opposable, enabling accurate gripping and the use of tools.

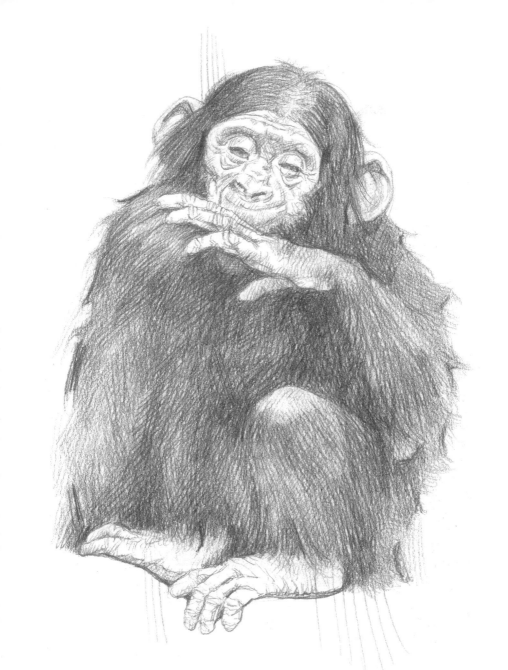

The face of the chimpanzee has 23 mimetic muscles and consequently is very expressive:
it clearly displays various feelings and emotions, some similar to humans and which can be
interpreted in the same way. The lips, in particular, behave in a whole wealth of different
ways although the eyes and gaze are also expressive and make drawing these animals a real
pleasure. Care must be taken, however, to ensure that these behaviours and expressions are
not too humanized (anthropomorphized).

SKETCHBOOK STUDIES

The study of wild animals is even more complex than that of pets. After all, pets and other domesticated animals can be quite easily and regularly viewed, whether in the home, garden or countryside (livestock or farm animals). In the case of wild animals, such as those on which this chapter focuses, documentary, photographic and video images are essential if only as reference material (see page 338).

Owing to issues of safety and environmental conditions, it is rare to be able to study wild animals in their natural habitat in the detail necessary, up-close and comfortably, with enough time to analyze and draw the most characteristic forms and behaviours. For this reason, history museums offer great observation opportunities. Many large cities boast such museums and they almost always present a pretty accurate reconstruction of prepared (stuffed) animals in their habitats. They consist of static models, which it is possible to draw peacefully and in your own time from multiple angles, noting both the overall form and specific and significant details, while also making a comparison of the differences between similar species. Using such a study is a good way of safely and surely completing a more complete drawing of the animal in the flesh, although if this opportunity isn't open to you, you can also use film documentation.

The sketchbook pages that follow give you an example of what you might concentrate on in your studies.

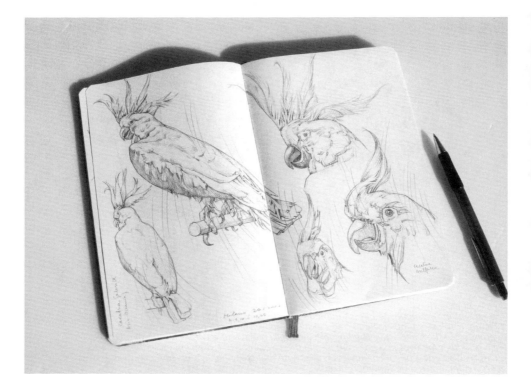

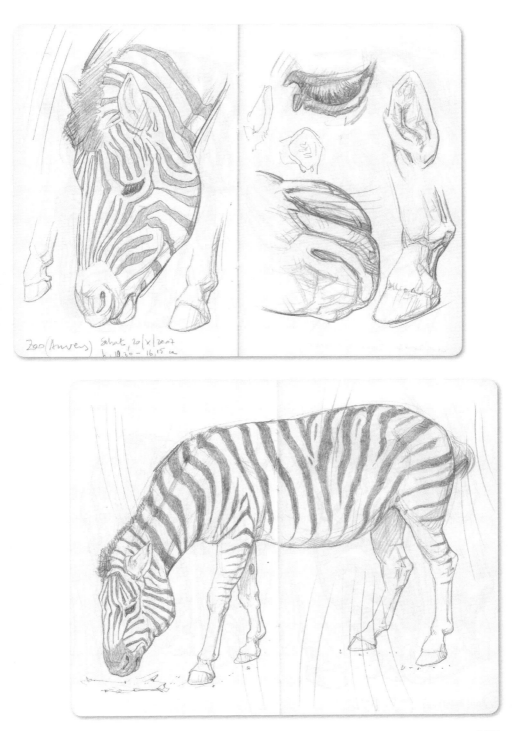

Zoo (Anvers) Sabat, 20/X/2007
l. 19.30 - 16.15 ca

385

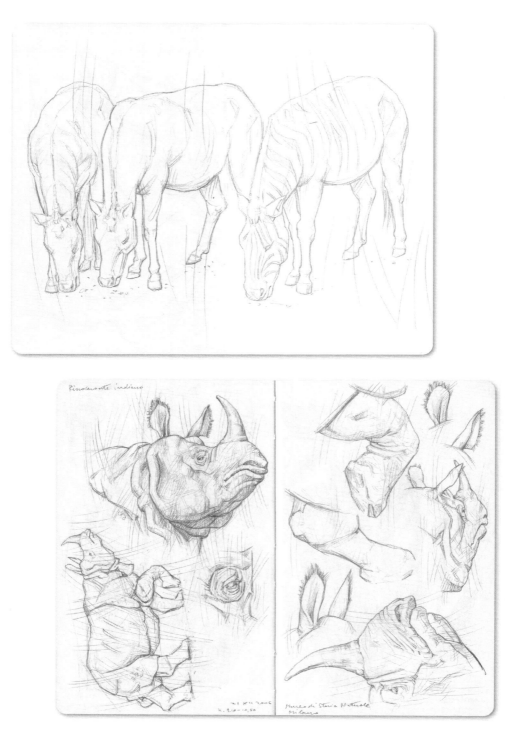

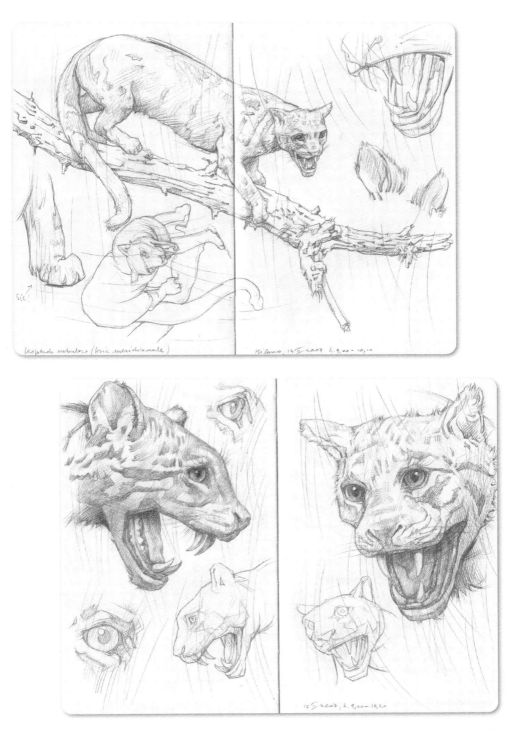

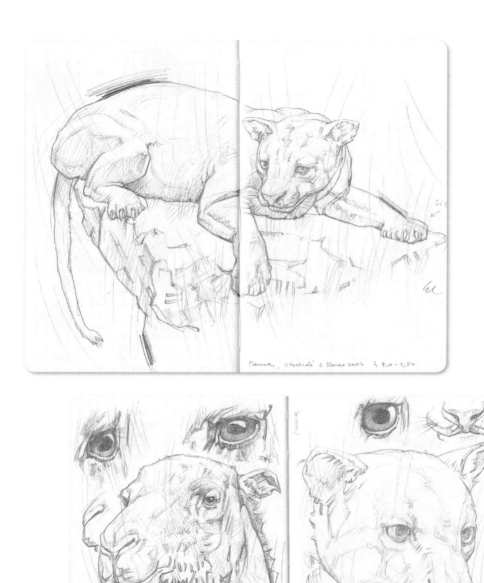

Parma, venerdì 2 Marzo 2007 h 9.10 - 9,50

1 Marzo 2007
h 14,30 - 15,10

1/3/2007
h 15,20 - 15,50

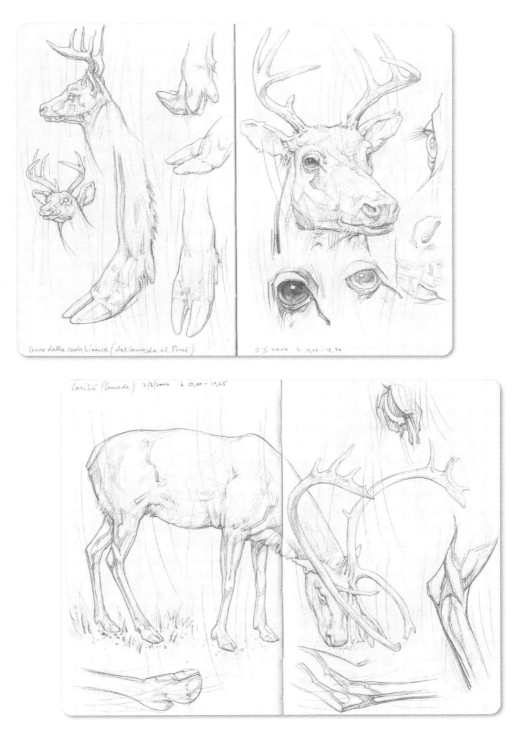

(cervo dalla coda bianca (dal Canada al Perú) 15 V 2007 h. 16,30 - 18,30

Caribú (Canada) 2/3/2007 h 10,00 - 10,45

389

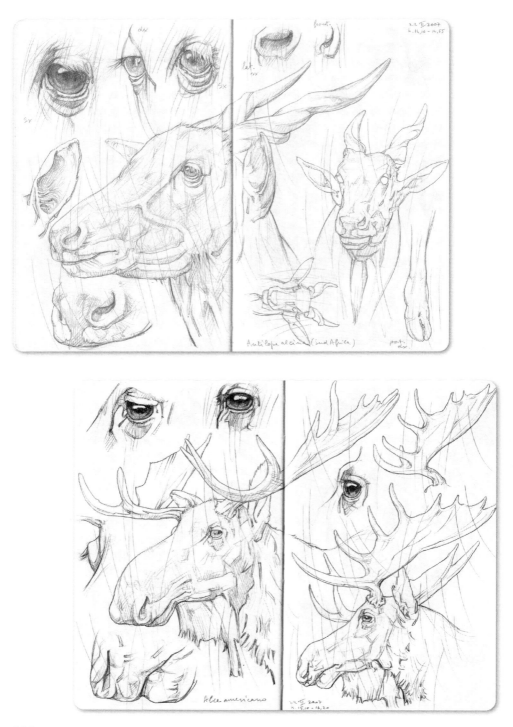

Antilope alcina (sud Africa)

Alce americano

390

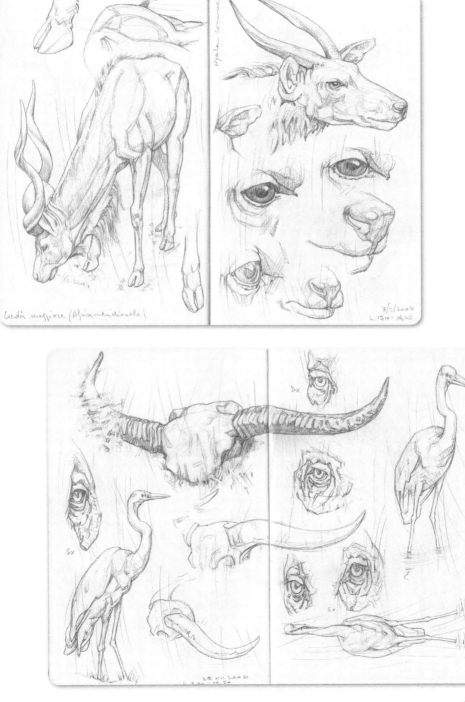

Cudù maggiore (Africa meridionale)

7/2/2007
h. 15,10 - 16,25

Dx

Sx

Sx

28 XII 2006

391

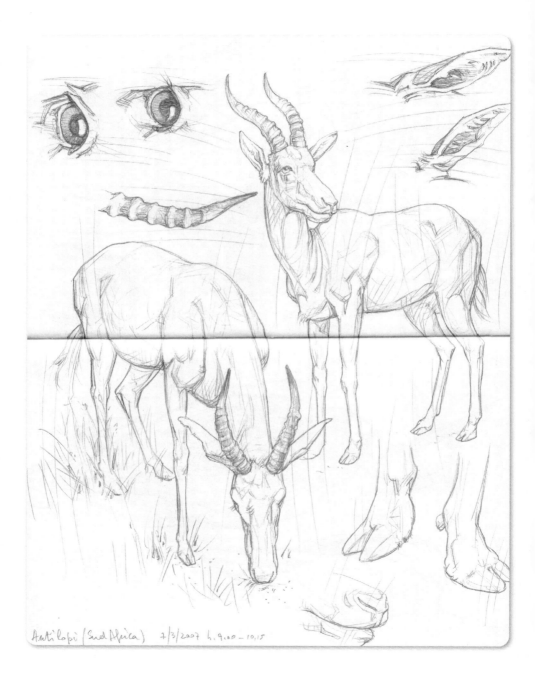

Antilopi (Sud Africa) 7/3/2007 h. 9.00 – 10,15

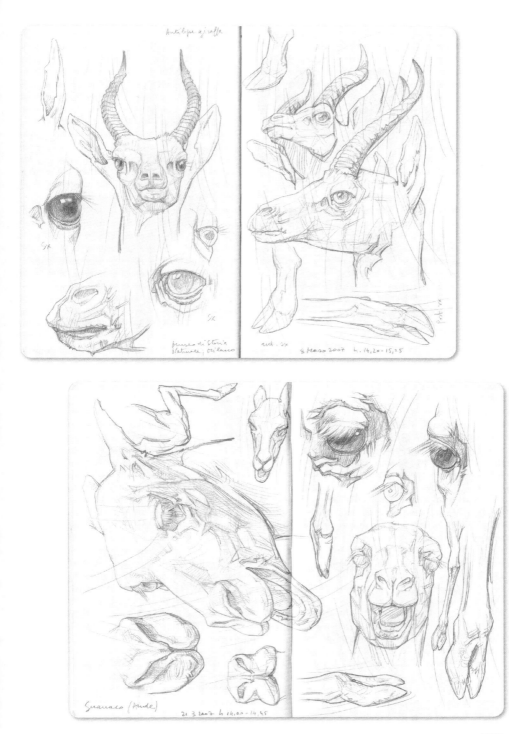

Antilope giraffe

Sx

museo di Storia
Naturale, Milano

art. Sx 8 Marzo 2007 h. 14,20-15,25

Guanaco (Ande) 21.3.2007 h 14,00-14,45

393

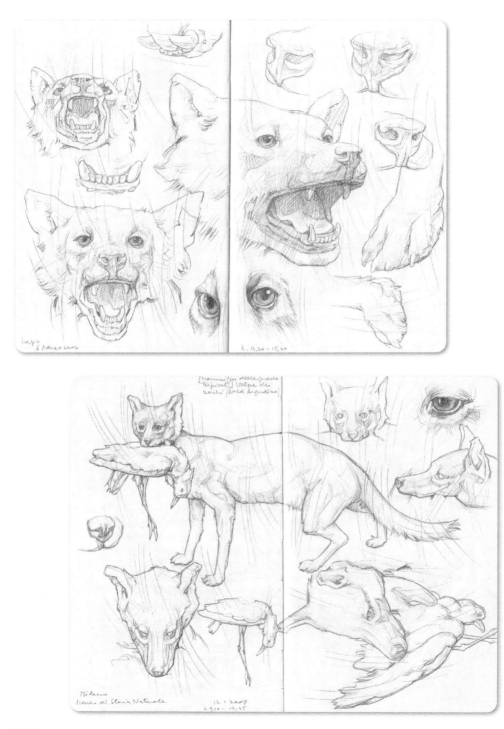

394

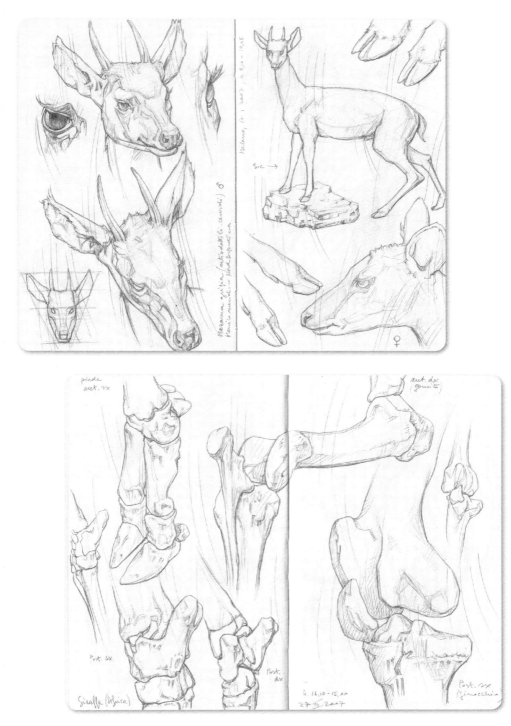

395

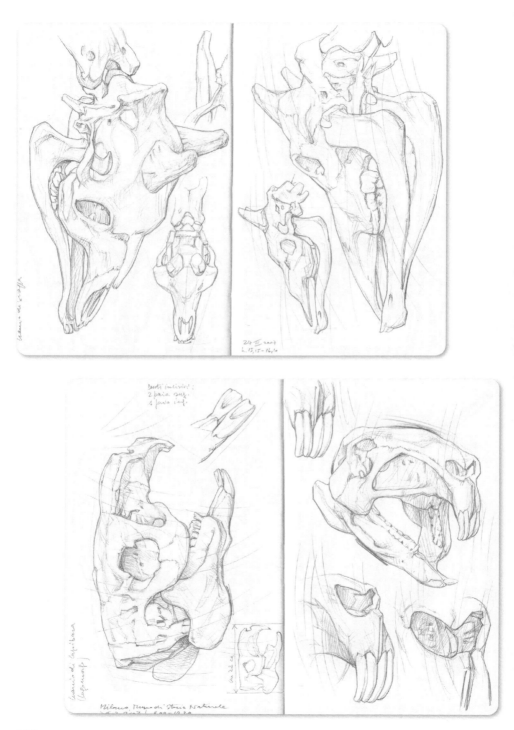

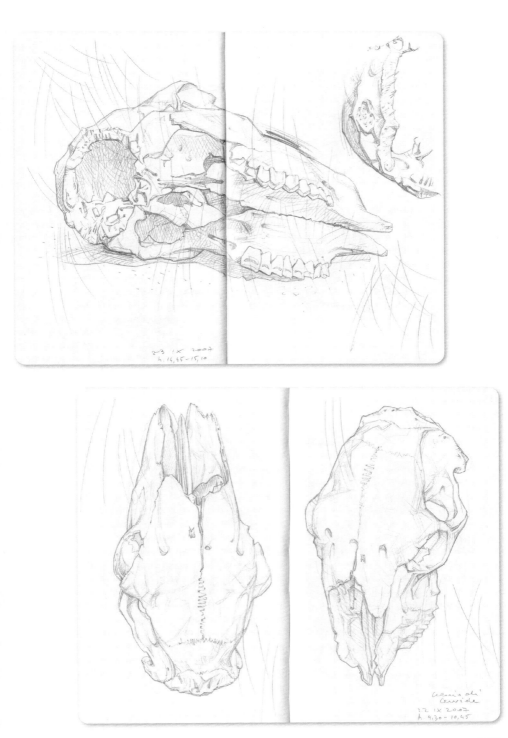

23 IX 2007
h. 16,45 - 15,10

Almin oli'
Cervide
22 IX 2007
h. 9,30 - 10,45

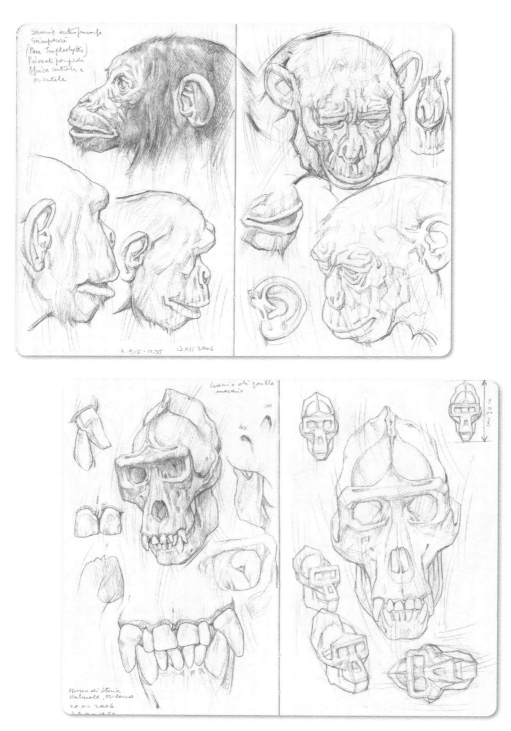

398

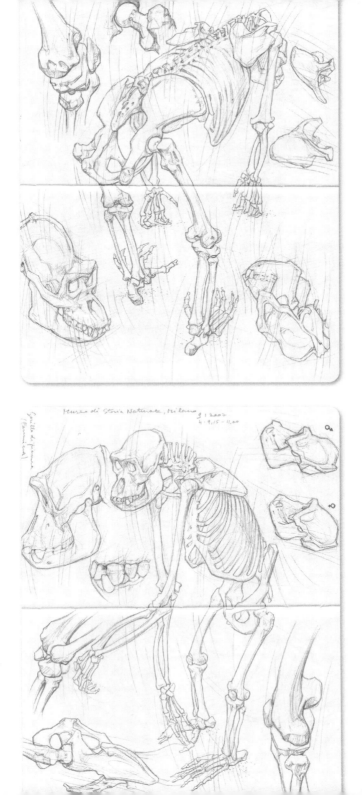

Museo di Storia Naturale, Milano 9 | 2007
 4.9.15 - 11.00

Gorilla di pianura
(femmina)

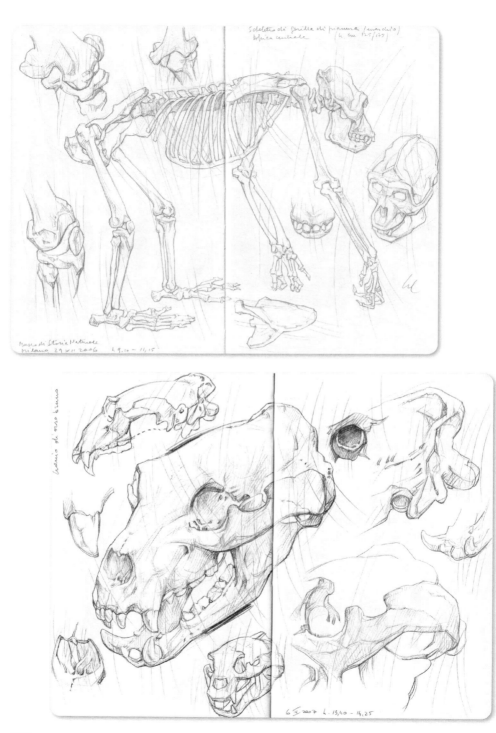